German Romantic Painting

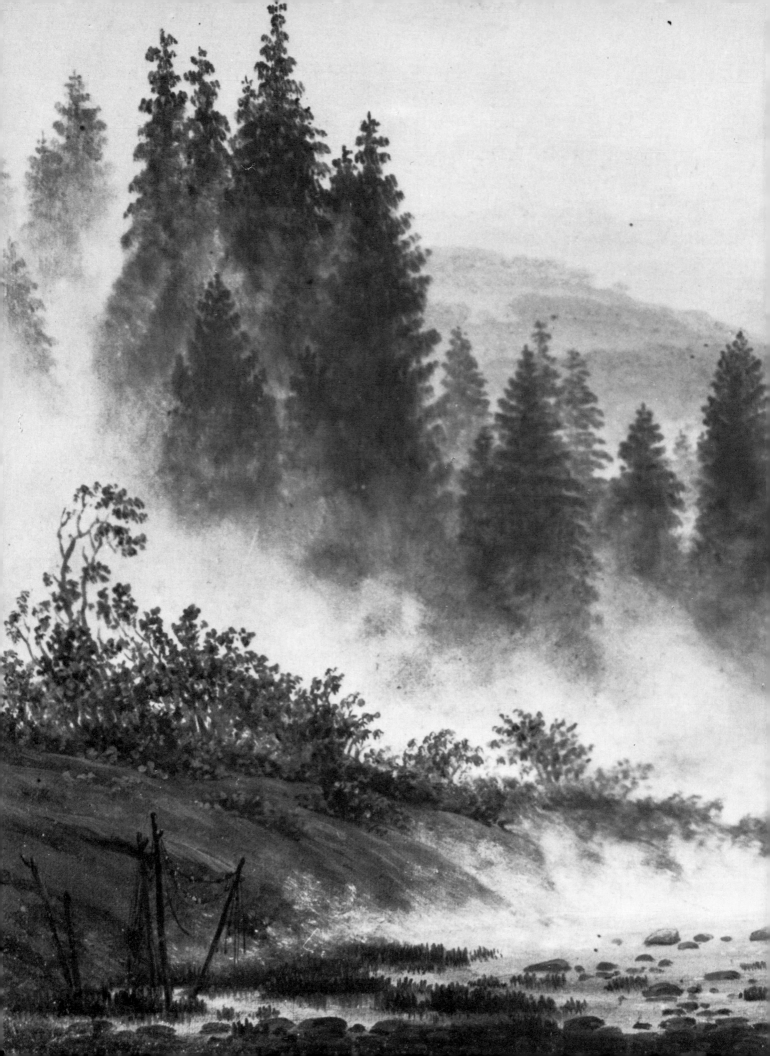

German
Romantic
Painting

William Vaughan

Yale University Press · New Haven and London

Designed by Faith Brabenec Hart.
Filmset in Monophoto Baskerville and
printed in Great Britain by
BAS Printers Limited, Over Wallop, Hampshire.
Colour illustrations printed in Great Britain by
Jolly & Barber Limited, Rugby, Warwickshire.

Published in Great Britain, Europe, Africa,
and Asia (except Japan) by Yale University Press,
Limited, London. Distributed in Australia and
New Zealand by Book & Film Services, Artarmon,
N.S.W., Australia; and in Japan by Harper & Row,
Publishers, Tokyo Office.

Library of Congress Cataloging in Publication Data

Vaughan, William, 1943–
　　German romantic painting.

　　Bibliography: p.
　　Includes index.
　　1. Romanticism in art—Germany. 2. Painting,
German. 3. Painting, Modern—19th century—Germany.
I. Title.
ND567.5.R6V38　1980　　　759.3　　　80-13170
ISBN 0-300-02387-1
ISBN 0-300-02917-9 (pbk.)

For Stary
and in memory of Kooee

Preface

THE PRINCIPAL INTENTION of this book is to provide an introduction to a subject that is little studied in the English speaking world. My own interest in German Romantic painting developed out of a fascination with the pictures of Caspar David Friedrich. This artist is given pride of place in this book. But I hope that I have shown that there are many other painters of great interest who were at work in Germany at the same time.

During the years that I have been thinking about and writing this book I have received help and encouragement from many friends in England and Germany. I owe a particular debt of gratitude to Professor Michael Kitson and Dr Alex Potts, both of whom read through the entire text and made invaluable suggestions. Bob Saxton edited the manuscript at an early stage, and greatly helped with clarifying parts of it. Amongst the many others who discussed and aided me with the themes of this work are Keith Andrews, Dr David Bindman, Dr Helmut and Dr Eva Börsch-Supan, Professor L. D. Ettlinger, Dr John Gage, Dr Jens Christian Jensen, Dr Hans Joachim Neidhardt, Professor Robert Rosenblum and Dr Charles Stuckey.

It is a great sadness for me that one of the dedicatees of this book, Mrs Elisabeth Katkov, died before being able to see it completed. Her love and understanding of German literature and art inspired me in a way that nothing else could have done. It was a rare privilege to be able to share her view of the culture she had grown up with. I am also most grateful to my wife, Pek, for her encouragement and help during the writing of this book, and to Christine Anderson for her careful typing of the final draft.

Finally I should like to thank the staff of Yale University Press for their help, in particular John Nicoll, who made the publication of this work possible, and Faith Hart, who has edited the text and given untiring support to the whole project.

William Vaughan
London 1980

Contents

Introduction

THE YEARS AROUND 1800 were those of one of Germany's greatest cultural flowerings. Not since the Renaissance and Reformation in the sixteenth century—the age of Dürer and Luther—had Germans achieved so much in so many varied fields, or made such crucial contributions to the development of European civilization. Much of this is evident today. Mozart, Haydn, Beethoven and Schubert are still among the 'classics' of our concert halls. Goethe—probably the most famous author of his age—is still regarded as a pivotal figure in European literature. And Kant is still seen as having brought about a turning point in European philosophy.

The high stature of the German music, literature and philosophy of this period is generally recognized in other countries. But this is not the case with the visual arts. Today German painting of the early nineteenth century receives little attention outside its native country. Even its greatest representative—the landscape painter Caspar David Friedrich—is referred to in no more than the haziest of terms by most British and American critics and art historians. Yet much of the German art of this period is extremely beautiful and of great interest. It has a historical importance, too, even for non-German countries; for it attracted a great deal of international attention at the time it was created. In 1839, for example, the London magazine the *Art Union* went so far as to declare contemporary German artists to be the 'first in Europe'. This was a partisan view, but it does indicate the strength of feeling that German art of that time could arouse.

This book sets out to provide an introduction to that art—to the pictorial achievement that emerged out of the great German cultural resurgence of around 1800. It will trace the development of this art during the first half of the nineteenth century—that period so closely associated with the Romantic movement. In Germany Romanticism was a very strong and self-conscious tendency amongst many writers and critics. It was in Germany that the notion of Romantic art was first formulated and many of the artists discussed in this book were deeply influenced by the movement. It would be misleading to suggest that the whole character of the painting of this period can be accounted for in terms of Romanticism, but there are a number of significant tendencies that emerged as a result of it. Principal amongst these were a new response to nature—largely evidenced in landscape painting—and a new approach to the Middle Ages, which largely affected figure painting. Both these tendencies can be found elsewhere in Europe, but both had peculiarly characteristic developments in Germany. The enthusiasm for nature had a strong mystical element. This is epitomized in the esoteric allegories of Philipp Otto Runge and in the entrancing landscapes of Caspar David Friedrich. There were many followers of this tendency. Friedrich, in particular, provided an example for younger generations. Yet interest in this symbolical form of landscape waned around 1840 as the Romantic assumptions that had encouraged it began to lose credibility. It was only at the end of the nineteenth century that this art began to take on a new importance in the very different spiritual milieu of the symbolists and expressionists. Meanwhile a less

emotionally charged form of naturalism had come to the fore—most notably in the work of Adolph Menzel. To some extent this naturalism was also a product of the Romantic era, where the emphasis on the love of nature had led to a new enthusiasm for the careful description of natural effects. Throughout Germany schools of local landscape and genre painters had sprung up, producing works that are noticeable for their modesty and charm. Menzel's early pictures produced in Berlin in the 1840s share the intimacy of such paintings. It is only after 1850 that his naturalism developed a cooler tone.

The medieval revival in German art perhaps has less direct appeal now than does landscape painting. Yet at the time it was regarded as being by far the more important, not least because of the moralizing attitudes that it expressed. As with the enthusiasm for nature, it grew out of a common European preoccupation. The growing uncertainty caused by the political upheavals that surrounded the French Revolution of 1789 encouraged the development of a new sympathy for the Middle Ages. Since the time of the Renaissance these had been habitually characterized as 'barbaric'. Now they were cast in the role of a mythical golden age, an 'age of faith' to be contrasted with the degenerate atheism and materialism of modern times. In Germany this attitude became particularly prevalent during the period of the French invasions under Napoleon (1806–14). It was during this time that the Nazarenes emerged. This group of artists attempted to revive the spirit of the medieval world by forming a 'Guild of St Luke' in 1809, and living a quasi-monastic existence. After the Napoleonic Wars this group became a paradigm for official art in Germany and much of Northern Europe. In England they deeply impressed artists interested in reforming standards in the 1840s, and were an appreciable influence in the formation of the Pre-Raphaelite Brotherhood. Apart from such high-flown idealism, the revivalist tendency encouraged other developments. The interest in folk literature that accompanied it led to a reappreciation of the fairy-tale. It was this that stimulated the famous collection of such works by the brothers Grimm. In the visual arts there emerged a 'fairy-tale' art of great charm and inventiveness, seen most clearly in the work of Moritz von Schwind and Adrian Ludwig Richter. The medieval revival had begun as a reforming movement, but in later years it was used to reinforce conformism to reactionary regimes. There were, however, more subversive forces at work which had reverberations in the visual arts. In the Rhineland, the most industrialized part of Germany, much of the bourgeoisie supported a spirit of radicalism. This was the milieu in which the young Karl Marx was active and which supported the uprisings of 1848. Among the painters of the local Düsseldorf Academy there were those like Karl Friedrich Lessing who expressed radical sympathies in their history painting. They sought to break away from the archaism of the Nazarenes, emulating the realistic tendencies in contemporary French history painting. Their art affected even those painters who sought to maintain revivalist standards, such as Alfred Rethel. Another striking development in German graphic art was stimulated by the emergence of the new technique of lithography. Invented by the Bavarian Alois Senfelder in the 1790s, this method enabled artists to bring a new freedom and directness to the reproduction of their images. In France the painters Gericault and Delacroix used lithography to reproduce works in a vivid chalk-drawing manner. In Germany there was a tendency to exploit the lithograph's ability to reproduce the qualities of pen drawings. The florid penmanship of Dürer and other artists of the sixteenth century was emulated, most notably in the production of ornate 'ballad' books.

The archaisms of revivalist artists led at times to a deadening effect in their paintings. But this happened less often in their graphic work. Perhaps the stricter technical limitations were more attuned to the deliberate simplifications in their manner. Certainly this seemed to have been the case with wood-engraving, which was used to emulate the characteristics of German woodcuts of the sixteenth century. The Nazarenes and 'fairy-

tale' artists excelled in designing for this medium. So did Alfred Rethel, whose *Another Dance of Death* is one of the finest graphic achievements of the century.

As has already been indicated, the German Romantics tended to lay greater emphasis on theory than did artists in other countries. This is both a strength and a weakness in their art. At times it led to penetrating insights and powerful expression. But it also encouraged tedious systematization and 'programme' painting. The theoretical bias was, however, very much a reflection of the milieu in which these artists worked. In many ways it expressed a peculiar German predicament: intellectual strength and political impotence. Jean Paul Richter's quip 'providence has given to the French the empire of the land, to the English that of the sea, to the Germans that of—the air!' summed up a widespread feeling in Germany in the early nineteenth century. At a time when the French were masters of Europe and English imperial power was buttressed by their naval supremacy, Germany remained a conglomeration of disparate principalities. Any sense of nationality that they had was based solely on their cultural strength.

This situation encouraged a strong emphasis on intellectual prowess. It also fostered a mounting desire for political consolidation. The nineteenth century was the great age of nationalist movements in Europe, and Germany was one of those countries that moved under its impetus towards unification, a goal that was finally achieved in 1870. In the early years of the nineteenth century the movement gathered momentum as a consequence of the reaction to the Napoleonic invasions. In the visual arts—as in literature—there was an emphasis on 'Germanness', a desire to uncover the cultural roots that seemed to have been overlaid by so many foreign influences. In landscape painting there was a concern to paint native scenes rather than idealized Italianate ones. Friedrich certainly felt this need. In some ways there is a parallel with Friedrich's English contemporary John Constable, who habitually painted his native Suffolk. However, Friedrich was far more explicit in investing his interpretation of his native land with political overtones. In revivalist art there was a conscious desire to return to the glories of the golden age of German art, the age of Dürer; though paradoxically this usually led to a closer study of the Italian Renaissance. This was particularly the case with the Nazarenes. Although the group was formed in Vienna in 1808, its principal leaders soon settled in Rome. Here the overwhelming effect of Italian Renaissance art gradually modified their enthusiasm for the sixteenth-century artists of the North.

These new directions led the Romantics to present their art as a rebirth. To some extent they exaggerated. Since the time of Dürer there had, after all, been a number of distinguished German artists. In the early seventeenth century Elsheimer had been a generative force in the development of Roman Baroque art. A century later Germany was enjoying its own distinctive form of Baroque, in which painting played a part alongside architecture, sculpture and the decorative arts. Yet such works—for all their consummate skill—were now seen as being too foreign, too inexpressive of the indigenous spirit. More equivocable was the position of those German artists and theorists who had played a part in the European-wide classical revival of the later eighteenth century. Many of these were figures of the highest importance. The writer Winckelmann had provided one of the rallying points of neoclassicism with his essay on the imitation of the art of the Greeks (1755). His close associate the painter Anton Raphael Mengs had exemplified the new creed in his ceiling painting *Parnassus*. Angelica Kauffmann, Fuseli and Carstens were amongst the other Germanic artists of this time who established international reputations. Some of these painters—in particular Carstens—were in fact admired by the German Romantics. They looked up to them for the high standards that they established and for their independent outlook. Despite this, there was still a critical change that took place in German art around 1800. There was a move away from classical values towards the

indigenous, the emotional and the irrational. This change was intimately connected with cultural and political developments within Germany. To gain an intimation of this, it is necessary to consider the painter's relation to his milieu at this time, and this will be a task undertaken in Chapter I.

I. Friedrich Overbeck: *Franz Pforr*. 1810. Oil (62 × 47 cm). Nationalgalerie, Berlin (West).

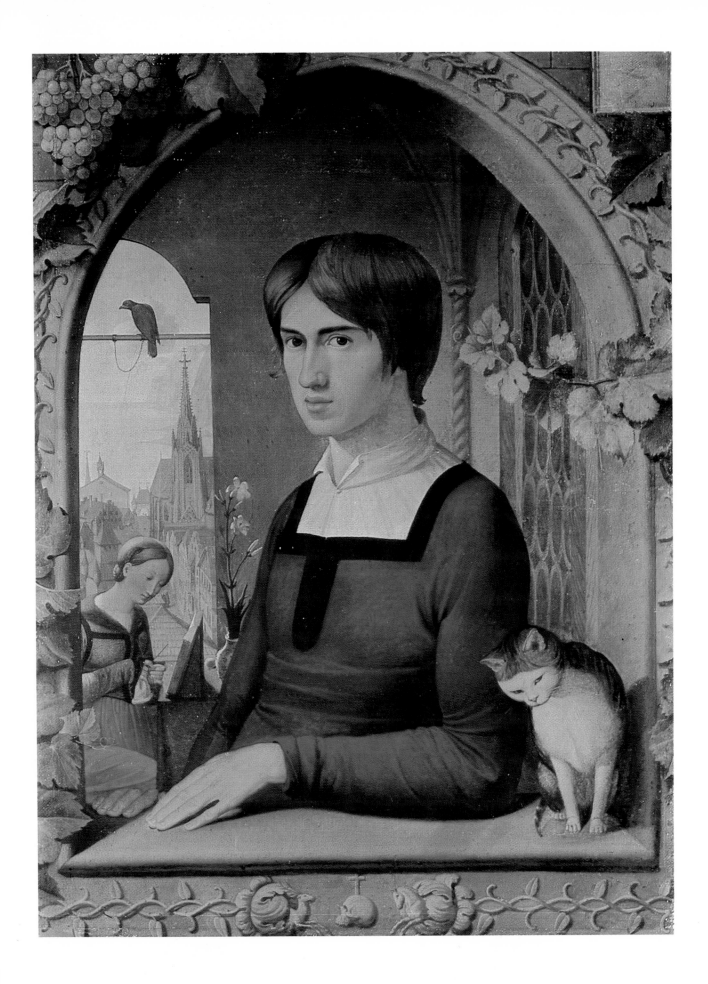

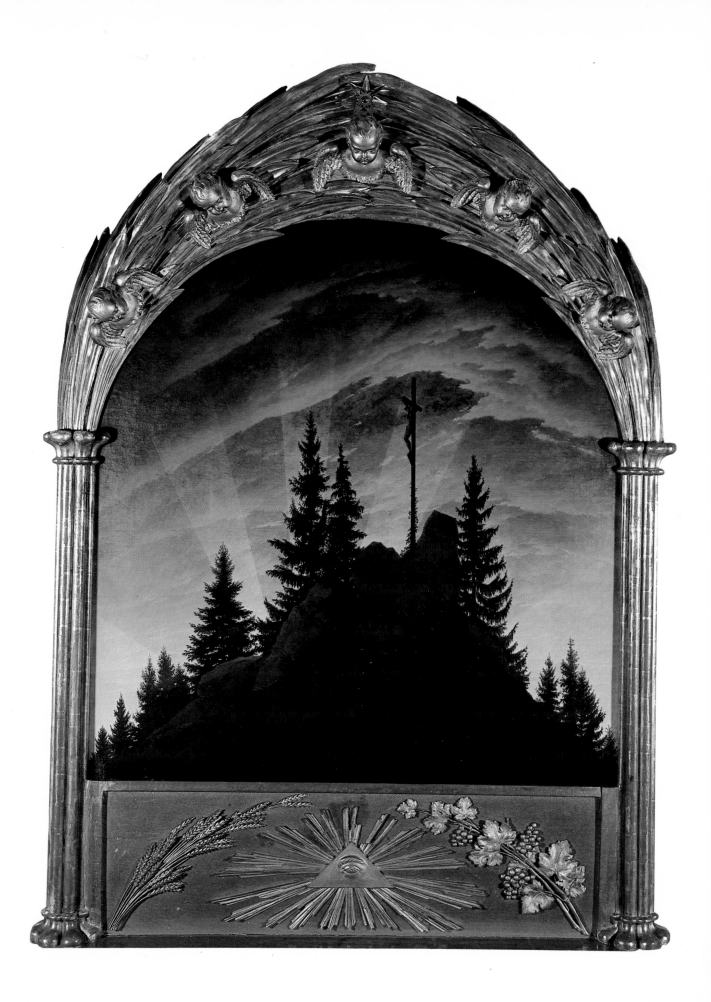

The Painter's Germany, 1800–50

THE CHANGES THAT bring about a new direction in art usually take place gradually, almost imperceptibly. Only when a work is created that can present these changes with boldness and conviction does it become apparent that a startling transformation has taken place. In the history of the Romantic movement in German painting, this occurred with Caspar David Friedrich's *Cross in the Mountains* (Plate II). When the picture was put on public show in Dresden at Christmas time in 1808, its originality was felt at once. A heated critical exchange took place.

The silhouette of the cross and the fir-topped mountain against the rays of the setting sun are immediately arresting even today. However, it was not the image alone that caused the disturbance but also its intention. The remarkable frame—a palm leaf fantasia on a Gothic arch, embedded with Christian symbols—alerts one to the fact that this is not the kind of picture to be sent to an annual academy exhibition or hung in a drawing room. Any visitor who came to the special showing, and saw the whole ensemble displayed in a dim light on a table draped with a dark cloth, would have been left in no doubt that what he saw before him was in fact an altarpiece.

The picture was destined for the private chapel of Count Thun und Hohenstein's castle at Tetschen. It is now known that the idea of using a landscape painting for an altarpiece was the artist's own.[1] It is hardly surprising, therefore, that he pursued the project with such enthusiasm. Not only did he paint the work on a larger scale than anything that he had done previously, but he also had the frame carved from his own design. And, in order to make the work known to the Dresden public, he displayed it for a while in his studio before sending it to the Count's castle in Bohemia.

To use a landscape painting for a devotional purpose (albeit a private one) was certainly an innovation. It was for this heresy against art and religion that the artist was taken to task. Soon after the picture was put on show, a local critic, the Freiherr von Ramdohr, published an attack in which he asserted that it would be a 'veritable presumption, if landscape painting were to sneak into the church and creep onto the altar'.[2]

Ramdohr has subsequently been used as a butt by Friedrich's defenders, but his opinions do at least have the virtue of consistency. Beginning with a technical critique, he pointed out that the image lacks clarity. There are none of those indications of scale and distance that normally define the space in a landscape. Instead, the mountainside is cut off abruptly by the picture frame, without any indication of where we, as spectators, are standing in relationship to it. Furthermore, the lack of any view into the distance, and the placing of the central form against the light, give an effect of flatness unrelieved by the few rocks and trees which cluster among the shadows on the foreground slope.

Having dealt with these and other shortcomings of design and execution, Ramdohr posed a more fundamental question. He asked whether pure landscape could be used to convey an explicit meaning. No one as familiar as Ramdohr was with the classical

II. Caspar David Friedrich: *The Cross in the Mountains*. 1808. Oil (115 × 110.5 cm). Staatliche Kunstsammlungen, Gemäldegalerie Neue Meister, Dresden.

landscapes of Claude and Poussin would have doubted that landscape could be evocative, or that it could serve as an emotive setting for human drama. In this painting, however, human drama is absent. The *Cross in the Mountains* does not show the actual Crucifixion. It shows a cross bearing a statue of Christ, of the kind to be found on mountain tops throughout central Europe. It was absurd, Ramdohr argued, to attempt to present a narrative or allegory by such means. In figurative pictures allegorical significance could be conveyed only by making the protagonists assume particular gestures or expressions, or by giving them special attributes, such as an anchor for hope or a halo for holiness. How could a tree be made to assume rhetorical posture or be given a symbol to hold? And without such clear indications, any 'meaning' that the picture had could be no more than an arbitrary supposition. This was the weakness of the *Cross in the Mountains*.

Although many of Friedrich's friends came to his defence, and vigorously asserted his right to strike out on a new path, none of them dealt effectively with Ramdohr's main objection. Indeed, the point about allegory seems to have got home to the artist, for by way of reply Friedrich published a programme for the picture, a concession that he had never made before and was never to make again. According to Friedrich's own account, the work is to be interpreted as a Christian allegory. The sun stands for God the Father, and because the time when God used to reveal himself directly to man is past, it is shown sinking. The figure of Christ on the cross is gilded, and it is this which glints in the fading light and keeps it bright for us mortals on the darker slopes. Around the crucifix are evergreens and ivy, images of man's faith and hope in the Redeemer.[3]

Friedrich's programme, however, is hardly satisfactory as an account of the painting. Even on its own terms it could be faulted. When the sun finally sets, we are entitled to ask, will not the image of Christ too be plunged into darkness? Are not the clouds, in any case, a better reflector of the departing glory than the murky form on the cross? Like the objections of Ramdohr, however, these quibbles miss the vital point. The obscurity of the picture's symbolism in no way weakens its impact, for the artist's main concern was to create a sense of devotion and mystery. Friedrich regarded Ramdohr's logic with disdain, and it was precisely this attitude that showed him to be an exponent of the new movement that sought to pass beyond the explicit statement to a deeper level of experience.

It was in fact mysticism rather than incompetence that aroused Ramdohr's antipathy. He was aware, as anyone living in the cultural centre of Dresden at that time must have been, of the similarity of Friedrich's ambivalent portrayal of nature, his use of Gothic imagery and his invocation of religious sentiment, to the attitudes of the literary and critical school that had given new currency to the term 'Romantic'. Indeed, the climax of Ramdohr's article had been an outburst against 'that mysticism, that is now insinuating itself everywhere, and that comes wafting towards us from art and science, from philosophy and religion, like a narcotic vapour'.[4]

In a sense, Ramdohr was settling old scores. In the very work that had sparked off the movement, Friedrich Wackenroder's improbably yet aptly titled *Herzensergiessungen eines kunstliebenden Klosterbrüders* (Heartfelt Effusions of an Art-Loving Monk, 1797), Ramdohr had been singled out as one of those soulless commentators who 'separate the good works from the so-called bad ones, and finally place them all in a row, so that they can survey them with a cold, critical gaze'.[5] For Wackenroder aesthetic experience was a matter of the heart, a spiritual elation rather than an exercise in good taste.

However, there was more at stake than the *amour propre* of a critic of the old school. The confrontation between feeling and judgement that the Romantics provoked was an important cultural turning-point. It is true that under the impact of the writings of the Swiss-French philosopher Jean Jacques Rousseau and such English nature poets as Thomson and Gray, there had been a growing emphasis on sentiment in the arts

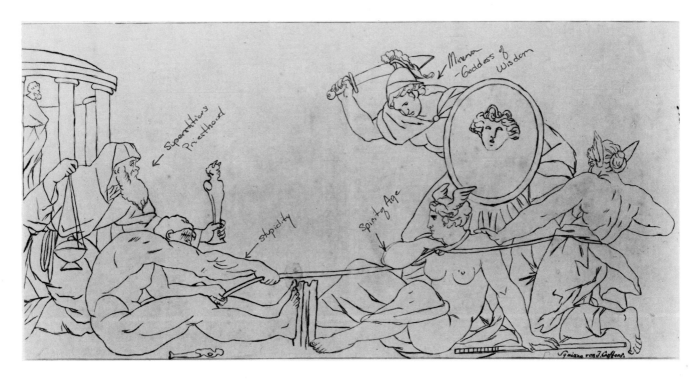

1. Asmus Jakob Carstens: *Allegory on the Eighteenth Century. c.* 1785–8. Pen and watercolour (30 × 59 cm). Georg Schäfer Collection, Schweinfurt.

throughout Europe in the latter part of the eighteenth century. But even Rousseau had conceded that man, if guided by sentiment, was nevertheless 'made by reason'. It was the German Romantics who first took the decisive step of pursuing subjectivism to the point where it actually conflicted with the rational.

In many ways these critics and writers were encouraged to move in this direction by the course of events around them. They could no longer share that confidence in the achievements of their age that Asmus Jacob Carstens, the most distinguished of German classical artists, had expressed a few years earlier in his *Allegory on the Eighteenth Century* (Plate 1). In this drawing—a sketch for the lost painting that was exhibited at the Berlin Academy in 1788—Minerva, the goddess of Wisdom, can be seen on the point of cutting the rope with which Stupidity, supported by a superstitious priesthood, is trying to hold down the Spirit of Age. Both the sentiment and the style of this work would have pleased Ramdohr. The allegory is an explicit one, each figure taking part unequivocally in the action and bearing specific attributes. While the picture is no more than a study, all the forms are clearly stated in the succinct outlines and close-knit frieze-like composition that are among the hallmarks of neoclassical art.

The subject of Carstens' allegory was appropriate for the capital of Prussia, the German state that had sprung to international prominence by virtue of the ruthless efficiency of its recently deceased monarch, the atheist Frederick the Great. Like many other 'enlightened' rulers, Frederick was in fact an autocratic despot, and visitors to Berlin, such as the French philosopher Voltaire and the artist Fuseli,[6] rapidly recognized that the rationalism reigning in the kingdom was no aid to humanitarianism or personal liberties. But it was the French Revolution of 1789 that first severely shook the confidence of the supporters of the Enlightenment in the ability of reason to guide human destiny. The revolutionaries' attempt to establish a society based on rational justice degenerated into a totalitarianism that, with the rise of Napoleon to power at the turn of the century, threatened to engulf the whole of Europe. It was against this background that the poet Novalis, in *Die Christenheit, oder Europe* (1799), looked back to the Middle Ages, when society, he supposed, existed harmoniously, by virtue not of reason but of faith. The French Revolution was for him nothing more than the ultimate consequence of the doubting spirit that had entered European life with the Reformation.[7]

9

However, Romanticism was not simply an escape to a mythical age of faith. These enthusiasts were disturbed by the soullessness of contemporary society. But they were excited as well by the apparent invitation to subjectivism that was expressed in the most significant of recent philosophical developments: the *Critiques* of Immanuel Kant. One of the central points made by the German philosopher in these works (especially in the first, the *Critique of Pure Reason*, 1781) had been that, while our knowledge is derived from our experiences, these experiences can only have a meaning for us once they have been organized according to pre-existing categories in the mind. The ultimate truth about any phenomenon—the 'thing-in-itself'—must remain unknowable.

This limitation of knowledge to sensory impressions did not shake Kant's faith in the existence of an external reality, and he went to great lengths to refute the charges of subjectivism that were laid against him. But for the younger generation the *Critiques* opened up exciting new areas of speculation. When philosophers like Fichte went on to explore the full consequences of Kant's transcendentalism and dwelt on the possibility that the world can only be said to exist to the extent that we are aware of it, artists were encouraged to view their own activities in a new light. In so far as they were enriching the world through the powers of their heightened awareness, they could be said to be giving it a new meaning. It was for this reason that Wackenroder saw aesthetic sensibility as a kind

2. Franz and Josef Riepenhausen: *St Genevieve*. Engraving from Tieck's *Genoveva*, Dresden, 1806.

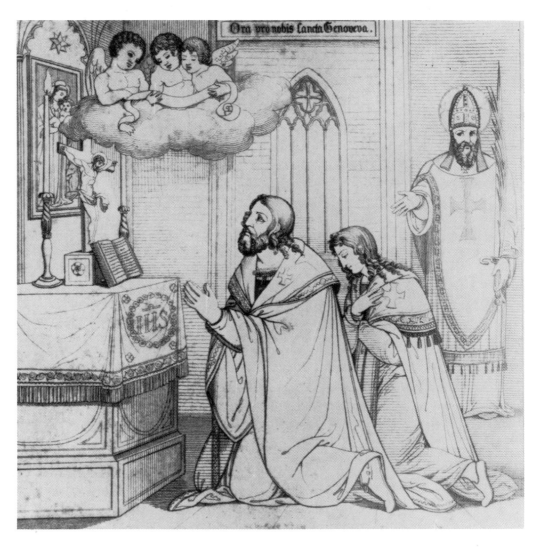

of religious experience, and Novalis declared poetic reality to be the 'ultimate reality'. Aware that such 'ultimate' reality could only be intimated, never fully known, they sought an art that was above all evocative, that would stimulate the imagination to its limits. The effect of this was to strengthen their admiration for the art of the Middle Ages (because the soaring complexity of a Gothic edifice or the other-worldly happenings of medieval romance seemed more inspiring than the formal perfection of a classical statue or poem) and to encourage an exploration of the fantastic, the bizarre and the arcane.

However, it was not Wackenroder and Novalis, both of whom died in their twenties, who were to become the principal champions of a Romantic movement, but two critics, the brothers August Wilhelm and Friedrich Schlegel. It was in their magazine *Athenaeum* that a definition of Romantic poetry first appeared, in 1798. Written by Friedrich Schlegel, this article hailed Romantic poetry as 'progressive, universal'. Indeed, its very essence was that it was 'eternally evolving, never completed'.[8] It was through the Schlegels' efforts that Romanticism came to be seen not as an isolated literary phenomenon, but as an all-embracing cultural movement, the true successor to that spirit of 'modern' Europe that the classicizing influences of the Renaissance had done so much to destroy. Their view of Classicism and Romanticism as two distinct stages in the development of man's spiritual awareness received ultimate sanction by being incorporated into the philosopher Hegel's dialectical notion of cultural history.[9] And it was carried abroad by accounts of German culture such as the French writer Madame de Stael's *De l'Allemagne* (1813).

Yet, although the Schlegels did so much to establish the idea of a Romantic art, they also encouraged an oversimplified view of it. After the death of their friend Novalis in 1801, they moved increasingly away from the more challenging aspects of the movement. Friedrich Schlegel became obsessed with a literal-minded medievalism and neither brother had anything to do with those who sought to continue the early Romantics' exploration of the limits of experience, such as E. T. A. Hoffmann and Heinrich von Kleist.[10]

The Schlegels were no less exclusive towards painters who were affected by the movement. The two most original artists to respond to the new mysticism—Philipp Otto Runge and Caspar David Friedrich—were regarded with suspicion by these officials of Romanticism. Indeed, the artists in Dresden who came nearest to gaining their approval were the meagrely talented brothers Franz and Joseph Riepenhausen, who in 1806 produced a set of outlines, laden with medieval trappings, illustrating scenes from the poet Ludwig Tieck's archaicizing *Leben und Tod der Heiligen Genoveva* (Plate 2). The Riepenhausens' art formed a prelude to the more thorough-going revivalism of the only modern group of artists that Friedrich Schlegel ever publicly defended, the Nazarenes. As can be seen in the portrait painted by one of the group's leading members, Friedrich Overbeck, of his friend and fellow-leader Franz Pforr (Plate I), these painters took their beliefs to the point of medievalizing their own dress. And if the setting of this picture is, as the artist admitted, a wish fulfillment, the reality of the Nazarenes was hardly less fanciful. For in 1810, the year that the work was painted, they had just moved from Vienna, where they had been students, to set up a quasi-monastic life in a deserted monastery in Rome.

However, the limited outlook of the Schlegels was by no means typical of the Romantics' attitude towards the visual arts. The scope of the Romantics' sympathies in painting was in fact extraordinarily wide. Emerging from the widespread interest in creating an all-embracing cultural movement, innumerable interchanges took place between the arts. Painting began to emulate the effects of music and poetry and to use narrative and symbolic devices that in the opinion of the classicists lay beyond its proper

sphere. If this synthesis might be felt by purists to have weakened the pictorial tradition, in another sense the Romantics strengthened it. Painting, they asserted, was the one visual art that was quintessentially Romantic, and they contrasted its illusory qualities and its reliance on such intangibles as atmosphere, light and colour with the more material properties of the classical art of sculpture.[11] No longer were painters recommended to emulate the volume and contours of antique statues. Instead they were exhorted to concentrate upon the painterly.

But perhaps the most important, if least assessable, effect of the Romantic critics was not so much their influence upon the artists themselves as the way in which they altered the public's expectations of painters and their works. Romanticism was a genuinely popular movement in Germany, and the novels and periodicals in which the role of the artist was so urgently discussed reached far beyond the coteries in which they were devised. It is impressive to discover how closely non-professional enthusiasts like Runge's brother Daniel or Overbeck's father—both merchants on the Baltic, the northernmost limit of the German world—kept in touch with the most recent publications.[12] And, while works such as these encouraged a literary bias, they also provided the artist with a wide and attentive public.

The literary emphasis in Romantic art can certainly be found in other countries, but in the German states it took on a particular significance, for it was literature that provided the Germans with their sense of a common culture. 'After all, what have we in common apart from our language and literature?' asked the philologist and collector of folk-tales, Jacob Grimm, in the preface to his famous dictionary in 1854.[13] Since the Reformation, Germany had been divided into a Protestant north and east and a Catholic west and south. And by the late eighteenth century the land that had once been the principal province of the Holy Roman Empire had fragmented into more than fifteen hundred autonomous units, ranging from international powers like Austria, Prussia and Bavaria to large family estates. Although this number had been reduced by over two-thirds at the time that Grimm was writing (largely on account of the rationalizations that followed the

3. Map of Germany in 1815.

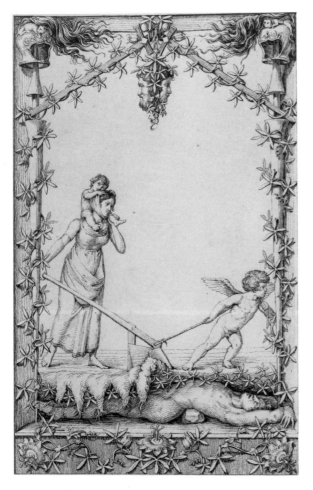

4. Philipp Otto Runge: *The Downfall of the Fatherland*. Cover design for *Vaterländisches Museum*. 1809. Pen (35.4 × 23.6 cm). Kunsthalle, Hamburg.

5. Georg Friedrich Kersting: *On Sentry Duty*. 1815. Oil (46 × 32 cm). Nationalgalerie, Berlin (West).

Napoleonic Wars), the situation was still chaotic (Plate 3). Even the semblance of unity had disappeared when Napoleon abolished the title of Holy Roman Emperor after he invaded southern Germany in 1806.

The lack of a coherent German state at this time is reflected in the broad geographical range of German culture. It extended far beyond the borders of the German states of our times. In the eighteenth century the literature and art of northern Switzerland, Austria and southern Scandinavia were an integral part of German culture. Indeed, a high number of major German artists of the period 1790–1815 were born or were active in non-German states. Asmus Jacob Carstens came from Schleswig, which was then a part of Denmark. As western Pomeranians, both Runge and Friedrich were Swedish subjects, and seemed to find no contradiction in being loyal supporters of Sweden as well as being German patriots. And the spearhead of the medieval movement was formed among a group of students in the capital of Austria.

As elsewhere in Europe, the Romantic movement in Germany fostered a strong sense of national identity. While the eventual unification of Germany under Prussian domination in 1870 was far removed from the kind of pan-Germanic union that had been envisaged by the Romantics, it cannot be denied that the movement played its part in this achievement. In the period between Napoleon's intervention in German affairs and his final defeat in 1814, the Romantics provided the focus for a popular nationalist movement that sought both to expel the French and to establish a democratic united Germany to replace the small-minded and mostly repressive regimes that had governed the German states previously. Both Friedrich and Runge designed nationalist allegories (Runge's *Downfall of the Fatherland* (Plate 4) was actually suppressed on account of its overt political overtones),[14] and the revivalist movement was from the start nationalist in its

implications. When the freedom fighters who took part in the resistance movement against Napoleon came to devise a costume that would be distinct from the modish styles of France, they came up with a tunic and floppy hat that had an unmistakable *altdeutsch* air about it. This can be seen in the picture painted by one combatant, Georg Friedrich Kersting, as a memorial to three of his comrades who had fallen in action (Plate 5). Friesen, Hartman and the poet Theodore Korner are seen on sentry duty in the midst of a Teutonic forest of oak trees.

In the short term Germany became neither unified nor liberal as a result of this struggle. The rulers whose power was consolidated after the Congress of Vienna (1815), were in many cases men such as the King of Bavaria who had previously benefited from Napoleon's presence in Germany to attain the status of monarch. They gradually brought increasingly reactionary regimes into their countries. The most liberal of the freedom fighters were persecuted or driven into exile, and in many states even their 'German Coat' was banned. While the new regimes were prepared to exploit the patriotic tendencies in Romanticism, they were careful to excise all its subversive aspects. The blessings of the Kings of Prussia, Bavaria, and Saxony were bestowed upon the later Nazarenes, with their harmless piety and morality, and upon the folksy narrators of legends and fairy-tales like Moritz von Schwind.[15] Caspar David Friedrich, on the other hand, who continued to bewail the illiberal outcome of the Wars of Liberation in the 1820s,[16] was ostracized by the ruling houses of Prussia and Weimar who had patronized him during the time of the invasions.

To a large extent the attitudes of the governments were condoned by their subjects. Despite the persistence of a few protestors, the most striking feature in the German states at this time was the widespread docility of the bourgeoisie. The poet Heinrich Heine's taunt that in 1814 'we were commanded to become patriots, and we became patriots; for we do everything that our rulers command',[17] was spoken with a personal chagrin. Although he had been too young to take part in this earlier struggle, he had witnessed the failure of the 1830 uprisings to command any effective support, and had consequently become an exile in Paris. Just as these uprisings were a pale reflection of the July Revolution in Paris that toppled the Bourbon monarchy, so too the German revolutions of 1848 were less radical than the French insurrection that had inspired them. It is true that the King of Bavaria was obliged to abdicate and the King of Prussia to honour those among the insurgents who had been killed by his guards.[18] But the achievement was momentary. The democratically elected pan-German 'parliament' that was subsequently set up at Frankfurt collapsed, largely on account of the bumbling inadequacy of its members. As the anonymous contemporary cartoon illustrated here suggests (Plate 6), the bourgeoisie rapidly recovered their habitual posture after their outburst of revolutionary fervour.

In one way 1848 did mark a major turning-point in German history. From then on the liberals' dream of unification lost ground to the more practical ambitions of Prussian aggrandizement. The demise of radicalism in a country that was growing rapidly in economic and military strength was symbolized by the departure of Karl Marx from the Rhineland, where he had been active as an agitator during the 1840s, to his permanent exile in England.

The year 1848 was not so important a milestone in the fortunes of Romantic art as it was in the decline of revolutionary politics. Romanticism did not entirely lose its impetus. Runge and Friedrich were both long since dead by this time, but many of the Nazarenes and lyrical narrative painters were to survive for several decades. Nevertheless, amongst the younger artists of the 1840s there was a sense of withdrawal from the sentimental ideal. In Berlin the young Adolph Menzel was painting landscapes, interiors and street scenes

that delighted in pure effect, without any burden of associations or subjective intimations. Even his record of the height of the Berlin revolutionaries' success in 1848 (Plate 7), when the King gave a state funeral to all those who had fallen in the uprising, could hardly seem more dispassionate. He represented it as if he were a curious but impartial spectator, with the catafalque a distant mass of black against the portal of the cathedral, the crowd in front chattering away as they would for any public spectacle. It is an art without heroism, without ideals and without irony. And even in idealist art at this time there was a new sense of actuality, which was visible, for instance, in the finest of all German works of art to be created under the impact of 1848, the series of wood-engravings entitled *Another Dance of Death* by Alfred Rethel (Plate 9). Trained at the Düsseldorf Academy, Rethel had absorbed the archaizing tradition of his Nazarene master Wilhelm Schadow. But the model he took from the past for these works was not the ideal of harmonious beauty to which the Nazarenes aspired. It was the populist tradition of the woodcut. And the medieval allegory of the Dance of Death that he emulated led him not to create abstractions but to focus instead upon the starkest reality of the present. It is not inappropriate that such an artist should also have produced, in his view of the Harkort factory painted in the 1830s (Plate 8), one of the first and clearest records of the industrial changes that were beginning to affect the German economy.

So far, the art of this period has been briefly considered in so far as it reflects the pan-German tendencies of the time. But one should remember that painting is a much more local art than literature, and that such a view can take little account of the vast number of different localities in which painting flourished in Germany. These schools, growing up around courts and towns, often sustained quite indigenous traditions in portraiture, in landscape, even in religious painting, with little reference to current fashions.

This provincialism was an inheritance of the fragmented condition of Germany. Yet during the eighteenth century a more international outlook had begun to emerge. Under the influence of the Enlightenment many governments had brought about the foundation of academies along the lines of those in France. In these, students might receive a liberal

6. Anon.: *Ways of Wearing Coats*. 1850. Wood-engraving.

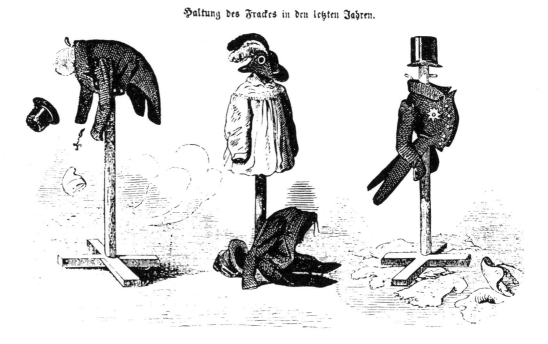

Haltung des Frackes in den letzten Jahren.

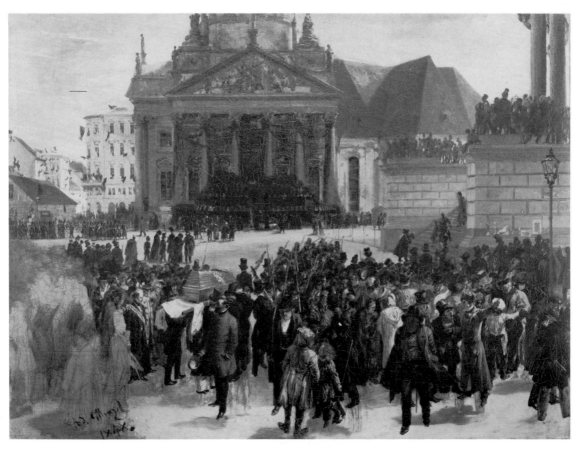

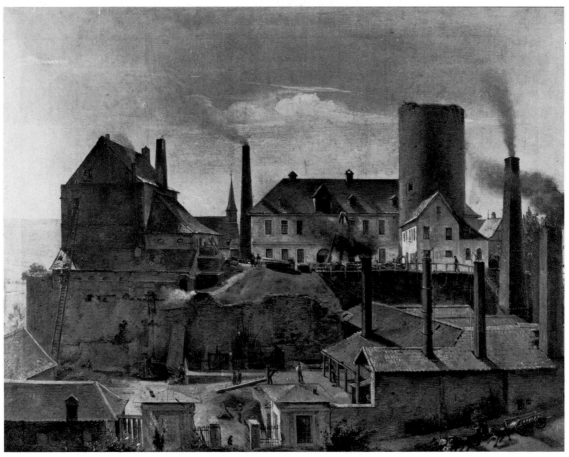

artistic education instead of being apprenticed to a craftsman in the traditional way. For the most part these academies were under the protection of the rulers, and it is hardly surprising to find the most celebrated of them attached to the larger courts. The changing fortunes of the academies reflected the destiny of their sponsors. Before 1815 the most important centres for German artists were Vienna, Dresden and Copenhagen, and there were other influential academies at Kassel, Stuttgart and Düsseldorf. Later, Vienna and Copenhagen became less frequented as Austria and Denmark began to withdraw from German affairs. Within Germany, meanwhile, the emergence of Prussia and Bavaria as the two main powers was accompanied by the rise in prestige of the academies within their territories: Düsseldorf and Berlin in Prussia, and Munich in Bavaria.

Even so, the growth of art education within Germany did not undermine the tendency to move on to larger cultural centres abroad. From the mid-eighteenth century Paris had been a favourite place,[19] especially for artists from Berlin (where the francophile Frederick II had established a strong taste for French art) and from the Rhineland provinces which were nearest to France. But above all the main place of study was Rome. Although Rome was the proper objective for all historical artists until the early nineteenth century, the Germans were particularly prevalent there. The Roman neoclassical movement was dominated at first by such Germans as Winckelmann, Mengs and Angelica Kauffmann,[20] and the most interesting event in Roman art in the early nineteenth century was the success of the Nazarenes. It was easier for the Romantics to reject classicism than the image of the idyllic city of the South. Runge and Friedrich, eager to maintain the indigenous Northern spirit in their art, were alone in firmly resisting the suggestion that they should continue their studies in Rome; though Friedrich conceded somewhat wistfully that the southern land must be an improvement on his native country.[21]

Wherever German painters trained, they faced the perennial and ubiquitous problem of employment. In many ways the Romantic movement seems to have been helpful in this

7. Adolph von Menzel: *The Honouring of the Insurgents Killed in March 1848*. 1848. Oil (45 × 63 cm). Kunsthalle, Hamburg.

8. Alfred Rethel: *The Harkort Factory at Burg Wetter*. *c.* 1834. Oil. Private Collection, Duisburg.

9. * Alfred Rethel: Plate 2 of *Another Dance of Death*, Dresden, 1849. Wood-engraving.

respect, for its emphasis on culture, and on painting in particular, provided the artist with a new role. As elsewhere in Europe, this was the great age of the establishment of public cultural institutions, but only in Germany was painting used with such thoroughness to explain the didactic functions of these new foundations. The prime mover in such patronage was Ludwig I of Bavaria, who even while he was Crown Prince had begun in 1811 to build a museum of sculpture, or 'Glyptothek', at his own expense. By the time of his abdication in 1848, he had turned his capital of Munich into what one guidebook called the 'art city of Europe',[22] with its new museums, libraries, churches, palaces and recreation grounds all decorated with the appropriate symbolical and historical murals. An English commentator of 1839 can perhaps be forgiven for having drawn the conclusion from all this that 'the Germans have a reason for every work of art'.[23]

Ludwig's example set a new standard for court patronage in Germany. He was emulated in particular by the Kings of Prussia and Saxony. The range of painting served by such patronage, though, was highly limited. There were probably no greater opportunities anywhere for historical artists to work in the Grand Style than those offered in Germany during the period from 1820 to 1850. But the propagandist setting of such an art ran counter to the individualist tendencies of the Romantics. Few of the major artists of the day actually took up these options, and those who did never seem to have produced their best. The most distinguished historical artist of the period, the Nazarene Peter Cornelius, was called to Munich by Ludwig in 1820 to supervise the decorative schemes there. Yet, although he established a whole school of mural painters and was given the opportunity of painting a *Last Judgement* (Plate 10) larger than Michelangelo's, his frescoes never attained the dramatic vigour of his more personal graphic work. For Alfred Rethel, the greatest of the historical painters to be trained by the Nazarenes, mural painting had a disastrous effect on his health as well as his artistic excellence. While working on the vivid *Another Dance of Death* he was at the same time being worn down by a commission to decorate Aachen town hall with scenes from the life of Charlemagne, and the exhaustion caused by this undertaking helped to unhinge his reason.

Most of the artists discussed in this book were less dependent upon royal, or even aristocratic, patronage than upon that of the bourgeoisie. The same emphasis on pictorial culture that had given new scope to history painting also encouraged a fresh attitude towards more modest works. Even in the strictly Protestant north painting began to come into vogue. In the mid-eighteenth century it had been possible to complain that the wealthy mercantile city of Hamburg, which had an opera house and a thriving literary circle, took no interest in visual artists. By the end of the century, however, Hamburg was organizing a Patriotic Society which put on regular exhibitions,[24] and this pattern was being repeated throughout the cities of Germany.

The most striking development in bourgeois patronage took place after the Napoleonic Wars with the establishment of the art unions (*Kunstvereine*). These organizations were rapidly set up in every major city during the 1820s. In contrast to the academies, whose exhibitions and educational activities were under royal patronage, they were completely financed by subscription. The main incentive for membership was an annual lottery, in which the lucky drawers were awarded one of the pictures that the union had purchased from a contemporary artist, while the losers were consoled with engravings of the prizes. However, the activities of the art unions did not stop at the organization of raffles. They also bought larger works for presentation to churches and museums and even commissioned murals from artists such as Rethel. Some idea of the scale and nature of their activities can be derived from the accounts of the Art Union of Düsseldorf, which between 1829, the year of its foundation, and 1900 spent 827,000 marks on gifts to churches, 2,047,300 marks on purchases for the lottery and 1,263,614 marks on the

10. Peter von Cornelius: *The Last Judgement*. 1836–9. Fresco (*c*. 1800 × 1100 cm). Ludwigskirche, Munich.

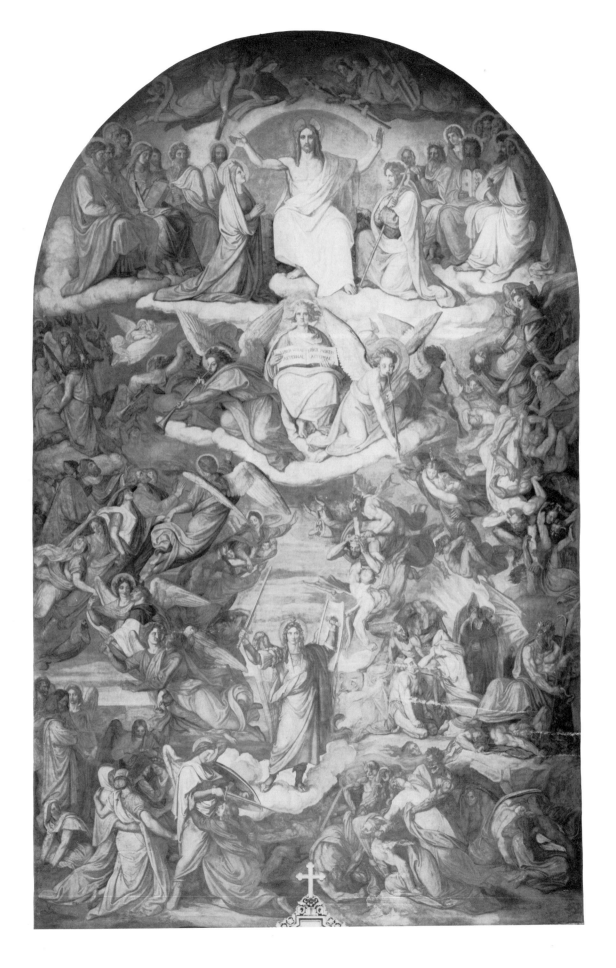

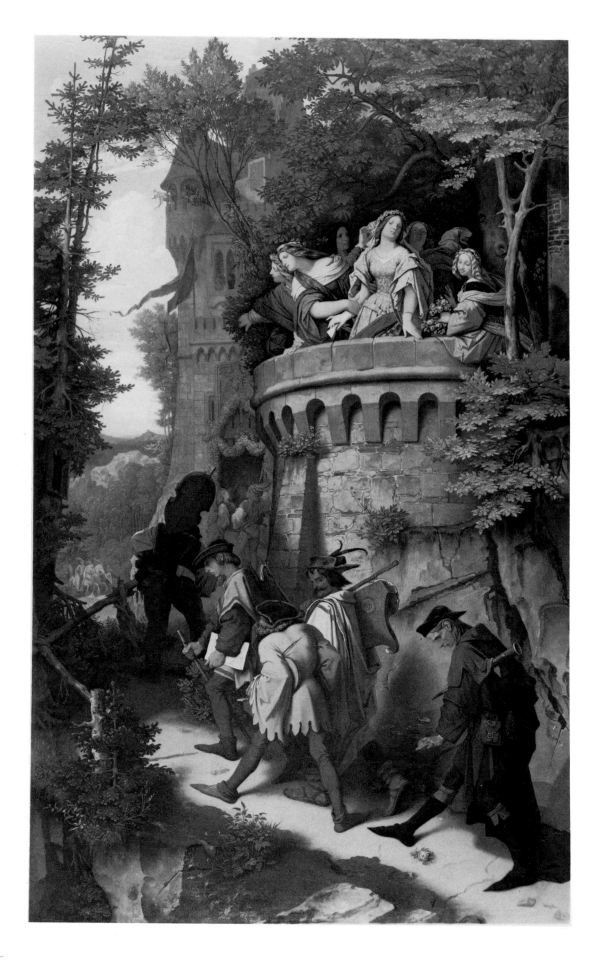

distribution of engravings to members—an overall expenditure that in present-day terms would amount to something in the region of ten million pounds.[25]

The Düsseldorf Art Union, supported by a rapidly developing industrial community, was unusually wealthy, but even the activities of the more modest unions, multiplied throughout Germany, represented a substantial middle-class investment in contemporary art. In the opinion of the Dresden painter Adrian Ludwig Richter, it was the art unions that had done most to revolutionize public taste and the position of the artist:

> They have educated a broad section of the public, which now takes an active interest in the manifold directions of art and often approaches it with a refinement of understanding that was not previously there. How many talents used to perish lamentably through the death of every kind of commission . . . In Dresden a painter could not exist at all without a position at the Academy, unless he possessed independent means.[26]

This last remark was not entirely accurate: Friedrich survived in Dresden for sixteen years before being made an academician. But if Richter exaggerated he did so from the bitterness of personal experience, for he had himself been obliged to work as a drawing instructor at the porcelain factory at Meissen for seven years before being made professor of landscape painting at the Dresden Academy in 1836.

The art unions, represented a popular form of patronage but, as Richter suggests, it was not undirected. Unlike the English art unions that were set up in early Victorian England in imitation of the German ones,[27] the choice of picture to be purchased was not left to the winner in the lottery but was made by a governing committee. Although this often led to the favouring of the kind of official art already well provided for by royal patronage, it could also result in more perceptive purchases. It was the committee of the Dresden Art Union, after all, that bought the greatest painting of Friedrich's later years, the *Large Enclosure near Dresden* (Plate 79), at a time when the artist had already fallen out of public favour.

Despite Ludwig and the art unions, however, few artists made their fortune in early nineteenth-century Germany. Prices were modest by present-day or even late-Victorian standards, and the broadening of the range of patronage did not mean that an artist's individualism was now more respected. However much the Romantics emphasized the personal nature of the artist's vision, he was still a man providing a commodity for a client, be it an allegory for a monarch, or a portrait, local view or illustration to a favourite story for a bourgeois. There were, it is true, attempts at disengagement. Runge sought to put his vast scheme for the *Times of Day* (Plate 31) into effect at his own (or rather his brother's) expense, and the Nazarenes began their career as a secessionist group. But there was no equivalent in Germany at this time to the ongoing avant-garde that had become established in Paris by the French Romantics.

In terms of both subject matter and technique the vast majority of German art of the period is closely related to popular interests. On the one hand, there were the large 'philosophical' murals favoured by official patronage. Concurrent with this, however, was a lyrical homely taste, much influenced by the folklore aspects of Romantic literature. It was the popularity of this style, commonly referred to in Germany by the term 'Biedermeier', which stimulated the production of so many fairy-tale pictures by artists like Richter and Schwind (Plate 11), and an unpretentious, though highly sentimental or humorous, portrayal of everyday bourgeois existence that affected even Friedrich's work in the 1820s. Friedrich's exquisite *Meadows before Greifswald* (Plate III), a nostalgic memento of his old home town, shows how far Biedermeier could extend beyond mere kitsch. Even the fairy-tale pictures of the period often contained psychological insights.

11. Moritz von Schwind. *The Rose.* 1845–7. Oil (216 × 137 cm). Staatliche Museen, National-Galerie, Berlin (East).

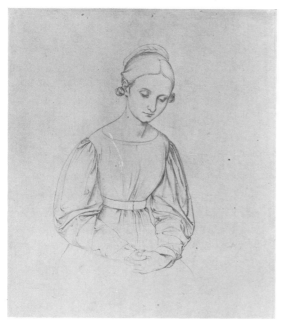

12. Friedrich Overbeck.
Nina, the Artist's Wife.
c. 1818. Pencil (20.6 ×
18.4 cm). Ashmolean
Museum, Oxford.

13. * Adolph von Menzel:
Wood-engraving from
History of Frederick the Great,
Berlin, 1840.

III. (facing page) Caspar
David Friedrich: *Meadows
before Greifswald. c.* 1827. Oil
(34.5 × 48.3 cm).
Kunsthalle, Hamburg.

As might be expected, these pictures were chiefly executed on a small scale, to make them suitable for the drawing-room or boudoir. These works have an intimacy commensurate with their destination. An intimacy of a different kind can be found in most of the painters' drawings. Here, for once, the German Romantic artist was working purely for himself; and even the most straight-laced of religious artists, like Overbeck, could indulge in a moment of sensibility (Plate 12).

But perhaps the most striking of all technical developments was in the field of illustration. The educational ventures of the period stimulated a mass readership which in its turn led to the expansion of a popular press. The 1840s saw the establishment of illustrated magazines like the *Leipziger Illustrierte Zeitung*, which was the German equivalent of the English pioneer in this area, the *Illustrated London News* (1842). Decades before this, moreover, book illustration had become a profitable sideline for many subject painters. It was the perfect corollary to the literary bias to be found in their paintings. For Menzel (Plate 13), it was illustration that first provided both a source of income and an international reputation. In many ways the illustrator came closer than any other kind of visual artist to enjoying the freedom of his contemporaries in music or literature, his works being purchased by an anonymous public like novels, or tickets to a subscription concert. Nevertheless, there was a price to pay for this enlargement of audience: instead of the authoritarianism of the old patron, the artist had now to contend with the vagaries of public taste.

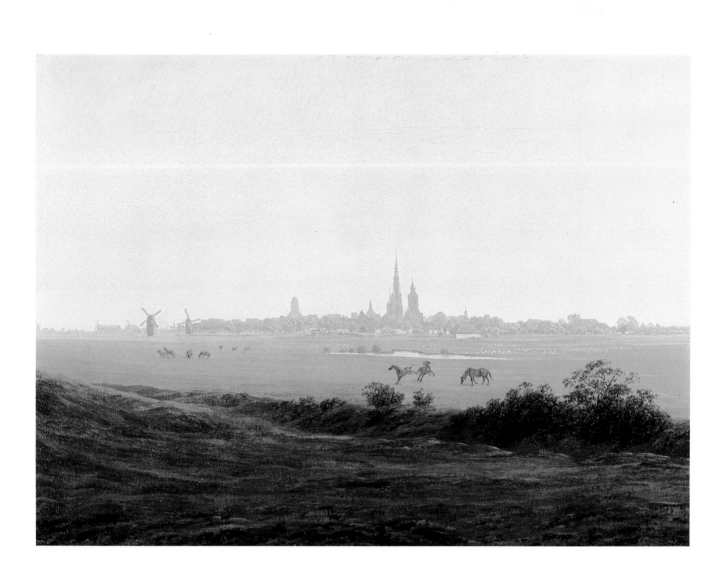

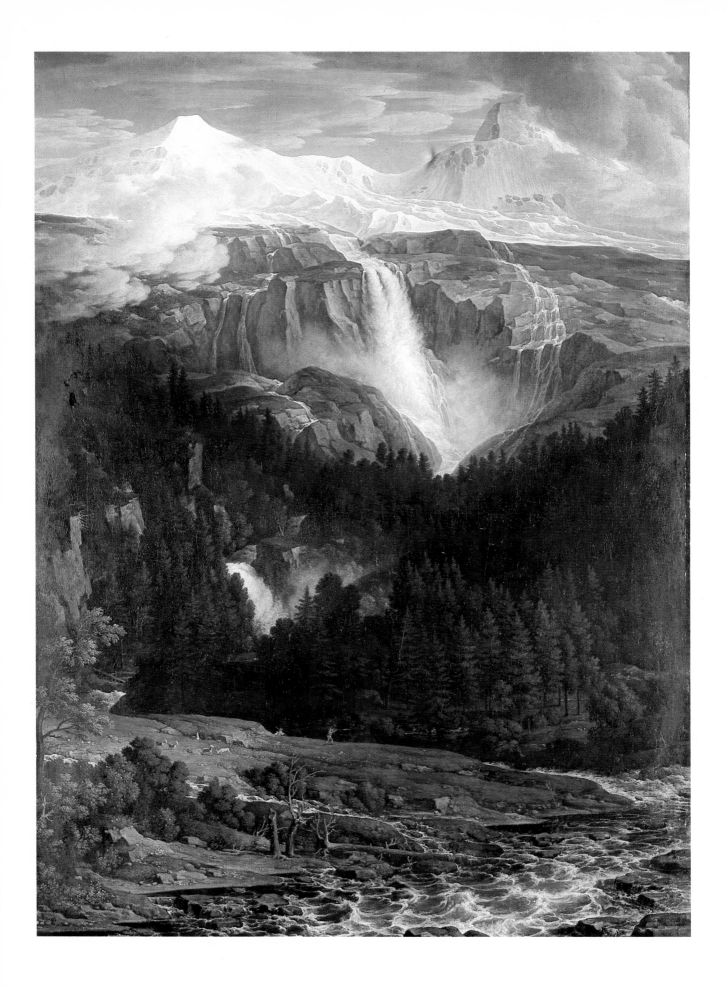

CHAPTER II Classicism and Expression

ONE OF THE MOST familiar objections of the Romantics to classicism was that it lacked relevance. 'We are no longer Greeks,' complained Runge to his brother in 1802, 'and when we contemplate their perfect works of art we can no longer feel the totality in the way that they did.'[1] For Runge a contemporary work of art had to address itself to the present, and this could happen only if the artist used as a guide his own instincts and feelings, rather than an inherited set of motifs, however immaculate these might be.

Runge certainly remained true to his faith and tried to produce an art that would be the pure expression of his complex emotions. And even the medieval revivalists, who were the most traditional of the Romantics, could see their work as a modern phenomenon, returning to the true direction of modern Christian Europe after the long relapse to paganism during the Renaissance.

Despite such claims, however, the Romantics in fact owed much to both the conventions and the ideals of the classical movement that had preceded them. Certainly, the first generation of Romantics did not seem to feel the need to free themselves from that taslisman of classicism, the precise, outline style of drawing that they had learnt at the academies, even if they did embellish it with bright colours, atmospheric effects and arcane symbols. What is more, there were few historical painters during the period who felt confident enough to throw over the canons of classical beauty when it came to depicting the human form. The most they did was to modify the taste for timeless nudity and classical draperies by introducing the more localized requirements of costume painting. Indeed, the mature work of the most prestigious of the 'Christian Romantics', Peter Cornelius, is so pure in its draughtsmanship, so regular in its features and so synoptic in its rhetoric, that one can only see it as an extension of that heroic classicism initiated by Carstens, and which was to be continued into the later nineteenth century by the idealist painter Anselm Feuerbach.[2]

Most paradoxical of all, the Romantics inherited their concern for contemporary relevance from the classicists. It is this which inspires the most significant contribution made by a German to the international neoclassical movement: *Thoughts on the Imitation of Greek Work in Painting and Sculpture* by Johann Joachim Winckelmann (1717–68), published in 1755. In this short polemical text, so lucidly and persuasively addressed to the educated layman, the vision of Greek art that is put forward feeds upon the same contemporary dream as that which informs Rousseau's revolutionary tracts on society. Like Rousseau's Noble Savage, Winckelmann's Greek enjoys not only a liberal and equitable social order, but also, through constant exposure and exercise in an ideal climate, a perfect physique. It was an example of this union of spiritual and bodily excellence that made the unsurpassable 'noble simplicity and calm grandeur' of Greek art possible. Turning next to his own degenerate age, Winckelmann went on to suggest that it was only by imitating art inspired by such flawless qualities that similar long-lost virtues could be rediscovered—an attitude that prefigures the arguments of the medieval revivalists.

IV. Joseph Anton Koch: *The Schmadribach Falls*. 1811. Oil (122 × 92 cm). Museum der Bildenden Künste, Leipzig.

Winckelmann also took care to emphasize that the apparently impassive perfection of the Greek figure was due not to the outcome of a lack of emotion but to a stoic self-control: 'As the depths of the sea remain always at rest, however the surface may be agitated, so the expression in the figures of the Greeks reveals in the midst of passion a great and steadfast soul.'[3] It mattered little that the statue that inspired these words, the famous Hellenistic group of Laocoon and his sons writhing in agony as they are crushed by serpents, is neither from the classical period of Greek art, nor has much sense of restraint about it. The inaccuracy went unnoticed; Winckelmann had successfully persuaded contemporaries that Greek art was not only ideal, but also sensitive and natural.

When he wrote this book, Winckelmann was more of a polemicist than a connoisseur. He was the son of a poor Prussian shoemaker, and had overcome immense difficulties to provide himself with a classical education. The collection at Dresden, near his place of employment, had provided him with a rudimentary knowledge of antique art, but it was only when he went to Rome, later in 1755, that he began to come into first-hand contact with the achievements of the Greeks and started to build up the knowledge that enabled him to write the first systematic *History of Ancient Art* (1764). However, despite the immense importance of this treatise for classical studies and for theories of stylistic development, Winckelmann's own standards of discernment remained shaky. His image of antiquity made Greek art a living ideal for countless art-lovers in the later eighteenth century; yet the painting that he personally considered to have restored the glory of this past completely fails to convey the inspiration of his writings. The *Parnassus* (Plate 14) painted by the Dresden-born Anton Raphael Mengs (1728–78) for Winckelmann's Roman patron, Cardinal Albani, was certainly a model of erudition and decorum. Showing the nine Muses on Parnassus, presided over by Apollo and their mother Mnemosene (Memory), it was an allegory on artistic and intellectual accomplishment. In itself this would have appealed to Winckelmann, since he considered allegory to be the highest form of artistic expression, both for its learning and for the opportunity it provided for combining the tranquil depiction of the human form with noble thought. Although the picture is a ceiling painting, Mengs refrained from showing his subject illusionistically, from a low viewpoint, in order to preserve the purity of his figures. The only movement in this family portrait of the liberal arts is the gentle flow that begins with the softly dancing figures of Euterpe and Terpischore on the left, and swells to enclose the whole group in the kind of low oval shape so popular in the mid-eighteenth century. The result suggests not so much an example of Greek purity as a vapid reworking of the *Parnassus* of Raphael in the Vatican, combined with references to the Apollo Belvedere, the recently discovered antique frescoes of Herculaneum, and seventeenth-century classicists such as Guido Reni.

Winckelmann's arresting prose seems well suited to the striving personality of a man who achieved international fame through his own unaided exertions. Mengs's *Parnassus* has an equally biographical appropriateness. The son of a court painter to the Elector of Saxony, Mengs was subjected to the most tyrannical training by his father, and in *Parnassus* one feels that he is taking care not to put a foot wrong. Certainly his own views on art, as reflected in his *Gedanken über die Schönheit und über den Geschmack in der Malerei* (1762) show less of the impact of Winckelmann than of the eclectic tradition of academic painting as exemplified in the writings of the Italian theorists Lomazzo and Bellori.[4] In these the student is encouraged to acquire perfection by combining judiciously from the excellence of the greatest masters. Mengs's particular recipe was Raphael for composition, Correggio for grace, Titian for the 'appearance of truth' and the Greeks for idealism.

Mengs in fact was not always as dull an artist as his ideas or his *Parnassus* would suggest.

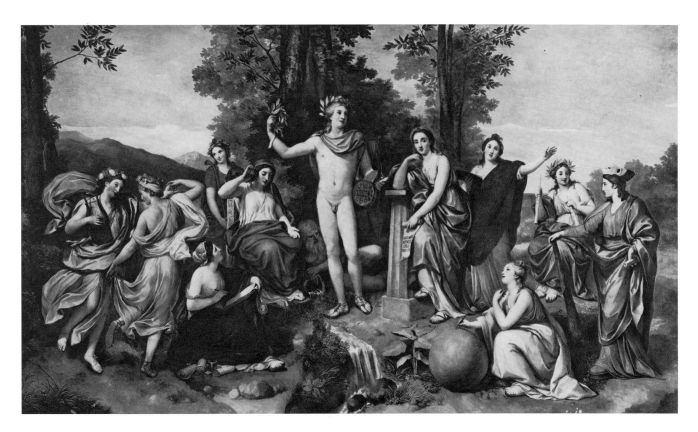

14. Anton Raphael Mengs:
Parnassus. 1761. Fresco
(*c*. 300×600 cm). Villa
Albani, Rome.

If this book were concerned primarily with eighteenth-century art, it would be only fair to describe as well such charming historical scenes as the *Anthony and Cleopatra* at Stourhead, the Baroque ceiling paintings he executed in Madrid after going to Spain as court painter to Charles III in 1761, and, above all, his meticulously observed and often sympathetic portraits. But these were not the aspects of Mengs's art that were most in evidence during the period under discussion. Unfortunately, Mengs was known to the Romantics primarily as the epitome of the mindless schoolman. This was partly because his treatise and the *Parnassus* were the most accessible of his works. But it was also because his followers were to be found well entrenched amongst the higher ranks of the teachers at the principal academies in Germany. In Dresden his right-hand man, Giovanni Battista Casanova (brother of the libertine), was director of the Academy until his death in 1796. Another associate, the sculptor Johannes Wiedewelt, was active in the Copenhagen Academy. And in Vienna his follower Friedrich Heinrich Füger (1751–1818) was director of the Academy at the time when the Brotherhood of St Luke staged their secession.

The officials with whom Mengs was associated were often far from being intransigent either in their own art or in their personal attitudes to other artists. Füger, for instance, showed much sympathy for the young malcontents. His own work, too, was rarely insensitive or dull. His large classical history pieces (such as the *Death of Germanicus*)[5] were staged with much drama and painterly effect. Even more striking are his portraits. Some—notably the one of his actress wife walking, book in hand, beneath a cloudy sky (Plate 15)—have a relaxed sensibility that has caused them to be compared with the portraits of Gainsborough. Yet in a sense the discrepancy between Füger's theory and his practice only added to his students' irritation, for it seemed to show that such theories were inadequate even for those who propagated them. What the dissidents sought was an art in which idea and action were one, and the artist's creation was witness to his inner conviction; and this was something Füger could not provide.

There were others among the Vienna Academy staff, however—notably Eberhard

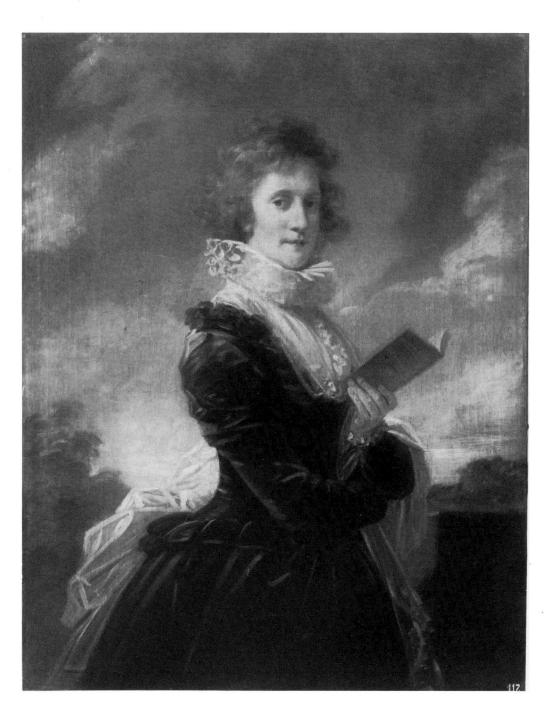

15. Friedrich Heinrich
Füger: *Hortensia, the Artist's
Wife*. Oil. Österreichische
Galerie, Vienna.

Wächter (1768–1852)—who pursued a more impassioned classicism. These took their
inspiration from Asmus Jacob Carstens,[6] an artist of a very different stamp to Mengs. Like
his contemporaries Goethe and Schiller, Carstens had been inspired by Winckelmann to
make antiquity a living ideal. Like them, too, he had only been able to achieve this after a
crisis of self-expression.

It was the *Sturm und Drang* (Storm and Stress) movement in Germany that provided the
focus for Carstens' experience. Although technically the term can only be applied to a
small group of writers between 1770 and 1778 (the most notable of whom were Goethe
and Herder) it had much broader implications. Inspired by Rousseau and the English
nature poets these writers followed the path of their emotions to the point where it brought
them into conflict with the existing values of the moribund society of contemporary
Germany, and it was this engagement that started the interaction between the artist and

society that accompanied the great rebirth of German culture during the next half century. Their courage was strengthened by their faith in the authority of original genius, which became epitomized for them in the 'wild' originality of Shakespeare and also, as we see from Goethe's seminal essay on Strasbourg cathedral (1772), in the striving forms of Gothic architecture. They looked back too to the same primitive sources, finding in Homer the elemental power of an oral tradition of folk poetry, and rediscovering as well the sagas of the North.

However, these men were never able to find a way either of resolving or of pursuing the conflicts that they experienced. Their outburst unlike that of the Romantics, was a disembodied cry. It is appropriate that the most lasting literary monument of the movement was Goethe's *Werther* (1774), a novel in which the hero's suicide on account of unrequited love epitomizes the more fundamental plight of a man debilitated by his inability to adapt himself to a world of compromise.

Goethe himself explored a more conciliatory path, and found increasingly in classical forms the structure to formulate his experiences. Herder, the leader of the *Stürmer und Dränger*, similarly came to accept that classical forms were valid. While he believed that each nation had its own independently developed cultural heritage, he could not bring himself in the end to recommend the modern German to ignore the classical rules. He asserted that Nordic mythology was more appropriate to the German spirit than that of Greece and should be the basis of the 'mode of thought' of the modern poet, but he should still respect the 'rules of Greek taste in art and poetry'.[7]

The combination of expressiveness and classical form can be found in the painter who is most frequently associated with the *Sturm und Drang* movement, Johann Heinrich Füssli (1741–1825). Füssli can only be considered a part of German culture in the terms outlined by Jacob Grimm,[8] that is by virtue of a shared language and literature. A Swiss by birth he spent the majority of his working life in England (where he is better known as Fuseli) having been expelled from his native Zurich at the age of twenty-two for protesting against a corrupt administration. Although the son of a painter, he trained, at his father's wishes, as a Zwinglian minister. His first chosen profession was as a man of letters. It was as such that, after a brief period in Berlin, he settled in London in 1764, where he translated, among other things, Winckelmann's *Thoughts on the Imitation of Greek Works* (1765), before deciding to become a painter. In 1770 he went to Italy to complete his training in this profession. At the same time as the *Stürmer und Dränger* were disconcerting the German public, Fuseli was astonishing the Roman art world with his startlingly conceived and boldly executed compositions. Fuseli shared much of the heritage of the German rebels. Through his Zurich mentor Jacob Bodmer he had been introduced both to the notion of the supremacy of the poetic imagination and to the work of Shakespeare and Milton and the ancient sagas such as the *Nibelungenlied*. While Fuseli was keeping well up with the most recent developments in German literature, the *Stürmer und Dränger* were in turn made aware of him through his old Zurich intimate, the poet and theologian Lavater, who described Fuseli to Herder in 1773 in terms that were likely to be a strong recommendation: 'He is everything in extremes—always an original: his look is lightning, his word a thunderstorm; his jest is death, his revenge hell.'[9]

After returning to England in 1780, Fuseli settled down to a distinguished career. Elected an academician in 1790, he later became both keeper and professor of painting, and when he died in 1825 he was accorded the singular honour of being buried in St Paul's Cathedral next to the first president of the Royal Academy, Sir Joshua Reynolds.

Neither age nor respectability abated the painter's fury. No doubt, as Gert Schiff has recently suggested,[10] much of the extravagance and violence in Fuseli's pictures was the expression of personal aberrations and frustrations. Certainly the projection of individual

temperament through art accorded well with his background and generation. On the other hand, the notion of art as a moral force was totally alien to him. Most of his work, with its erudite display of sources ranging throughout European literature and legend, and its highly idiosyncratic manner of interpretation and presentation, seems to be addressed at most to an informed élite.

Fuseli's diploma painting for the Royal Academy, *Thor Battering the Midgard Serpent* (Plate 16), certainly suggests this. In it he uses a little-known scene from Norse mythology as an exercise in sadistic violence: the phallus-like monster spurts blood from its hooked mouth, while a giant and a god look on in comic helplessness. The heroic form of Thor shows how Fuseli had managed to reconcile expressiveness with classicism by taking as his paradigm the figures of Michelangelo. And, while strongly leaning towards a mannerist style, he took great care to dissociate himself from the 'vagaries' of Romanticism. However complex the subject of a work of art, he felt its form should be clear, ideal and succinct. Nor was he an admirer of realistic detail, and in later life he found it hard to accept that the naturalist horses and riders of the Elgin marbles could have been carved by the great Greek sculptor Phidias. Fuseli was well known in Germany through engravings after his work. But ironically his excesses, which were much censured by Goethe in later years, were considered as symptomatic of English informality.

A more immediate exponent of expressive classicism was the Danish painter Nicolai Abildgaard (1743–1809). Strongly impressed by Fuseli while studying in Rome between 1772 and 1775, Abildgaard returned to become an influential professor at the Copenhagen Academy. He was always more regular in his forms than Fuseli, especially in later years when he tempered his rhetoric with the rhythms of the classical frieze. Nevertheless he shared Fuseli's admiration for Michelangelo and for the more obscure reaches of classical and Nordic mythology, and like so many other painters and writers of the period, his interest in the primitive made him a dupe of the most famous hoax of the period, the poems loosely derived from Celtic legend which were published by James Macpherson in 1762–3 as the work of the Gaelic bard Ossian. In his designs based on scenes described by the 'Homer of the North' (Plate 17) Abildgaard achieved an intermingling of North and South that pupils of his such as Carstens, Runge and Friedrich all found sufficiently arresting to feel the need to come to terms with.

That a Swiss and a Dane should have been the painters to come closest to the ideals of *Sturm und Drang* says much for the broad geographical range of Germanic culture in the century before the drive towards unification. Within the German states themselves, the only significant visual manifestation of the movement emerged late, in the 1790s, in a striking throwback to *Sturm und Drang*.

This was in the landscape etchings and drawings of Carl Wilhelm Kolbe (1759–1835), which have none of the respect for classical regularity and formal simplification that Fuseli and Abildgaard felt, but are full, instead, of the sense of organic growth and character that had obsessed Herder and Goethe in their youth.

Kolbe, a Berliner of half-French extraction, came to art late in life. His first career was as a teacher of French in a school in Dessau. Only after his drawings had been admired by the Berlin artist Daniel Chodowiecki did he enrol at the Berlin Academy, at the age of thirty-one, in 1790. Here he had the good fortune to be taught by the impassioned classicist Asmus Jacob Carstens, who declared 'Kolbe has genius, a sickly body and a good mind'.[11] His progress was rapid, and within a few years he had been elected a full member of the Academy. As we can see from his autobiography,[12] he had a shrewd sense of the scope of his talents, and kept well within their limits. He never attempted to be more than an etcher and draughtsman, and after learning the 'difficult part' of art (that is, figure drawing) felt free to relax with the type of intimate local landscape whose power he had

16. Henry Fuseli: *Thor Battering the Midgard Serpent.* 1790. Oil (131 × 91 cm). Royal Academy of Arts, London.

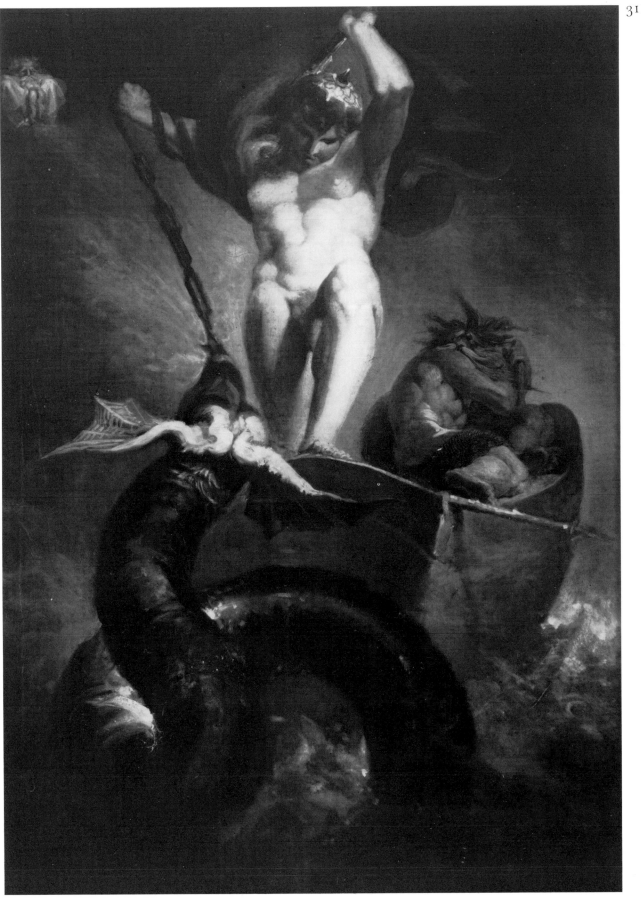

felt as a 'magic force' since childhood. Around 1795 he returned to Dessau, where an appointment at the court as etcher and French tutor provided him with secure employment. He remained in this small principality for the rest of his life, his only prolonged absence being the two years he spent in Zurich from 1805 to 1807 making etchings after the drawings of the Swiss poet and painter Salomon Gessner.

Kolbe's art was so original that it is difficult to associate him with any broad stylistic development.[13] His contemporaries seemed only capable of responding with nicknames. They called him 'Eichen' (Oak) Kolbe after the oak trees that predominate in his early works and which he was to develop so fantastically towards the end of his life (Plate 18). He was also known as 'Kraut' (Plant) Kolbe on account of his equally fantastic portrayal of smaller plants (Plate 19). He was disarmingly specific about his own sources. Apart from nature, he restricted himself to Dutch art (in particular the etchings by Waterloo and the paintings by Paul Potter) and to the idyllic scenes by Gessner. However, there are no oaks in Dutch art—not even those of Ruysdael—to match Kolbe's bizarre dead tree whose gnarled trunk and branches have become transformed disconcertingly into a clawing beast. And Kolbe's landscapes with figures seem almost travesties of those by Gessner that he so admired. In place of Gessner's arcadian harmony, we are thrown into a

topsy-turvy world where maenads are glimpsed between outcrops of giant undergrowth. There is no classical balance between man and nature here, only an uncontrolled fecundity. It comes as no surprise to learn that Kolbe arrived at these images not by making studies but by harking back to his impressions of frequent rambles in the woods near Dessau. Both in its reliance on subjective intuition and also in its obsessive sense of detail, which could be exploited so richly with the etching needle, Kolbe's approach to nature prefigured that of the Romantics. Indeed, it was the sight of his 1796 etchings that finally convinced Runge of his ability to become an artist. And it was Kolbe's instruction of the Olivier brothers that helped him develop that sensitivity to the intimate and minute that distinguishes their landscape drawing from that of most of their fellow Nazarenes.

In the *Sturm und Drang* movement there had been more concern for expression than for commitment. Through *Sturm und Drang*, writers like Goethe, Herder and Schiller had been able to invest the classical ideal with a new urgency. The vision of antiquity that can be found in Schiller's *Aesthetic Letters*, where individual liberty is combined with a deep sense of responsibility, has its closest parallel in the visual arts in the designs created by Asmus Jacob Carstens (1754–98) in Rome in 1790.

No doubt Carstens was aware of Schiller's letters—particularly through such *cognoscenti* as his friend and later biographer C. L. Fernow—but even before this time his career had been guided by a strong sense of destiny. Like Winckelmann he had struggled from a poverty-stricken north German background to the ultimate goal of Rome. However, while Winckelmann was always prepared to waive a few principles for the sake of advancement—even to the point of changing religion—Carstens was constantly making difficulties for himself by his refusal to compromise. The son of a miller in Schleswig, he was orphaned by the age of fifteen. Yet, when he was offered the opportunity of a seven-year apprenticeship with the distinguished Leipzig painter Johann Heinrich Wilhelm Tischbein, he rejected it on the grounds that so traditional a training was not to his purpose. The outcome, however, was something even less to his purpose: apprenticeship as a cooper. It was exactly seven years before he was able to enrol at the Copenhagen Academy, in 1776. Once there, he soon found that the teaching fell short of his expectations. He avoided copying directly from antique models, as recommended by his master Abildgaard, because it 'chilled his feelings'. Instead, like Kolbe and Friedrich, he preferred to rely on the inspiration of memory. He would wander through the Academy's collection of plaster casts for hours 'and impress the forms on my memory so firmly, that I could subsequently draw them correctly from my recollections'.[14] It now became his strong intention to see the originals of these figures that had so stirred his imagination. Impatient of official support, he set out for Rome at his own expense in 1783, but the funds he had gathered together were inadequate and he did not get further than Mantua, where the powerful forms in Guilio Romano's frescoes at the Palazzo del Te made a deep impression on him. For some years he lived in north Germany, where he was supported by, among others, Overbeck's father. In 1788 he came to Berlin and succeeded in being appointed a teacher at the Academy. He also executed some murals for the royal family and the minister of education, Karl Friedrich von Heinitz. It was the Prussian government that finally gave him leave of absence and provided him with the means of travelling to Rome in 1792. He was then thirty-eight and desperate to make up for lost time. When von Heinitz demanded his return in 1794, he could not tear himself away, and he was dismissed from his post.

By all normal standards, it was Carstens who was at fault. It is hardly surprising that von Heinitz should have decided to stop paying a man who showed no signs of returning to his position or of providing a full account of what he was doing in Rome. But Carstens saw the matter in a completely different light, and his reply to von Heinitz's notification of

17. Nicholas Abraham Abildgaard: *Malvina Mourning the Dead Oscar*. *c*. 1790. Oil (62 × 78 cm). Nationalmuseum, Stockholm.

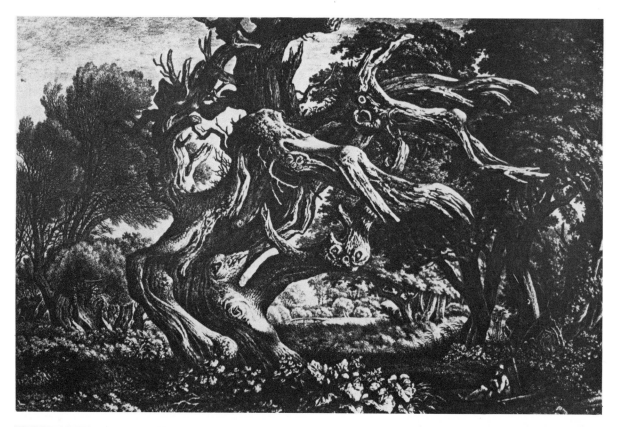

dismissal has justly become one of the *loci classici* of artistic integrity: 'I must tell your excellency that I do not belong to the Berlin Academy, but to mankind, which has a right to demand the highest possible development of my capabilities . . . my capabilities have been entrusted to me by God. I must be a conscientious steward, so that when I am asked "Give an account of thy stewardship", I do not have to say, "Lord, the talent that you gave me I have buried in Berlin".'[15]

The outcome of so arrogant and high-minded an ambition was disappointing. Goethe designated Carstens the artist 'with whom one gladly begins the new epoch of German art',[16] and this seemed to sum up his position for contemporaries. But with the exception of his early decorative work, which is now mostly destroyed, his art was always fragmentary. The pictures of his mature Roman period were largely studies and sketches—preparation for the imaginary grand project, the mural as large as Michelangelo's *Last Judgement*, with which he hoped, as Fernow put it, 'to work himself to death and become immortal'. Furthermore, his technique had its shortcomings. Oil painting never interested him, and the few remnants of what he did in it are dull. Even as a draughtsman he had limitations that betray all too clearly his refusal to make direct studies. A quality that his broad, slow-moving figures undoubtedly do possess, however, is a unique sense of fateful grandeur. His interest in the heroic led him to seek quite different prototypes from those of Winckelmann and Mengs, to prefer the Herculean and Michelangelesque to the Apollonian and Raphaelesque. His sense of grandeur was similar to that of Fuseli's, but he displayed little of the Swiss artist's mannered exhibitionism.

The grandeur is especially remarkable in the works of Carstens' Roman period, when all earlier tendencies towards violent expression had been brought under control. While he was in Berlin, he designed a *Fall of the Angels* whose clouds of struggling figures have an almost Baroque convolutedness.[17] But when in 1795 he depicted a comparable classical cataclism, the *Battle between the Titans and Gods* (Plate 20), his approach was much more restrained. In the later work the fighting Titans were made less prominent than those who are laboriously rolling rocks uphill to provide ammunition for their comrades. No doubt this hopeless but Herculean task is meant to signify the doomed outcome of the Titans' struggle. Certainly, Carstens' marked preference for the static and symbolic over the active and narrative links him with those other exponents of neoclassical taste, notably Flaxman and Canova, who were dominant in Rome in the 1790s. Like these artists, too, Carstens showed in these last years a growing respect for the archaic. This is already evident in the *Battle between the Titans and Gods* both in the use of the early Greek poem the *Theogeny* of Hesiod, and also in the use of the rocks to divide the groups in clear vertical planes. A. F. Heine has seen in this the inspiration of the famous fourteenth-century Hell of Orcagna in the church of Santa Maria Novella in Florence.[18] Certainly it is a device that would not have been suggested by Michelangelo's *Last Judgement*, to which Carstens pays tribute in the drawing's double-arched top.

These tendencies emerge more clearly in Carstens' most remarkable work, the large chalk drawing *Night with her Children Sleep and Death* (Plate 21). Taking the *Theogeny* again as his source, Carstens shows Night with Sleep and Death enfolded in her lap. Beside her, Nemesis, 'that pain to Gods and men', glances morosely out of the picture, scourge in hand, and in the background the 'ruthless Fates' spin and cut the thread of man's life. Although the forms, particularly that of Nemesis, are strongly reminiscent of Michelangelo, the conception and design are Carstens' own. Against a background of darkness and conspiratorial gestures, the foreground figures form a rhythmic frieze. Most moving of all is the sorrowful expression of Night as she draws her veil down over her youngest offspring. For this Carstens moved completely from the traditional classical representation of Night to capture something of the pathos of the Christian *pietà*. This

18. Karl Wilhelm Kolbe: *Dead Oak. c. 1830.* Engraving (31.9 × 48.2 cm).

19. Karl Wilhelm Kolbe: *Thicket with Antique Figures. c. 1800.* Chalk (39.2 × 59.9 cm). Staatliche Kunsthalle, Karlsruhe.

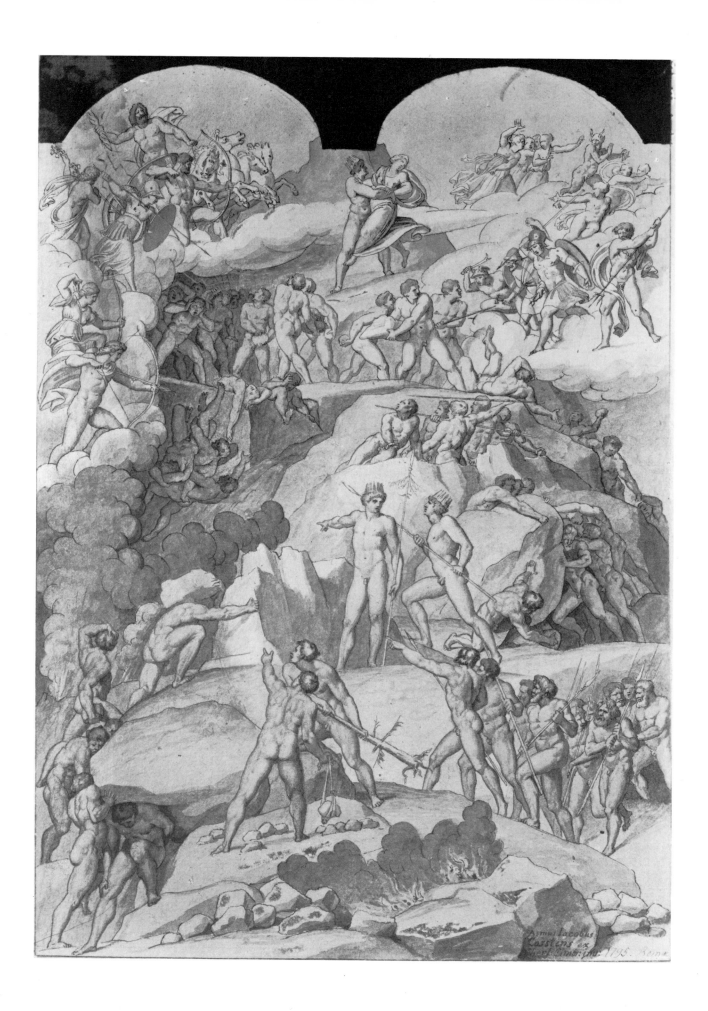

combination of powerful sentiment with the purest classical form made Carstens seem to his German contemporaries, as the Berlin artist Genelli told him, the one artist who could 'realize and bring to life the inner greatness of feeling that Homer gave his gods and heroes'.

In 1795 Carstens held a one-man exhibition in Rome. This established his reputation amongst the artists and connoisseurs there. In the three years between this exhibition and his death, there gathered around Carstens a group of young artists who sought to continue the tradition of 'heroic' art. Closest to him was Joseph Anton Koch (1768–1839), a Tyrolese painter who arrived in Rome in 1795 after having broken away from a rigorous academic training in the Karlsschule in Stuttgart and wandered for a couple of years through France and Switzerland. For some years Koch continued Carstens' inheritance in a literal way, making etchings from his unfinished cycle the *Voyage of the Argonauts* and copying many other designs 'to shake off the dust of Academic stupidity'. Although continuing to make figurative compositions, Koch developed after 1800, however, principally as a landscape painter; and it was upon his landscapes that Carstens' sense of grandeur had its most stimulating effect. Koch became one of the leading exponents in Rome of a new 'heroic' landscape in which the classical compositions of Claude and

20. Asmus Jacob Carstens: *Battle between the Titans and Gods.* 1795. Pen and watercolour (31.5 × 22.6 cm). Georg Schäfer Collection, Schweinfurt.

21. Asmus Jakob Carstens: *Night with her Children Sleep and Death.* 1795. Chalk (74.5 × 98.5 cm). Staatliche Kunstsammlungen, Graphische Sammlung, Weimar.

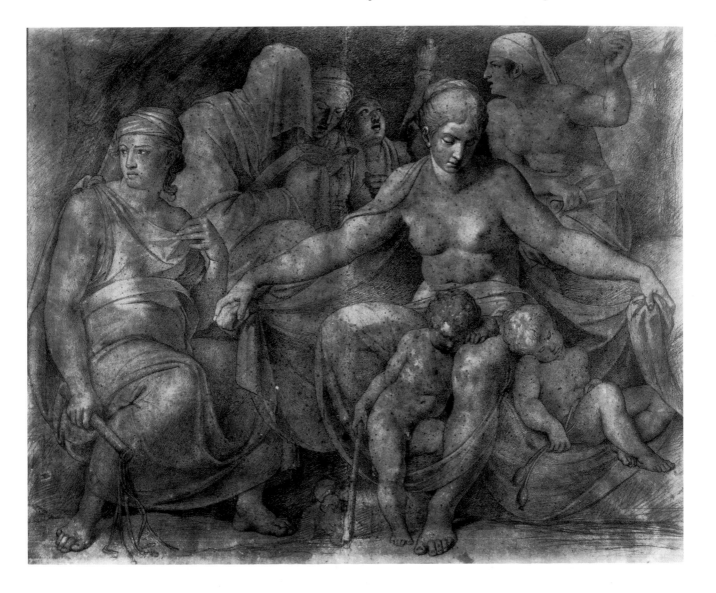

Poussin were revised to accommodate a more muscular, mountainous type of scenery. In *Schmadribach Falls* (Plate IV) Koch seems to be moving even further beyond the towering effect of snow-capped mountains rising through torrents, firs and clouds. This is intensified by bringing the upper regions as close to the spectator as the lower, a device that puts one in mind of the superimposed strata of figures in another vast vertical mural, Michelangelo's *Last Judgement*. Koch seems to have taken to heart Carstens' remark that high mountains such as the Alps inspire sensations similar to those aroused by a Michelangelo. He also appears to have been encouraged by the important essay on landscape painting written by Carstens' friend and defender, C. L. Fernow.[19]

In its harmonious balancing of great and small, in which man can be seen playing his part on the lower slopes, such a 'universal painting' as *Schmadribach Falls* still belongs to the classical ethos. By the time he painted it, however, Koch was already undergoing a transition. Always drawn to the non-classical themes, such as those from Ossian and Dante, that could be found in Carstens' repertoire, he became increasingly involved in the growing medieval movement. The climax of this involvement came when he left Rome to stay in Vienna from 1812 to 1815, as a protest against the invasion of the French. Here he fell under the influence of Friedrich Schlegel and the enthusiasts for old German art. In an attempt to get a more German character into his landscapes he moved increasingly towards a harsher style which blunted his precise linearity and turned the clear, penetrating light of his earlier works into a metallic insensitivity. It was a development that had far-reaching implications, for Koch's new style affected a whole generation of German landscape painters visiting Rome.

Koch's shift towards the Romantics demonstrates something of the complexities in the relationship between the emotive classicism of the Carstens circle and the new school. It is understandable that the younger generation should revere the passion in such artists as Koch and Wächter while they despised the cautious art of Mengs. But the elder painters were never wholly successful when they tried to assimilate the more recent direction; they could modify the reliance of tonal modelling, generalizing features and traditional rhetoric on which their style was based, but they could never abandon these for the dominant luminosity, colour or local detail that can be found in Pforr, Runge or Friedrich.

The artist who came closest to making the break was Christian Gottlieb Schick (1776–1812). A fellow pupil of Koch at Stuttgart, he went on to study under David in Paris, and by the time he arrived in Rome in 1802 he had fully assimilated the manner of French historical classicism. His contact with Koch and Wächter, however, brought about such a strong change that by 1805 his *Sacrifice of Noah* (Plate 111) could be hailed by A. W. Schlegel as a triumph for the new Christian school when it was exhibited at the Pantheon.[20] Yet the work was still clearly a modification of a seventeenth-century composition then thought to be by Poussin.[21] In fact its style does not seem so different from that of earlier Biblical pictures such as *Eve* (Plate 22). Although some of the foliage in this painting has something of the neat schematization of the quattrocento about it, Eve herself, caught succumbing to that vanity that was to make her a prey to the lurking serpent, has the supple modelling and theatrical pose of a less innocent age.

22. Gottlieb Schick: *Eve.* 1800. Oil (192 × 150.5 cm). Wallraf-Richartz-Museum, Cologne.

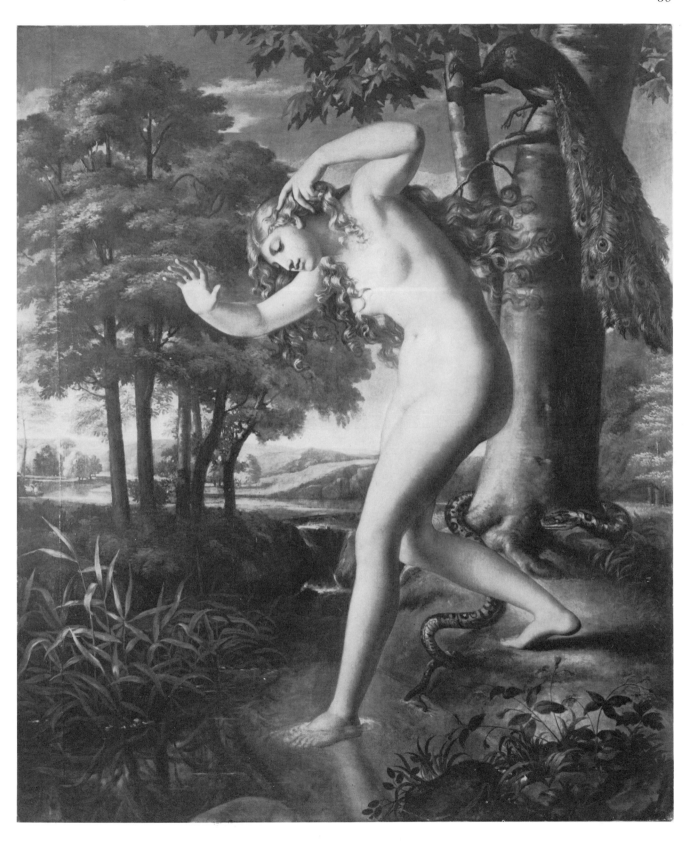

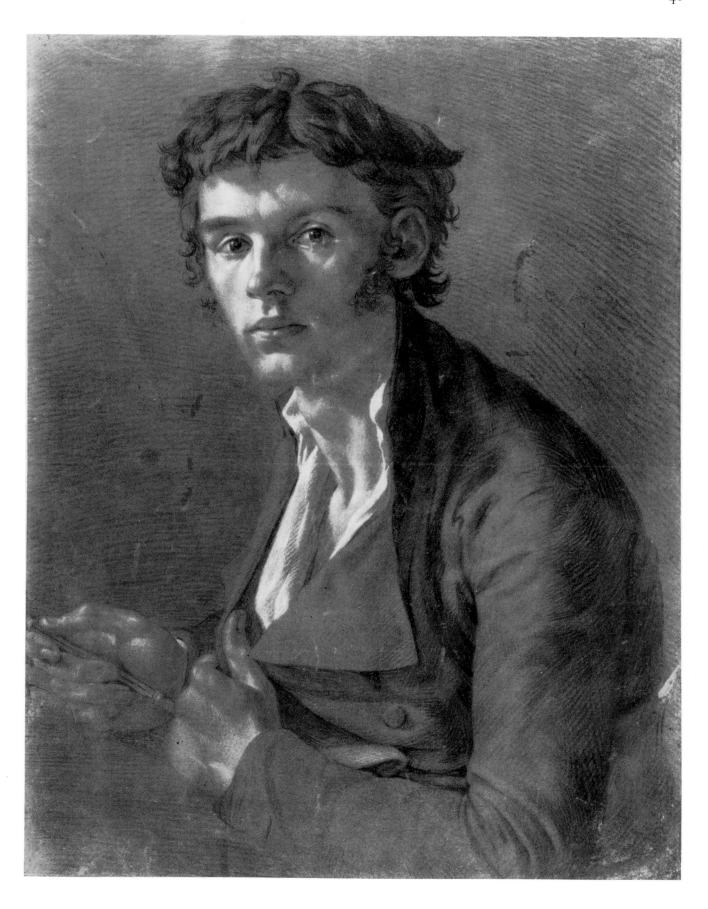

Philipp Otto Runge

PHILIPP OTTO RUNGE is an artist whose theories and aspirations are more immediately striking than his artistic achievements. His exciting insights are communicated in the enthusiastic speculations of his notes and letters more readily than in the pictures themselves. Like many of his time, he felt the need for a new kind of art before he was clear about the way in which it could be realized. Thus in 1802 at the beginning of his brief artistic flowering he proclaimed landscape to be the art of the future, while remaining in his own work predominantly figurative. He shared the contemporary opinion that the ancient Greeks had achieved perfection of form and that the 'modern Romans'—that is, the painters of the High Renaissance—had produced the greatest historical art. But he wrote that he could see no point in imitating either of these. Their spiritual climates had been different from the one in which he now found himself: 'We are standing at the brink of all the religions that grew out of Catholicism, the abstractions are dispersing, everything is lighter and airier than before; everything tends towards landscape, seeks something definite in the indefiniteness and does not know how to begin it. Is there not then in this new art—call it landscape if you like—a highest point to be achieved?'[1]

To talk of landscape in such terms at the beginning of a century in which the genre was to play a dominant role seems remarkably prophetic. Yet there was already some evidence for the claim. As Runge was writing, the English painters Turner and Constable and his own countryman Friedrich were already putting the idea into practice. The prediction, moreover, was not original, for a similar one had been expressed fifteen years earlier in *Ardinghello* (1787), the quixotic art novel of the veteran *Stürmer und Dränger* Wilhelm Heinse. 'Landscape painting', Heinse wrote, 'will, in the end, supercede all other genres. And it is by this means that we can expect to surpass the Greeks to a certain degree: precisely because we apply ourselves to the very subjects that they lacked.'[2] Runge's speculation brought a different dimension to Heinse's belief. But even this was not entirely new, for the same viewpoint can be found in the extravagant ideas of the Romantic theorists whom Runge had encountered in Dresden through his friendship with the writer Ludwig Tieck. Ecstatic descriptions of landscape are an important feature in Tieck's novel about an artist's life, *Franz Sternbalds Wanderungen* (1798). This was a work which Runge took to heart at an early stage in his career.[3]

To stress the derivativeness of Runge's theories is not to belittle his achievement, however, for the true uniqueness of his writings lies in the quality of feeling to which they bear witness. No one but Runge could have written this passage:

> When the sky above me shimmers with countless stars, the wind whispers through the broad space, the waves break with a roar in the distant night, the aether reddens over the woods, and the sun lights up the world, the valley is damp and I throw myself on to the grass amidst glittering dew drops, every leaf and blade of grass shimmers with life, the earth comes to life and moves beneath me, and everything harmonizes in a chord: then my soul leaps up and flies about in the immeasurable space around me.[4]

23. Philipp Otto Runge: *Self-Portrait*. 1801. Chalk (54.6 × 52.7 cm). Kunsthalle, Hamburg.

Its sense of spiritual ecstasy transcends that of passages in Goethe's *Werther* and Tieck's *Sternbald* which have often been cited as literary prototypes for such enthusiastic descriptions of nature.[5]

From this passage one recognizes why Runge's intense feeling of the universal could not be expressed in any conventional form of landscape art. In this sense, his writings lead one not away from but towards his pictorial achievement. This achievement remained fragmentary, for a number of reasons: his ambitions were impossibly complex, his life was cut short at the age of thirty-three and his one major painting, *Morning* (Plate 24), was dismembered after his death. Yet the works themselves are the centre of his activities, the focus of all his theorizing. While he fully admitted to being a 'thinking artist', he believed that ultimately it was the realization alone that was important: 'If one wants to do anything in art, theory can do as little on its own as can practice; and only practice, in the highest sense of the word, is actually art.'

Runge's art was firmly rooted in the cultural traditions and *mores* of his north German

24. Philipp Otto Runge: *The Child in the Meadow* (detail of the large version of *Morning*). 1809. Oil. Kunsthalle, Hamburg.

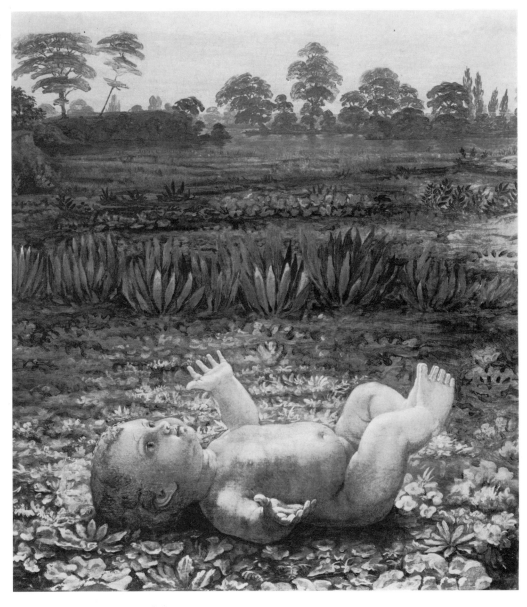

Protestant background. Like Friedrich, he was of Pomeranian peasant origin, coming from the small port of Wolgast, where his father had built up a shipping business. The ninth of eleven children, he always remained close to his family, and he did not begin to study as an artist until, at the age of twenty-two, he obtained the permission of his parents by convincing them that art could have a spiritual meaning, and that he could use it as an expression of the family's deeply felt religious faith.

Four years before this, in 1795, Runge had been set to work as a clerk in the carrier firm established in Hamburg by his elder brother Daniel and the merchants Speckter, Huelsenbeck and Wuelffing. In his second year with the firm he began to be allowed time off to study art, first with a young student, H. J. Herterich, and later with the more established local artist Gerdt Hardorff. During this apprenticeship Runge acquired the skills that were of most practical value for a painter seeking to make a living in Hamburg, namely, portrait drawing and decorative work. He rapidly became adept at the economical two-toned chalk portrait so in demand in this mercantile community (Plate 23).[6] This enhanced his gift for accurate observation. At the same time the proficiency that he was gaining in designing arabesques on the model of the fashionable antique grotesque work encouraged a sense of rhythmic symmetry that was later to be the basis of his great project the *Times of Day*.

Although Runge found work at the carrier's irksome, he maintained close contact with the business circles in which his employer moved, for there were many among them who had strong sympathies with contemporary developments in German culture. Daniel himself had been a poet, and, though his own unsuccessful struggles to be creative led him at first to discourage his brother, he later became his firmest supporter. In 1804, after five years of study in Copenhagen and Dresden, the newly married Runge returned to Hamburg with every intention of supporting himself, but it was in fact Daniel who provided for the artist and his growing family.

It was largely through literature that Runge first received the stimulus to become an artist. The degree to which Daniel's circle kept up with contemporary publications has already been mentioned. There were also more conservative local traditions. Matthias Claudius, the most eminent writer in Hamburg, combined the persuasive north German pietism with the new enthusiasm for nature. It was a synthesis already familiar to Runge through Ludwig Theobul Kosegarten, the pastor and poet who was his teacher in Wolgast from 1789 to 1792 and who, it is reputed, first encouraged Runge's father to let him pursue an artistic career. Despite the passionate melancholy of his poetry—which is full of echoes of Ossian, Thompson and Gray—Kosegarten was most remarkable for his peculiarly Christian pantheism. Caspar David Friedrich appears to have been most influenced by the poet's particular attachment to the Baltic coastlands. Runge, on the other hand, responded to Kosegarten's neo-Platonic interpretation of Beauty as the striving of the soul towards perfection, as outlined in his treatise *Über die wesentliche Schönheit* (On Essential Beauty, 1790).

Kosegarten may have provided Runge with a basis for regarding the interpretation of the visible world as a divine calling, but he himself remained an exponent of the nature sentiment of the eighteenth century, and fought shy of the more penetrating mysticism of Runge's later years. When Runge tried to interest his former teacher in the writings of the seventeenth-century mystic Böhme, who so fascinated the early Romantics, he declined to read him on the grounds that he 'set himself higher than the Apostles; an optical delusion that was perhaps unavoidable from his viewpoint'. And of Runge's new acquaintances in Dresden he remarked gloomily: 'I am now too old and cumbrous to keep step with the seven-league boots of the younger and more vigorous generation.'[7]

Literary traditions were stronger than pictorial ones in the Protestant north of

Germany, but the latter were also important to Runge. They mark the starting point of his own efforts, and affected much of his mature production. Runge was always seeking a practical outlet for his art, and seriously hoped to set up as a decorative designer after his return to Hamburg in 1804.

Even before he first came to Hamburg, however, Runge had acquired one practice that was to remain with him throughout his life. From his mother he had learnt how to make paper cut-outs and had become dextrous at the technique. His surviving cut-outs of plants (Plate 25) have a breathtaking delicacy and expertise that aroused the admiration even of Goethe. The latter was a strong opponent of the current fashion of silhouettes. However,

Runge's cut-outs owed less to this vulgarization of neoclassicism than to an authentic folk tradition. The control of shape and sense of detail that he gained from them remained a constant feature in all his work.

Through the print collections of the Hamburg merchants M. Speckter and G. J. Schmidt, Runge was first introduced to the major works of the Renaissance and of contemporary French, German and English painting. Of these it was the engravings of Kolbe, shown to him in 1797 by the bookseller Perthes, that first convinced him of his own artistic powers. Perhaps this was because he could relate Kolbe's preoccupation with plant life to the subject matter of his own cut-outs. But one can also find echoes of Kolbe's curious dislocations of scale in pictures like the *Huelsenbeck Children* (Plate VII), with its dramatic juxtaposition of plants and figures.

In October 1799, when he was already twenty-two, Runge took the course followed by so many other aspiring north German artists at that time and enrolled at the Academy of Copenhagen. It was here that he first became fully aware of the neoclassical movement, and set out to become a history painter according to the highest classical ideals—an ambition he did not abandon until after the failure of his *Achilles and Skamandros* in the Weimar competition of 1801. His experience of academic teaching methods, however, was no more favourable than that of Carstens. He was intrigued by Abildgaard's particular synthesis of sentiment and classicism, but like Carstens he rapidly became dissatisfied with the regime imposed by Abildgaard at Copenhagen for the copying of plaster casts of antique sculptures. His personal sympathies lay more with Jens Juel, the professor of painting whose own art was strongly influenced by the informal portraits and landscapes of contemporary English artists. Yet, although Runge took great pains to get himself admitted into Juel's painting class (an effort which was finally rewarded in the summer of 1800), he was careful to avoid the painterly 'effect-seeking' manner that he associated with English art.[8] His own style was tending more towards control and succinctness.

25. (left) Philipp Otto Runge: *Leaves and Firelily*. *c*. 1808. White paper cut-out on black ground (76 × 58 cm). Kunsthalle, Hamburg.

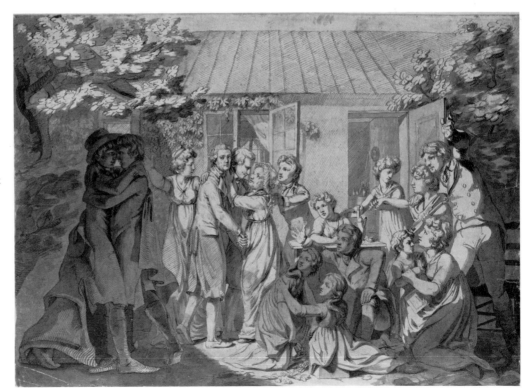

26. Philipp Otto Runge: *The Return of the Sons*. 1800. Pen (44.5 × 63 cm). Kunsthalle, Hamburg.

Runge's absorption of these influences can be seen in the major project that occupied him in Copenhagen, the *Return of the Sons* (Plate 26). Here an informal portrait group is handled in the manner of a historical subject piece. The scheme was intended to decorate a wall in the new house of the artist's brother Jacob at Wolgast, and represented Runge and Daniel being greeted by the family on making a visit home. It is characteristic of the artist in both its ambitiousness and its relationship to personal experience. Runge was finally forced to admit that he lacked the experience to handle such a full-scale mural project; but before he abandoned the idea he had made many detailed compositional studies.[9] An early one places the scene indoors (as in Hardorff's conversational portraits) but it was later to be moved to the garden (reproduced here)—a change which may have been suggested by the casual open-air groups of Juel. Unlike Juel, however, Runge has brought the figures together in a shallow frieze, with repeating diagonal accents as the sons' arrival on the left generates a rhythm of excitement across the room. This arrangement clearly shows his emulation of the antique; while the elongated, gesturing forms reveal a clear debt to the expressive manner of Abildgaard.

In August 1800 Runge was introduced to a new visual paradigm—'the like of which I have never seen before in my life'[10]—when Daniel sent him some of the cycles of outline engravings executed in 1793 by the English sculptor John Flaxman after drawings of scenes from Homer (Plate 27), Aeschylus and Dante. The neoclassical penchant for grasping the essential form of a work of art by reproducing it in pure outline was already familiar to Runge, as he had previously made copies from J. H. W. Tischbein's outlines of Sir William Hamilton's Greek vases. Flaxman's use of the genre for original compositions fired Runge's imagination in a new way, however, and had a similar effect on artists throughout Europe, including David in France and Goya in Spain. This was partly because Flaxman executed his designs with the utmost rigour, eschewing all volumetric shading and reducing detailing and background to a minimum. There were other more complex attractions, however. The outlines have a rhythmic suppleness of line that betrays Flaxman's concurrent interest in the more fanciful forms of Gothic. But, more important than this, the faint indications of 'inessentials' surrounding the main figures (instead of the enclosed spaces characteristic of classical reliefs) give these works the

27. * John Flaxman: *Achilles Fighting Xanton.* Engraving from the *Iliad*, Rome, 1793.

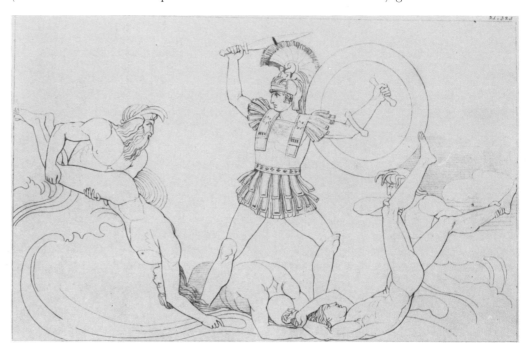

28. Philipp Otto Runge:
Fingal with his Spear Raised
(illustration to Ossian).
1805–6. Pen (39.5 ×
24.2 cm). Kunsthalle,
Hamburg.

29. Philipp Otto Runge:
Achilles and Skamandros. 1801.
Pen and wash (53 ×
67.2 cm). Kunsthalle,
Hamburg.

suggestive power of sketches. Their few, allusive lines stimulate the spectator to complete the forms in his imagination, and it was this quality that led A. W. Schlegel, in an article in the *Athenaeum* in 1799, to compare their technique to that of poetry. Although Flaxman himself rejected such a notion,[11] Schlegel's opinion stimulated the German Romantics to look upon the outline drawing as a kind of hieroglyph, a symbolic representation of some ineffable meaning. This is certainly what Runge attempted in his own preliminary outline drawings for his *Times of Day* cycle (Plate 31). And when in 1804 Runge was commissioned by Perthes to produce outlines for a volume of Ossian (Plate 28) as a pendant to the same publisher's edition of Flaxman's Dante, the artist produced designs in which the allusive details greatly extended the range of meaning. Indeed, the illustrations were so successful in breaking free from the purely literal significance of most neoclassical art that Count Stolberg, Perthes's translator for the Ossian volume, objected to their pantheistic overtones, and they remained unpublished.

The Ossian illustrations were not designed, however, until after Runge had been in contact with the Romantic circle in Dresden. At the time of his first encounter with Flaxman he was still thinking of his work in a strictly classical perspective, and could see no conflict between this frame of reference and his ambition to explore an individual symbolism.

Runge's impatience with the Copenhagen Academy was such that he left, just eighteen months after he had arrived, in March 1801. By this time he had already encountered a more vivid image of antiquity than could be provided by the ageing Abildgaard. This was supplied by Goethe, who first won Runge's admiration with his defence in his art magazine *Propylaen* (1798–1800) of the liberal system of art education practised by the French, in which more attention was paid to the free study of the living model than to the kind of slavish copying of selected paradigms that was enforced in Copenhagen. Runge, who always had an emotional need for a hero, soon cast Goethe in this role. His removal to Dresden in 1801 was partly motivated by a desire to be near the poet in Weimar. Disillusionment followed rapidly, however, when Runge failed to win Goethe's admiration with the composition *Achilles and Skamandros* (Plate 29), which he submitted for the Weimar competition in 1801.

Goethe's reaction was not unpredictable. It is true that his concern for *Bildung* (that untranslatable word that implies both education and formation) led him to give a theoretical assent to methods which encouraged students to view the classical as a living idea. But his own intervention in the careers of new artists was less enlightened. The annual competitions staged from 1799 to 1805 by his Weimar 'Friends of Art' (essentially himself and his artistic aide-de-camp, the painter Heinrich Meyer) for tonal drawings on one of a limited range of set subjects (usually taken from Homer) were judged with a restrictive partisanship that often failed to recognize individual talents. Even an artist as gifted in classical expression as Cornelius went unnoticed (although two sepias by Friedrich were rewarded in the last of the competitions, after the ruling about subject matter had been modified).

However, when Runge settled in the 'art city' of Dresden in May 1801 to complete the great work, he was unaware that Goethe (who had leanings towards the style as well as the teaching methods of French academic classicism) would view his efforts unfavourably. Judging the previous year's winner—Joseph Hoffmann's *Death of Rhesus*—on Goethe's published account of it, he was encouraged by the belief that it corresponded closely with his own ideas on the subject. Moreover, he found much to excite him in one of the optional themes for the present competition. The subject he chose came from a passage in the *Iliad* describing the moment when the river god Skamandros, outraged at the number of dead Trojans Achilles has deposited in his waters, rises with fellow river gods to attack the Greek hero, who is saved from them only by the intervention of celestial deities. Runge drew inspiration from Flaxman's design for a related theme (Plate 27). An early sketch for the subject is very close in composition to Flaxman's illustration. Even in the final version Runge retains Flaxman's frieze-like quality; for only the foreground features are fully shaded, while the background remains flat and without detail. Further simplification is achieved by severely reducing the number of deities and dead bodies in the design, so that the incident becomes distilled into a direct confrontation between Achilles and his main assailant, the opposing arcs of their bodies expressing simultaneously both the structure and the content of the work.

Runge was encouraged in this synoptic treatment by a new Dresden acquaintance, the painter Ferdinand Hartmann. As winner of the first Weimar competition of 1799, Hartmann seemed likely to be a reliable guide to the young aspirant. Recently, however, he had been falling under the influence of the Schlegels, and he advised Runge to emphasize those features that would make the work 'more symbolical'. It was precisely this aspect of *Achilles and Skamandros* with which Goethe found fault. He complained that there were too few figures in the design and, more importantly, that, except for a diminutive Minerva scurrying with her moonshield through the clouds, there was little sign of those gods who actually came to the rescue of Achilles. By suppressing these details, Runge had turned a moment of dramatic action into an allegory on the struggle between man and the elements. Goethe was alienated, not only by this interpolation of symbolism, but also by the morphology of the protagonists. In the elongated, Abildgaardian figures he recognized the same mannerist tendencies that he found so objectionable in Fuseli.[12] In Goethe's view there was only one solution for this; and Runge, having recently escaped from the cast room at Copenhagen, was now faced with the final indignity of being recommended by his former hero to make a closer study of the antique.

By the time Runge learned of Goethe's verdict, in February 1802, he had already begun to move away from the classical outlook. His meeting with the poet Ludwig Tieck and his first experiences at the Dresden Gallery of masterpieces of modern European painting encouraged him to search for a more sensuous and personal form of expression. The indignant outburst that he wrote to his brother against the 'tittle-tattle' of Weimar[13]

was not just a cry of disappointment; it was also an affirmation of the supremacy of emotion, and of its independence of reason.

This new direction did not, however, lead immediately to a break with the pictorial conventions of classicism, but rather to a deepening of symbolical overtones within a classical framework. The *Triumph of Love* (Plate 30), which Runge finished in time for the Dresden Academy exhibition in March 1802, exemplifies this trend. A monochrome relief in which each group of putti is rigorously profiled against a featureless background, this is in a sense the most severe of all his paintings. The theme, however, was deeply emotional. It was inspired by some verses of Herder which speak of a cupid Love, borne by butterflies, flitting where it will. Runge had first toyed with the idea in 1799, intending the picture initially as a gift for the Hamburg merchant collector G. J. Schmidt.[14] At that time it had depicted nothing more than a rococo group of cloud-borne infants—a fitting accompaniment to the playful elegance of Herder's poem. In the later version, however, planned as a *sopraporte* for the artist's brother's house, the central group has been flanked by further putti, who act out a cycle of man's life. The culmination of Love's intervention is explicitly sexual, for he and his entourage are approaching the embracing couple. Depicted in high relief the couple represent the apex of man's development. Love's arrival inspires as much awe as excitement. The girl hides her head while her lover stares apprehensively through the deep shadow they are casting towards the deity and beyond to the responsibilities of parenthood and the fading sadness of old age.

Runge's new interest in the intervention of love was no doubt a reflection of his recently aroused feelings for the sixteen-year-old Pauline Bassenge, the Dresden shoemaker's daughter whom he eventually married. As well as having this biographical appropriateness, however, the subject also allowed Runge to experiment with multiple associations of the kind explored by Tieck and his friends Wackenroder and Novalis, who sought to find some mystic unity in the resonances set up by different sensations. Thus, in the *Triumph of Love*, there are references to music in the lyre that Love plays—an image of the human heart—and to the approach of dawn in the rosebuds that his attendants scatter upon the earth. These associations were developed in Runge's next painting, the *Nightingale's Lesson* (first version, 1802–3, destroyed; second version, 1805, Kunsthalle, Hamburg), an allegory on the 'secret language' of natural sounds, which presaged the complex interaction of emotion and nature that was embodied in the *Times of Day*.

The scheme that was to be the consummation of Runge's artistic career began modestly enough as a project to design some mural decorations in the fashionable style of antique grotesques (Plate 31). Even when they had developed into something far more ambitious,

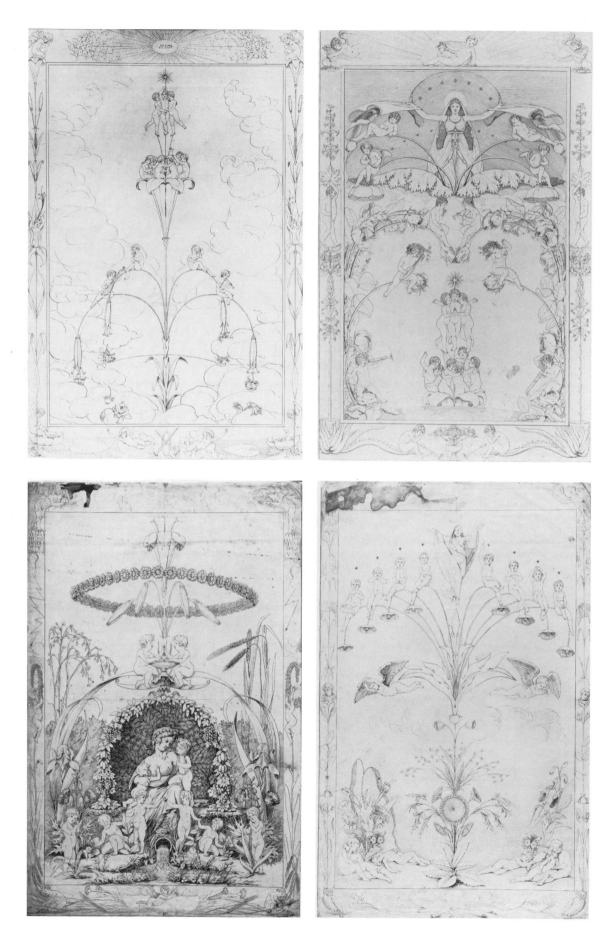

in the version that he engraved in 1805, Runge still hoped to use them as the basis for decorative commissions. The one mural that he did execute—an alcove cover for Perthes (Oskar Reinhart Stiftung, Winterthur)—was in fact a variant of the top section of *Night*.

The *Times of Day* evolved from the type of patterning with which Runge had become acquainted in his early years in Hamburg, but the religious sense of nature that he had absorbed from Kosegarten, and which had been reaffirmed through his friendship with Tieck, also led him to give these designs the hieratic quality of altarpieces. Like so many other visitors to the Dresden Gallery, Runge had been deeply moved by the *Sistine Madonna*, the great painting by Raphael which shows the Virgin descending to earth. The memory of this picture haunts the *Times of Day*, not only in features like the clouds of angels' heads around the sun inscribed with the name of Jehovah at the top of the border of *Morning*, but also in their pervasive sense of revelation. Runge's greatest debt to the *Sistine Madonna*, however, was in the discovery of the multiple resonances that can be set up by a painting. He wrote to his father that this picture had first shown him how 'a painter must also be a musician and an orator'.[15] And it ultimately became his ambition to make his *Times of Day* the focus of a *Gesamtkunstwerk*, in which the paintings would be exhibited in a specially designed Gothic building to the accompaniment of poetry and music. This was never realized, but even the images themselves have a reference that reaches beyond the visual, striving to embody the mystic experience of totality, 'when everything harmonizes in one chord', that Runge had described to his brother in 1802.[16]

Association was at the heart of Runge's method. It was with this principle in mind that he built up each composition in the *Times of Day* around the forms of flowers, for him the most evocative of natural phenomena. Like Novalis (whose novel *Heinrich von Ofterdingen* had as its *leitmotiv* the search for the visionary and unattainable 'blue flower') Runge followed the seventeenth-century mystic Jacob Böhme in using flowers to symbolize different states of awareness. 'We see in every flower the living spirit which man has placed in it', he wrote; and in the *Times of Day* the flowers are accompanied by childlike genii—representative of the age at which man is most innocent and elemental—who articulate the moods of each picture by their actions. In *Morning* some of these unfurl from the petals of the white lily, the symbol of light, as it rises above the globe of the earth; while others accompany the softly falling rosebuds of the dawn with the tinkling music of their lyres. In *Day* the lily reigns supreme in the sky, surrounded by a diadem of daisies; while on the earth, under a bower of cornflowers, bluebells and convolvuli, the genii form a group that surrounds the figure of Earthly Abundance. In *Evening* the genii of the lily sink behind the earth, while the roses and poppies are bowed down by other genii making music (as in *Morning*, but with the addition of deeper-toned brass instruments). The figure of *Night*, drawing her veil over the scene, completes the melancholy mood. In *Night* itself it is the poppy, symbol of sleep and death, that dominates. Seated between the poppies and the stars, eight genii perform a mystic semaphor, while the winged figures of Sleep and Death emerge from the poppy leaves, and down below the genii of earth lie insensate.

As can be seen from this brief account these hieroglyphic outlines are full of sensuous associations of light, colour and sound. These were intended not to add up to an enclosed allegory, but rather to stimulate a seemingly endless number of trains of thought that would bear witness to the elusive but ubiquitous presence of the Divine throughout nature. However, Runge never abandoned his Protestant faith in favour of a thoroughgoing pantheism. The designs are full of allusions to classical mythology (for example, Night and her children). But the images in the frames bring one back to the explicit Christian doctrines which underlie the whole. Like Böhme, Runge saw light as the mystic force that came to release the human soul from its material bondage. Colour, stimulated by light, represented the interaction between the physical and the spiritual.

31. Philipp Otto Runge: *The Times of Day*. 1803. (top left) *Morning*. Pen (72.1 × 48.2 cm). (bottom left) *Midday*. Pen (71.7 × 48 cm). (top right) *Evening*. Pen (72.1 × 48.2 cm). (bottom right) *Night*. Pen (71.5 × 48 cm). Kunsthalle, Hamburg.

And the three primary colours that combined to make a pure white light were for him the natural symbol of the Trinity.

Already by this time, light and colour were Runge's principal symbols. Each of the 'Trinity' of primaries had its direct association. Blue, the colour of day, stood for God the Father. Yellow, whose connection with Night he considered 'self-explanatory', represented the Holy Ghost. And red, the colour of passion, was for Christ, who sacrificed himself for man. In the morning, mingled with white, it was a reminder of the hope he offered humanity; in the evening, mingled with darkness, it was a memento of his death.

The Romantics' interest in nature mysticism did more than reaffirm the views of Kosegarten. Their unique contribution to Runge's highly personal synthesis came from their concurrent interest in the transcendental philosophy that men such as Fichte and Schelling had developed from the *Critiques* of Kant. These 'transcendentalists' had taken subjectivity to the point of asserting that the universe existed meaningfully only in so far as man was aware of it. Runge himself was particularly close to the scientist Henrik Steffens, who shared his teacher Schelling's view (as expressed in his *Naturphilosophie*) that man brought the spiritual within nature to consciousness, and that the artist's duty was not to copy the outward form of creation, but to 'follow the spirit of Nature working at the core of things and speak through form and shape as by symbols only'.[17] The *Times of Day* are not based upon any observed landscape therefore but are reconstitutions of natural elements according to Runge's own sense of a mystic unity in the natural world. Believing that 'strong regularity is the hallmark of those works of art that spring directly from our imaginations and the mysticism of our souls',[18] he used symmetry as the basis of these designs. This extends to the planned arrangement of the pictures on the four sides of a square, with *Morning* balancing *Evening* and *Day* balancing *Night*. Yet it is a living symmetry of visual echoes rather than the dead symmetry of a mirror image. In the *Gesamtkunstwerk* which Runge envisaged, only the frames would have repeated each other exactly across the room. Each design contains gestures which are individual—similar but not identical to those of its counterpart. Thus, the morning lily rises like a fountain, while in the evening there is a gently declining motion beginning with the cloak of *Night* and repeated in the bending of the plants. In *Day*, the time of fulfillment, the design is formed out of circles and arcs, while in Night there is a meagre angularity.

It has often been remarked that Runge resembles his older English contemporary, the painter and poet William Blake (Plate 32). There are certainly many affinities in their mystic beliefs and in their hieratic and symbolical imagery.[19] Both, moreover, tended to be regarded with curiosity by their fellow countrymen. Runge came to be seen increasingly as an intriguing eccentric, especially after the publication of the engravings of the *Times of Day*. When talking of these shortly after Runge's death Goethe remarked 'It is enough to drive one mad, beautiful and at the same time nonsensical . . . the poor devil couldn't stand the pace, he's gone already; there is no other solution: anyone who stands on the brink like that must either die or go mad; there is no salvation.'[20] Even those Romantic writers who had inspired and encouraged Runge, began to turn away from him in the latter part of his brief career. Since the death of Novalis the official movement had been turning away from heady speculations towards a more simple-minded medievalism.

Tieck, who had employed Runge to illustrate his *Minnelieder* (1803), had promised to write an accompanying text for the *Times of Day*, but he began to lose interest around 1804 as he became involved with the revivalist artists the Riepenhausen brothers. Friedrich Schlegel went so far as to give a thinly veiled warning in his magazine *Europa* against artists who try to create their own mythology rather than following the 'safer' path of tradition.[21] One can readily appreciate the poetic force of the *Times of Day* and the delicate precision of the draughtsmanship, but it is also easy to imagine the perplexity that

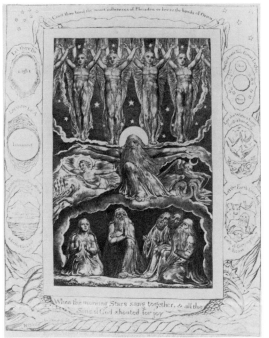

32. William Blake: Plate 14 from *The Book of Job*, London, 1826. Engraving.

33. Philipp Otto Runge: *We Three*. 1805. Oil (100 × 122 cm). Destroyed, formerly Kunsthalle, Hamburg.

their highly individual symbolism caused. However, judgements by contemporaries were premature. Runge had not intended these engravings to be more than outlines in the literal sense. He had achieved in them a mastery of form and design. He now set himself the more formidable task of turning into a sensuous experience the mystic feeling of colour and light to which his engravings alluded.

It was not until the summer of 1807 that Runge began painting the cycle. By this time, in search of some means of support for himself and his new wife (whom he married in May 1804), he had returned to Hamburg. Here, Daniel's wealthy friends were able to offer him commissions for a variety of items, from altarpieces to playing cards, and these proved to be a regettable but necessary distraction from the completion of the grand project. There were other reasons for the delay, moreover. Runge, who always maintained the strictest standards for his cycle, was aware of his shortcomings as an oil painter and therefore began to take lessons from a local artist, Johann Friedrich Eich. As he began to develop as a colourist, he also felt it necessary to make thorough investigations into the nature of colour and its interrelations—investigations that won him the admiration of Steffens and Goethe, and which were eventually published in 1810 in his study *Die Farbenkugel* (The Colour Sphere). In 1806 he was obliged to curtail his painting activities when his brother went bankrupt as a result of the trading blockade imposed after the French invasion of Germany. For a year the Runge family retreated to the parental home of Wolgast, and only in mid-1807 was the situation in Hamburg restored.

Runge shared with Blake the knack of turning any commission into an occasion for an individual statement. This is especially true of his portraits, which are among the most penetrating of the early nineteenth century. Ironically, this was the one type of work that he regarded with disdain.[22] Throughout his artistic career, Runge occasionally made chalk portrait drawings, but soon after his return to Hamburg in 1804 he also began a number of more ambitious groups in oil. From Runge's own comments it would seem that these pictures of his family and close acquaintances were viewed largely as experiments. Set for the most part in the open air, they explore various formal relationships between figures and the landscape in which they are placed. They vary greatly in their handling—from a rich bravura in the portrait of his wife and young child (Nationalgalerie, Berlin (West)) to the thin glazes of the *Huelsenbeck Children*.

35. Philipp Otto Runge:
The Artist's Mother (study).
1806. Oil (27.8 × 24.4 cm).
Kunsthalle, Hamburg.

34. Philipp Otto Runge:
The Artist's Parents. 1806. Oil
(194 × 131 cm). Kunsthalle,
Hamburg.

The earliest of these portrait groups is the one commonly known as *We Three* (Plate 33). Painted as a gift for Runge's parents in 1805, this shows the whole Hamburg branch of the family, and also hints at their relationships: Runge and his wife Pauline close together on one side, with his brother Daniel leaning apart on the other, linked only by the intertwining of hands with Pauline at the base of the picture. Each of them stares solemnly at the spectator, very much an individual presence. Daniel, the unwilling merchant, is melancholy and withdrawn, while Runge is almost defiantly alert as he protects his curious and timid young wife.

These relationships are given a further dimension by the landscape. As far as one can tell from photographs (the original picture was destroyed in the Munich Glaspalast fire of 1931), the setting was painted with a more fanciful bravura than the sharply observed foreground figures. It is less a fully realized rural landscape than a gap-filling backcloth. Nevertheless, just as flowers were 'personified' by genii in the *Times of Day*, so the trees in this painting can be seen to provide a commentary on the human figures. The sturdy oak on which Daniel leans spreads its foliage protectively over his dependants, whose frailty is mimicked by the crossed saplings in the distance.

Landscape is used here almost as a series of allegorical attributes. In Runge's next portrait group, that of the three young children of Daniel's partner Huelsenbeck (Plate VII), the relationship of landscape to figures is far more complex. The children are seen playing in the garden of their home at Eimsbüttel, just outside Hamburg, whose towers and roofs can be glimpsed over the garden fence. It is therefore a portrait of a place as much as of a group of people. Runge, writing of the work afterwards, felt that he had failed to achieve the correct proportions between landscape and figure: either one or the other should have been made predominant.[23] As in the designs of Kolbe, however, it is the tension between these two that provides much of the picture's fascination. The lack of the direct pairing of *We Three* also enhances its intensity. There is a strong sense of the children themselves as vigorous, strong-willed creatures. Although the motif of two children towing a baby in a cart has its origins in the informal portrait conventions of the late

eighteenth century, there is none of the sentimental approach to children here that can be found in Romney, Reynolds or Juel. One has to go back further, to the *Graham Children* of Hogarth,[24] to come across a comparable hint of self-absorbed wilfulness in child portraiture. The pudgy face and hands of the infant are alive with primal energy, and the elder boy is shown rushing forward, heedlessly wielding his whip. Only the girl possesses any forethought. She looks back in consternation as the baby instinctively grasps at one of the lower leaves of the sunflower looming above him. Most arresting of all is the picture's handling of scale. Looking at the painting, we find ourselves in the children's world. We are on their level, below the sunflower and close to the ground. The children are made to seem larger, moreover, by the scale of the fence, which has been reduced in size so as not to overshadow them. The effect of all this is to emphasize their monumental presence. Yet any sense of *gravitas* is curiously undermined by a disturbing effect on the extreme right of the picture: the violent perspective of the fence as it turns back sharply towards the house.

Runge felt—quite unjustly—that the picture was a failure. But he also realized that he had learnt much by painting it. Certainly it seems to mark the moment when his mastery of oils enabled him to use light and colour as more than mere symbols. In the *Huelsenbeck Children* Runge has captured the luminosity of midday. This is not an actual *plein air* painting (if Daniel is to be believed it was executed in mid-winter, though the scene is set in summertime). In spite of this it displays an unprecedented understanding of the brightness and reflectiveness of colours in the open air. This is apparent in the figures themselves as well as in their surroundings, for the boy's suit is no more densely green than the leaves of the sunflower, and the girl's dress no less reflective in the shadows than the white fence behind. Particularly striking is the way in which the child in the cart is illuminated from beneath by the brown reflections from the ground, so that his toes acquire a strange translucence. Effects such as these remind one that, after Raphael's *Sistine Madonna*, Runge's favourite paintings in the Dresden Gallery had been the mysteriously illuminated nativities of Correggio. Runge's memories of Correggio's *Night* were indeed refreshed in 1806 by his friend Klinkowström, who was at that time in Pomerania trying to sell a copy he had made of the work.

The largest of Runge's group portraits was a full-length painting of his parents with his eldest son and his nephew (Plate 34), which occupied him during his retreat to Wolgast during 1806–7. It is somewhat ironical to see these proud and upright burghers, who were at this time in such straitened circumstances, promenading with an air of authority in front of their house and shipyard. But in other respects one is struck, as in all Runge's portraits, by the clearsightedness of the record. The honesty of Runge's portraiture is comparable to that of the bourgeois portraits of David in the 1790s and during his last years in exile in Brussels. Both artists were applying to the genre a standard of neoclassical precision that was to remain an invigorating force in portrait painting even during the Biedermeier period. In the direct studies that Runge made for this work, the mixture of affection and sincerity that characterizes the finished portrait can already be seen, especially in the study of the artist's mother (Plate 35), in which the firm, bold brush strokes beautifully describe the crevices of the care-worn face and the calm sympathy of the eyes. One is reminded of the realism of the bourgeois art of sixteenth-century Germany, epitomized in Dürer's drawing of his mother.

After finishing the portrait of his parents Runge determined never again to work in portraiture on such a scale. In his last years he produced several small and affectionate records of his family, as well as some tragic ones of himself, prematurely aged by illness, but from 1807 he chanelled his major efforts towards large-scale subject painting.

While his large-scale portraits had greatly helped him in his development of the technical proficiency and handling of figures in open air settings that were so essential to

36. Philipp Otto Runge: *Rest on the Flight into Egypt.* 1805–6. Oil (96.5 × 129.5 cm). Kunsthalle, Hamburg.

make the *Times of Day* convincing, Runge had at the same time been engaged in oil paintings that came closer to his theoretical interests. The Dresden themes had been followed by the *Source and the Poet* (1805, Kunsthalle, Hamburg) and a reworking of the *Nightingale's Lesson* (1805, Kunsthalle, Hamburg), in which he had greatly extended his personal mythology of landscape.

It is scarcely surprising that these should have culminated in two schemes for altarpieces. Painting was for Runge a religious act, and as a firm Protestant he welcomed the opportunity to make a new contribution to conventional worship. The projects in which he attempted to do this were the *Rest on the Flight into Egypt* (Plate 36) designed for a church in Greifswald and *Christ Walking on the Waters* (1806–7, Kunsthalle, Hamburg), intended for Kosegarten's fisherman's chapel in Vitte on Rügen. They were scarcely as revolutionary in concept as Friedrich's *Cross in the Mountains* painted at much the same time, but both involve religion and landscape, depicting examples of divine intervention in the laws of nature. Unfortunately for Runge, his reputation for allegorical obscurity seems to have gone before him, and neither submission was accepted. Headed by Quistorp, the committee responsible for allocating the Greifswald commission eventually decided against Runge because they feared, as his brother Jacob told him, that he would produce 'something too mystical, that people would not understand'.[25] Kosegarten too had misgivings about his former protégé, now that Runge had returned from Dresden with a passion for the ideas of Böhme and the new subjectivism. His reply to Runge's offer to provide the altarpiece for the pastor's new chapel (a commission that Friedrich

had recently been asked to fulfil) was full of dissemblings. He pleaded that owing to the hardships brought about by the French invasion he would be unable to pay the artist for his pains. This was reasonable. But Kosegarten also made it clear that Runge would be charged rent if he came to stay with him while working on the altarpiece, and this was undoubtedly an attempt to put an end to the whole idea.

These unfavourable decisions were made known before Runge had quite finished either work. With his usual penchant for synthesis, however, he found other applications for the themes on which he had been working. Using the poetic but perfectly familiar German habit of referring to the Occident as *Abendland* (Evening Land) and the Orient as *Morgenland* (Morning Land), he turned the *Rest on the Flight into Egypt* into a pendant for the *Source and the Poet*. The latter picture, which shows the poet, lyre in hand, pressing to the source of a Nordic woodland stream became the *Evening of the Evening Land*, while the former, in which the miracle of the palm tree bending down at daybreak to offer its fruit to the fugitive Holy Family, became the *Morning of the Morning Land*. Indeed, the miracle of the tree is subordinated to the miracle of light, the shadowy Joseph extinguishing the fire that kept them warm through the night while the Virgin kneels before her offspring as he stretches out his hands to catch the first rays of the sun.[26] In *Christ Walking on the Waters* light also underlies the theme; for the scene is set at night, with Christ as the sole luminary to guide the faithful in times of adversity.

During the years 1805–7, therefore, Runge had painted a series of works which covered the four times of day that were to be the basis of his cycle. On each occasion he had been concerned to achieve a perfect alignment of symbol and experience. In *Rest on the Flight into Egypt*, the way the light is broken down into separate colours on the fingers of the Christ-child symbolizes the interaction of the spiritual with the physical; but it is also a careful observation of the way that the sun lights up the semi-translucent material of skin.

It was Runge's desire to make his symbolism a sensuous rather than a merely cerebral experience that led him to give colour increasing importance in his work. Nothing indicates his departure from academic theory so much as his interest in colour as an observable phenomenon. While the effects of this 'last art which remains, and must always remain, mystical'[27] might ultimately be explicable only in spiritual terms, nevertheless its manifestations could be studied and calculated. The neoclassicists had confirmed the conventional view of colour as an 'inessential', a mere adjunct to the pure beauty of form. Mengs and Casanova had propounded theories on colour which Runge had studied in Dresden when preparing the first version of the *Nightingale's Lesson*. But their ideas showed the most rudimentary analysis of differentiations of hue and little interest in the interrelation of colour sensations. Runge, on the other hand, was concerned with the empirical balances and harmonies of colour as they appeared in nature. Like Goethe, Runge rejected the inference drawn from Newton's optics that colour was determined purely by different wavelengths of light, preferring the Aristotelian notion that colour properties were inherent in objects and were simply made visible by the effect of light falling upon them. The importance of the Aristotelian theory for both of them was that it made colour a matter of local variations and emphasized that colour could be understood only by studying it in all possible circumstances, and not simply by the dissecting approach of Newton's analysis. However indefensible such a view might be in terms of pure physics, it did pave the way towards a greater understanding of the physiological bases of perception, leading to the explanation of subjective phenomena such as after-images and induced chromatic contrasts. In brief, Runge's approach to colour showed that he shared the attitude to science held by Goethe and the Romantics, viewing the universe not as the sum of mechanical forces but as an organic, living entity.

In *Die Farbenkugel* (which was intended as a practical guide for artists) Runge

Farbenkugel.

37. Philipp Otto Runge:
Colour Sphere. Illustration
from *Die Farbenkugel*,
Hamburg, 1810.

concentrated upon the phenomenological aspect of colour. The only speculations on colour associations and symbolism were to be found in the appendix provided by the 'nature philosopher' Steffens. The sphere itself was a three-dimensional colour chart (Plate 37) with the lines of the spectrum encircling its equator and black and white at the poles, and all observable differences of hue and tone (which, with characteristic love of precision, Runge calculated to number 3405) registered on it.

Not only was this sphere a far more sophisticated model for identifying colour differentiations than any scheme that had preceded it; in addition its structure seemed to provide a measurable indication of how colours relate to one another. The positioning of hues round the equator seemed to correspond with their natures, with complementary colours balancing each other on opposite sides of the sphere. The symmetrical construction of the sphere reflected the Romantic desire to see in colour relations a series of natural divisions similar to those that, since Aristotle, had been held to form the basic intervals in musical harmony. In practice, however, the results were not entirely regular.

Runge's system of colour harmonies remained conjectural, like all attempts in this field, yet it had the definite effect of sharpening his sense of colour. His investigations had shown him how in nature every different set of objects, every different type of luminosity, sets up its own harmonies. He recognized a basic division between 'transparent' and 'opaque' colours—the former ethereal and boundless, the latter earthbound and limited—and could see each moment as bringing its own particular luminosity to interact with the particular objects under observation. And from the limitless reflections that exist between those there is a constant process of modification of harmonizing of tones, as light, through the agency of colour, produced a perfect natural chord.

In 1807, after the failure of his religious ventures and the improvement of the family's economic situation, Runge turned again to the problem of painting the *Times of Day* on a monumental scale. From June 1807 he worked to produce the oil sketch now known as the

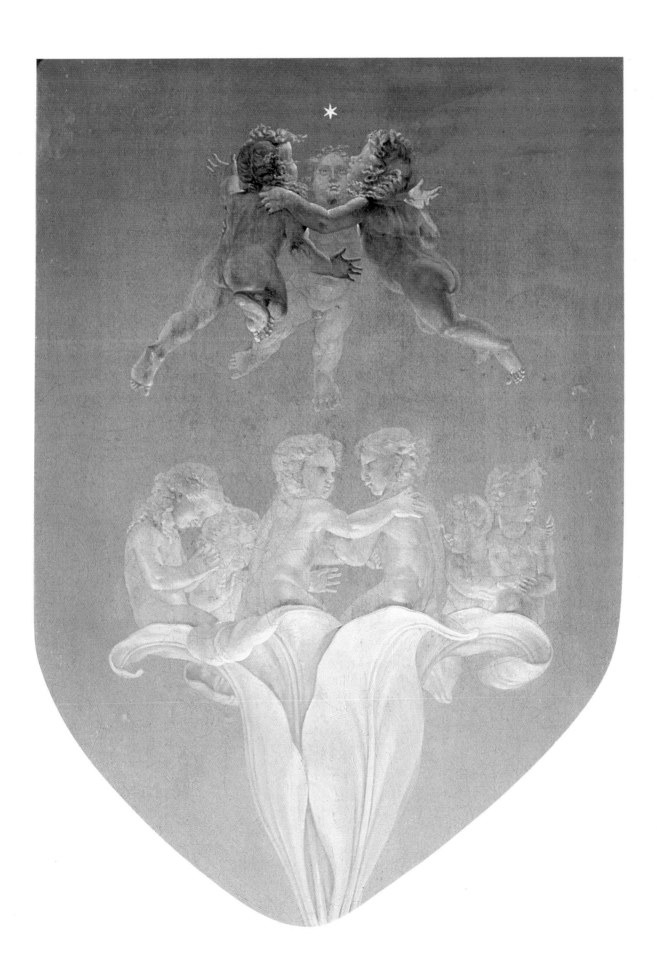

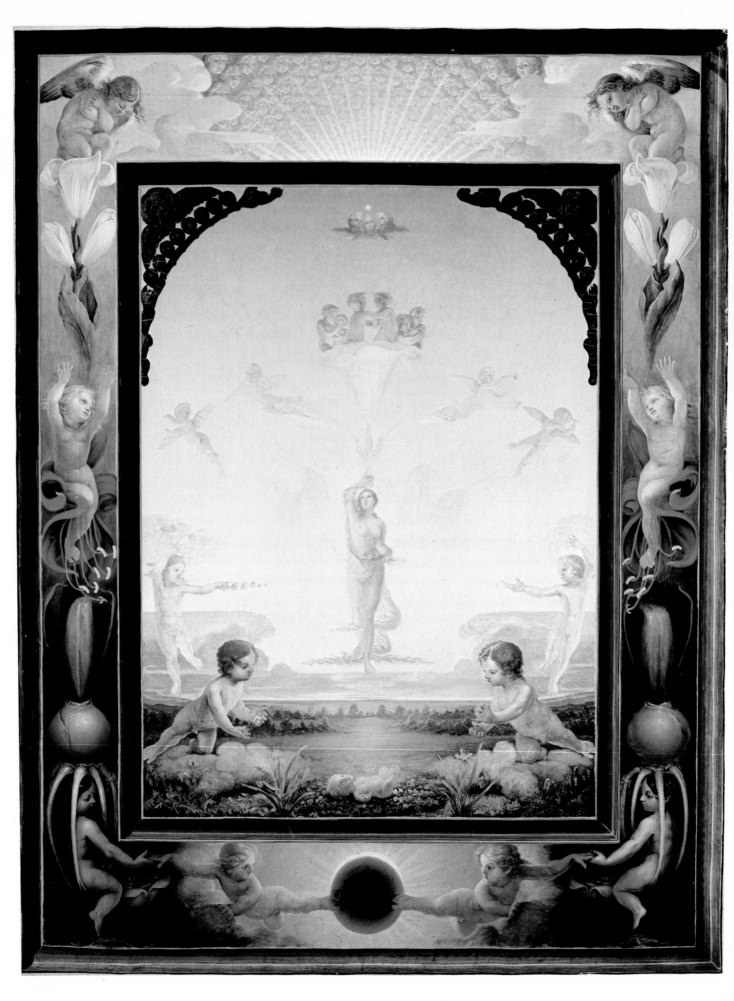

'small *Morning*' (Plate VI), and by October 1808 he was sufficiently advanced to produce the large version of *Morning*, which he completed in mid-1809 (Plate V).

This small version differs from the original 'hieroglyph' in conception as well as in execution. The whole scheme has been rethought in terms of the particular rather than the universal. The earth is no longer a symbolic globe but an individual (though unnaturally symmetrical) landscape, whose light effects poignantly evoke the north German plains at sunrise. The rosebuds of the dawn are not scattered at random through clouds, but are borne down to a baby lying supine in the dewy fields, with an expression of rapture on its face (rather like the Christ-child in the *Rest on the Flight into Egypt*). Most striking of all is the way in which the fountain lily of the early version has dissolved before an explosion of luminosity from which the genii are thrust outwards, while an ideal woman (whom Runge referred to as both Aurora and Venus) is the dual bearer both of the day and of a new era of love. In this small version of the painting, even the frame has become a drama of light, showing an enactment of the Böhmeian concept of sunlight as the liberator of the soul. As the sun rises above a blackened earth (burnt by the Devil, according to Böhme), two genii fly out to offer a freeing hand to two images of the human soul encaged beneath the ground in the roots of the amarylis. The reddish flower of this plant—whose colour symbolizes passion—is being opened by the light, and the twin souls are breaking free, their upstretched arms prefiguring the forms of the pure white lily above, upon whose blossoms two angels kneel in adoration of the eternal sun of Jehovah.

The large version of *Morning*, as it exists today, is no more than a series of fragments. On his death bed Runge begged his brother to cut up the picture as he was dissatisfied with it. He felt in particular that the image of the woman was too hard. Daniel never performed this act of vandalism; but someone else did in the latter part of the nineteenth century. The work has subsequently been reconstituted, but not enough of the original parts have survived for the overall effect to be preserved. One can, however, gain some idea of the intricacy of the scheme. From the group of genii circling the morning star, and the compositional study for it (Plate 38), one can see that Runge lost none of his sense of harmonious forms as he acquired his feeling for luminosity. The main intervals of the picture, as Daniel made clear in the *Hinterlassene Schriften* are based on the proportions of three to four and two to three—the same divisions in lengths that set up the vibrations of perfect fifths and fourths in music and which had been used since antiquity as a basis for harmony and architecture.[28]

In both form and colour, then, the large *Morning* was a series of harmonies. Indeed, the harmonies almost make the figures immaterial, for the genii have become so much the reflectors of colours that they are virtually translucent, while the symmetrical re-formation of nature has made them a part of some larger plan. By such means the divine harmony that Runge felt in rare moments became a sensuous presence.

Had he lived, Runge might have gone on to produce an art which expressed his ineffable feelings in terms of pure landscape. This is an impossible speculation to resolve. Yet it also seems impossible not to arouse it, for the most poignant glimpses of cosmic harmony that one finds in Runge's art are those that occur in his depictions of nature. Fleeting though these are, they are too moving and intense to be ignored.

previous pages

38. Philipp Otto Runge: *Lily of Light and the Morning Star* (study for large version of *Morning*). *c.* 1808. Pen (60.8 × 44.5 cm). Kunsthalle, Hamburg.

V. Philipp Otto Runge: *The Lily of Light* (detail of the large version of *Morning*). 1809. Oil. Kunsthalle, Hamburg.

VI. (left) Philipp Otto Runge: *Morning* (small version). 1808. Oil (106 × 81 cm). Kunsthalle, Hamburg.

Caspar David Friedrich

FRIEDRICH is recognized today as the supreme German painter of the Romantic era, but in his own time his genius was not so widely acknowledged. This was not because the aims of his art were foreign to the interests of his generation. On the contrary, his allusions to the spiritual in nature, his close study of local landscape and his emphasis on the need for inspiration were all commonplace preoccupations of the period. His art was undervalued because it explored these areas with a new uncompromising vision that was too personal and original to be easily grasped.

The only German Romantic painter who can be compared with Friedrich for independence of outlook is Runge. Their early careers, as well, are remarkably similar, and they shared a common cultural background. Friedrich, the son of a prosperous candlemaker and soap-boiler, was born in 1774, only three years earlier than Runge, in Greifswald, which is in the same part of Pomerania as Runge's hometown of Wolgast. Furthermore, both of them trained at Copenhagen, found their feet in Dresden and devoted their careers to extending the scope of landscape art. Their achievements might have been comparable too if Runge had lived longer, but he died at the age of thirty-three, a year younger than Friedrich was when he produced his first major work, *Cross in the Mountains* (Plate II).

The comparison should not be drawn too closely, however, for there is more than the greater length of Friedrich's career with which to distinguish their work. Friedrich was always more involved than Runge in the practice of landscape painting (he began his career as a topographer). While given to investing his landscapes with allegorical overtones he never attempted to represent some mystical universality. His pictures remained descriptions of actual moments and of the forms in nature he had seen and studied. The spiritual world is intimated but is not, with a few exceptions, at all explicit. Even the *Cross in the Mountains*, which is an altarpiece, does not show a supernatural event. When figures occur in Friedrich's paintings, they are not the ethereal genii of Runge's *Morning* but ordinary earthbound mortals. If at times they look up, with their backs towards us, to gaze on infinity in a distant range of mountains or an immeasurable ocean, they do not become one with what they see, but instead remain rooted in the foreground, images of yearning and transience.

This melancholy note in Friedrich's art—sometimes wistful, sometimes morbid—was accounted for by most of his contemporaries as a consequence of the artist's personal melancholia. Large, pale and withdrawn, he answered to the popular idea of the taciturn man from the North. After Friedrich's death, his friend Carus remembered the 'peculiarly melancholic expression on his normally pallid face',[1] and connected it with a boyhood experience. Friedrich, he wrote, 'suffered as a youth the horror of seeing a beloved brother, with whom he was skating near Greifswald, fall through the ice and become swallowed up by the depths before his very eyes'.[2] This event took place on 8 December 1787, when Friedrich was thirteen. If, as some accounts suggest, the brother was drowned

39. Caspar David Friedrich: *Self-Portrait. c.* 1810. Chalk (23 × 18.2 cm). Staatliche Museen, Kupferstichkabinett und Sammlung der Zeichnungen, Berlin (East).

as a result of trying to save Friedrich, who was himself in danger, the incident must have been doubly traumatic.

However, before seeing Friedrich's art as a sustained requiem (or even an expiation of guilt), it should be remembered that melancholy was highly fashionable at the time. Years before he evolved a symbolic landscape, Friedrich was feeding this fashion with his sepia views of the barren north (Plate 43). In assuming the cloak of dourness, Friedrich was living up to the expectations placed on a painter of such scenery. But there were those who could penetrate the guise, though perhaps not Carus, who was a worldly man and whose view of Friedrich was dominated by the image of the artist in the last decade of his life, when he was ailing in both health and popularity, and dogged by feelings of persecution. But the painter Louise Seidler, who knew Friedrich in middle age, saw a softer side to his character; beneath the harsh appearance of the 'old Teuton'—which is recorded in his remarkable Berlin self-portrait (Plate 39)—she detected 'the almost feminine tenderness of his unaffectedly sentimental soul'.[3] For the Russian poet Zhukovski—a faithful friend who persuaded his own patrons, the Russian royal family, to buy a substantial number of Friedrich's works when the artist was in dire need at the end of his career—there was nothing of the stage melancholic in the painter. On the contrary, he felt the outstanding feature of his face, and of his character, to be candidness. More important still, he found nothing affected about his pictures: 'they please us by their precision, each of them awakening a memory in our mind.'[4]

Yet there were few others who recognized that Friedrich's paintings were less acts of self-indulgence than penetrating attempts to bring some submerged experience to consciousness. The painter Dahl, the closest companion and neighbour of Friedrich in his last years, complained that people only bought his friend's pictures as 'curiosities'. Himself a naturalist (Plate 95), Dahl was as aware of the descriptive sincerity in Friedrich's art as Zhukovski had been of the psychological: 'Artists and connoisseurs saw in Friedrich only a kind of mystic, because they themselves were only looking out for the mystic. . . . They did not see Friedrich's faithful and conscientious study of nature in everything he represented.'[5]

Friedrich's art came into fashion under the aegis of the taste for melancholy. When this taste had changed Friedrich's art was then commonly felt to be forced and full of mannerisms only explicable by its creator's personal aberrations. Few, either before or after his period of popularity, suspected the real dimensions of the situation he was attempting to describe.

Dahl emphasized the assiduousness with which Friedrich studied nature. However, he also shared his friend's interest in the subjective. He remarked that 'Friedrich knew and felt quite clearly that one does not or cannot paint nature itself, but only one's own sensations, which must, nevertheless, be natural.'[6] Like other artists working in Dresden, Friedrich had been influenced by the transcendentalism which the Romantics had derived from Kant. As in the case of Runge, the most pertinent parallel was the 'nature philosophy' of Schelling—the belief that it was man's awareness both of himself and of the world around him that brought the unconscious life in nature to conscious expression. The theories expounded by Schelling in his lecture on the relationship of the plastic arts to nature (*Über das Verhältnis der bildenden Kunste zu der Natur*, 1807) also have affinities with Friedrich's painting. Here, Schelling concluded that 'The plastic arts provide an active bond between the soul and nature',[7] an infusion of the material with the spiritual. The artist had to grasp the essential, instinctive spirit of nature, 'working at the core of things and speak through signs and shapes as by symbols only'.[8] Schelling's ideas on this subject are echoed by Friedrich's attack on the unreflective artist. 'The artist', he wrote, 'should not only paint what he sees before him, but also what he sees within him. If, however, he

40. Georg Friedrich Kersting: *Caspar David Friedrich in his Studio*. 1812. Oil (51 × 40 cm). Nationalgalerie, Berlin (West).

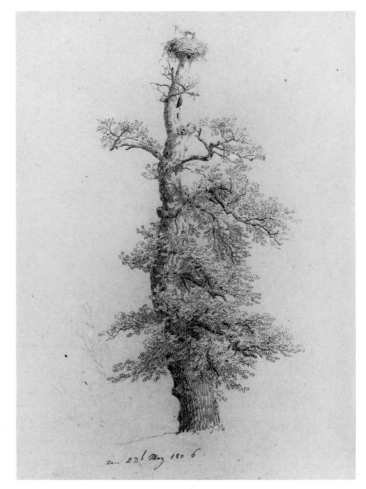

41. Caspar David Friedrich:
Oak Tree with Stork's Nest. 1806.
Pencil (28.6 × 20.5 cm).
Kunsthalle, Hamburg.

42. (facing page top) Caspar
David Friedrich: *Village
Landscape in the Morning Light.*
1822. Oil (55 × 71 cm).
Nationalgalerie, Berlin (West).

43. (facing page bottom)
Caspar David Friedrich: *Dolmen
by the Sea.* 1806. Sepia (64.5 ×
95 cm). Staatliche
Kunstsammlungen, Graphische
Sammlung, Weimar.

sees nothing within him, then he should also omit to paint that which he sees before him.
Otherwise his pictures will resemble those folding screens behind which one expects to
find only the sick or even the dead.'[9]

This and most other similar aphorisms come from a document written around 1830,
long after Friedrich's mature manner had been formed. In spite of the similarity with
Schelling, there is little evidence of direct influence. It is more likely that Friedrich
became aware of the new philosophy through acquaintance with Gotthilf Heinrich
Schubert and Christian Semler. Schubert, a disciple of Schelling, became an admirer of
Friedrich as early as 1806, the very year in which his art was beginning to show the daring
tendencies towards a new synthesis. And it was Semler, another advocate of nature
philosophy, who helped him to formulate his published explication of *Cross in the
Mountains*.[10]

Friedrich's emphasis on the vitalisation of nature through the activity of the inner being
was not merely a theory but also a part of his actual working method. In his best-known
comment, he advised the painter: 'close your bodily eye so that you may see your picture
first with the spiritual eye. Then bring to the light of day that which you have seen in the
darkness so that it may react upon others from the outside inwards.'[11] This process seems
to have been related literally to his own method of composition. Carus describes how
Friedrich, before beginning a picture, would wait in his studio—characteristically bare of
all distracting paraphernalia (Plate 40)—until the image 'stood lifelike in his mind's eye',
he would then immediately sketch it on the bare canvas, first in chalk and pencil, then
more definitely in pen and ink, and proceed, without further preliminaries, with the
underpainting.[12]

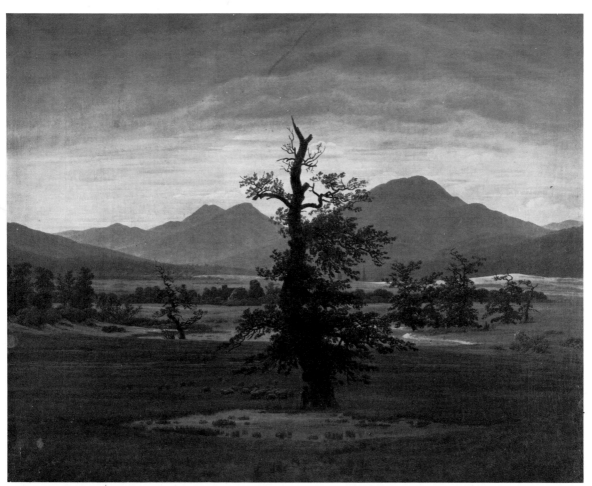

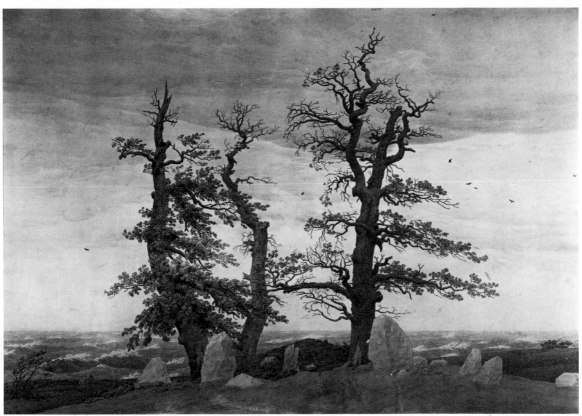

Carus's account is almost certainly incomplete in one respect, for it is clear that the individual forms in Friedrich's pictures are often based on the features he recorded with such diligence on his frequent sketching tours (Plates 41–2). However, although the details of his pictures were taken up from studies, the actual arrangements of these details were of his own invention. 'Eigene Erfindung' (own composition) is the proud comment he frequently added to the catalogue entries for the scenes he exhibited. It is rare to find a picture painted by Friedrich after 1806 that is based in its entirety on a sketch, and rarer still to find a compositional study. Composition took place in his imagination, and after he had formed the overall plan he would then find the appropriate studies from which to carry it out. The studies were executed with a fine-lined precision that accurately captured the most minute details of the landscape (Plate 41); but they were used in the pictures themselves with a total disregard for topography. The *Village Landscape in the Morning Light* (Plate 42) might look like the record of an actual place, yet it is in fact built up from sketches of several parts of Germany, ranging from Pomeranian oak forests to the mountains of the Riesengebirge. Friedrich used some of the studies again and again, like a still-life painter returning to some favourite studio prop. Thus, the central oak of *Village Landscape* came from a drawing made seventeen years earlier, which had first done service, at a slightly different angle, on the left-hand side of the sepia drawing *Dolmen by the Sea* (Plate 43). Once the scene had been assembled, the actual painting would be carried out in a meticulous manner, as though faithfully describing something already fully formed.

Friedrich's idea of working from an imagined image was not new. The assumption that an artist began with an image in his mind was an essential part of academic doctrine, a legacy from the neo-Platonism of the Renaissance, and one which had been bolstered by the story of Raphael painting the Galatea from 'a certain idea', and selecting the best parts from the most beautiful models to embody it, rather than copying a particular woman exactly. Among landscape painters the notion was no less familiar; and in one of the contemporary works cited by Ramdohr to prove the incompetence of *Cross in the Mountains*—the *Traité de perspective* (1800) by the French landscapist Pierre Henri de Valenciennes—Friedrich could have read the opinion that the greatest artists are those who, 'by closing their eyes, have seen nature in her ideal form, clad in the riches of the imagination'.[13]

Unlike Valenciennes, however, Friedrich was not seeking to 'improve' nature, to make it approximate more closely to some Platonic ideal, but rather to discover images that would trigger off associations through which the spectator would find himself transformed in mood. For this procedure a sense of the individual was vitally important. The achievement of this quality in the *Village Landscape* is owing to the forms having been gathered together in the best eclectic tradition without having in any way been idealized or generalized. In being transferred from sketch to painting, the central oak tree has lost nothing but its stork's nest.

Without idealizing his landscapes Friedrich nevertheless conferred upon them an intensely powerful evocativeness. The nature of this characteristic intensity can perhaps be best indicated by a comparison. The *Arctic Shipwreck* of 1824 (Plate VIII) shows Friedrich handling one of the stock themes of the Romantic era, an image of man at the mercy of the elements. Yet when one compares this painting with the treatment of a similar theme (Plate 44) by Friedrich's great English contemporary, Turner, one finds a radical difference. While Turner shows a moment of the highest drama, with the shipwrecked mariners tossed about in lifeboats and trying to save each other from the waves, Friedrich depicts a motionless conclusion, a less animated scene in which the last remnants of a ship are being crushed beneath the strata of ice. In the Turner, landscape is still being used traditionally, as a setting for a human situation. The vortex formed by the

VII. Philipp Otto Runge: *The Huelsenbeck Children*. 1805–6. Oil (130.5 × 140.5 cm). Kunsthalle, Hamburg.

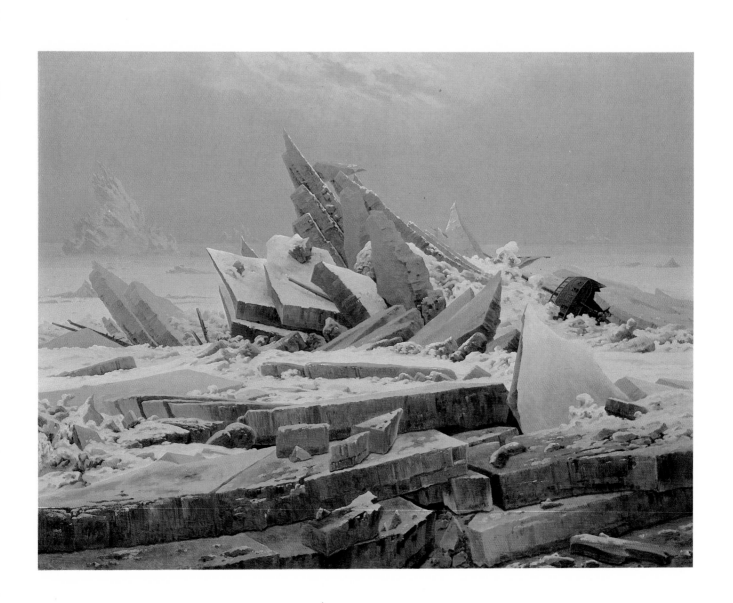

44. Joseph Mallord William Turner: *The Shipwreck*. 1806. Oil (170.5 × 241.5 cm). Tate Gallery, London.

45. Théodore Gericault: *The Raft of the Medusa*. 1819. Oil (491 × 716 cm). Musée du Louvre, Paris.

VIII. (left) Caspar David Friedrich: *Arctic Shipwreck*. 1824. Oil (96.7 × 126.9 cm). Kunsthalle, Hamburg.

waves and the ships creates a stage on which the mariners' drama is acted out. In Friedrich's work, on the other hand, it is the pyramidic layers of ice—massive, slow-moving and relentless—that are at the centre of the design. To find anything similar to this in structure, one has to turn away from landscape painting altogether to Gericault's near-contemporary representation of a shipwreck, the *Raft of the Medusa* (Plate 45), in which the sense of monumentality is created by similar means. This adoption of an essentially figurative convention was far from arbitrary; indeed, it represented Friedrich's

most radical achievement. Throughout Western art it had been accepted that landscape could be made meaningful only by peopling it with some human event. Now, however, Friedrich was choosing as his protagonists the elements of the landscape themselves.

In many of Friedrich's paintings, however minutely the images are described, the space in which they are set remains enigmatic and ambiguous. In *Arctic Shipwreck*, the foreground blocks of ice are so compressed that they seem to be seen from a different viewpoint to that of the central spine of the strata. The effect is of a multiple image, in some ways similar to that in a cubist picture. The eye is drawn to the pyramidic shape of the central form. Yet it cannot define its dimensions conclusively, or find a point of rest. The painting is therefore like that most romantic of forms, the hieroglyph—clear, static and symmetrical, yet full of unresolved associations.

This enigmatic quality in Friedrich's works is often heightened by his sense of illumination. He loved to choose times of day and year in which objects appear under unfamiliar aspects: twilight, when well-known forms become haunting silhouettes, or winter, when snow or mist creates similar illusions. Even when painting landscapes illuminated by the midday sun, Friedrich's sense of changes in light and tone transforms his subject. The Romantic propensity for seeing even the most commonplace of things anew—an aptitude that can be found in Novalis's 'transcendentalization of the everyday object'—was constantly at work in his art.

It is clear enough that Friedrich intended his paintings to be full of allusions. Much less clear is the degree to which he intended them to be explicitly allegorical. Like Runge, he had a pantheistic attitude to nature, and once declared that one should 'seek the Divine in everything'.[14] Whether he attempted to express this perception of divinity by means of an exact symbolism, as well as more vaguely by suggestiveness and atmosphere, is difficult to ascertain. Certainly, there are a handful of pictures—notably *Cross in the Mountains* and *Chasseur in the Forest* (Plate 61)—which are known to have been meant as specific religious or political allegories. It seems hard, however, to credit the assertion that virtually every detail of every landscape is to be read as a component in a symbolic language.[15] Even if this were so Friedrich would have been the first to admit that such an inventory of significances did not constitute the essential meaning of a picture. He made few attempts to control a spectator's response to his art by external means. He seldom used descriptive titles. Furthermore, he seemed to find it of little consequence whether his motifs were interpreted symbolically or not. When writing of his *Cross by the Baltic* (Plate 46), for example, he gave the following account of its subject: 'On a bare stony seashore there stands, raised on high, a cross—to those who see it as such, a consolation, to those who do not, simply a cross.'[16] If Friedrich was prepared (perhaps with ironic resignation) to have the obvious symbolism of a cross overlooked, he was hardly likely to insist on the possible double meanings of rivers, cornfields and clouds.[17] And it was even possible that the true meaning of a picture was something the artist himself could not explain,[18] for the main importance of a work of art for Friedrich lay not in any programme but in the feeling it evoked: art, he wrote was 'the language of our feeling, our disposition, indeed, even our devotion and our prayers'.[19] Any arcane symbolism in a picture was merely a complement to its mood, to the feelings engendered by the portrayal of particular aspects of nature.

Yet Friedrich was in no doubt that these feelings, whatever their origins, were religious ones. He himself remained throughout his life a Protestant—even if not a regular church-goer. The confrontation of transience and the eternal that underlies so many of his pictures becomes less despairing—more commensurate with the beauty and awe of his effects—when one realizes that he himself believed in personal redemption. Like the Holy Sonnets of John Donne, Friedrich's pictures are less statements than meditations on death and salvation. In one of his pithy verses, Friedrich himself gave a reason for his obsession:

46. Caspar David Friedrich: *Cross by the Baltic. c.* 1815. Oil (45.5 × 33.5 cm). Wallraf-Richartz-Museum, Cologne.

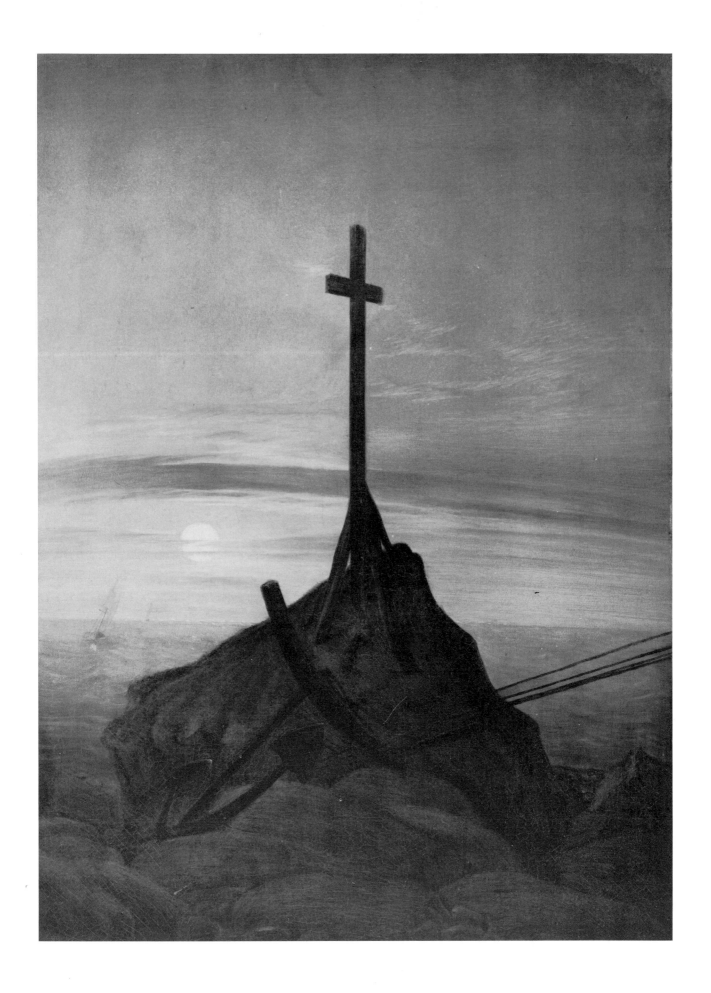

#1

Warum, die Frag' ist oft zu mir ergangen
Wählst du zum Gegenstand der Malerei
So oft den Tod, Vergänglichkeit und Grab?
Um ewig einst zu leben
Muss man sich oft dem Tod ergeben[20]

(Why, the question is often put to me, do you choose so often as a subject for your paintings death, transience and the grave? To live one day eternally, one must give oneself over to death many times.)

Friedrich's way of investing landscape with a devotional significance can be traced not only to the probable influence of Romantic transcendentalists, but also, further back, to an earlier version of pantheism that he encountered in his youth. This was the proto-Romantic nature worship of the late eighteenth century which he became aware of (like Runge) through the pietism of the local Pomeranian pastor and poet, Ludwig Theobul Kosegarten. The relevant connections are not hard to establish. In 1790, at the same time as Runge was being taught by Kosegarten in the nearby town of Wolgast, Friedrich began a four-year apprenticeship with the pastor's close friend, the Greifswald University drawing master Johann Gottfried Quistorp. Quistorp had been the dedicatee of Kosegarten's early collection of poems *Melancholien* (1777), and had provided a frontispiece for these that is similar in composition and subject matter to some designs Friedrich had executed as woodcuts around 1802–3 (Plate 52). Kosegarten became one of the earliest collectors of Friedrich's art. Two years before the exhibition of *Cross in the Mountains* he had unsuccessfully attempted to commission from the artist an altarpiece for his chapel at Vitte.

Kosegarten is the likeliest person to have introduced Friedrich to a pantheistic approach to nature. He may also have encouraged him in his choice of imagery. Inspired by Ossian and books on Scottish travel,[21] the poet had come to invest the local landscape of Pomerania with mythic associations similar to those which were later to fascinate Friedrich. In particular, the large offshore island of Rügen became a primeval 'land of the soul', its rugged, windswept cliffs and oak trees suggestive of ancient Teutonic heroes, whose tombs were thought to be the large groups of dolmens that could be seen there (known then, as now, as *Hünengraber*, or 'Giants graves'). Friedrich, who made several visits to Rügen, frequently used the same motifs in his paintings (Plate 43). The poet did not go unnoticed by contemporaries. When Heinrich von Kleist, for example, reviewed *Monk by the Sea* (Plate X) when it was exhibited in Berlin he spoke of its 'Ossianic or Kosegarten-like effect'.[22]

Despite his interest in the legendary past, Kosegarten was no revivalist. The heroes of prehistory might awaken in modern man a sense of awe or longing, but his own salvation lay through the revealed religion of Christianity. As a Protestant, Kosegarten saw his faith as an empirical one, based upon natural feeling. He regarded the Catholic medieval world as no more of a valid guide than the pagan worlds of Ossian or of classical antiquity. To a large extent, Friedrich shared this outlook. Except for a brief period of enthusiasm during the Wars of Liberation, he took no interest in the medieval revival movement. And in his *Observations* he came down firmly against those artists, such as the Nazarenes, who had attempted to regenerate the spiritual in art by reverting to the styles of the early Italian and German masters: 'What pleases us about the older pictures is, above all, their pious simplicity. However, we do not want to become simple, as many have done, and ape their faults, but rather become pious and imitate their virtues.'[23]

This viewpoint also affected Friedrich's attitude to Gothic. It is true that shortly after the Napoleonic Wars he made some Gothic designs for monuments and for a church

interior. In his paintings, however, he used Gothic more as an image of transience than of restoration. The Gothic buildings he depicted, of which the most frequently used was Eldena, the Cistertian abbey three miles from his home town, are always in ruins—monuments to a past spirituality and symbols of the incompleteness of earthly existence. Friedrich even once envisaged showing the still existing and well-preserved cathedral of Meissen as a ruin because 'The time of the magnificence of the temple and of its servants is past, and from the destroyed totality a different time and a demand for a different sort of clarity and truth has arisen.'[24] In his imaginary picture, a priest would stand among the ruins staring up to heaven in search of a direct and personal revelation. Gothic was also valued for the way in which it appeared to derive from nature. Friedrich frequently referred to the pre-revivalist myth which saw the origin of Gothic architecture in the interlocking branches of two trees. In the Weimar *Procession at Dawn* the priests are walking through such a natural arch with the monstrance; and in the frame of *Cross in the Mountains* the arched palms suggest a more complex association between Gothic architecture and the blessing of God spanning the universe. The image of Eldena haunted Friedrich's imagination because Gothic art in ruins was a perfect symbol of his complex feelings about transience, beauty and religion. At times, however, his paintings depict an intact edifice rising like a misty vision beyond the tangible (Plate 64). This was a complementary symbol of the perfection that lies beyond the physical world. And just as the desolate state of a Gothic ruin is underlined by the proximity of a barren deciduous tree, so the perfect visionary building is normally surrounded by unchanging evergreens (Plate XII).

Friedrich gravitated towards forms and lighting effects that could become spiritual metaphors, and his search for these phenomena took him beyond the frontiers of his native Pomerania. The characteristic northern feeling of yearning that the classicists and Nazarenes directed towards a paradisal vision of southern lands, was focussed in Friedrich on the intense and the extreme in nature. He found these qualities not only in Pomeranian forests but also in the central European mountains of the Harz and Riesengebirge. Further south than this, however, he declined to venture. Afraid that a richer landscape might destroy his spiritual asceticism, he refused a suggestion made in 1817 that he should travel to Rome; for, like his collaborator Christian Semler, he remained convinced that 'the gloomy and meagre nature of the North is best suited to the representation of religious ideas'.[25]

Though Friedrich's Pomeranian homeland provided the basis of his spiritual approach to landscape it had little to offer him by way of practical education. In Greifswald he learned scarcely more than the rudiments of his craft, being set by Quistorp to make drawings from academic copybooks and taking his first lessons in etching. He practised the latter technique in his early years, when still emulating Dutch landscapes, but found little use for it later on.

It was no doubt on Quistorp's advice that Friedrich went in 1794 to the Copenhagen Academy to continue his studies. He spent four years there, and there is no evidence that he experienced the frustrations felt by Carstens and Runge. Nevertheless, his progress was far from spectacular. For two years he attended the freehand drawing class, where he copied engravings from the old masters. Only after this was he allowed to study from the antique, and it was not until he was about to leave, in the summer of 1798, that he did any work in oils. His progress contrasts strongly with that of Runge, who gained admission into the painting class within a year of his arrival.

Friedrich's slow advancement was perhaps partly due to the fact that instruction in Copenhagen was centred upon the study of the human figure. To judge by the subject pieces he drew in the year after he left the Academy (for instance his illustrations of scenes

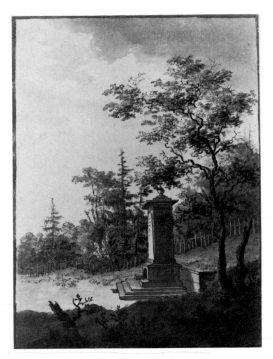

from Schiller's *Robbers*),[26] he was never particularly at ease with purely figurative motifs. These designs are not remarkable for any signs of future skill, but for showing that Friedrich, like Runge, fell under the influence of the elongated mannerisms of the despot of the Copenhagen antique class, Nicolas Abildgaard.

However, Friedrich also came into contact in Copenhagen with contemporary landscape painting through the works of Jens Juel and Christian Lorentzen who both taught at the Academy. Both these painters were exponents of the emotive style of landscapes. Lorentzen tended more towards the tempestuous scenes made internationally popular by the French artist Claude Joseph Vernet, while Juel preferred to paint idyllic local scenes that sometimes have affinities with the landscapes of his English model, Gainsborough. Friedrich may also at this time have first encountered portrayals of silent, sublime mountain scenery. He is reputed to have eked out his funds by colouring prints after drawings of Norwegian mountains by a recently deceased Copenhagen artist, Erik Pauelsen.[27]

Friedrich attempted landscapes in all these modes, but his best works of this time were his watercolours of local scenery. These were based on his direct study of nature, and show how the gentle countryside surrounding Copenhagen could be presented in the serene, contemplative manner that was to become his forte. *Emilias Kilde* (Plate 47) shows his sympathetic response to a tranquil setting, and also reveals a debt to the current vogue for evocative ruins and monuments. The monument in this watercolour, erected over the source of a stream by Count Ernst Schimmelmann in memory of his first wife, was designed by Abildgaard. It was a favourite motif among Copenhagen landscapists of the time. Friedrich was certainly interested in the topographical aspect of his subject, for he recorded the monument's inscription on the back of his painting. At the same time, however, he was aware of the conventions of the picturesque and accordingly he framed his central motif with a darkened foreground and with an overhanging tree. Both the staging of the light and the generalized rococo treatment of the foliage are reminiscent of the view paintings of Juel (Plate 49). It is not difficult to understand why Ramdohr and Goethe, being connoisseurs of 'park' landscapes and Claudian scenes, should have preferred the earlier work of Friedrich to the more challenging style of his later years.

These politely elegant scenes, so consistent with contemporary taste, had technical as

47. (far left) Caspar David Friedrich: *Emilias Kilde: Monument in Park near Copenhagen.* 1797. Watercolour (21.8 × 16.7 cm). Kunsthalle, Hamburg.

48. (left) Caspar David Friedrich: *Plant Study.* 1799. Pen (24 × 19 cm). Staatliche Museen, Kupferstichkabinett und Sammlung der Zeichnungen, Berlin (East).

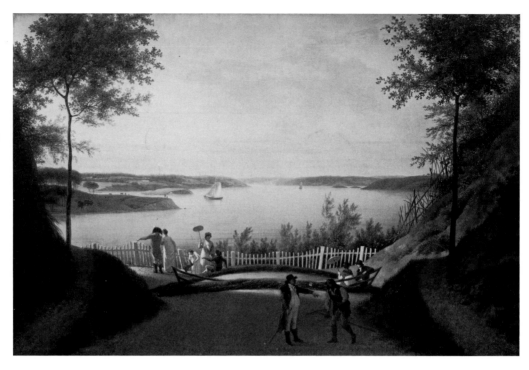

49. Jens Juel: *View of Hindsgavl. c.* 1800. Oil (42 × 62.5 cm). Thorwaldsens Museum, Copenhagen.

well as emotional limitations. The accuracy of observation evident both in the carefully outlined details of Friedrich's monument and in the distant inlets of the view of Juel's illustrated here is not sustained in the foliage or in smaller details of the foreground. Before long, however, as Friedrich's feeling for landscape grew in intensity, it was accompanied by a growing sense of realism, a more penetrating investigation of the actual appearance of things.

This development was initiated in 1798 when Friedrich moved to Dresden, where he was to be based for the rest of his life. Here he came into contact with a tougher school of landscape painting. In the mid-eighteenth century the Dutch paintings in the Dresden Gallery had stimulated a realistic tradition of landscape, whose first exponent was Christian Wilhelm Ernst Dietrich. At the time Friedrich arrived in Dresden, this tradition was being maintained by Johann Christian Klengel and Adrian Zingg. Friedrich made copies of compositions and studies by Zingg. It may have been this artist who stimulated him to make the careful studies of small forms in nature that first begin to appear in the sketchbooks of his tours around Dresden in 1799 and 1800 (Plate 48).

In one respect, however, Dresden reinforced the impact of Copenhagen, for the delicate outline method used to record these forms shows that the neoclassical taste for linearity was as prevalent in Friedrich's new home as it was in the Danish capital. The technique that Friedrich had acquired in order to grasp the essential form of the human body he now began to apply with similar precision to forms in nature. In later life he was to explore a fuller form of sketching which allowed a greater investigation of texture (Plate 41), though outlines were to remain his principal means of arranging a design. This was to strike later generations as a curiosity, yet it was this method which enabled him to construct the careful balancing and correlation of forms on which his effects depended.

It was an essentially neoclassical taste that dominated Friedrich's output in the next few years. This was apparent not only in his landscape views, which he probably undertook for financial reasons (he was now having to support himself entirely), but also in his more ambitious subject pieces which he concurrently exhibited at the Dresden Academy. The latter works show that he had not yet abandoned that type of 'historical' subject painting that his academic training would have taught him to consider supreme. At the same time, he was conceding to a current vogue in turning to sepia. The neoclassical interest in pure

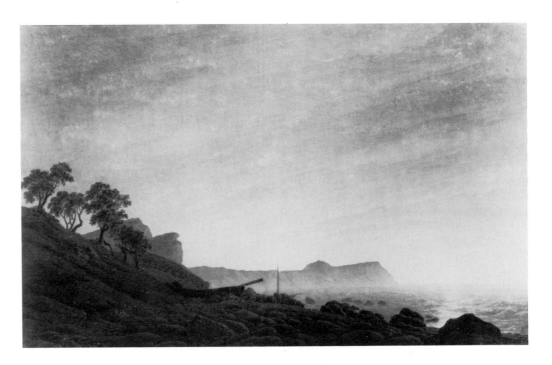

form had made this essentially monochrome technique highly fashionable. Its principle exponent in Dresden, Crescentius Joseph Johann Seydelmann (1750–1829), specialized almost exclusively in reinterpreting famous oil paintings from the Dresden Gallery purely in terms of line and tone. For Friedrich the manner was in many ways an extension of his sketching method, in which he used pen outline and wash. However, sepia allowed greater emphasis in the modulation of tonalities and this later developed into controlled gradations of light that were to become one of the most outstanding features of his later works in oils.

Friedrich soon became highly expert in the art of sepia painting. For most of 1801 and 1802 he returned to his homeland, and while making some final experiments with figure compositions he also undertook extensive tours through Rügen and Pomerania, producing landscape studies that were to become the basis for many sepias. A large number of these were exhibited at the Academy in Dresden, where both their skill and their subject matter brought Friedrich a growing reputation.

Unfortunately most of these sepias are now faded, but the *View of Arkona* (Plate 50)— showing the northernmost point on Rügen with its prehistoric settlement seen from the beach of the village where Kosegarten had built his chapel—gives an idea of the superb precision of tone and design for which Friedrich became famous. The gentle light of the moon is suggested with exquisite control. The picture is equally remarkable for the way in which the conventional picturesque view has been intensified. The foreground leads in to the distant headland of Arkona, but Friedrich has compressed the relationship by cutting out the middle-ground and using the boats to throw up silhouettes against the ethereal land in the distance, making it both more mysterious and qualitatively different from the foreground.

It was for two sepias, *Summer Landscape with a Dead Oak* (Schlossmuseum, Weimar) and *Procession at Dawn* (Plate 51), that Friedrich was awarded a prize by the Weimar Friends of Art at the Weimar exhibition of 1805. These were not Nordic views, but reflected an equally topical preoccupation: the religious revivalism of the Dresden Romantics. By 1805 the original heady and wide-ranging enthusiasms of the group were becoming narrowed towards a return to traditional beliefs, particularly those of Catholicism. In *Procession at Dawn* even the emphatically Protestant Friedrich can be found depicting a Catholic ceremony. Goethe, who had recently lost two of his protégés, the Riepenhausen

brothers, to the medievalizing Catholic group, responded to the subject matter of Friedrich's sepias with caution, as can be seen from the account of them given in the *Jenaisches Literaturblatt* by his associate Heinrich Meyer.[28] The religious iconography was still displayed within the framework of a landscape sufficiently conventional to be appreciated in purely technical terms; thus the subject—a procession moving towards a wayside cross—was summarily outlined in the article and the main praise was reserved for the naturalism with which the whole scene had been rendered. It did not matter to Goethe or to Heinrich Meyer that this procession combined natural elements with religion at almost every stage: that the monstrance the priests are holding coincides with the sun, that the two trees entwine to form a Gothic portal, and that the wayside cross can be taken for an altar. All this could be overlooked as yet. Indeed, it took Goethe some time to realize that Friedrich's spiritual tendencies were leading him on a path different from his own. For several years their relationship remained cordial; they exchanged visits in 1810 and 1811, and only when Friedrich refused to take part in Goethe's scientific investigation of the classification of clouds—commenting that such a practice would be the death of landscape—did the poet realize that Friedrich's vision, with its emphasis on the psychic response before nature, was essentially different from his desire to achieve an objective understanding of the organic forces that determine natural phenomena. A year after this rebuff Friedrich was listed in the famous review written by Meyer in *Kunst und Alterthum*, 'Neudeutsche religiös–patriotische Kunst', amongst those whose 'religious mysticism' had led to the diversion of contemporary art away from good taste and wholesome beauty.[29]

50. Caspar David Friedrich: *View of Arkona with Rising Moon.* 1806. Pencil and sepia (60.9 × 100 cm). Albertina, Vienna.

51. Caspar David Friedrich: *Procession at Dawn.* 1805. Pen and sepia (40.5 × 62 cm). Staatliche Kunstsammlungen, Graphische Sammlung, Weimar.

52. *Caspar David Friedrich:
Boy Sleeping on a Grave.
c. 1803–4. Woodcut (7.7 ×
11.3 cm).

53. (facing page top)
Caspar David Friedrich:
Spring from *The Times of
Year.* 1826. Sepia (19.1 ×
27.3 cm). Kunsthalle,
Hamburg.

54. (facing page bottom)
Caspar David Friedrich:
Summer from *The Times of
Year.* 1826. Sepia (19 ×
27.1 cm). Kunsthalle,
Hamburg.

The religious allegories in the two Weimar sepias were not so prominent as to disrupt accepted convention of taste, yet within three years of their successful reception the innovations in Friedrich's *Cross in the Mountains* proved striking enough to goad Ramdohr into his detailed, comprehensive attack on Friedrich's art and ideas.[30] The transformation that had taken place in the artist's work was aesthetic rather than iconographic, for, although the decision to use a landscape painting for an altarpiece was a bold one, the theme itself was not fundamentally different from that of *Procession at Dawn*. In both pictures the wayside cross is used as the focus for an allegory linking Christian salvation with the workings of God in nature.

Friedrich had previously explored more conventional methods of creating landscapes of meaning. Apart from his early 'park' scenes (Plate 47), he had also experimented with landscapes as a backcloth for human drama. During his visit to Pomerania in 1801–2 he had tried out a number of designs showing emotive human figures in a landscape setting—a familiar pre-Romantic genre which was represented in England by such works as Wright of Derbys's *Sir Brooke Boothby*,[31] and in Germany by Quistorp's frontispiece to Kosegarten's *Melancholien*. In these pictures, the landscape itself tends to become reduced to an attribute of the human subject. In the *Boy Sleeping on a Grave* (Plate 52)—one of the designs that Friedrich commissioned his brother Christian to engrave in wood and exhibited at the Dresden exhibition of 1804—the gesture of the youth is suggestive of death, while the cross emphasizes this, and the butterfly is present as an image of the soul. The resulting picture is like a design from an emblem book. In the Weimar sepias, on the other hand, the human drama is acted out within a coherent landscape. They are dramas acted out in space, like Turner's *Shipwreck* and like historical landscape in general.

It was through the exploration of traditional associations between the life of man and the cycles of nature that Friedrich created his first strikingly evocative imagery. This was in his earliest attempt, in 1803, at an allegorical cycle on the theme of the *Times of Year* a subject to which he was frequently to return (Plates 53–4). In the 1803 version, which is now lost, the nature imagery was already present. *Spring* showed infants sporting beside a stream, excited by the birds and the blossoms; in *Summer* a broad, rich valley meandered through the landscape, and two lovers embraced in a bower; *Autumn* depicted a

55. Caspar David Friedrich: *Winter*. 1808. Oil (70 × 103 cm). Destroyed, formerly Neue Pinakothek, Munich.

verdant but rather more awesome scene, with mountain peaks rising in the distance; and finally, in *Winter*, an old man contemplated a grave near a ruin (based on Eldena) and a barren tree, while the sea into which the river of the previous pictures had emptied was visible in the background.

Much of the imagery of the *Times of Year*, as well as the theme, was conventional: the lovers and doves in the bower possibly derived from Claude's *Acis and Galatea* in the Dresden Gallery;[32] and both the imagery and the composition of the most striking painting of the series—*Winter*—show an obvious debt to another work that could be seen in Dresden, Ruysdael's *Jewish Cemetery*.[33]

Friedrich had already drawn upon Ruysdael's picture—a landscape with a ruin and a blasted tree—in an early sepia of a burial, probably painted around 1801.[34] *Winter* differs from this early version in essentializing the image, bringing the tree and the ruin into a meaningful and tense relationship, making them both part of the same zigzag of forms, creating a vital surface pattern. As in the *View of Arkona*, painted three years later, one can see the build-up of a tense image. The debt to Ruysdael is interesting too, as an instance of Friedrich looking back beyond his own age to the great landscape painters of the seventeenth century who had felt in nature something of the same elemental strength that he had discovered himself. Ruysdael's picture taught Friedrich how to use imagery powerfully, but it was not concerned with the creation of enigma. Before Friedrich could view landscape in this way, it was perhaps necessary for him to come into contact with the Dresden circle of Romantics. It is significant that by the time he painted *Cross in the Mountains*, he had seen Runge's *Times of Day*, which reconstitutes the images of nature into a mystic hieroglyph. Like Runge's allegory, *Cross in the Mountains* is based on a

IX. (facing page) Caspar David Friedrich: *The Cross in the Fir Woods*. c. 1811. Oil (45 × 38 cm). Kunstmuseum, Düsseldorf.

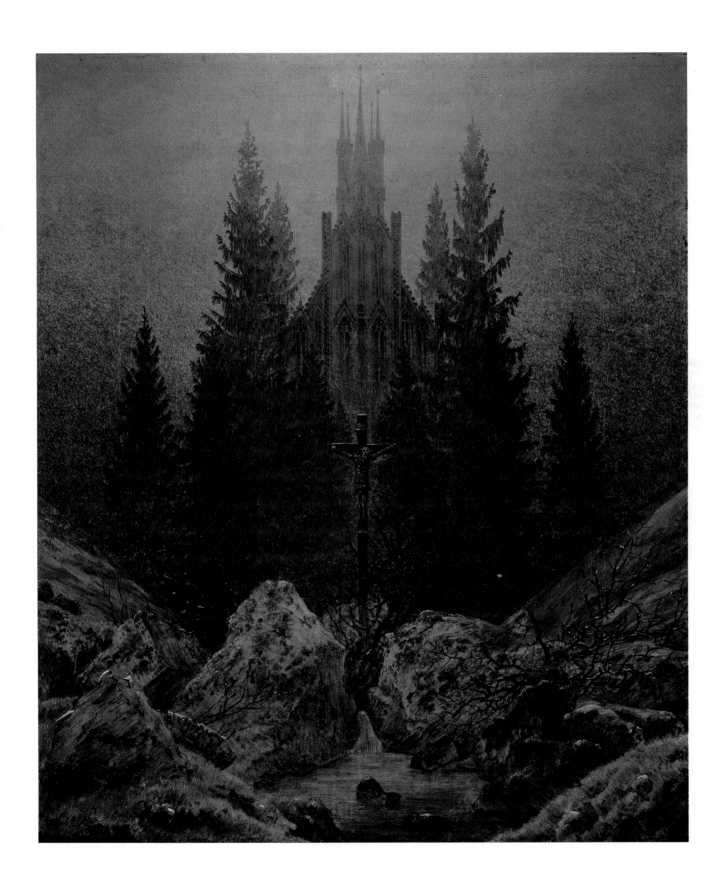

Monk by the Sea

Abbey in the Oakwoods

previous pages

X. Caspar David Friedrich:
Monk by the Sea. 1809. Oil
(110 × 171 cm). Staatliche
Schlösser und Gärten,
Schloss Charlottenburg,
Berlin (West).

XI. Caspar David
Friedrich: *Abbey in the
Oakwoods* (detail). 1810. Oil.
Staatliche Schlösser und
Gärten, Schloss
Charlottenburg, Berlin
(West).

XII. (left) Caspar David
Friedrich: *Winter Landscape
with Church.* 1811. Oil (33 ×
45 cm). Schloss
Cappenburg, Museum für
Kunst und Kulturgeschichte
der Stadt Dortmund.

56. Caspar David Friedrich:
*Rocky Gorge in
Elbesandsteingebirge. c.* 1812.
Oil (94 × 73 cm). Neue
Galerie, Kunsthistorisches
Museum, Vienna.

symmetrical design. Yet the similarity between the two works is perhaps due not so much to Runge's impact on Friedrich as to the influence on both of them of a painting in the Dresden Gallery. This was Raphael's *Sistine Madonna,* whose devotional nature had made a deep impression on Runge, Wackenroder and the Schlegels, and is likely to have stirred Friedrich's imagination also.

The formal qualities of *Cross in the Mountains* were almost certainly a response to the devotional nature of the commission. However, Friedrich's pictorial method had already by this time become more severe and hieratic, with a clear separation between foreground and background. The earliest instance of this tendency is in a sepia of 1806, whose central motif is almost identical to that of the altarpiece. The development is also apparent in a version of *Winter* (Plate 55) which Friedrich painted in oils, as part of the *Times of Year,* in 1808. In the earlier, 1803 version of this work, the ruined abbey is seen from a dispersive,

diagonal angle along the nave. When Friedrich came to repaint it in 1808 he showed the front wall of the ruin parallel with the picture plane (a viewpoint anticipated in *Dolmen by the Sea*, 1805)[35] and created a strong contrast between the foreground image and the misty wastes behind. Everything balances on a centre point, even the meaning; as the old monk stumbles towards the ruined abbey, so there is a cross viewed through a window on the other side.

These changes reveal that around 1806 Friedrich's designs were becoming more radical and simplified. Perhaps, as Börsch-Supan has suggested,[36] it was a trip to Rügen in 1806 (the same one in which he discussed the altarpiece project with Kosegarten) that accelerated this change. Certainly the studies he made in Rügen show him using the flat landscape in a new way to achieve balance of form.

The care with which Friedrich's oils are finished and their dependence upon draughtsmanship, especially in these early years, are evidence that they followed upon a decade of working solely in monochrome. In a sense this was limiting, though his apprenticeship in sepia had taught him a number of subtle devices for suggesting light and texture, and these were exploited very effectively in his oil paintings (Plate 56). Monochrome techniques are used especially skilfully in one of the finest oils from this period, *Morning Mist in the Mountains* (Plate 57), which looks forward to the *Cross in the Mountains* in squarely presenting to the spectator a triangular mountainside with a crucifix (albeit a tiny one) on the summit. Here, Friedrich achieved a matchless luminosity by careful control of the glazes and by the use of stippling (a technique which he had perfected in the sepias) to bring dots of colour to the brightest and most shimmering moments in a way that is suggestive of pointillism.

The silhouetting of the foreground image against an intangible background was to

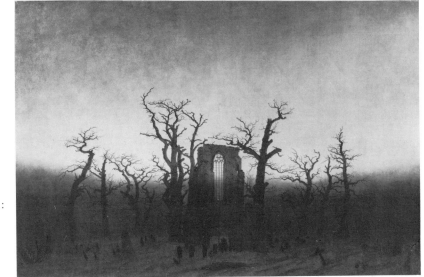

57. (left) Caspar David Friedrich: *Morning Mist in the Mountains*. 1808. Oil (71 × 104 cm). Staatliches Museum, Heidecksburg, Rudolstadt.

58. Caspar David Friedrich: *Abbey in the Oakwoods*. 1810. Oil (110.4 × 171 cm). Staatliche Schlösser und Gärten, Schloss Charlottenburg, Berlin (West).

59. Caspar David Friedrich: *Bohemian Landscape*. *c*. 1810. Oil (70 × 104.5 cm). Staatsgalerie, Stuttgart.

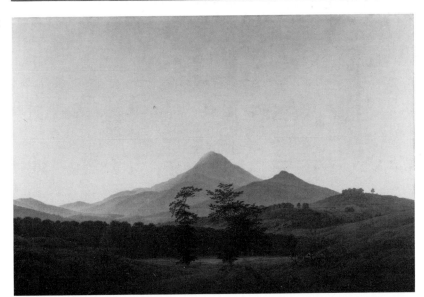

60. Caspar David Friedrich: *Garden Terrace*. 1811. Oil (53.5 × 70 cm). Staatliche Schlösser und Gärten, Potsdam-Sanssouci.

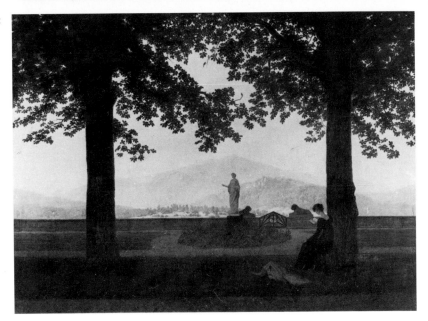

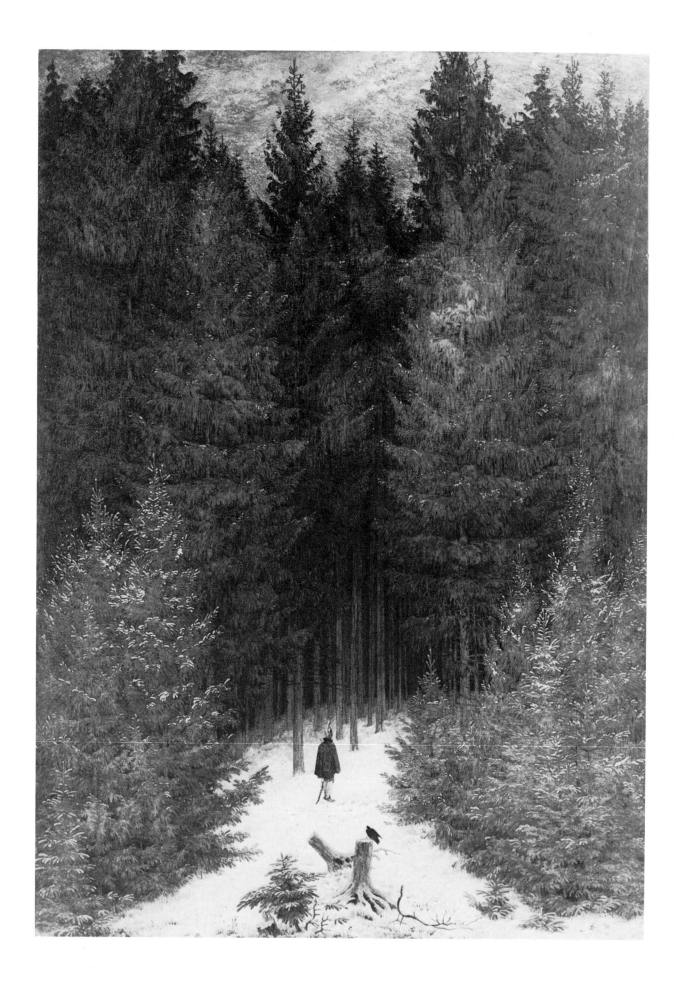

61. Caspar David Friedrich:
The Chasseur in the Forest.
1813 × 14. Oil (65.5 ×
46.2 cm). Private Collection,
Bielefeld.

62. Caspar David Friedrich:
War Memorial Design.
c. 1815. Pen and watercolour
(53.6 × 36.8 cm). Städtische
Kunsthalle, Mannheim.

remain a characteristic feature in Friedrich's paintings for almost a decade. Nevertheless, his compositions during this period were rarely repetitive. By simplifying depth, Friedrich placed the emphasis on the grouping of shapes within two main planes, and within these planes an infinite variety of compositional arrangements was possible. In some cases, especially in paintings showing visionary intimations of the life beyond, a balance was created by absolute symmetry. This is exemplified in the Düsseldorf *Cross in the Fir Woods* (Plate IX) where the head of Christ is placed at the intersection of the orthogonals. But it was often of a more informal nature. Often the different compositions seem to be related to the iconography of the pictures. Those in which a visionary intimation of the life beyond appear are, on the whole, those in which a symmetrical balance is established, while the terrestrial compositions have more informal arrangements.

This is certainly the case with the two major pictures Friedrich exhibited at Berlin in 1810, and which he had begun immediately after finishing the *Cross in the Mountains*. The painting that deals with man's life on earth, the *Monk by the Sea* (Plate X), is asymmetrical; the *Abbey in the Oakwoods* (Plates XI and 58), which shows the departure from earthly life—in the burial—is centred and symmetrically balanced, a reworking once again of the *Winter* theme into something now totally hieratic.

Monk by the Sea is perhaps the most radical and memorable of all Friedrich's images. The simplification of forms that is found in *Cross in the Mountains* has here been carried further to create a landscape of startling barrenness in which a solitary monk holds his head in his hands in silent contemplation. As in Friedrich's other mystical paintings, different areas of the subject are distinctly separated from each other, so that the monk appears to be surrounded by the uncompromising elements of earth, sea and sky. The unbroken line of the horizon, below which the monk stands, powerfully suggests the boundlessness of nature and the minuteness of man within it. When the work was exhibited in Berlin it created amazement and confusion. The writer Heinrich von Kleist, who did not claim to understand the painting, nevertheless paid tribute to its originality and power by directly recording his immediate impression: 'Since in its uniformity and boundlessness it has no other foreground than the frame, when one looks at it, it is as if one's eyelids had been cut away.'[37] Despite such disturbing implications, the Crown Prince of Prussia thought the picture and its companion important enough to buy for a sizable sum.[38]

The development of Friedrich's ability to create an emotive symbolism out of the imagery of his landscapes is reflected in his changing approach to the human figures within them. From the dramatic tableaux of the earlier works he increasingly turned towards figures involved in a direct, emotive response to nature (Plate XIII). The monk in *Monk by the Sea* is not making a self-determining gesture like that depicted in *Boy Sleeping on a Grave*, but instead peers into the landscape which we ourselves see. The vision that he is experiencing is thus subsumed into our own experience of the painting, and this is a common characteristic of the pictures Friedrich produced around 1810. The emphasis is always upon the landscape rather than its human inhabitants. Even when figures are shown acting out a drama, they are usually placed in the larger perspective of a heightened sense of nature. For instance, in the last major painting of Friedrich's early period, *Morning in the Riesengebirge*,[39] the foreground cliffs are dominated by the rather melodramatic incident of a woman helping up a man towards a cross on an outcrop of rock; yet the strongest impact of the picture comes from the setting—the sunrise dispersing the mist that lies on the mountains, and the cluster of horizontal and vertical axes formed by the rocks around the cross.

By this time, Friedrich had developed a new, more intense sense of landscape and had discovered conventions by which this could be articulated. These conventions were far

from rigid and allowed for great variety of subject and treatment. It is instructive in this respect to compare *Abbey in the Oakwoods* with *Bohemian Landscape* (Plate 59) which was painted the same year. There is a remarkable difference in mood between the misty Baltic landscape with its solemn burial and the brighter verdant country scene, executed with just as much authority and finesse. Different again is the intimate, genre-like nature of *Garden Terrace* (Plate 60). Apart from the technical brilliance, the only common factor between these is Friedrich's reverence before nature, his undying sense of its variable beauty.

With the exhibition of his range of large-scale masterpieces at Dresden, Berlin and Weimar between 1808 and 1812, Friedrich moved out of relative obscurity into a position of considerable renown. Admired by Goethe and patronized by both the Prussian monarchy and the Grand Duke of Weimar he seemed to have attained a secure foothold. And yet the same circumstances that had brought him to public notice were also to contribute to his later neglect. After 1812, royal patronage dwindled. This was partly owing to the difficult conditions in Germany during the Napoleonic invasions, but that this patronage was not resumed after the Wars of Liberation suggests that there were other reasons for Friedrich's declining fortunes. One of these was the disappearance of the vogue for mystical Romanticism. There were also political influences at work.

As we know from G. H. Schubert's account, Friedrich was deeply concerned with the contemporary political situation, and it was this interest that seems to have brought him into contact with the 'second generation' of Dresden Romantics, the circle associated with Kleist and Müller's magazine, *Phoebus*. Throughout the Wars Friedrich remained sympathetic to the cause of pan-Germanic patriotism, whose objective was not merely the expulsion of the French but also the creation of a liberal German state. Within this movement, which was widely supported by artists and writers throughout Germany, the

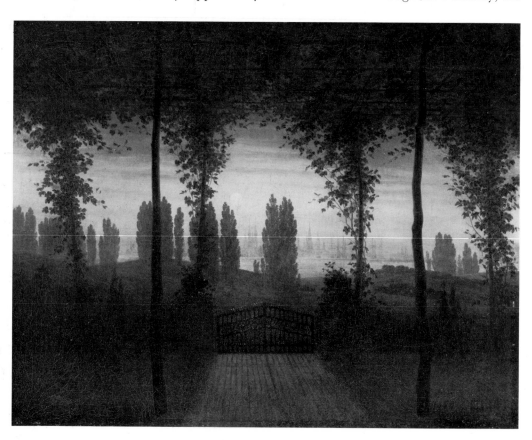

63. Caspar David Friedrich: *Memorial Picture for Johann Emanuel Bremer. c.* 1817. Oil (43.5 × 57 cm). Staatliche Schlösser und Gärten, Schloss Charlottenburg, Berlin (West).

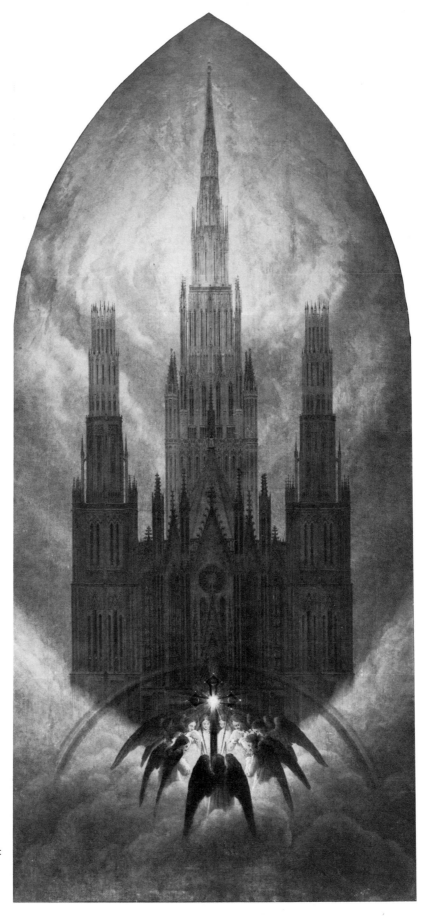

64. Caspar David Friedrich:
The Cathedral. c. 1818. Oil
(152.5 × 70.5 cm). Georg
Schäfer Collection,
Schweinfurt.

revival of interest in medievalism that was common throughout Europe took a highly specific direction. It became a symbol for the unification of Germany, focussing on a fanciful Utopian vision of the Holy Roman Empire during the late Middle Ages.

Friedrich, who remained a democrat throughout his life, had shared the enthusiasm of the patriots before 1814. As early as 1806 he is known to have designed a painting with patriotic connotations showing an eagle hovering above a misty sea, riding the storm.[39] In March 1814 he contributed two subjects to the exhibition held in Dresden to celebrate the liberation from the French. Here, he applied his landscape iconography of ancient graves, trees and wintry wastes to suggest a specifically patriotic message. In one of these works he showed the imaginary grave of the old Germanic hero Arminius,[40] and in the other a French chasseur wandering lost through a thick German forest of evergreens (Plate 61). A contemporary review remarked: 'A raven perching on an old branch sings the death song of a French Chasseur.'[41] During this period Friedrich also made a large number of designs for war memorials and monuments (Plate 62) combining armour, weapons and Gothic motifs in the popular style favoured by the Prussian state architect Schinkel.

Perhaps even more surprising than these designs is Friedrich's momentary interest in architecture. He prepared plans in collaboration with his brother Christian for the restoration of the Marienkirche in Stralsund. These drawings, which emphasize verticals and sparseness of ornamentation, display a style of neo-Gothicism that is not at all archaeologically exact. It must be remembered that, in its proportions at least, this form of neo-Gothicism is not simply a concession to a still prevailing neoclassical taste, it is also a reflection of the peculiar sparseness and economy of the north German *Backstein* Gothic, the style in which more recurrent edifices in Friedrich's paintings, the Abbey of Eldena, the Marienkirche in Greifswald and the walls of Neubrandenburg, were built.

Friedrich's interest in architecture seems to have affected his style, and he began to experiment with more complex compositional arrangements. Nothing can illustrate this better than a memorial picture he painted in 1817 in memory of the Berlin doctor Johann Emanuel Bremer (Plate 63). In this evening picture, Friedrich uses light to bring into sharp relief the name of 'Bremer', entwined in the ironwork of the gate. Beyond the gate and the poplar trees is a distant land with a ghostly town of spires and ships. Particularly interesting is the way the space has deepened, especially evident if one compares the work with the *Garden Terrace*. The symmetrical trees are now presented in several layers.

If the interest in architecture led to more complex spaces, it also led to more interest in architectural detail. This can be seen in his reworking of the *Abbey in the Oakwoods*, and also in the visionary *Cathedral* (Plate 64), a fanciful alteration and enlargement of the Marienkirche at Stralsund. But here the church has returned to being a transcendental apparition, unrealized.

Few of Friedrich's designs were executed, and this may have aggravated his disillusionment with the present political situation and even with the employment of Gothic as a living style. As early as 1814 Friedrich had written to his friend the patriot Ernst Moritz Arndt when they were planning a memorial for their friend Scharnhorst, who had died in the Battle of Leipzig, that he doubted if any such monuments to patriots could be erected 'as long as we remain the minions of the monarchs'.[42] His own epitaph on the patriotic movement, *Ulrich von Hutten's Grave* (Plate 66), suggests that all hope of liberation had been abandoned. Painted in 1823, on the three-hundredth anniversary of the death of the patriot Ulrich von Hutten, it shows a Gothic ruin with a man in the medievalized costume of the *Freiheitskrieger* reflecting on a monument to Hutten. On the sides of this monument are the names of prominent figures in the Wars of Liberation, since exiled by the Prussian Government. On the wall behind is a statue of Faith with her head broken off.

XIII. Caspar David Friedrich: *Traveller Looking over a Sea of Fog. c.* 1815. Oil (98.4 × 74.8 cm). Kunsthalle, Hamburg.

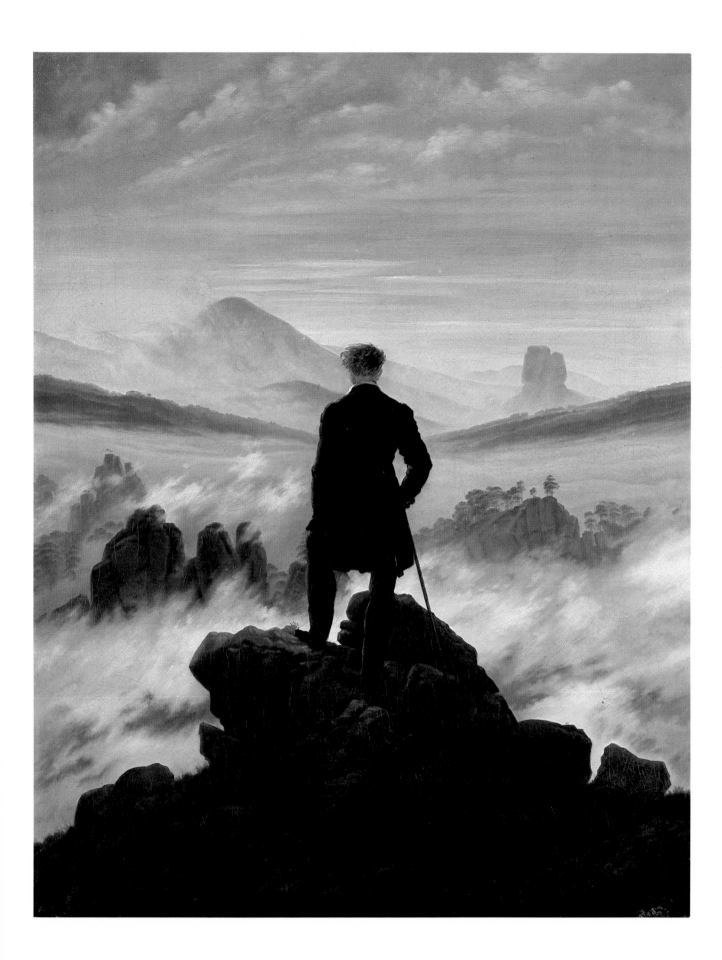

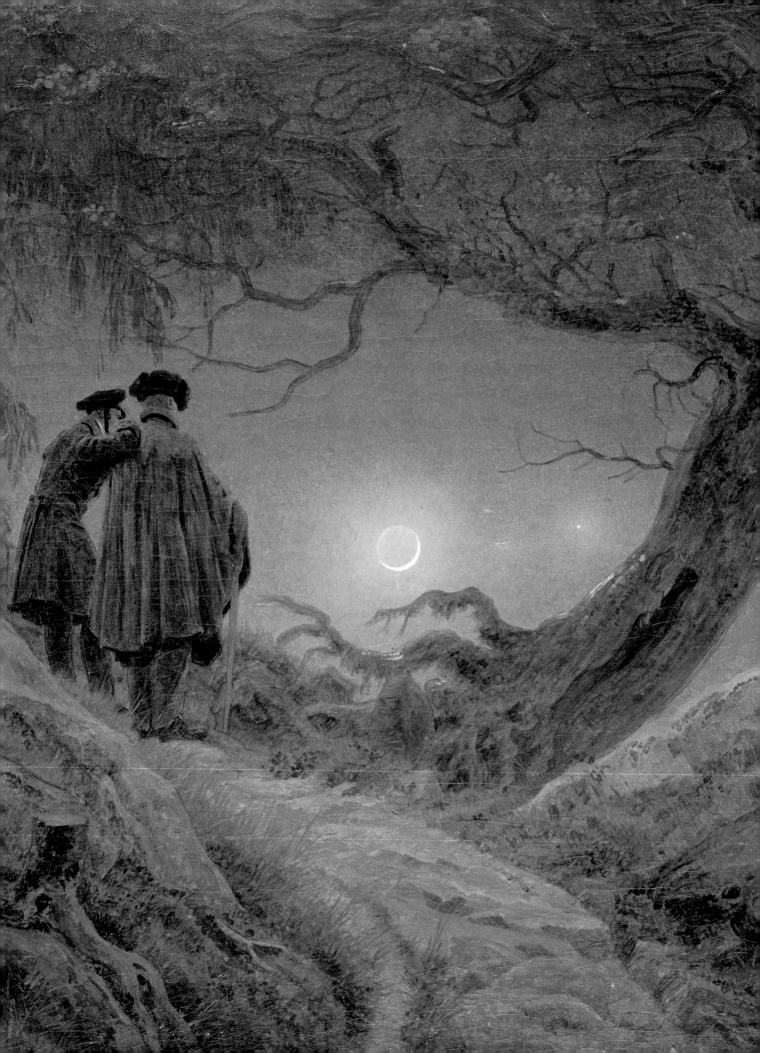

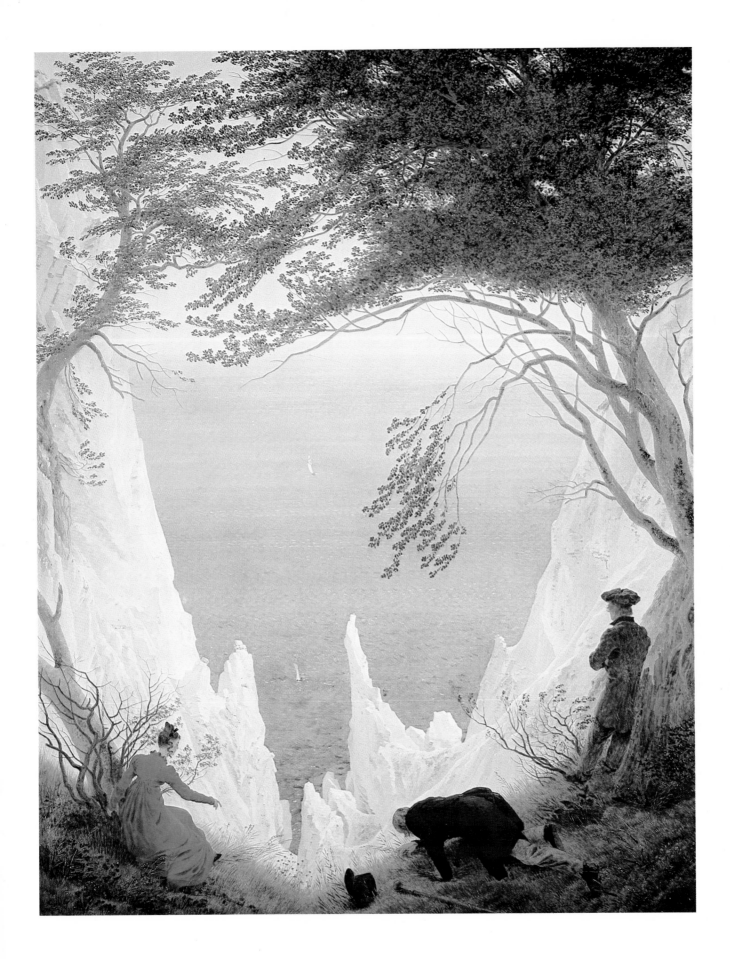

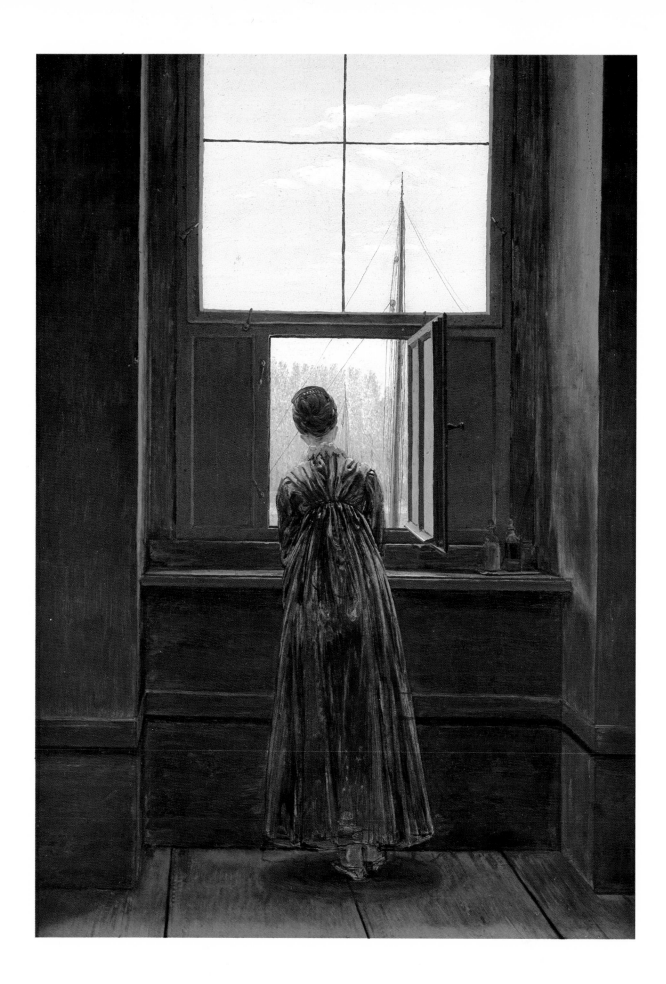

Friedrich—The Modern Painter

THE PAINTING of *Ulrich von Hutten's Grave* (Plate 66) demonstrates how much Friedrich continued to use landscape symbolically in later life. Nevertheless in the period following the Napoleonic Wars his style underwent considerable change. The growing interest in spatial complexity that accompanied his architectural ventures was the prelude to more fundamental transformations. During the 1820s he moved away from the esoteric atmosphere of his earlier works and turned his attention instead towards a more contemporary world. In the place of the distinctive foreground silhouette set against a hazy distance he used more informal designs. The dramatic tonal and atmospheric contrasts were replaced by fresher deeper blues and purples for the night. His forms, too, became less attenuated, as can be seen by comparing the lanky firs of the *Chasseur* (Plate 61) to the more compact ones in *Early Snow* (Plate 76), painted a decade and a half later. And, in keeping with this change, the shapes of his canvasses, especially the larger ones, tended towards a squarer format.

Friedrich's imagery also showed a significant shift towards the present. The repertoire of hermits, soldiers, wanderers and picturesque rustics virtually disappeared, being replaced by figures in contemporary bourgeois dress. His metaphors on transience, too, became less stagey. In the place of mists and visionary edifices are images of ships, cliffs and towns. Crosses, for once, are rare; and even ruins are made less exotic. In a painting exhibited in Dresden in 1825, the Abbey of Eldena actually appears as it then was—covered with bushes, its main window blocked up, and with a lean-to shack against a wall of the nave (Plate 65).

In many ways these developments reflect a greater personal tranquility. Official approval had begun as early as 1805 with his prize at the Weimar competition, and in 1810 he was elected a member of the Berlin Academy following the purchase of the *Monk by the Sea* and the *Abbey in the Oakwoods* by the Prussian Crown Prince. But it was not until 1816 that recognition began to bring with it lasting benefits. In this year he was elected a member of the Dresden Academy, and with this honour came an annual stipend of 150 thalers.

No doubt it was this regular income that encouraged him in 1818, at the age of forty-four, to marry the twenty-five-year-old daughter of a Dresden dyer, Caroline Bommer. According to Carus, this marriage to a gentle, unassuming, virtuous woman who bore him three children brought about little alteration to his life-style. But, in the early days at least, he seems to have been appreciative enough of the new companionship. 'Since I has been changed into We', he wrote to his Greifswald relatives soon after the marriage, 'many things have altered. There has been more eating, drinking, sleeping, talking, jesting and laughing.'[1] Though his life never became luxurious, this domesticity brought out a new tenderness. When the family moved to a larger residence in 1820, after the birth of their first daughter, the new studio seems to have been in a no less Spartan residence than the former one. Yet Friedrich's view of it exhibited in 1822 (Plate XVI) is given a touching

previous pages

XIV. Caspar David Friedrich: *Two Men Contemplating the Moon* (detail). 1819. Oil. Staatliche Kunstsammlungen, Gemäldegalerie Neue Meister, Dresden.

XV. Caspar David Friedrich: *Chalk Cliffs on Rügen. c.* 1819. Oil (90.5 × 71 cm). Oskar Reinhart Foundation, Winterthur.

XVI. (left) Caspar David Friedrich: *Woman at the Window.* 1822. Oil (44 × 47 cm). Nationalgalerie, Berlin (West).

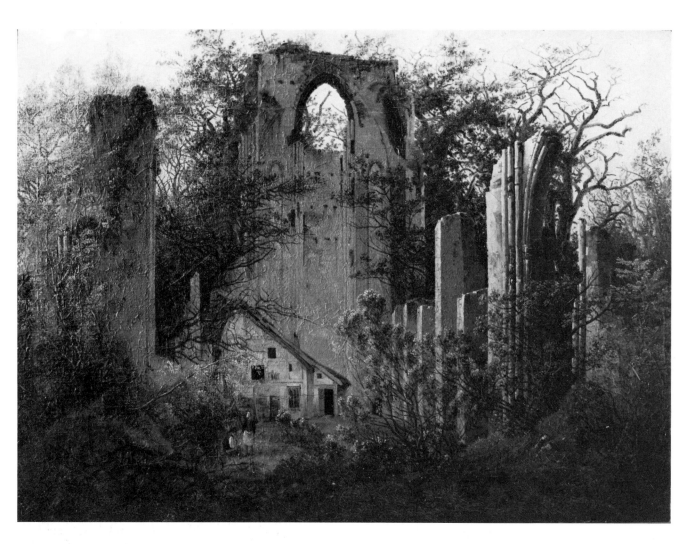

poignancy by the image of his wife peering out of the lower window opening. While the bare walls and window frame have been organized to emphasize their rectilinear structure with austere elegance the leaning figure of Caroline introduces a more tender accent. Nothing could contrast more strongly with the *Monk by the Sea* than this watching figure. The monk, sunk in solitude, is surrounded by an endless and monotonous nature. Caroline gazes with expectant curiosity on to a bright river with ships and banks of poplars which seems all the more enticing to us by the fact that we can glimpse no more than a fragment of them.

Nor is there anything awesome about the more overtly spiritual *Woman in the Morning Sun* (Plate 68), a work now commonly dated—for stylistic reasons—to about 1820.[2] As with the *Woman at the Window* this picture is concerned with the woman's reaction, for her silhouette blocks the rising sun that she is watching. In the gesture of her gently lifted arms and parted fingers there is a hint of erotic tenderness. Runge's mysticism had frequently contained a sexual element, but it was only at this stage that anything similar can be felt in the art of Friedrich.

This empathy with another person's response (a stimulant, but not a substitute, for our own) also led to the portrayal of shared experiences. In the summer of 1818, Friedrich took his new bride to Pomerania to meet his relatives. Together with the artist's favourite brother Christian and his wife the couple made a tour of the coastlands of Rügen, and for once Friedrich witnessed the Baltic in the company of more conventional sightseers. On his return to Dresden he painted a number of works which could be taken as mementoes of this trip: the *Chalk Cliffs on Rügen* (Plate XV) in which a pair of sightseers peer over a

precipice while another figure, which could be Friedrich, stares out to the distant sea; and *On the Sailing Ship* (Plate 67) in which a couple crouch hand in hand near the prow of a ship watching the spires of an approaching harbour town. Purchased by the Russian royal family, the latter was presumably the boat scene seen by the Crown Prince Nicholas on his visit to Friedrich's studio in 1820.[3] In any case, the structure of the picture shows a continuation of the interest in spatial depth that had been preoccupying Friedrich in recent years in 'architectural' pictures like the *Memorial Picture for Johann Emanuel Bremer* (Plate 63). However, there is a new informality in the way the scene is viewed aslant through mast, sails and rigging; an innovation so daring for Friedrich that he took the unusual step of making a compositional study for the idea before risking it on canvas.[4]

Usually these watching figures are differentiated in their responses. In *Two Men Contemplating the Moon* (Plates XIV and 69)—probably the version of this theme that the painter Peter Cornelius saw in Friedrich's studio in 1820[5]—the slighter man is leaning on the other as they pause on their nocturnal walk. He is dressed as a student, which lends substance to a contemporary assertion that the people here are Friedrich himself and his favourite pupil, August Heinrich (although the art of identifying figures viewed from the back can, in the nature of things, never be a precise one).[6] Certainly the different stances of the two—the outer one picking up the rhythm of the tree's spectral silhouette—suggest a greater and lesser degree of experience brought to the contemplation of nature.

The intimate mood of this small night scene, with its carefully modulated greys and browns suggests that it was intended to have purely personal resonances. Yet Friedrich hinted at something more conspiratorial when he told Cornelius that the two were engaged in 'demagogic machinations'. No doubt this was a wry allusion to the Austrian

65. (left) Caspar David Friedrich: *Ruin at Eldena*. 1824–5. Oil (35 × 49 cm). Nationalgalerie, Berlin (West).

66. Caspar David Friedrich: *Ulrich von Hutten's Grave*. 1823. Oil (93.5 × 73.4 cm). Staatliche Kunstsammlungen, Schlossmuseum, Weimar.

67. Caspar David Friedrich: *On the Sailing Ship*. c. 1818. Oil (76 × 56 cm). Hermitage State Museum, Leningrad.

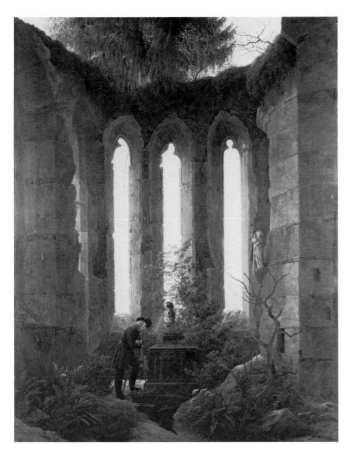

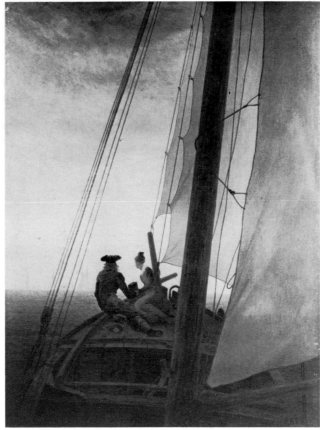

foreign minister Metternich's scornful term for liberals. Certainly the costumes of the men are those of the patriots, the cloak and floppy hat of the older man being identical to the ones Friedrich wore himself.

However much personal changes may have encouraged the new intimacy in Friedrich's art, his mode of painting was also undoubtedly affected by a younger generation. In 1819 a new force entered Dresden landscape painting when the Norwegian Johann Christian Clausen Dahl exhibited at the Academy. With the exception of Runge, this was the first time that Friedrich crossed paths with an artist whose talents came somewhere near to his own. It is tempting to ascribe the more spontaneous handling that emerges in his art around 1820 to this contact. Dahl had come recently from Copenhagen where his master had been the pioneer of naturalistic landscape in Danish art, Christoffer Wilhelm Eckersberg (1783–1847). Eckersberg, trained under David in Paris and later in Rome, painted his views with a sharpness that is quite different from the more painterly manner of Dahl. Yet he provided his pupil with a new standard of observation and, more importantly, introduced him to the habit of making direct oil studies before nature, common in the French Academy and amongst landscape painters in Rome. When Dahl went on to visit Rome in 1820–1 this habit became more dominant in his working process, but even before this time the practice had left its mark on Friedrich. In the winter of 1820–1 he made a series of oil studies of blocks of ice when the Elbe froze; and he used these for the Arctic shipwreck scene exhibited in 1822, a forerunner of the *Arctic Shipwreck* now in Hamburg.[7] It was at this exhibition, too, that Friedrich showed a picture which appears to have been a direct study in oils. The *Woman at the Window* was actually described in the exhibition catalogue as 'The artist's studio, painted from nature. . . .' Certainly the picture has all the appearance of a direct study both in its sense of freshness and in its freedom of handling. The lower part of Caroline's dress is so loosely brushed in that it has frequently been suggested the work was unfinished. In particular, the treatment of her hair shows how much Friedrich was now using the brush strokes themselves to form the shapes. This contrasts with the fine filling in of drawn contours evident in his earlier work, which can be seen in the detail of the earlier *Abbey in the Oakwoods* (Plate IX). And the technique of the former style has broadened into a more impressionist application of pure touches of colour—as can be seen in the way the sunlight glowing through the lobes of Caroline's ears has been captured with single dabs of an earthy red.

Dahl was to become a close friend of Friedrich's, and he moved into the same block of apartments as the older artist after marrying a Dresden woman in 1823. It was to be a fruitful relationship for both, with Dahl deriving much from the imagery of Friedrich—like so many other younger artists at this time. Under the influence of Dahl, on the other hand, Friedrich even went as far as to paint a number of studies of skies (Plate 70).

The direct oil painting of skies is often taken as a talisman of naturalism, especially in view of the importance of cloud studies to Constable in gaining a closer knowledge of atmosphere and light effects. It is certainly remarkable that Constable should have begun making such studies in the early 1820s—at much the same time as Dahl and Friedrich. Some years ago, Kurt Badt suggested a link between the interest in cloud studies in England and Germany. This was through the influence in Germany of Luke Howard, the 'father of British Meteorology', who invented cloud nomenclature. Howard's three volume work on the climate of London was known to Goethe, who wrote a poem in his honour.[8] Yet, although it is significant that such studies should show a common interest in a closer study of the more spontaneous and transient effects of nature, it should not be supposed that the interests of all these people were identical. Friedrich's sky studies of 1824 are in no way a recantation of his former refusal to be of help to Goethe in his

68. Caspar David Friedrich: *Woman in the Morning Sun.* c. 1818–20. Oil (22 × 30 cm). Folkwang Museum, Essen.

69. Caspar David Friedrich: *Two Men Contemplating the Moon.* 1819. Oil (35 × 44 cm). Staatliche Kunstsammlungen, Gemäldegalerie Neue Meister, Dresden.

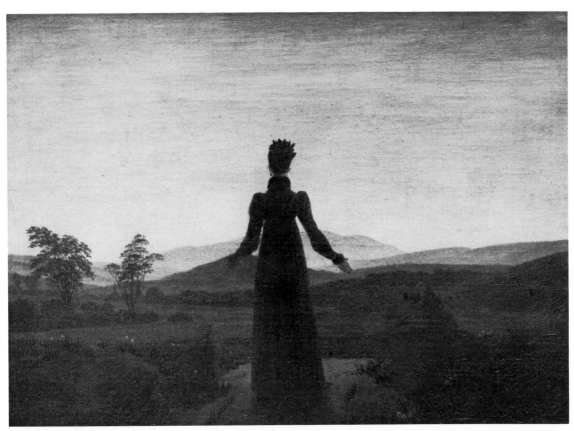

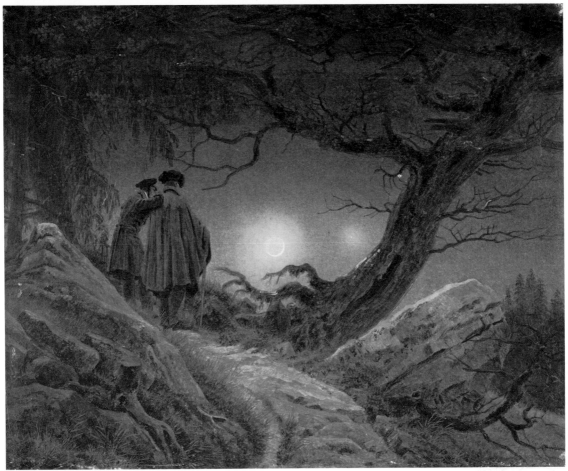

70. Caspar David Friedrich: *Evening*. 1824. Oil (20 × 27.5 cm). Städtische Kunsthalle, Mannheim.

71. Caspar David Friedrich: *Morning. c.* 1821. Oil (22 × 30.7 cm). Niedersächsisches Landesmuseum, Hanover.

72. Caspar David Friedrich: *Evening. c.* 1821. Oil (22 × 31 cm). Niedersächsisches Landesmuseum, Hanover.

classification of cloud types. Unlike Goethe and Constable he never came to see landscape painting as a form of scientific observation. Goethe and Constable both wished to come closer to an understanding of the laws of nature. In their eyes this in no way interfered with a poetic intuition of the 'life-force' that governed it—but Friedrich remained interested in a more subjective synthesis of experience, a measuring of inner mood with observation. He considered scientific investigation to be extraneous and detrimental to this. His sky studies are not analyses of clouds or climatic conditions, but impressions of overall effects. In contrast to Constable, who would frequently record on the back of these pictures the hour and even the direction of the wind, Friedrich was only interested in reminding himself that it was a record of an autumnal evening. He had previously made similar studies in wash. It is significant that he should now wish to use oil to make such a record. But his intention still does not seem to have gone beyond a desire—mentioned as early as 1806[9]—to heighten his control of gradations of light.

The effect of these studies can be felt in his composed pictures by 1820. The four pictures of the *Times of Day* that he began to paint for Dr Korte of Halberstadt in this year show a new approach to the common Romantic preoccupation with the cycle of nature. All the overt symbolism to be found in the earlier *Times of Year* (Plates 53–4) or Runge's *Times of Day* (Plate 31) has been suppressed in favour of a series of simple scenes of lowland landscape. And one of them at least is known to have been very closely related to a pencil study of some fields and a clump of trees.[10] The choices of location were, of course, not without 'significance'—from the mists rising above a flowing river in *Morning* (Plate 71) to the barrier of trees in a darkened wood in *Evening* (Plate 72). Yet even the *Evening* has no more than a hint of the symmetry that Friedrich normally reserved for spiritual moments, while the *Morning* seems to hark back to the picturesque river scenes of the Dutch seventeenth-century painter Van Goyen. In all the scenes the principal charm comes from a breathtaking sense of a particular moment. Small pictures painted for a bourgeois patron, these modest but enchanting evocations of the beauty of a familiar middle-German landscape are the perfect embodiment of Biedermeier sensibility. In this they are akin to the sentimental portrayal by Friedrich of his home town (Plate III), a work that, with the exception of the joyfully bucking horse in the middle-ground, was also closely related to a pencil study.

However, Friedrich's involvement with naturalism was never more than tangential. He is not known to have made any oil studies after 1824, and in his critique of an art collection written *circa* 1830 he is scathing about the naturalist painter.[11] Furthermore the informality of his smaller scenes did not distract him from the desire to continue working on a monumental scale.

The difficulty of uniting the controlled sense of design necessary to achieve the monumental with the spontaneity of direct observation was a recurrent problem in naturalist art. Constable for one was never able to resolve the problem to his satisfaction. For Friedrich, on the other hand, there was no such problem. He never experienced any difficulty with imposing the strictest sense of organization onto his large works—even when he experimented with more complex arrangements after 1814. His sense of the effect of scale can be seen by comparing two versions of a theme—one a two-metre high canvas (Plate 73), and the other less than a quarter of that size (Plates XVII and 74). Both are related to the Baltic visit of 1818, and portray groups watching ships approach the shore at night-time. In both there is a sense of differentiation between the men and women as they stare silently into the distance. The separation of the sexes led Friedrich's Russian admirer Zhukovski to make the following interpretation when he saw the work in the artist's studio in 1821: 'Two young women are sitting on the rocks and looking at the sail with hope and resignation. Two men, less patient in their hope, have leapt over the rocks and are standing, surrounded by water, looking in the same direction. More rocks are in front of them, but beyond their reach.'[12] The elaborateness of this drama forms a contrast to that in the later and smaller work—painted in 1822 together with a companion work, the *Village Landscape in the Morning Light* (Plate 42), for the Berlin collector Consul Wagener. In this smaller work the whole action takes place along a single central diagonal axis. In the larger *Moonrise over the Sea* the frontality of the picture is imposed by a horizon line almost as dominant as that in the *Monk by the Sea*. And, as in the *Monk by the Sea*, this line is touched by the climax of the composition: in this case the two men who have stepped furthest into the sea: Yet, when the spectator stands before this work and views it in scale, he is aware that in the lower half of the canvas there is a discreet progression towards the insuperable horizon. The anchor becomes an indication of scale, by which the spectator can align himself along the path of the first of the diagonals that zigzag from the seated women to the standing men. But the whole of this progression, including the spectator's

own viewpoint, lies beneath the horizon, where the broad and gentle yellow moonlight arcs upwards through the deep slate-blue sky.

Such consummate balancing of forms and mood shows that the new intimacy had in no way affected Friedrich's sense of the monumental. But he was nevertheless feeling the pressure of competition from more conventional forms of large-scale landscape. In terms of patronage this presented a problem, for he could hardly devote himself to these large-scale ventures without some likelihood of their being sold. Yet, with the exception of the Russian royal family—who bought the larger *Moonrise*—he was in the 1820s rarely attracting the attention of monarchs. Although a number of private Berlin patrons continued to show some interest in such pictures, Friedrich virtually ceased to produce large-scale works after the exhibition of the *Watzmann* in 1825.

The strongest competition that Friedrich encountered in the painting of these monumental works was provided by the Roman painters of classical and 'Heroic' landscapes. In 1821 he was encouraged to provide a Nordic alternative to the Grand Manner when he was invited by von Quandt, a major collector of classical and Nazarene art, to paint a 'Northern' pendant to an Italian scene by one of the 'German Romans', Martin von Rohden. Friedrich's response was an arctic shipwreck, the forerunner of the one in Hamburg (Plate VIII). It was in every way a contrast to the conventionally structured earthly paradise envisaged by Rohden—a work now known only through an engraving.[13] Friedrich does not open out but encloses the space in his picture, focussing attention on the pyramidal mass of ice against an endless waste, emphasizing the barrenness and the inhospitality of one of the extremes of nature. In the place of von Rohden's timeless tranquility there is a pervasive transience. This is evident not only in the greater naturalism which Friedrich brought to the depiction of the scene, but also in

73. Caspar David Friedrich: *Moonrise over the Sea.* 1821. Oil (135 × 170 cm). Hermitage State Museum, Leningrad.

74. Caspar David Friedrich: *Moonrise over the Sea.* 1822. Oil (55 × 71 cm). Nationalgalerie, Berlin (West).

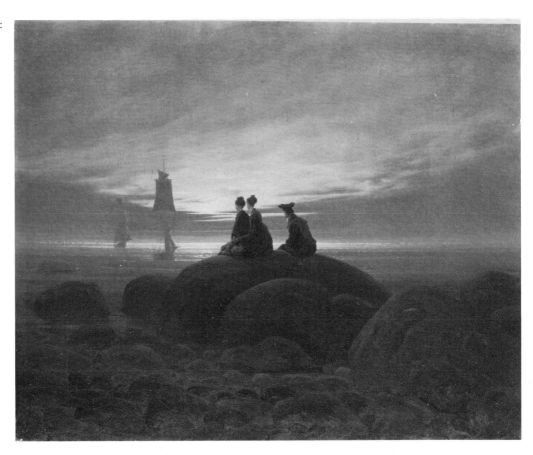

the work's topicality; for the disastrous shipwreck of a polar expedition was much in the news at that time.[14]

Friedrich produced this view of an extreme of nature as an alternative to a classical idyll. He turned to another type of extreme, high mountains, to confront the classical heroic landscape. Although he had himself never visited the Alps, he felt the need to paint two large Alpine scenes—the *High Mountains* (Plate 75) and the *Watzmann* (National-galerie, Berlin (West)) in the mid-1820s. The *High Mountains* was shown in Dresden in 1824 at the same exhibition in which Adrian Ludwig Richter, recently returned from Rome, exhibited his version of the *Watzmann* (Plate 145). Richter's picture was in the manner of Koch's *Schmadribach Falls* (Plate IV). It has recently been suggested that Friedrich's painting of the *Watzmann* for the exhibition of the following year was in direct response to the younger artist's treatment of the theme.[15]

Both the *Watzmann* and the *High Mountains* could hardly be more different from Richter's *Watzmann* and Koch's *Schmadribach Falls* in the handling of monumental mountain scenery. Where Richter and Koch created the sense of greatness through the building up of multiple layers in which many stages are surveyed at once—a kind of multiplicity which contemporaries described with the term 'Universal picture'—Friedrich worked by means of concentrated effect. His design, which shows a distant mountain hard up against the diagonals of two foreground coulisses, was literally a contraction of a sketch of Mont Anvert by Carus; for in his composition Friedrich suppressed the glacier that, in Carus's drawing, intervenes between foreground and background.[16] The contraction not only emphasizes a strict surface structure, but also transforms the glinting snow-capped peaks into a translucent apparition. It is small wonder that a contemporary reviewer could talk of 'sublime church music' in the presence of such an abstraction. Whatever Friedrich may have borrowed from Carus in the way of motif, the sense of unrelieved loneliness is his own. He knew very well what it was to be alone in the mountains, having once described spending a week of isolation amongst them in order to 'see and perceive nature completely' and 'merge with my clouds and cliffs'.[17] High mountains were for him places of utter lifelessness and silence; when he saw Koch's creation of grandeur through multiplication rather than economy, he found it to be a boastful striving after abundance.[18]

Friedrich was not in a position to stem the tide of naturalists, medievalists and classical landscape painters that surrounded him in increasing profusion in his later years. Richter was not the only person to find his work forced and unnatural in the 1820s. When the position of the teaching professorship of landscape became vacant at the Dresden Academy on the death of Klengel in 1824, the post was offered not to Friedrich but to Dahl. While this snub has been interpreted as anxiety towards his stylistic idiosyncracies or even his suspect political attitudes, it was also a recognition that Dahl was more topical and fashionable amongst the younger generation on account of his vivid naturalism.

Friedrich not only suffered from growing unpopularity at this time, he was also beginning to experience a decline in his physical health. In 1825–6, he suffered a severe illness, followed by a series of lapses that culminated in his permanent incapacitation after a stroke in 1835. These illnesses drove him in on himself and away from prevalent fashions—when he was too weak to work in oils, he reverted to the watercolour and sepia techniques of his youth. The subjects of these were frequently old ones as well—such as the revised version of the 1803 *Times of Year* (Plates 53–4).

Friedrich was able to return to oil painting by the end of 1826. But he seems to have been permanently shaken by his illness, and this, together with his fading popularity, led to a persecution complex. He became increasingly mistrustful, and even suspected his blameless wife of unfaithfulness. Terrestrial paganism became a preoccupation, and in

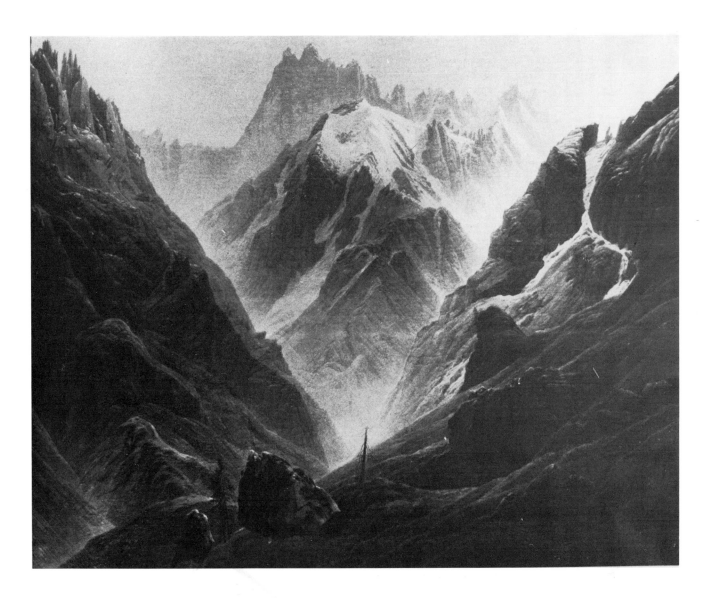

75. Caspar David Friedrich: *High Mountains. c.* 1824. Oil (132 × 167 cm). Destroyed, formerly National Gallery, Berlin.

these years he returned to themes of cemeteries, snow and ruins. The *Early Snow* (Plate 76) was described in 1859 by its owner W. Wegener in terms of 'the white winding sheet that heaven spreads across the earth'. It was in this frame of mind that Friedrich wrote the manuscript 'Observations on a Collection of Pictures'. In this he contrasted his own concept of spiritual empathy with the Divine in nature to the soullessness of the contemporary world. In painting, the art of the medieval revivalists is characterized as false piety, the imitation of the form rather than the spirit of religious art. Similarly the naturalists, with their skilful simulation of the appearance of nature are shown to be symptomatic of an age of soulless materialism. In the same spirit he viewed with horror the first effects of the industrial revolution, then beginning to spread from England to Germany. Reviewing a work in the new English technique of steel engraving he concluded that it had been carried out 'either by an Englishman or by a machine'.[19]

Despite his growing bitterness of mood, Friedrich produced some of his most lyrical works in the early 1830s. This new lyricism is intimated already in *Easter Morning* (Plate 77), a work which, sadly for English Friedrichophiles, was not acquired by any British public collection when it was made available to them a few years ago. The original owner of this picture, Wegener, described it as a pendant to the sepulchral *Early Snow*, which was also in his collection. *Easter Morning* shows the three Marys on their journey to the tomb where Christ was laid. The tender, diffused early morning light that pervades the

atmosphere presages the joyful outcome of their mission. Paintings like the *Large Enclosure near Dresden* (Plate 79) and the *Stages of Life* (Plate XIX) use the liberation of colour that he had experienced in his naturalist phase to create a heightened awareness of atmosphere. The fascination with scenes of twilight and sunrise has now come to be expressed with a new refinement in colour ranges of blue, silver, orange and yellow. The paradoxical unification of internal and external vision in these works appears complete. They are at the same time masterpieces of colour symbolism and of the naturalistic rendering of light. He seems at this time to have become fascinated by the interplay of differing light effects, combining in a work like *Evening on the Baltic* (Plate 78) the effects of natural and artificial illumination. He also designed a light box through which transparent pictures could be viewed, and sent one to Zhukovski for the Russian royal family in 1835.[20]

The pictures of the early 1830s are the culmination of Friedrich's career. In them the motifs of his earlier years are handled with an unprecedented refinement and mastery. The *Large Enclosure near Dresden* (Plates XVIII and 79) is deceptive in its simplicity. Exhibited in Dresden in 1832, it records an exact spot, showing the large common that ran along the Elbe to the northwest of the city and which was traversed by alleyways of trees. It is a late summer evening, the sun having just sunk below the bank of lilac clouds that sit on the horizon. All is silent and still, apart from a solitary vessel, whose billowing sail indicates that it is being blown towards the shore at the bend of the river ahead of the mudflats in the foreground. Never before had Friedrich captured a moment so precisely as here—that instant when the sun has sunk and yet the earth is still half lit by the diffused illumination of the sky. It is a picture about reflection and transformation. It captures the moment when the daytime values become inverted, when the trees have darkened more

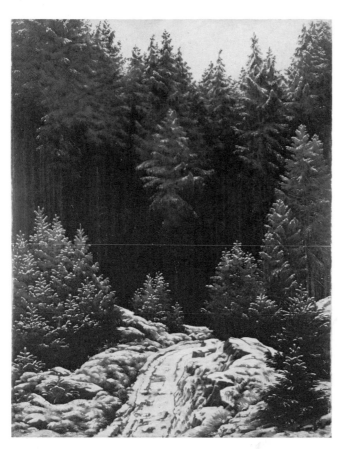

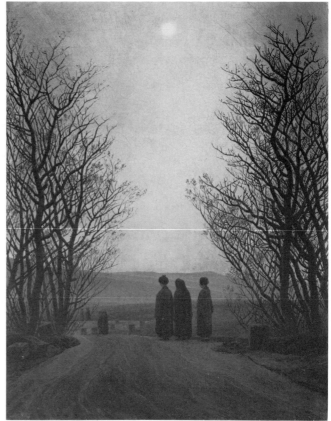

rapidly than the ground, and the river and pools become silver channels in the murkiness. This reflectiveness is also one of form, for the random flow of water in the foreground mudflats shapes an arc that mirrors the declivity in the clouds. Heaven and earth are brought to bear upon each other in a sequence of natural images. We are guided inevitably by the perspective of these curves towards the centre, compelled like the sail of the ship to the dark obstruction of the alleyway of trees through which the distance can be only uncertainly glimpsed. There is no narrative sufficient to paraphrase this drama. It touches the most elemental of feelings.

Friedrich never again painted anything quite like the *Large Enclosure*, yet one can see a similar refinement in many other revisions of older themes. *Before Sunrise* (Plate 80) brings a new beauty to his pure mountain paintings. Although it is every bit as barren as the *High Mountains* and contains the same organizing central type of design, it no longer has the strong diagonals that can be found in the paintings of the 1820s. Instead it has a softened arc, similar to that in the *Large Enclosure*. The gentle poetry of early morning prevails. Only gradually do we become aware that our experience is being discreetly shared by a seated traveller on a foreground rock.

This new sensibility also affected his depictions of the Baltic. These scenes are now drawn from distant memories, for he did not visit the area again after 1824. The picture now known as the *Stages of Life* (Plate XIX)—though there is no evidence that Friedrich ever gave it this title—was a memento painted for a member of his family around 1835. It shows the Utkiek in Wieck near Greifswald, a place from which the incoming boats could conveniently be observed. Most of the studies go back to the visit of 1818.[21] Yet his memory reached back even further than that, for the two children on the shore are waving a Swedish flag, though Pomerania had ceased to be Swedish in 1816.

The imagery in this picture may possibly have a private family significance. There may be biographical elements in it. The old man who is walking forwards in a costume similar to that Friedrich now habitually wore is also using a stick, a habit that Friedrich adopted after his illness of 1826. If one can agree with the identification of this figure with Friedrich, it would seem reasonable to continue the analogy and identify the two little children as Friedrich's own youngest and to find in the young woman his wife or more likely (since Caroline by that time was in her forties) his eldest daughter Emma. Börsch-Supan, who believes this, has also suggested that the younger man might be the young relative of Friedrich's, his nephew and godson Johann Heinrich Friedrich, who came to help look after the family in Dresden after Friedrich's stroke in 1835.

Although the symbolism of the picture has probably been lost with the generation it represents, one can still sense that a drama lies behind it. The design is a variant of those scenes from the 1820s of figures watching ships. But night has been replaced by the softer and more poignant moment so dear to Friedrich in his last years—when the sun's reflection alone illuminates the world, in the brief time after its departure from the sky. Ghostly ships become haunting silhouettes as they near the shore. The design is curiously dominated by the central ship, which lies just off-centre, but suggests an idea of symmetry around which all the forms subtly play. There are five ships on the sea, and five people on land. Possibly each one can be associated with an individual figure. But this seems to be less relevant than a mirroring of actions. The main line of the diagonal passes through both ships and figures as they are approaching the shore for their own worlds. As in the pictures of the 1820s, the whole drama is built up around the differences between the reactions of the figures to what they see. In the *Stages of Life* they all appear to be in separate worlds. The two children wave their flag in innocent excitement at the approaching ships, the young woman looks down in concern for them, the young man—the only figure looking in our direction—has turned to beckon to the old man who moves slowly but

76. Caspar David Friedrich: *Early Snow. c.* 1828. Oil (43.8 × 34.5 cm). Kunsthalle, Hamburg.

77. Caspar David Friedrich: *Easter Morning. c.* 1828. Oil (43.7 × 34.4 cm). Private Collection.

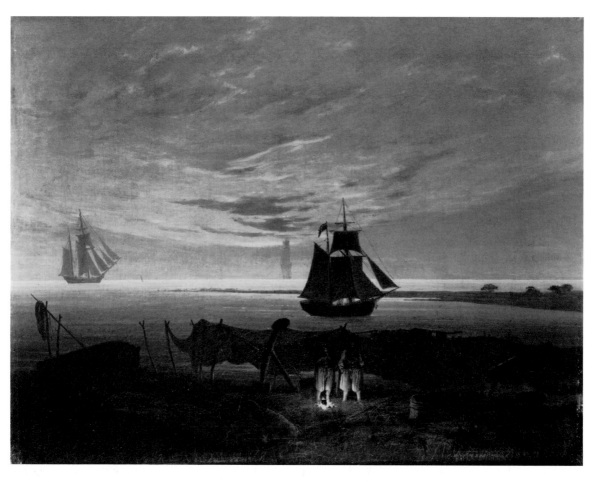

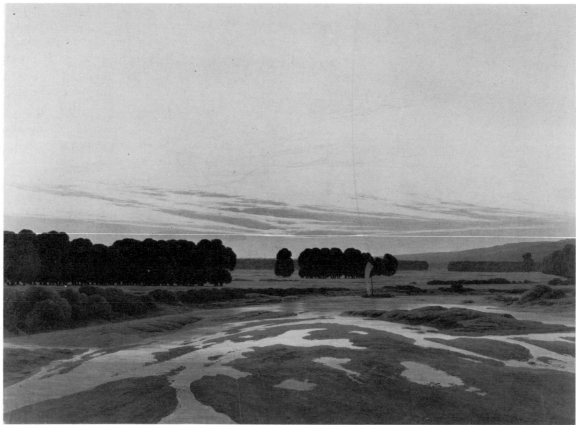

firmly forward, his eyes resolutely fixed on the horizon. On one level it is a family outing. But the design and the gesture and expression of the young man who has placed himself between the old man and the view give it more disturbing implications.

Only one thing suggests that this picture might be a premonition rather than a consequence of the final stroke of 1835, and this is the firmness with which it was painted. The pictures that are known to have been painted by him after this date exhibit a tragic loss of control. There is a large and depressingly feeble Baltic scene. It almost seems to have been undertaken as a separate attempt to convince himself that he retained his old powers of working on a large scale.[22] A few of the smaller works of this date—mostly repetitions of old designs—show that the looseness of hand that followed the stroke could produce a charming if saddening featheriness (Plate 81). But for practical purposes Friedrich's career as an oil painter was over. From 1835 until his death the only oils to be exhibited by him were ones painted earlier.

Once more he returned to working in sepia and watercolour, and, though many of these contain old images, the shadow of death can be felt even more strongly in them. In a startling series of sepias he depicted huge owls settled on ruins or in graveyards. The most frightening is one where a vast eagle owl—many times the natural size of even this large bird—perches on a coffin that has been closed and is ready to be lowered into the open grave (Plate 82). Behind is a view of Arkona, and the sense of the occult is heightened by the way the owl's tufted ears touch the lower edge of the full moon. Perhaps this is a symbol of the salvation offered by Christ that lies beyond death. But the theme exudes more a sense of fear than of trust. By this time Friedrich was an almost forgotten figure. Incapable after 1838 of executing any but the slightest of sepias and watercolours, he lived in great poverty, increasingly dependent for the support of himself and his family on the charity of his friends. Visitors like Zhukovski who met him in these years recorded sadly his diminished powers. His death in May 1840 caused little stir in artistic circles, although Carus published an appreciation of him.[23]

Friedrich was a fatalist, and seems to have become resigned to his change of fortune before the end. In his very last pictures the owls of the period soon after his illness are no longer there, but have been replaced by more tranquil renderings of the old views. His own pictorial epitaph (Plate 83) brushed in with the faintness of his last sepias, shows a clump of reeds with his palette slipping calmly beneath the waves. Above this shrouded scene amongst the grass minute birds flit insect-like in the air, images no doubt, as are butterflies, of the soul. It is a relief to arrive at this tranquil resigned image, and to

78. (top left) Caspar David Friedrich: *Evening on the Baltic. c.* 1831. Oil (54 × 72 cm). Staatliche Kunstsammlungen, Gemäldegalerie Neue Meister, Dresden.

79. (bottom left) Caspar David Friedrich: *The Large Enclosure near Dresden.* 1832. Oil (73.5 × 102.5 cm). Staatliche Kunstsammlungen, Gemäldegalerie Neue Meister, Dresden.

80. Caspar David Friedrich: *Before Sunrise.* 1830–5. Oil (72 × 102 cm). Nationalgalerie, Berlin (West).

81. Caspar David Friedrich: *Pinewoods with Pool. c.* 1835. Oil (19.5 × 25 cm). Wallraff-Richartz-Museum, Cologne.

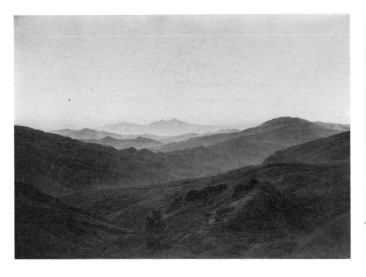

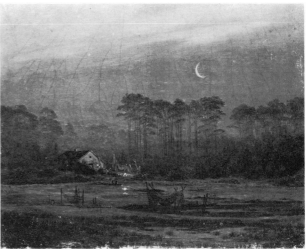

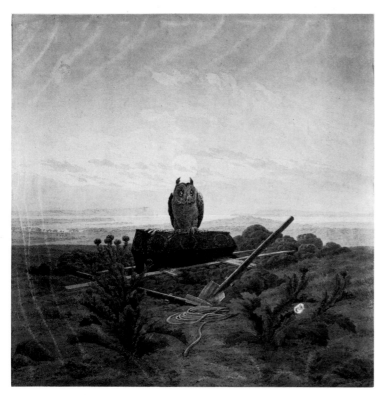

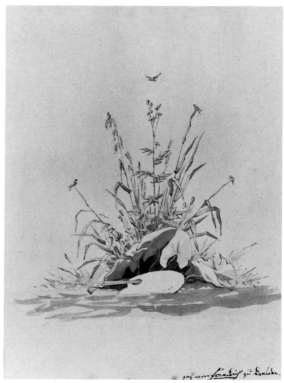

82. (above) Caspar David Friedrich: *Landscape with Grave and Owl. c.* 1836–7. Sepia (17 × 20.4 cm). Kunsthalle, Hamburg.

83. (above right) Caspar David Friedrich. *Clumps of Grass and Palette. c.* 1839–40. Sepia (20.2 × 25.4 cm). Private Collection.

XVII. (facing page) Caspar David Friedrich: *Moonrise over the Sea* (detail). 1822. Oil. Nationalgalerie, Berlin (West).

following pages

XVIII. Caspar David Friedrich: *The Large Enclosure near Dresden* (detail). 1832. Oil. Staatliche Kunstsammlungen, Gemäldegalerie Neue Meister, Dresden.

XIX. Caspar David Friedrich: *The Stages of Life. c.* 1835. Oil (41 × 63 cm). Museum der Bildenden Künste, Leipzig.

learn that this firm believer in the immortality of the soul had contemplated a more terrestrial resurrection for his art. When defending in his 'Observations' his own intransigence in the face of recent developments, he left it to posterity to make the final assessment: 'I am not so weak as to submit to the demands of the age when they go against my convictions. I spin a cocoon around myself; let others do the same. I shall leave it to time to show what will come of it: a brilliant butterfly or a maggot.'[24]

During the remainder of the nineteenth century Friedrich's art was remembered no more than occasionally as a curiosity, and it was only in the 1890s with the researches of the Norwegian art historian Andreas Aubert that his art began to be re-appraised. But the world into which it re-emerged was far removed from the one of simple faith in which he had lived, and both critics and artists now looked on him as a creator of psychological states or as a forerunner of naturalism. Neither of these viewpoints can reflect that intricate balance of observation and meaning that informed the Romantics and which made their art at the same time symbolist and naturalist without any hint of contradiction. It was only in an age that could accept the assertions of nature philosophy that a work like the *Large Enclosure* could have been painted.

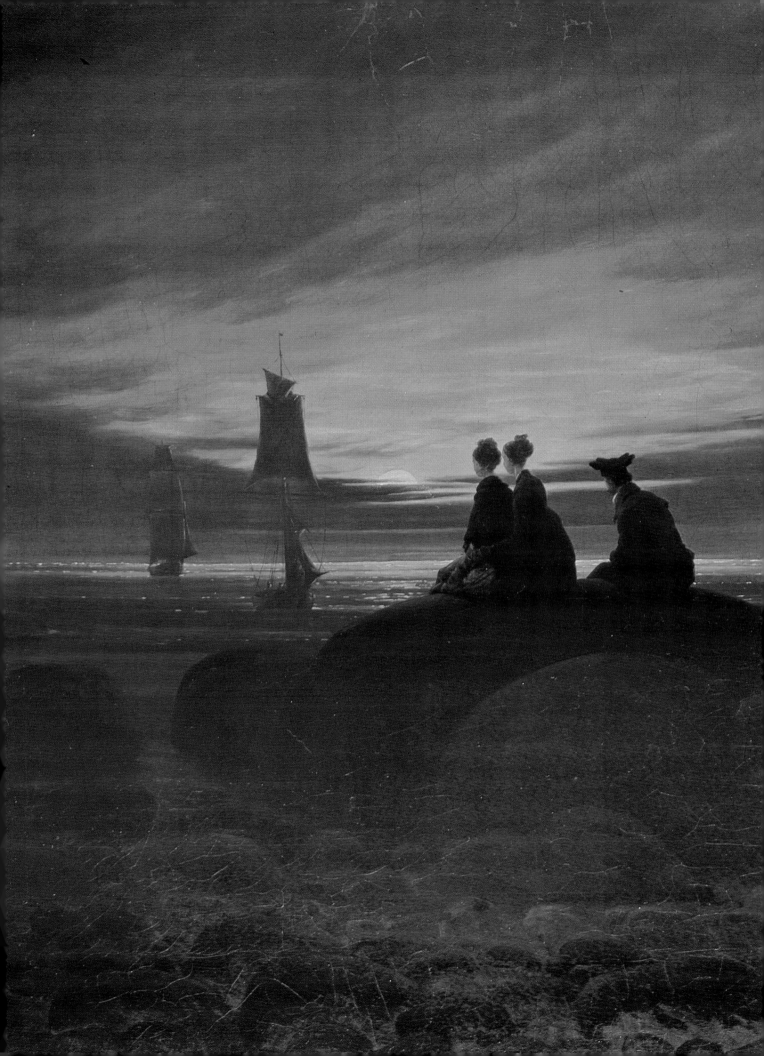

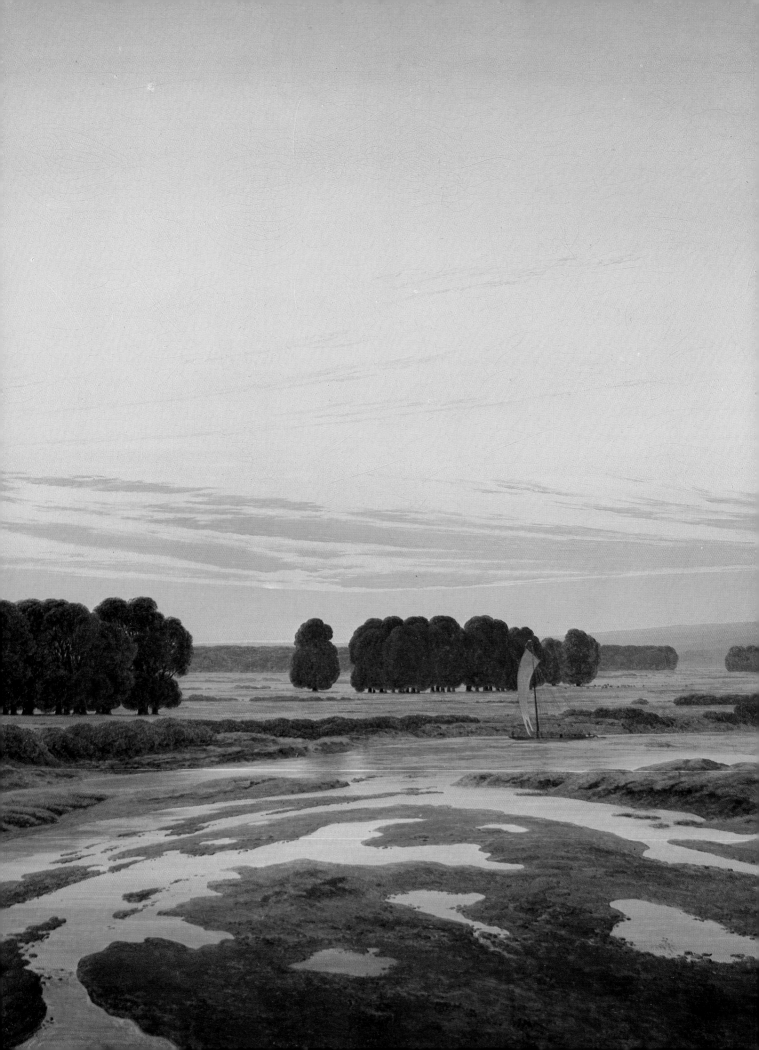

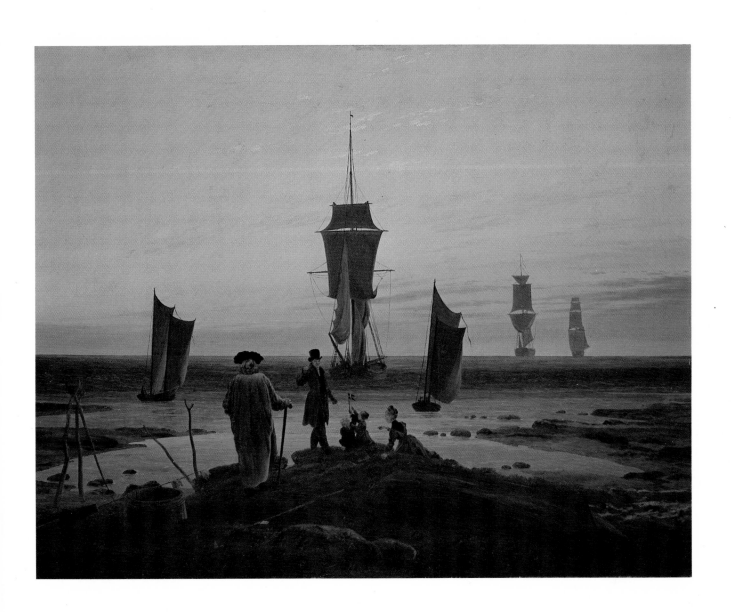

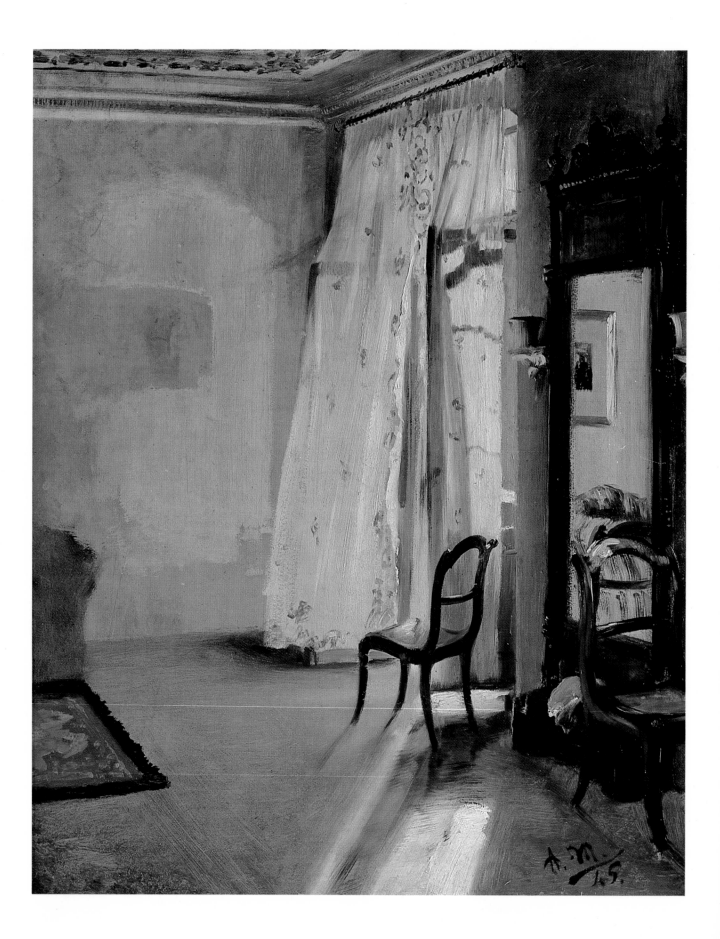

Friedrich's Followers and Imitators

'FRIEDRICH', complained the young Dresden artist Adrian Ludwig Richter in 1824, 'chains us to an abstract idea. He makes use of the forms of nature in a purely allegorical manner, as signs and hieroglyphs—they are made to *mean* that and that. In nature, however, everything expresses itself; her spirit, her language lie in every shape and colour.'[1] When Richter wrote this he was just completing his studies in Rome and had been having a heated discussion with friends about the problem that worried so many painters of his generation: the degree to which landscape could, or should, be used to convey human ideas and emotions. It was an attractive proposition—and one to which far greater artists than Richter have been susceptible—that there was a self-evident 'language of nature' which had simply to be recorded. A glance at Richter's own work will immediately show how much he underestimated the problem. In *Crossing by the Schreckenstein* (Plate 84)—which shows a cargo of stock Romantic figures being ferried over the Elbe at evening time—he imposes every bit as much meaning on nature as Friedrich ever did. Richter's very words about everything in nature 'expressing itself' suggest how little he had in fact managed to free himself from the Romantics' habit of investing the inanimate with feelings—what Ruskin called the 'pathetic fallacy'. His real objection to Friedrich's pictures was not so much that they presented ideas, as that these ideas conflicted with his own view of what was 'natural'. He complained that Friedrich indulged in 'gloomy, feverish images'; while he himself preferred to dwell upon such 'beneficial effects' as 'the feeling of freedom in a broad, beautiful, enlivening space'.[2]

Richter was no less an interpreter of nature than Friedrich, but his desire to move away from the subjective was shared by more radical contemporaries. When artists like Dahl and Blechen considered the problem of natural painting they neither supposed there to be a self-evident language of nature nor rejected the approach of Friedrich out of hand. Instead they recognized that 'naturalism', like all other outlooks, was a matter of observing phenomena with a particular end in mind. Even if they did not manage to divest landscape painting of all emotive associations, their *plein air* records of atmospherics and seemingly inconsequential moments did pave the way for an artist who could. It was the matter-of-factness of the young Berlin painter Adolph Menzel in the 1840s that finally presented an alternative to the associative approach to nature. Friedrich's dictum that one should not 'separate the small from the large, but rather the trivial from the important'[3] was the exact opposite of Menzel's delight in observing the moving surface of life without selection or rejection. While Friedrich asserted that the artist should cease to paint what he saw before him if he saw nothing within him, Menzel recommended the artist to undertake every task that was put before him. In his eyes there could be no such thing as a 'potboiler' since every commission presented a unique and instructive problem[4]—an attitude that certainly accords with his own prolific career of virtuoso performances.

The naturalist movement represented a change more in attitude than in standards of

XX. Adolph von Menzel: *The Balcony Room*. 1845. Oil (39 × 29 cm). Nationalgalerie, Berlin (West).

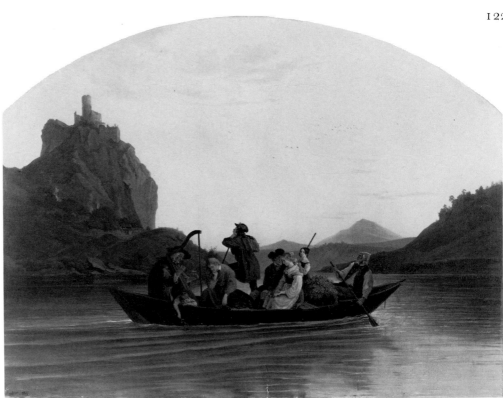

84. Adrian Ludwig Richter:
Crossing by the Schreckenstein.
1837. Oil (116.5 ×
156.5 cm). Staatliche
Kunstsammlungen,
Gemäldegalerie Neue
Meister, Dresden.

observation. Friedrich was no less assiduous in his recording of appearances than Menzel. Friedrich's sepia *View through the Studio Window* (Plate 85)—one of a pair of pictures of the two windows of his studio seen from the same viewpoint—is as skilful in its rendering of the fall of light and the effects of reflection as is Menzel's *Balcony Room* (Plate XX), even though its rigid frontality and precision of detail convey a sense of special meaning, while the *Balcony Room* delights in the purely transitory effect of the wind blowing into the corner of a room on a sunny day. Friedrich's high standards of observation are a reminder of his insistence that the impact of a picture must begin with its effect. It was this empiricism that proved so instructive to Dahl and Blechen and that set a level of attentiveness and craftsmanship to which Menzel was the heir.

It is a mark of the effectiveness of the descriptive side of Friedrich's art that his influence should first have been felt in the illusionistic rendering of interior scenes. For Friedrich himself, as for so many other Romantic writers and artists, the motif of the view through the window became a potent symbol for expectancy or aspiration.[5] This image became adapted in many ways. Only a year after the *View through the Studio Window* was first exhibited, in Dresden in 1806, another local artist, Carl Ludwig Kaaz (1773–1810), devised a *View through an Open Window* (Plate 86) that was clearly based on it.

Kaaz, the son-in-law of the Dresden portrait painter Anton Graff, had returned to settle in the city in 1804 after having studied in Switzerland, Paris and Rome. Uncertain of his direction, he was encouraged by the current trend to try his hand at landscape. This was a novel venture for him, and he seems to have brought more of his classical training to it than sympathy for the new Northern art. It is true that he emulated in his *Open Window* the minuteness of Friedrich's sepia, adding to it a positively Netherlandish touch of illusionism by painting a fly on the lower edge of the right window frame. But neither this nor the superficially similar format of the two can disguise the fact that both the realism and the symbolism of Friedrich's work have evaded Kaaz. Friedrich painted the window and the view through it without any attempt at idealization. He had shown the opposite bank of the Elbe as a random fragment rather than as a complete scene in itself. It

appears, in fact, exactly as it would have done from his position, which can be calculated from the reflection of the top of his head glimpsed in the mirror on the left. Typically, he has turned this randomness to his own purpose, introducing the mast of a passing ship to provide an enticing hint of the world beyond the darkened room. Kaaz's picture, on the other hand, is less a view through a window than a view framed by a window. Outside, the landscape—ostensibly before the villa of the Dresden Academy director Joseph Grassi—is as meticulously organized as a landscape by Poussin. Friedrich's symbolism is intimately connected with the spectator's situation. Kaaz's commentary is restricted to the frame, where the spyglass, open book of poetry and palette on a nail behind a reflecting window pane direct one to the contemplation and description of the beauties of a verdant countryside. Kaaz's picture reveals an artist with classical inclination attempting to assimilate Friedrich's innovations. His misunderstanding of the situation was no greater than that of Goethe, who actually exhorted Kaaz to follow the example of Friedrich. Ironically this advice was given to Kaaz a year after he had painted the *View through an Open Window*.

The work of Georg Friedrich Kersting (1785–1847) shows a closer involvement with the intimacy and individualism of Friedrich's indoor scene. Described by their mutual friend the painter Louise Seidler as 'an altogether splendid and comical fellow',[6] he had the good sense not to attempt the intensiveness of Friedrich's elemental landscapes, but concentrated instead on providing exquisite reflections of the modest social world he so enjoyed.

Like Friedrich, Kersting was from the north of Germany, being born at Gustrow in Mecklenburg. This no doubt helped to draw the two together when the younger artist

85. Caspar David Friedrich: *View through the Studio Window*. c. 1805–6. Sepia (31 × 24 cm). Kunsthistorisches Museum, Vienna.

86. Carl Ludwig Kaaz: *View through an Open Window*. 1807. Oil (92 × 71 cm). Private Collection, Dortmund.

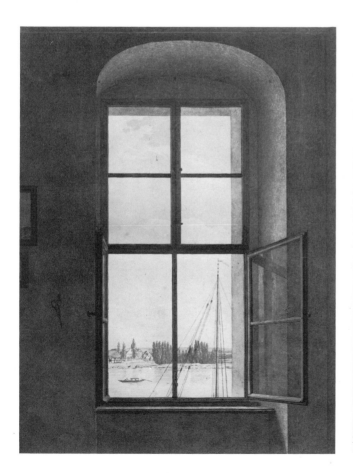

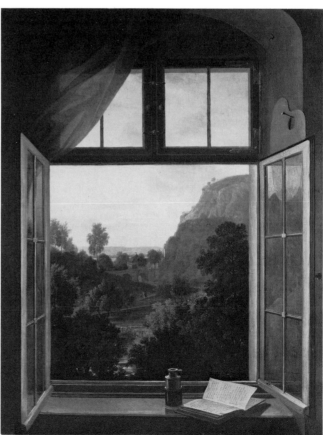

arrived in Dresden in 1808. Before this, he had spent three years at the Copenhagen Academy, where he was awarded a silver medal for his draughtsmanship. Kersting's skill in figure drawing may well have encouraged Friedrich to give more prominence to people in his own pictures. Kersting is reputed to have provided the figures for a number of Friedrich's paintings during the first years of their acquaintance—notably the figures in the *Morning in the Riesengebirge*,[7] the outcome of their journey to the Riesengebirge together in 1810. It was also on this journey that Kersting made a drawing of both of them viewed closely from behind looking into the distance. Friedrich had already used this motif on a small scale in a number of works, including *Monk by the Sea* (Plate X). But he did not use it in a prominent manner until after 1815.

Kersting's avoidance of symbolic landscape was not due to any ignorance of its conventions. Just after the Wars of Liberation he had made a brief excursion into the genre with *On Sentry Duty* (Plate 5) and the *Wreath Binder* (1814, Nationalgalerie, Berlin (West)). These were mementoes of his own service as a freedom fighter in the lützower Jägers. The portrait of his three fallen friends and the symbolic figure of the girl binding wreaths are both set in oak woods, images of Germanic endurance. He was using a similar vocabulary to that in Friedrich's *Chasseur* (Plate 61), and he was working against type. There is more charm than tragedy in these little scenes; and although set in the open they have the quality of interiors. The meticulously delineated trees close around the figures like the walls of a room, affording no more of a view of the lighter distance than might be glimpsed through an open door or window.

Kersting was dependent upon seventeenth-century Dutch genre paintings for his characteristic portrayals of figures in interiors. But he endowed these with a sense of personality and situation that was completely of his own age. His paintings of Friedrich are remarkable for the acuity with which they record the ambience of their subject. The one that shows him standing back from his picture in a meditative pose (Plate 40) has a pervasive sense of silence and introspection. The corner view of the room has an informality of design that is rare in Friedrich's own work. But it shares with these a similar care for illumination and geometrics. Bereft of all but the bare requirements of his craft, the artist gazes onto his canvas, which makes a dark silhouette against the light of the window, the climax of a carefully balanced arrangement of shapes and shadows. Working with Friedrich as a model brought out Kersting's deepest sense of organization. Yet when he turned in the same period to paint a quite different artist friend, the portrait and history painter von Kügelgen (1811, Private Collection, Berlin), his manner relaxed to capture the paraphernalia and bustle of that man's studio. The viewpoint expands to encompass the casts, pots, firearms, lyre, secretaire and stacks of half-finished portraits that lie around. Even Kügelgen is represented more genially as he works away, his head tilted to one side, with his foot resting casually against the rung of his easel.

Though Kersting was never an imitator of Friedrich, his contact with him sharpened his precision and attentiveness, giving his interiors their peculiar expectancy. Nor did his art develop in any significant new direction after he left Dresden to become a drawing master in Poland in 1814. In 1818 he returned to settle in Meissen as superintendent of the drawing department of the porcelain factory. The appointment—which led him to supervise, amongst other things, an elaborate and garish crockery set presented to the Duke of Wellington[8]—hardly encouraged him to maintain a sense of economy and purity in his art. Many of his later interiors are tinged with the more sentimental side of Biedermeier taste. Yet a consummate late work, *Before the Mirror* (Plate XXI), shows him capturing the charm of his bourgeois world with all his former refinement. The motif of a young girl absorbed in dressing her hair before an open window reminds one that Kersting would have known well the Vermeer *Woman Reading a Letter before an Open*

XXI. Georg Friedrich Kersting: *Before the Mirror*. 1827. Oil (46 × 35 cm). Kunsthalle, Kiel.

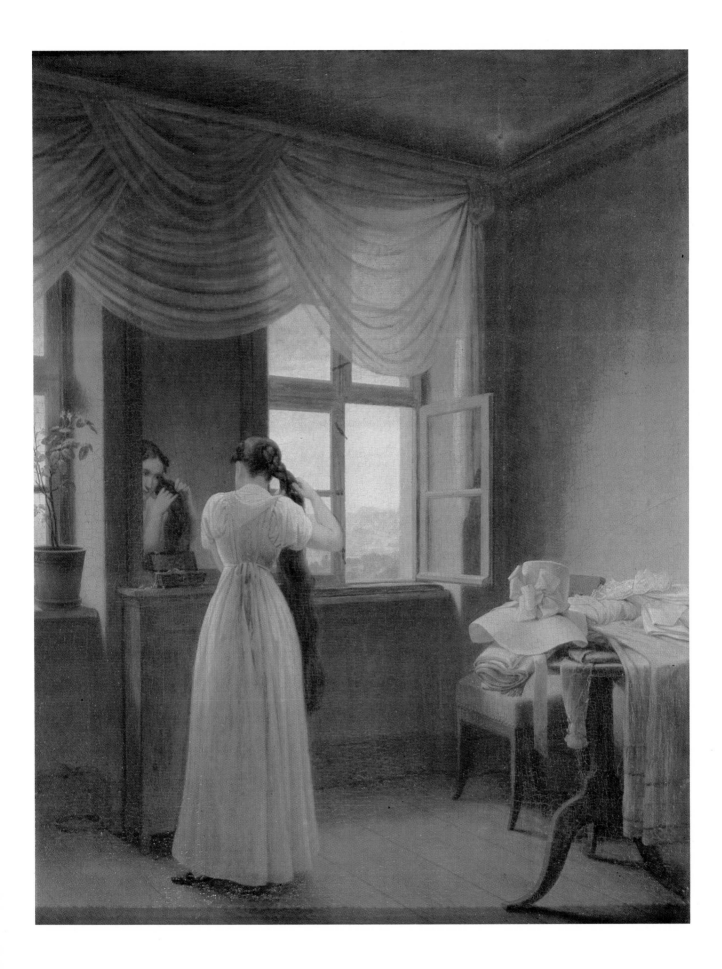

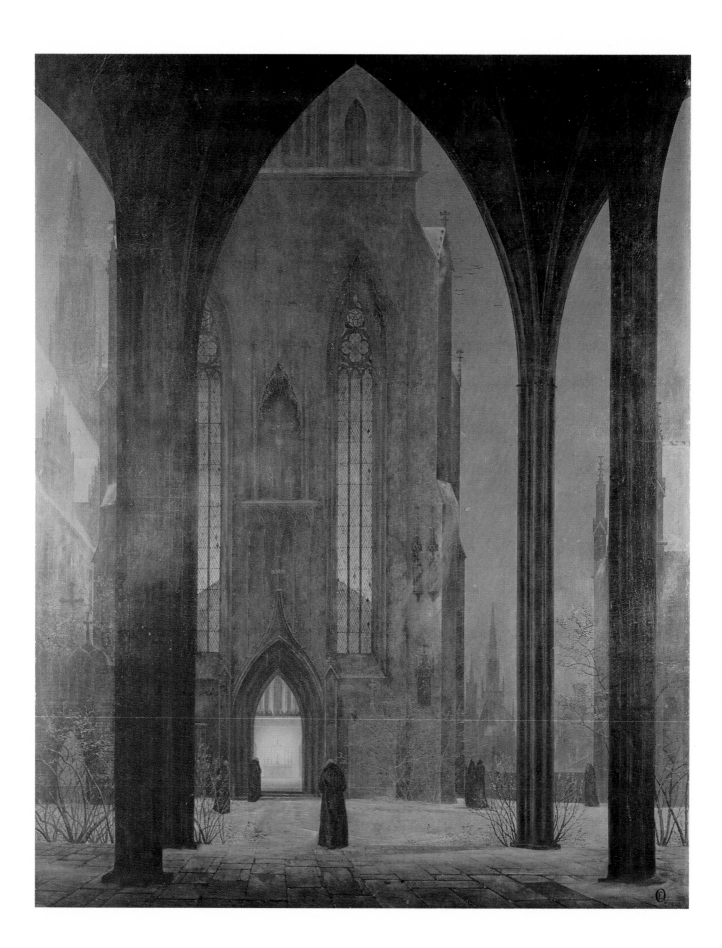

Window in the Dresden Gallery.[9] There is a similar control of the light falling from the window and use of reflections to heighten our sense of intrusion (one feels that the girl in her underskirt might catch sight of us at any moment in the mirror that reveals her face). However, while Vermeer focusses upon a single action, without feeling the need to explain the import of the letter the woman is reading, Kersting prefers to fill his scene with hints of narrative. Beside the girl at her morning toilet are the outdoor cloths she will wear out into the fields seen through the window. It is this sense of the humane that is the kernel of Kersting's art. His figures are usually single—there are never more than two—and usually, like Friedrich's, viewed from the back. Unlike Friedrich's, however, they are not engrossed in contemplation but in some mundane or social activity. They do not direct us towards the infinite, but allow us to creep up upon their private world.

Both Kaaz and Kersting had come to know of Friedrich before his *Cross in the Mountains* and *Monk by the Sea* had gained him a reputation as a painter of spiritually symbolic landscapes. In later years, all but a few close friends like Dahl associated this imagery predominantly with his art alone. When the Weimar Friends of Art turned against him in the famous article 'Neudeutsche religiös–patriotische Kunst' in 1817 and designated him 'still the only one who attempts to impose a mystical–religious significance on landscape painting and drawing',[10] they were either speaking from ignorance or indulging in wishful thinking. By that time he had imitators throughout Germany. The Wars of Liberation had made such work topical and emphasized the patriotic nature of Northern imagery. It is not surprising, therefore, to find that it was in the north of Germany that Friedrich's impact survived the longest. Apart from Dresden itself, it was in Prussia and the Prussian-dominated states of Pomerania and Westphalia that the Northern landscape continued to have currency up to the middle of the century.

In Dresden Friedrich's closest associate was Dahl,[11] but his imagery was most assiduously emulated by Carl Gustav Carus (1789–1869). Carus's involvement with landscape painting was only a partial one. He was first and foremost a doctor who had a distinguished career both in his professional practice and as a scientist. Coming to Dresden in 1814, after having trained and lectured at Leipzig University, he eventually rose to the position of personal doctor to the King of Saxony in 1827. His scientific studies accorded well with the Romantics' interest in organic growth and change, for he was an expert in comparative anatomy and the nervous system. It was his researches in these areas that attracted the attention of Goethe, whom he met in 1821.

The contact with Goethe was to be as influential to his attitude to landscape as it was to his scientific thought. He followed Goethe in attempting to establish an objective basis for understanding the changing flux of existence and saw landscape painting as a means of demonstrating 'that there is nothing lawless, insignificant, or accidental in the drift of clouds, the shape of mountains, the anatomy of trees and the motion of waves, but that there lives in all of them a significance and eternal meaning'.[12]

It was really this interest in the establishment of laws that separates his approach from the empathetic method of Friedrich, even if he did become fascinated by the effects achieved in the latter's work. Before he met Friedrich in 1818 Carus had already developed a certain expertise in landscape painting. He had studied first under Julius Dietz in Leipzig and then under Johann Christian Klengel in Dresden. Both of these masters belonged to the generation that had sought to revitalize landscape by returning to the example of the Dutch, and Carus himself found his own best work from this period, the *Spring Landscape in Rosenthal near Leipzig* (1814, Gemäldegalerie, Dresden), to be reminiscent of the 'old pure pictures of the Netherlandish school'.[13]

The meeting with Friedrich certainly extended the range of Carus's art, but at the same time it submerged something individual within himself. The strength of Friedrich's

XXII. Ernst Ferdinand Oehme: *Cathedral in Winter*. 1821. Oil (127 × 100 cm). Staatliche Kunstsammlungen, Gemäldegalerie Neue Meister, Dresden.

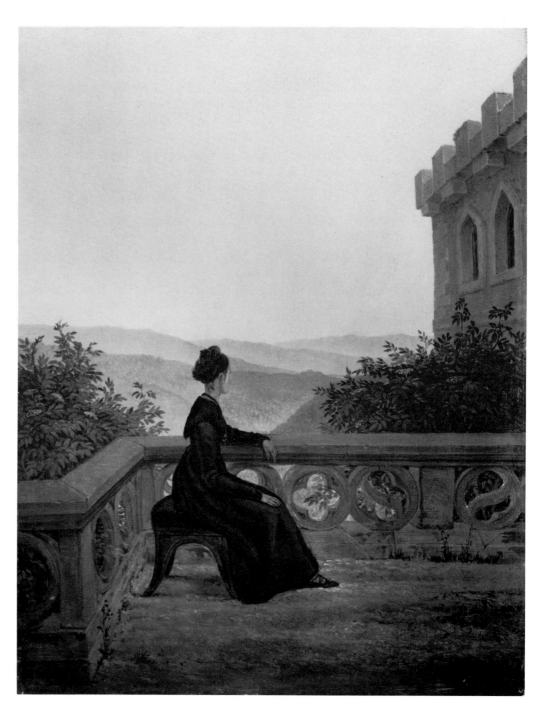

87. Carl Gustav Carus: *Woman on the Terrace*. 1824. Oil (42 × 33 cm). Staatliche Kunstsammlungen, Gemäldegalerie Neue Meister, Dresden.

artistic personality overwhelmed him with a type of landscape that he could only emulate in terms of themes and effects. In 1819 he dutifully made a trip to the Pomeranian coastlands, noting the bleak forms and local legends that he felt to be the source of Friedrich's inspiration. He was to make similar trips to the Riesengebirge and other haunts of Friedrich. Yet the paintings in which he emulated Friedrich's extremes are his least successful. It is only in his smaller and more intimate works, such as the *Woman on the Terrace* (Plate 87), that his talents do not overstep their limitations. Carus was more at home with the gentler emotions. The familiar contemplative figure of Friedrich's art is softened here by the asymmetry of her setting, and by the conventional spatial recession. Despite Carus's interest in capturing the 'concentration of the effect of light' found in Friedrich's work, he avoids the direct confrontation of light and dark of Friedrich's *Moonrise over the Sea* (Plate 73) or *Woman in the Morning Sun* (Plate 67). There is no drama of

the spiritual and material in *Woman on the Terrace*, simply the soulful charm of evening.

Carus's mentality was, above all, receptive and synthetic. This can be seen in the *Nine Letters on Landscape Painting* he wrote between 1815 and 1824 and published in 1831, in which he brought together the *Naturphilosophie* of Schelling, the meditative outlook of Friedrich, and Goethe's search for the laws that govern the flux of natural events. As Dr Goldschmidt showed nearly half a century ago,[14] the emphasis shifts towards the last of these after letter six, which was written after he had made personal contact with Goethe in 1822. In the earlier letters the contemplation of nature is seen as a mystical act of submerging the self in the universal: 'and you lose yourself in limitless space, your whole being experiences a calm purification and refinement, your Self vanishes, you are nothing. God is everything.'[15]

But in the end he moved away from Schelling's and Friedrich's view of the aesthetic experience as a form of spiritual awareness to the point of making a clear distinction between the spectator's emotive reaction to the landscape and the 'mighty spirit of nature' which dwells in all its forms. The optimistic tone of his earlier subjective delight in nature—so different from the fatalism of Friedrich—now becomes the objective standard. Like Richter he believed in a pure and beneficial 'language of nature'. Landscape painting becomes for him a form of enquiry into the workings of nature. It is for this reason that he devised the term 'earth-life painting' to describe it. By this time the first stage, the sheer joy intimated above, was seen as the 'naïve' approach; the second stage, that of Goethe, involved the synthesis of this delight with scientific knowledge in order to achieve a 'deeper insight'. This synthesis could be seen in Goethe's poems on clouds that made use of the classifications of the English meteorologist Luke Howard. Observation and intuition are combined in these to make art 'the highest form of science'.

An informed approach to nature turned the moods awakened in the spectator into no more than an initial impulse that had then to be confirmed and extended through knowledge. Carus still maintained conventional analogies. He compared, for example, the sky with the infinite. But he also wished to experiment with 'mixed sensations' by portraying 'contradictions'. One 'contradiction' he suggested was that of an opening bud with frost upon it. Neither was there need for him to limit his repertoire to the spiritual imagery of Friedrich. In later life, especially after his visit to Italy in 1828, he turned to the great masters of the past, to Claude, Ruysdael and Rosa, whom he felt had 'absorbed the unimpaired experience of the great life of nature' in its lyrical and dramatic moods.

In such rationalizations Carus is really trying to have it both ways. He wishes to retain the Romantic intuition of feeling but seeks to align this with the standardization of conventions of description. He overlooked the need for a landscape painter of mood to forge his own language to convey his unique, deeply felt experience. His Rosa-esque attempt at the terrifying, *Leafless Oaks in a Storm* (Plate 88), is not so much a record of a feeling, as an illustration of an idea; and a comic one at that. One feels that Moritz von Schwind must have had a similar description of 'earth-life' in mind when he drew his cartoon *Organic Life in Nature* (Plate 89) for the satirical magazine *Fliegende Blätter*.

Despite being made a professor in 1824, Friedrich was never offered a teaching post at the Academy. His activities as an instructor were therefore restricted to a few private students, none of whom, with the exception of the short-lived August Heinrich (1794–1822), appears to have had any marked talent.[16] Indeed, the first to be recorded, Karl Wilhelm Lieber, was dismissed by the master in 1812 for having made an incompetent copy of his *Winter Landscape* (Schloss Cappenberg, Dortmund).[17] During the 1820s, however, a number of Dresden Academy students who were nominally pupils of Dahl were inspired by the example of Friedrich. The most significant of these were Carl Julius Leypold (1806–74)—whose work was, until the recent research of Professor

Sumowski,[18] almost entirely confused with that of Friedrich—and the more independent-minded Ernst Ferdinand Oehme (1797–1855). Described by his friend Adrian Ludwig Richter as a 'night bird who was happiest flitting to and fro at dusk and at night',[19] Oehme seems to have shared something of Friedrich's personal disposition. His *Cathedral in Winter* (Plate XXII) was painted at the time of their closest contact, a year before Oehme went to study in Rome on a grant from the Saxon Crown Prince. Its Gothic revival imagery is close in feeling to that of pictures from Friedrich's 'architectural' period such as the now destroyed *Monastery Graveyard* (1819, formerly National Gallery, Berlin). However, Oehme goes one step further than Friedrich in his medievalism by envisaging the cathedral not as a ruin but as an intact, thriving centre. Through its open door can be seen a glittering altar, the source of light to which the shadowy monks are drifting, like phantoms. But the most striking feature of this work is the way in which it shows an understanding of Friedrich's radical use of spatial relationships to create a compelling image. There is a sophisticated interplay of real and imagined space in the darkened silhouette of the framing arches. The slightly off-centre perspective view provides an intriguing pattern of intervals around the symmetrically placed central opening. Against this, the buildings in the middle-ground, more faintly seen through mist and snow, become a series of delicate facetings that rise beyond the picture's limits. It re-forms the fundamental properties of architecture in terms of painting as Friedrich did those of landscape. Such a vivid feeling for the transcendent geometrics of the Gothic was not matched until Lyonel Feininger's abstractions from medieval buildings in this century.

Oehme's Roman experiences did not encourage this direction in his art. Even the Nazarene Schnorr felt that Oehme had made a mistake to come to Italy. He felt that 'Germanic nature corresponds more to his [Oehme's] mode of feeling than the Italian, and that for this reason he would be better off and have more confidence in his art if he were in his native country'.[20] Like so many other young German landscape painters in Rome at that time Oehme fell prey to the muscular stylization of Koch's 'heroic landscape', and his later works oscillate between a lifeless hard-edged archaism and wistful reminders of his earlier enthusiasm.

Outside Dresden, Friedrich's impact was strongest in Berlin, where he had achieved considerable success with his exhibition of the *Monk by the Sea* and *Abbey in the Oakwoods* in 1810. Here his work was responded to by an artist of major talent, Karl Friedrich Schinkel (1781–1841), who had made his intentions as a landscape painter clear through his one-man exhibition of 1809. Schinkel was first and foremost an architect. He had been trained in the radical classicism of his tragically short-lived master Friedrich Gilly. He was to become in 1815, after the Napoleonic Wars, the overseer of all Prussian building projects. From this position he was effectively to redesign Berlin (Plate 103) and also establish his own sparse and superbly logical style as part of the tradition of Prussian architecture. Around 1810, however, the economic and political setbacks of the state were obliging him to employ his talents in other directions.

Schinkel's interest in landscape had been seriously awakened during his years in Rome from 1803 to 1805, when he had thrilled to the grandeur of the scenery of southern Italy. Back in Berlin he became a painter of landscapes of sentiment. His concern to depict moods was so great that he wrote in 1810 beneath a lithograph of a church half concealed by a massive leafy tree: 'attempt to express the delightful yearning melancholy that fills the heart at the sound of church bells ringing for divine service'.[21]

Although there is no mention of Friedrich in the voluminous papers of Schinkel's *Nachlass*, he would have been well aware of the two paintings in the 1810 exhibition, especially after they had been acquired by his own Royal employers. Like Oehme he responded above all to the Gothicism in Friedrich. During the period of the Wars of

88. Carl Gustav Carus: *Leafless Oaks in a Storm*. After 1851. Chalk (58.1 × 79.4 cm). Staatliche Kunstsammlungen, Kupferstichkabinett, Dresden.

89. * Moritz von Schwind: *Organic Life in Nature*. Wood-engraving from *Fliegende Blätter*, 1847–8.

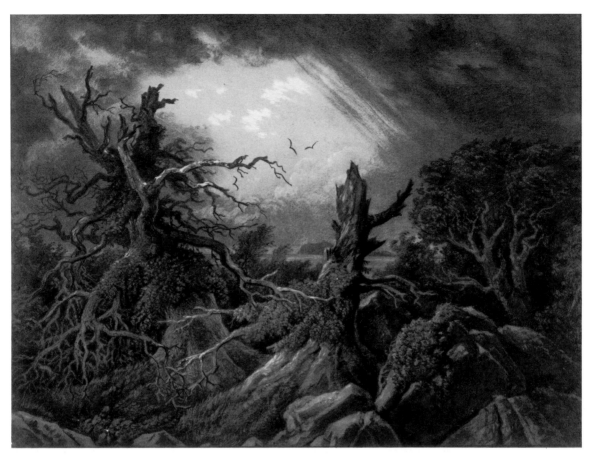

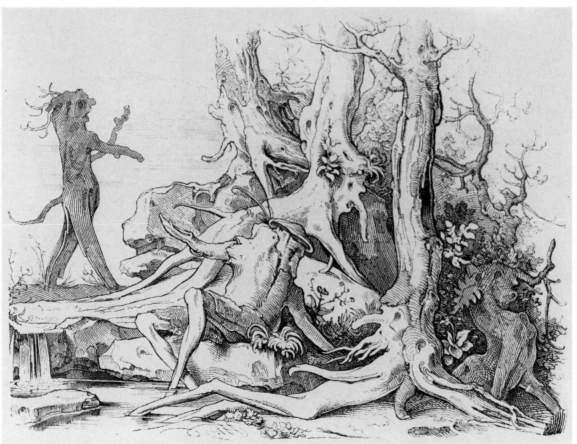

Liberation, Gothic was much in vogue in Berlin on account of its national associations, and Schinkel made many designs for buildings and monuments in the style including in 1810 a mausoleum to Queen Luise.

It was the use of Gothic as a symbol of national regeneration that emerges in the *Gothic Cathedral by a River* (Plate 90) exhibited in 1814. The mood of this picture is far removed from the sparse concentration of the *Abbey in the Oakwoods*. The frankly anecdotal interest in the life of the city—the minuscule bustle beneath the awe-inspiring but protective ancient edifice—contrasts strongly with Friedrich's use of detail to focus attention on the main event. Yet the dominating darkened central image of Schinkel's picture and his overall control of illumination show how much he had learned from the Dresden artist's work. It should be added, however, that this style was only employed by Schinkel when painting *altdeutsch* pictures. He was equally skilled at depicting Italian scenes in a classical mode. In both cases his views were used as earthly paradigms rather than as spiritual metaphors—a reflection, no doubt, of his practical preoccupations as an architect.

As also benefited an architect, Schinkel was more adept than Friedrich in handling perspectival complexities. It may be the case—as Eimer has suggested[22]—that Schinkel's novel application of Friedrich's architectural motifs encouraged the latter artist to augment the spatial dimensions of his own work. Ironically Friedrich's architectural ventures, such as the designs for Marienkirche, Stralsund, would have been vetted by Schinkel in his official capacity of overseer of all public buildings erected in Prussian territories.

It was not only his architectural expertise that accounts for Schinkel's sophisticated achievement of spatial effects. Since 1806 he had also been working as a scene painter. At first he painted dioramas, but after 1815 he was employed as a designer by the Berlin Royal Theatre. In this capacity Schinkel experimented with that interrelationship of the arts that so fascinated Romantic theorists. His exhibition of 1809 was staged to the accompaniment of music. He was also to take part in a remarkable competition of the arts when he designed a picture (Plate XXVIII) around a theme at the same time as the poet Brentano was creating a story out of it. This interest in the association of pictorial scenery with music and poetry was most fully engaged in his designs for opera, which set a new illusionistic standard in stage production. For Mozart's *Magic Flute* he conceived a series of designs in 1815 that seem a perfect accompaniment to the opera's arcane intentions. The stupendous symmetry of the *Hall of Stars of the Queen of the Night* (Plate 91) is the most remarkable of these. As with his *altdeutsch* landscapes, these designs had a more topical aim as well. *The Magic Flute* was performed on 16 January 1816 as a celebration of the coronation and peace festival. In this context the masonic fairy-tale of Mozart became an affirmation of the Prussian state's triumph over the tribulations of the Napoleonic period.

Schinkel's skilful but pragmatic adaptation of the conventions of the Northern landscape for rhetorical and theatrical purposes was to prove a serious problem for one of his protégés, Carl Blechen (1798–1840). Blechen, too, had a consummate gift for the painting of dramatic effects which he fully exploited in his work as a scene painter at the Königstadt theatre in Berlin from 1824 to 1827. In these years he gained a reputation for the fantastic and bizarre. 'Churches, cloisters, hermits, ghosts, magic' is how Goethe characterized his work. He was frequently compared in spirit to the writer E. T. A. Hoffmann. Yet Blechen was at the same time attempting to establish himself as a serious landscape painter. In the end he felt obliged to break away from the romantic imagery he could handle with such fluency, destroying its emotive impact by the use of parody— much the same way that the poet Heinrich Heine did in his lyrics.

While still working as a scene painter Blechen exhibited the *Rocky Gorge in Winter*

90. Carl Friedrich Schinkel: *Gothic Cathedral by a River.* 1813–14. Oil (77 × 107 cm). Nationalgalerie, Berlin (West).

91. * Carl Friedrich Schinkel: *The Hall of Stars of the Queen of the Night.* 1815. Engraving after design for *The Magic Flute.*

(Plate 92), which shows how thoroughly he had absorbed the conventions of Romantic landscape. We may not agree with the reviewer in the *Kunstblatt* who found the work virtually indistinguishable from a Friedrich,[23] but the source of the macabre foreground silhouette, wasted background and transforming illumination are clear enough. Blechen has also taken pains to make the lines of the gorge follow those of the bare tree branches. This reinforces the way they seem to bar the path that leads past the statue of the Virgin to the just discernible lights of the mountain refuge. As with Schinkel, there is a too knowing use of effect, a too conspicuous artifice in the stagey light, the spookey shape of the tree, or the mincing pose of the Virgin who seems on the point of moving towards us. As a game it is superb, but there is too little faith in it to make it a very serious one.

Blechen's paintings of the 1820s mark the demise of the Northern landscape as a serious form, but it was to survive on a more popular level for many decades. In the outlying regions of Pomerania, painters like Gottlieb Giese continued to exhibit works closely related to Friedrich's imagery. It was in the newly reformed popularist academy at Düsseldorf, however, that such scenes were produced effectively.

Karl Friedrich Lessing (1808–80), originally an architectural student of Schinkel, trained as a painter at the Berlin Academy until 1826, when he followed his master

XXIII. (facing page) Carl Blechen: *Gallows Hill*. *c.* 1833. Oil (29.5 × 46 cm). Staatliche Kunstsammlungen, Gemäldegalerie Neue Meister, Dresden.

92. Karl Blechen: *Rocky Gorge in Winter*. 1825. Oil (98 × 127). Nationalgalerie, Berlin (West).

93. Karl Friedrich Lessing:
Cloister in the Snow. c. 1829.
Oil (61 × 75 cm). Wallraff-
Richartz-Museum, Cologne.

XXIV. (left) Carl Blechen:
View over Roofs and Gardens.
c. 1828 (?). Oil (20 × 26 cm).
Nationalgalerie, Berlin
(West).

Wilhelm Schadow to Düsseldorf, where the latter had just been appointed director of the
Academy. Despite Lessing's removal from Berlin, his *Cloister in the Snow* (Plate 93)
contained, as Goethe observed, 'the whole romanticizing stage-like ambience of
Blechen'.[24] To Goethe this picture, like all 'Romantic' pictures, was reprehensible for its
unhealthy indulgence in melancholy and adversity. Worse still, it pointed to the
consolations of the Catholic religion. One looks through the grey snow-clad cloister to the
richness of the funeral ceremony taking place in the chapel. Despite its imagery, however,
Lessing's picture is further away from any spiritual experience even than Blechen's. Its
staging is even more contrived, the excited brushwork of Blechen having given way to a
more sober illusionism. Lessing has been even more ingenious in his transformations: the
creeping branches of the fir, the magnificent grotesque of the ice-bound waterspout in the
foreground and the grieving carvings on either side of the door. The almost photographic
realism for which the Düsseldorf painters became so popular is on the point of asserting
itself. If Blechen led the way from Romantic landscape painting towards naturalism,
Lessing was to usher it back into the conventions of academic painting.

CHAPTER VII # Naturalism and the Naïve

THE LANDSCAPE PAINTERS mentioned in the previous chapter responded to the imagery of Friedrich in different ways. But they all remained attached to the idea of landscape conveying a meaning, whether this was pantheistic, educational, political or—as was frequently the case—all three together. Such concerns were completely consistent with the close study of natural effects. Indeed, the emphasis on the North encouraged a revaluation of local German scenery, while the Romantic interest in growth and change stimulated a scrutiny of the more transient manifestations of light and atmospherics. As has already been seen, Friedrich himself provided an important focus for these developments. However, it was his close friend Dahl who was to take the observation of nature to the point where it seemed to have a self-sufficient interest.

'In his conception of landscape', wrote Carus of Dahl, 'he was a pure naturalist, seizing on the details of rocks and trees and plants and meadows with quite extraordinary mastery; working with amazing facility, but leaving much to chance, he often seemed to surrender himself too much to the objective.' The final comment is a reminder that Carus, for all his scientific approach, could not condone a type of art that ignored the spiritual side of 'earth-life'. Writing in 1865, he was well aware of the kind of painting that had resulted from the practice of 'leaving too much to chance'. In many ways he was justified in associating Dahl with this, for it does indeed seem a short step from his sky studies made in Dresden in the early 1820s (Plate 95) to the uncharged naturalism of Menzel—such as the view from the artist's window overlooking the garden of Prince Albrecht's palace in Berlin in 1846 (Plate 110). Furthermore, a direct link can be made between the two through the intermediary of the artist Carl Blechen.

It would be misleading, however, to suggest that the move towards naturalism in Germany can be summed up in so straightforward a manner. While this chapter follows the mainstream from Dresden in the 1820s to Berlin in the 1840s, it must also indicate something of the intricacies of the situation elsewhere. The very character of such painting encouraged the proliferation of independent local schools and there are few major cultural centres in central Europe that do not boast some artist who set out to record his native scenery in a pure and unaffected manner in the early nineteenth century.

To make generalizations in the face of so many different manifestations is a risky business, but two divergent tendencies are noticeable within this burgeoning naturalism. On the one hand there is the painterly exploration of effect by artists like Dahl to suggest life and movement—a development out of the interest in the 'spirit of nature'. On the other there is the meticulous, hard-edge recording of detail. This tendency can be related to a traditional provincialism. But it too had received a new impetus through Romanticism, in this case by way of the adulation of the primitive. It was an admiration for 'honest' naïvety that directed the attention of the Nazarenes to pre-Raphaelesque art, whereas Pforr wrote 'no virtuoso brush work, no bold handling was to be seen; everything presented itself simply, like something grown rather than painted'.[1] The outcome of this

94. Ferdinand von Rayski: *View of Castle Bieberstein.* c. 1849. Oil (209 × 167 cm). Staatliche Museen, National-Galerie, Berlin (East).

95. Johan Christian Clausen Dahl: *Evening*. 1823. Oil (16 × 21 cm). National Gallery, Oslo.

interest can be seen in the carefully wrought local views of Ferdinand Olivier (Plate 122) or in the figure studies of Friedrich Overbeck (Plate 12).

It is often hard to distinguish between such assumed innocence and the real thing; especially during the Biedermeier period, when the latter became complicated by a consciousness of its own charm. There are few, for example, who would care to say whether the naïveties of Friedrich Wasmann (Plate 101)—who had worked in Rome with Overbeck, but who spent most of his life painting portraits of the dignitaries of a small Tirolese farming town—were the outcome of a stylish primitivism or a simple lack of guile. Nor is the situation clarified by the fact that Wasmann was also in the habit of making outdoor studies in a spontaneous, painterly manner. In view of such interminglings of the natural and the naïve it seems preferable to review the artists involved in terms of locality rather than of method.

From the moment he exhibited a *Large Norwegian Mountain Landscape* at the Academy in 1819, the year of his arrival in Dresden, the Norwegian painter Johann Christian Clausen Dahl (1788–1857) became notorious amongst the artists there for his uncompromising realism. In his reminiscences Adrian Ludwig Richter vividly recalled the turmoil and dissent: 'The older professors smiled openly over this heresy or folly. The younger, however, marvelled at it and imitated it as best they could. The breath of the spring of a new time began to be felt.'[2]

At the time of his arrival in the Saxon capital Dahl was already over thirty and had been thoroughly trained. After a seven year apprenticeship to a decorative painter he had spent a further seven—from 1811 to 1818—at the Copenhagen Academy. Here he was first schooled (as Friedrich had been before him) in a declamatory, 'sublime' form of Nordic landscape by C. A. Lorentzen. A more profound influence on him, however, were the Norwegian landscapes of the Dutch seventeenth-century artist Everdingen that he first saw in the Danish capital. While these pictures gave him a lasting penchant for bold effects, his keen observation was encouraged more by his second master, the pioneer of

Danish naturalism, C. W. Eckersberg. It appears to have been Eckersberg who introduced Dahl to the habit of making *plein air* oil sketches—a habit the Danish artist had acquired during his years of study in Paris and Rome. Eckersberg's own oil sketches have a similar aerial clarity and fineness of tonal balance to those of the French classicists like Valenciennes. Dahl, on the other hand, adapted this direct method to the recording of more robust atmospheric effects.

Dahl's vigorous but clear-sighted manner was already formed before he arrived in Dresden. But he found considerable encouragement to pursue this direction further in the milieu he encountered there. One of his earliest acquaintances was Carus, who was then engaged in the composition of his *Nine Letters on Landscape Painting*. Possibly Dahl was already aware through Carus of Goethe's interest in the cloud classifications of Luke Howard before he made his trip to Italy in 1820–1. In any case, he made a number of sky studies while at Naples and returned to Dresden with his sense of atmospherics invigorated. His cloud studies made in Dresden from 1822 have remarkable similarities to those being made at the same time in England by Constable, and like the English master he insisted on the need for recording the meteorological phenomena of a locality if one were intending to paint it.[3]

Like Friedrich, Dahl profited from his Northern origins, building up a reputation for depictions of his native country. It was in the interests of authenticity that he returned to Norway five times between 1826 and 1850. His work is devoid of all religious symbolism, but he shared the pantheistic inclinations of other Dresden artists sufficiently to give his Norwegian scenes the stormy or overcast effects popularly associated with the elemental.

Dahl can be compared in many ways to Constable—particularly in his atmospheric studies and his devotion to local scenery. However, it is perhaps unwise to take this comparison too far. This is not because Dahl still saw landscape in terms of recording moods and impressions—for Constable did the same. It is rather because Dahl stopped short of Constable in the extent of his enquiry. His sky paintings—especially those in which the land has been reduced to a thin edging and some tree tops (Plate 95)—are close in format to those of the English master. Yet they do not have the same degree of bravura. He does not take his analysis of light or experimentation with markings to the point where they disrupt the surface pattern. Nor is there any evidence that his large finished pictures posed for him the problem felt so keenly by Constable: the problem of combining a myriad of individual perceptions into a whole. They do not have that unique tension of design and impression peculiar to such paintings as the *Haywain*. Instead he was frequently prepared simply to rework old formulae in his livelier manner. This is the procedure that he adopted, for example, in his night scene of Dresden (Plate 96), which is closely based in composition on a view from the same spot by the eighteenth-century topographer Bellotto.[4]

Dahl's pictures remain, essentially, landscapes of sentiment; and they are supreme achievements in the genre. His relative conventionality was not due to any limitations of understanding, but rather to a deep respect for the poetic tradition. He himself built up a fine collection of pictures that formed the basis of the National Gallery in Oslo after his death. A genial and sympathetic man, he remained faithful to Friedrich throughout his life, and was able to appreciate the validity of an approach that took intuition far beyond his own limits. It was such sympathy, too, that made him one of the most sought-after and influential of the teachers at the Academy after his election to a professorship there in 1824. Yet none of his gifted Dresden followers—like Oehme, Leypold or Georg Heinrich Crola (1804–79)—pursued his naturalism further. Instead they reverted to that lyricism most pervasively represented in Dresden landscape painting by their contemporary Adrian Ludwig Richter. It was left to another contemporary, the amateur Ferdinand von

Rayski (1806–90), a professional soldier who studied for a time from 1823 at the Dresden Academy and lived in the city for most of his life, to preserve a standard of freshness and directness. He is perhaps best remembered now for his lively portraits, but his curious *View of Castle Bieberstein* (Plate 94) has a haunting contemporaneity that seems to derive from the slightly naïve harshness of the morning light. However, Rayski had few admirers, and had been forgotten even before he gave up painting in the 1870s. His art was far removed from the taste of Dresden society.

Like Dresden, Munich had become a thriving cultural centre during the Baroque period. However, it was in the early nineteenth century that the city reached the height of its fame. A cardinal factor in this was the elevation of the Duchy of Bavaria into a Kingdom by Napoleon. The new King Maximilian I's endeavours to redesign his capital in accordance with its new status were continued by his son Ludwig I with such success that by the 1830s the city was gaining the epithet, the 'Art City of Europe'. This phenomenon was most intimately associated with the revivalist art that will be discussed in Chapters VIII and X. Its implications for landscape painting were by and large negative. Not only did the predominant revivalist outlook in Munich favour a development of archaic and classical landscape painting—the kind that looked to the prototypes of the seventeenth century and took as its contemporary model the Poussinesque 'heroic' art of Joseph Anton Koch. It also assured that landscape painting should be regarded in official circles in terms of the traditional hierarchy of the genres. According to this it was one of the minor art forms. One result of this outlook was that the dominant revivalist artist of Ludwig's early years, the Nazarene Peter von Cornelius, managed to suppress the professorship of landscape painting at the Academy in 1826.[5]

Despite these unfavourable circumstances, many landscape painters became involved

in the increasing patronage that attended Munich's rise in status. The painter who was deprived of the professorship of landscape painting in 1826, Wilhelm von Kobell (1766–1853), had come from Mannheim to Munich when his patron, Kurfurst Karl Theodor, moved his court there in 1792. Trained by his father, who had also been a court painter at Mannheim, Kobell was part of a tradition of artist–craftsmen, skilled in accurate and unpretentious view painting. In Munich this aspect of his art became sharpened under the impact of neoclassical taste, while his sense of accurate observation was heightened through his knowledge of the engravings of the English *animalier* George Stubbs. His own art was entirely devoted to the depiction of what he saw: to local views, animals, genre scenes, and informal portraits of friends and family in domestic interiors. The pictures of his immediate circle often reveal a shrewd sense of individual character. But his other works are virtually without emotion. The figures are shown engaged in mundane activities, performing some daily chore or chatting by the roadside. Yet for all this they are organized with a remarkable rigour that endows these incidental moments with a timeless monumentality. Clearly painted, with bright colours and strong raking shadows, his figures and animals seem to be acting out their roles according to the dictates of some concealed rectilinear grid. No doubt, like his idol Stubbs, his forms were captured in this manner so that his fascination with accurate detail could be indulged to the full. The flat plains and sharply rising mountains of Bavaria, the anatomy of animals, local fauna, and the distinctions of local peasant costumes, are all described with biting precision. This sense of clarity and organization gives his rustic genre scenes a curious prescience. It also enabled him to make a remarkable contribution to monumental painting when the opportunity arose in 1807. To celebrate the alliance between Bavaria and Napoleonic France that had brought so much good fortune to the ruling Wittelsbach dynasty, Kobell was commissioned by Maximilian I to paint a series of views of the successful battles of the two armies. This cycle—which amounted to twelve large canvasses—was Kobell's major occupation from 1808 to 1815. He took immense pains to record the events with the greatest possible accuracy. He also saw them as a series of formal compositional problems. These gradually evolve—as Professor Wichmann has shown[6]—from scenes dominated by a foreground of commanding officers, such as the *Siege of Kosel* (Plate 97) of 1808, to ones in which a close and a distant engagement are brought into a unified balance, as in the *Battle of Bar-sur-Aube* of 1815 (Bayerishe Staatsgemäldesammlungen, Munich). It is the first, the *Siege of Kosel*, that is the most striking. According to an inscription on the back, the action depicted here is the third sortie of the Prussians in the besieged Silesian stronghold of Kosel being driven back by French and Bavarian troops on 15 March 1806. The precision of this inscription is matched by the detail of the picture, which contains portraits of all the principal officers present. Yet nothing could be further from the contemporary conventions of battle painting. Although a few of the generals indicate the fighting to their comrades, this is obscured from us by the darkened tones of the middle-ground. Instead we are aware of a group of soldiers and horsemen calmly standing upon a hillock surmounted by bare trees; while the most affecting part of the picture is the beautiful, gemlike light of the rising sun, as it dispels the mists from the plain and floods the foreground, casting a grid of lanky diagonal shadows. Nothing but the freshness of this light and the budding state of the springtime trees indicates that what is being witnessed is a triumph. Yet there is no cynicism in so unheroic a presentation of a martial theme. It is instead a tribute to Kobell's overriding obsession for precision of effect.

Kobell's exacting manner was matched by that of many other landscape and genre painters in central Europe around the turn of the century, such as Agasse and Biedermann in Switzerland, Krafft in Vienna, and Juel in Copenhagen. Even in Munich

96. Johan Christian Clausen Dahl: *Dresden by Moonlight*. 1839. Oil (78 × 130 cm). Staatliche Kunstsammlungen, Gemäldegalerie Neue Meister, Dresden.

there was a kindred spirit in Lorenz Quaglio (1793–1869), who painted topographical views and genre scenes with a similar sharpness though with slightly more Biedermeier charm. Furthermore, his art seems to have been fully appreciated by the old King Maximilian, who was sufficiently enamoured of genre painting to buy the Scottish painter David Wilkie's *Reading the Will* in 1820. The situation changed when Ludwig acceded to the throne in 1825 and began to implement his patronage of high art on a more official level; Kobell's professorship did not survive the new reign by more than a year.

The liveliest Munich landscape painting of the period was unwittingly a consequence of the drive to turn Munich into an 'art city'. The inspector of the Hofgarten Gallery, Johann Georg von Dillis (1759–1841), the man who did more than anyone else to make the art collections of Munich the foremost in Germany, was also a painter of fresh, *plein air* oil sketches. It was the demands of his inspectorship (which he took on in 1790, and which involved him in the absorption of major collections from Mannheim and Düsseldorf into the Bavarian collection, as well as in frequent purchasing tours to Italy) that prevented him from using his sketches more extensively for finished pictures. In 1817, when accompanying the young Crown Prince Ludwig on a *Kunstreise* to Italy, he sadly noted in his diary: 'up till now I have often had to acknowledge with melancholy the sad thought that I will never be able to bring the vast assembled riches of my studies to fruition'.[7]

Dillis's studies (Plate 98) now seem the most fruitful part of his work. They have a striking freshness. By contrast his few finished oil paintings were completely within the moribund tradition of eighteenth-century classical landscape, with their conventional compositions and generalized morphology. His oil sketches can be related to the tradition

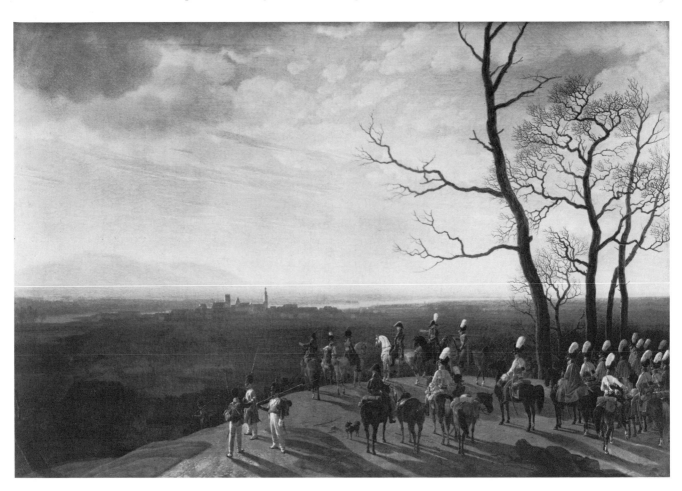

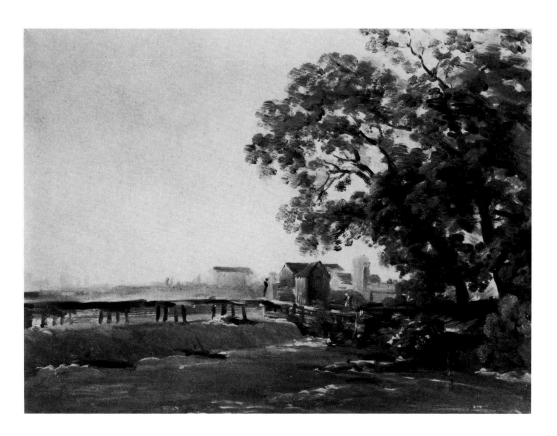

98. Johann Georg von Dillis: *The Isar Falls near Munich*. 1817. Oil (18.8 × 25.4 cm). Georg Schäfer Collection, Schweinfurt.

97. (left) Wilhelm von Kobell: *The Siege of Kosel*. 1807. Oil (207 × 302 cm). Neue Pinakothek, Munich.

of Roman landscape painters, and it is significant that the first ones date from his visit to Italy in 1794–5. In them one can see a remarkable spontaneity, a direct application of brush strokes over a uniform ground that describes both sky and ground primarily as reflectors of light. Details are captured as they glint in the sun amidst the atmospheric haze.

It was Carl Rottmann (1797–1850) who was to apply this painterly directness to finished landscapes in Munich. Born in Handschuheim, Rottmann had first been trained in nearby Heidelberg, where the English artist Georg Augustus Wallis had introduced a knowledge of the glazes and bravura of his native school during a stay there around 1812. This influence had given a new impetus to the art of Rottmann's father, and of his teacher, Christian Xeller. Wallis, while in Rome, had been an acquaintance of Koch and Schick, followers of Carstens, and he combined in his own works the painterliness of English art with the rigorous control of the heroic landscape. To these he added while in Heidelberg an interest in landscape as a form of narrative. This appears to have been stimulated by the Romantic writers Brentano and Achim von Arnim who were then living there.

Perhaps it was Rottmann's familiarity with such a synthesis that enabled him to withstand the direct influence of Koch's heroic paintings when he went to Munich in 1821. His own approach to classical landscape developed in a completely different direction. Like the Romantics he looked at the world of antiquity with fresh eyes, seeking there a more impassioned form of the elemental. The landscapes of his first Italian visit of 1826–7 were still relatively conventional, and it was their exhibition in Munich in 1828 that gained him the royal commission to paint a series of Italian landscapes for the Hofgarten Arcades. However, when he returned to Italy in 1829 to make studies for these, his understanding of the southern landscape became transformed. Perhaps he was affected by the exhibition that Turner held in Rome in the winter of 1828–9, for there subsequently appeared in his work a similar delight in broad panoramic effects and the use of hot vibrant colours.

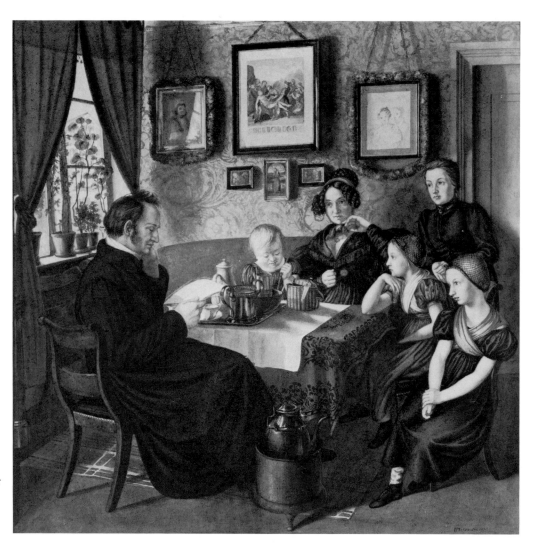

99. Carl Julius Milde: *Pastor Rautenberg and his Family*. 1833. Watercolour (44.7 × 45.1 cm). Kunsthalle, Hamburg.

In the murals he painted for Ludwig, however, such effects were judiciously tempered with the conventions and descriptive expertise of the topographer. They were approved of sufficiently for the King to commission Rottmann to paint a sequel to them. This was a series of classical scenes from Greece. Rottmann was in Greece in 1834 and it was here that his sense of the elemental reached its fullest expression, especially in the oil versions that he painted from his mural designs. He brought out above all the savageness of the scenes, the bright earth reds, the relentless sun and the solid blue of the sea. Rottmann was still enough of a classicist to relate these qualities to the sites of ancient settlements that formed the subject of his works. In *Aegina* (Plate 100), for example, the ruined temple of the island community that was eventually subjugated by their Athenian rivals appears on a promontory of pungent orange against the setting sun. One can see in the distant mainland, the darkened middle-ground, the framing tree to the right, and even in the observant deer in the slightly lightened foreground, the vestigial remains of the layout of a heroic landscape. But they are no more than vestigial remains. The spatial organization that they suggest is less evident than the prismatic juxtaposition of pure colours or the flat vertical division of the canvas between the lightness of the upper half and the shade of the lower. In both theme and handling, Rottmann moved from the classical notion of order to the rediscovery of those more instinctive elements in the ancient world that fascinated the Romantics, and later Nietzsche: the dionysiac and the maenadic.

Munich landscape painting was affected by the brightness and clearness of the local high plateau climate and by the close links between Bavaria and the classical worlds of

Italy and Greece (where a Wittelsbach became monarch in 1833). The landscape and genre painting of the northern states were modulated by very different local traditions. The close proximity of Düsseldorf to the Netherlands encouraged a particularly strong revival of the Dutch style in the Academy there, notably in the views of the low-lying north German countryside of Andreas Achenbach (1815–1910) and Johann Wilhelm Schirmer (1807–63), and the humorous domestic scenes (Plate 151) of Johann Peter Hasenclever (1810–53). Further north in Hamburg the Dutch influence was also prevalent—a legacy from the cultural links that had been forged between the north German coastlands and the Netherlands during the seventeenth century. However, there was no academy or other teaching institution in Hamburg with comparable authority to the one in Düsseldorf, and the painting there was altogether on a more provincial level. There was a frankness in Hamburg painting that could lead to remarkable results, as it did in the portraits of Runge. It can be found in the freshness of the landscapes of Hermann Kauffmann (1808–89) or the portraits of Carl Julius Milde (1803–75). The latter's interior scene of *Pastor Rautenberg and his Family* (Plate 99) shows the world of a poor member of the bourgeoisie without any sentimentality, the naïvely recorded detail according perfectly with the circumstances of the subjects. This directness remained even with those painters who left their native city to study elsewhere, like Victor Emil Janssen (1807–45) and Julius Oldach (1804–30). It even endured in the art of Rudolf Friedrich Wasmann (1805–86), the most gifted Hamburg artist of his generation. He settled in Meran in the Tyrol after having trained at Dresden (1825–8) and Munich (1829) and having spent three years in Italy (1832–5) where he became closely associated with Overbeck. The clearsightedness of his portrait of his sister (Kunsthalle, Hamburg), painted in 1822 before he ever left Hamburg, is in no way diminished in his portraits from Meran. It is true that the later pictures show a greater subjection of detail to broadly massed areas, but they have every bit as much concentration upon character. His portrait in 1845 of the widow Mary Krämer (Plate 101), who was a year later to become his mother-in-law, shows the woman in her weeds against a plain light background. Her

100. Carl Rottmann: *Aegina*. After 1835. Oil (52.7 × 53 cm). Georg Schäfer Collection, Schweinfurt.

101. Friedrich Wasmann: *Mary Krämer*. 1845. Oil (21.7 × 18.2 cm). Kunsthalle, Hamburg.

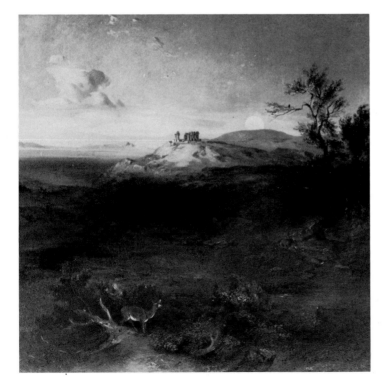

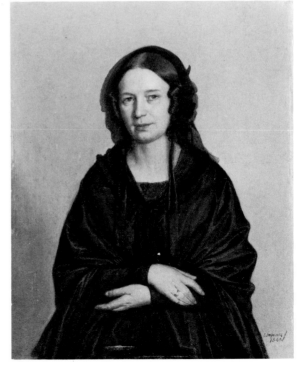

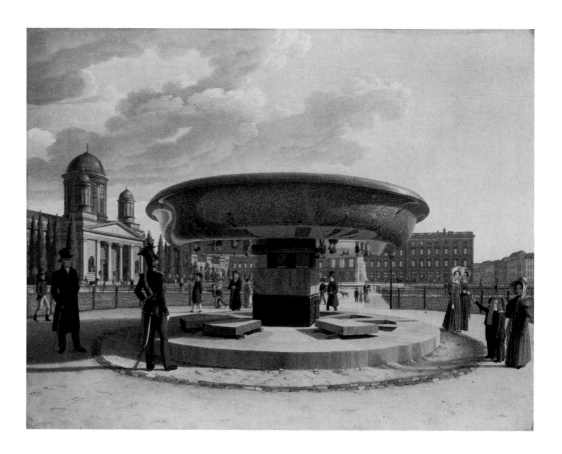

stark form is demure in its stance, with softly folded hands and slightly bowed head. Her firmly modelled face is the culmination of the picture. It bears a sorrowful but kindly expression. In the clear, sympathetic, but unidealized descriptiveness of these pictures Wasmann can be associated with the finest tradition of German realism that reaches back to the portraits of Holbein.

Like Munich, Berlin developed rapidly as a cultural centre during the early nineteenth century. Under the supervision of Schinkel, it became a model of urban planning. Its Academy, too, gradually rose in prestige. However, it never became renowned for idealist art in the way that the Bavarian capital did. The metropolis that was to become in 1870 the capital of the German Empire was expanding at this time as the chief city of a state dedicated to political aggrandisement and rapid modernization. From the start of this dramatic process under Frederick the Great in the mid-eighteenth century this Prussian pragmatism had its counterpart in the outlook of the principal artists of Berlin. As Goethe complained in 1801, the 'masters of naturalism' in this city 'appear to be most at home with the requirements of reality and utility and to reveal above all the prosaic spirit of the age'.[8]

Certainly the admiration of Frederick for the French Enlightenment had encouraged a form of art that combined a Gallic rationality and wit with an indigenous north German candour. Many French artists were employed in Berlin, and it became a habit for Prussian artists and architects—like Gilly, Schinkel and Gärtner—to visit Paris to complete their education. The influence of France is clearly felt in the work of Daniel Chodowiecki (1726–1801), whose piquant vignettes of contemporary life remained greatly admired in the nineteenth century, particularly by Menzel. Around 1800, at the time that Goethe wrote his critique of Berlin, realism was flourishing in the portraits of the sculptor Gottfried Schadow (1764–1850). This artist's combination of exactitude of observation with a classical sense of elegance and decorum is in many ways comparable to that of the great French sculptor Houdon. Nor did Schadow feel any need to be ashamed

of the 'prosaic' element in his art, and took it on himself to write a devastating response to Goethe's criticism.[9]

Although the fortunes of Prussia suffered a setback during the Napoleonic invasions of Germany, Prussia, like Britain, emerged from the wars a victor. She became a major beneficiary of the reallocation of territory agreed at the Congress of Vienna. In the years that followed, while Schinkel was redesigning the city, the view painters and portraitists of Berlin recorded the changes in its appearance and mood with a sharp-eyed accuracy that mingled pride with humour.

This outlook is often present in the paintings of Johann Erdmann Hummel (1769–1852). This Kassel-born and Kassel-trained painter had been active in Berlin since 1800. By the time he came to paint the *Granite Bowl in the Pleasure Gardens of Berlin* (Plate 102) there was no hint that he had once been the familiar of Koch and his circle in Rome in the 1790s. More relevant to his sharply delineated work is the fact that he had been a professor of perspective and optics at the Berlin Academy since 1809. But this curious view of a highly reflecting object is more than an academic exercise. It is one of a series of pictures that record the arrival of civic improvements to the area in front of the royal palace. It is also an essay in a comedy of manners. Hummel displays the Berlin burghers coming to admire the new embellishment before it is lowered into position. As these well-dressed people and their children look up with curiosity, the highly polished surface of the bowl reflects them back again, upside down, and in fairground distortions. Despite the care with which he has recorded the layout of this part of Berlin, Hummel's interest was not primarily topographical. The royal palace is almost totally obscured by the granite bowl. It is the situation that concerns him most, the way in which the unexpected throws a new light upon people and their attitudes.

102. Johann Erdmann Hummel: *The Granite Bowl in the Pleasure Gardens of Berlin.* c. 1831. Oil (66 × 89 cm). Nationalgalerie, Berlin (West).

103. Franz Krüger: *Parade in the Opernplatz.* 1839. Oil (250 × 393 cm). Staatliche Schlösser und Gärten, Potsdam-Sanssouci.

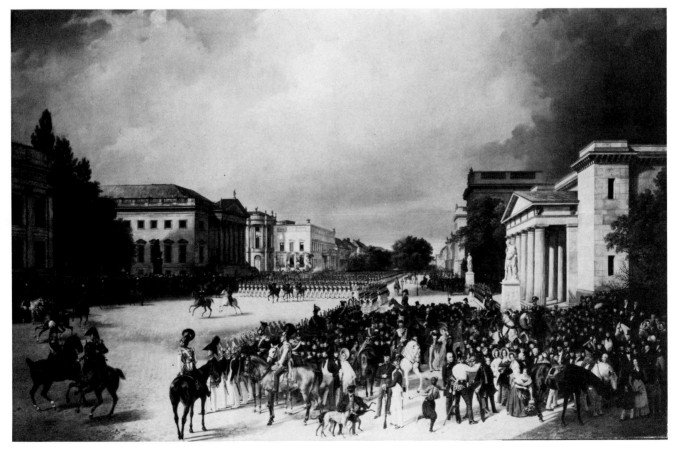

This sense of the unexpected can be found even in the most official side of Berlin view-painting and portraiture. The court painter Franz Krüger (1797–1857)—a pupil of the Berlin Academy who specialized in paintings of animals and military parades—could even turn the arrival of the Prussian King's ally and son-in-law, Archduke Nicolas of Russia, into an occasion for studying informal attitudes. The picture (Plate 103) was a royal commission and is set in the splendid, newly laid out thoroughfare Unter den Linden. But the actual ceremony it is intended to depict is relegated to the middle distance. Attention is diverted to the small tumults of disturbance amidst the expectant crowd in the foreground; and, while these figures—the soldiers at ease, the boy trying to control his dogs, the running negro—are all closely observed portraits, the couple for whom the whole event is taking place can hardly be seen at all.

There is too little subversiveness in such good-natured game-playing for the word irony to apply. Yet it is worth recalling that the society which enjoyed these pictures was the same one that fostered the paradoxical absurdities of E. T. A. Hoffmann and the ironic poems of Heine, both of which sought to deflate the pretentions of classical and Romantic idealist alike by means of mockery.

Both Hummel and Krüger were masters of precision. This quality was used to even greater effect by Eduard Gärtner (1801–77), the most consummate view-painter of the period. He was continuing a tradition of city scenes well established by Bellotto and Canaletto in the eighteenth century; but he brought a new outlook to the genre. He does not record so much a famous building as the ambience of a place. His *Neue Wache, Unter den Linden* (Plate 104) tells one less about this building by Schinkel that one can learn from Krüger's *Parade in the Opernplatz*. Gärtner has shifted his position slightly back from the street so that the *Neue Wache* is seen from the side and is largely concealed by a tree. Unter den Linden itself is obscured by a statue. Yet such accidentals give the spectator the most vivid impression of actually being present. Gärtner has caught above all the kind of configuration that would have struck the strolling pedestrian. The harmoniousness of this subsidiary view is a tribute to Schinkel's skill in civic layout. Gärtner was equally interested in the unplanned back streets of Berlin. His *Parochialstrasse* (Plate 105) shows the daily life in one of these, with its craftsmen's wares, workmen mending the road, lounging

104. Eduard Gärtner: *The Neue Wache, Unter den Linden*. 1833. Oil (47 × 77 cm). Nationalgalerie, Berlin (West).

105. (facing page) Eduard Gärtner: *Parochialstrasse*. 1831. Oil (39 × 29 cm). Nationalgalerie, Berlin (West).

figures and sparring cat and dog. Viewed in deep shadow, the spectator's gaze is led through the maze of details to the bright intersection of a fashionable thoroughfare in the distance. Every form is carefully described and the perspective is handled with consummate illusionism. This creates the impression of looking in on this microcosm as if it were a peep show. It is hardly surprising to learn that Gärtner was as well a painter of panoramas.

Admirable though such painting is, its limitations are evident. Gärtner, Krüger and Hummel appear to have regretted the absence of any sense of the ideal no more than Schadow did. But the lack of any convincing ideal was to become a major concern for the most perceptive Berlin painter of the period.

No painter suffered more from the Berlin penchant for wry humour than Blechen. Having become notorious in his youth for his playful paintings of 'terrifying' scenes, he was assumed by most contemporaries to be indulging his bizarre wit when he introduced pictorial innovations into his later landscapes. But when Blechen 'boxed one's ears' (as the critic Kugler put it) with his bright colours and lively handling, he was not having a joke at the expense of the spectator; he was attempting to communicate an unusually vivid feeling for atmosphere and luminosity. It is certainly true that Blechen had a keen sense of the absurd. This comes across not only in his subject matter, but also in his observations. The cast of his mind can be seen at work in a sheet of sepia studies—possibly made at the theatre—which includes a pair of stage characters, a demure lady, two gawpers, and his own solemn profile, clouded in shadow.[10] It is not surprising, perhaps, that he was compared so often to that master of the bizarre, Hoffmann, whose own career had recently ended in Berlin as unhappily as Blechen's was to. In 1836, at the age of thirty-eight, the artist was to lapse into an incurable madness.

Blechen's career was a brief one, lasting little more than a decade. Cut short by insanity, it had not even begun until he was in his mid-twenties. Born in Cottbus, the son of a poor civil servant, he had originally been destined for the Church. Lack of funds caused him instead to be enlisted in a Berlin banking house as a clerk at the age of seventeen. He remained in this profession, with the interruption of a year's military service, until the age of twenty-four. Then, in 1823—after having attended drawing classes for a year part-time—he enrolled in the landscape classes of Professor Lütke at the Berlin Academy as a full-time student.

This step was not taken without professional encouragement. Indeed, the degree to which Blechen's career was furthered by Ministerial officials is an impressive example of the intelligent but rigorous supervision of the Prussian administration that had exasperated Carstens a generation earlier. In Blechen's case one gets the feeling that his talents were employed a little too early and a little too assiduously—something that might in fact have contributed to his final collapse. Within a year of entering Professor Lütke's landscape classes he was appointed through the good offices of Schinkel in his capacity as *Oberbaurat* to the position of scene painter at the Königstadter Theatre. Blechen had both the versatility and the sense of the dramatic to make him eminently successful at this job. But from the point of view of his development as a landscape painter it encouraged him to go too easily for the showy effect. A visit to Dresden to see Dahl in 1823 made him fully conversant with the conventions of the Northern landscape, and in the subsequent years he exhibited at Berlin a whole repertoire of ruins, monks, and supernatural phenomena—among them, the *Rocky Gorge* (Plate 92)—which gained him widespread praise for placing the 'terrifying' at the service of landscape painting.

Blechen's visit to Dresden encouraged him to exploit the repertoire of the Northern landscape. It also introduced him to a new standard for naturalist painting. He would have seen there the cloud studies of Dahl—a genre that he was soon to practise himself—

106. Carl Blechen: *Sea at Evening. c.* 1828. Oil. Oskar Reinhart Foundation, Winterthur.

and appears to have appreciated too the value of studying directly from the local landscape. When he gave up his career as a scene painter in 1827 as a result of a disagreement with the theatre management, he set himself the classic task of allying naturalistic studies with a historical theme. The outcome, shown at the Berlin Academy in 1828, was a view of a part of the sandy woodlands around Berlin with a scene from the time of the Roman occupation. Entitled *View of Müggelsberg, near Köpenick, looking south. Staffage: Semnons arming themselves preparatory to opposing the advance of the Romans* (Berlin Academy), it was based on careful studies of the locality. However, it was also an attempt to paint a landscape of meaning, and an appropriately nationalistic one at that. Despite the phrasing of the title, the figures in it are more than an afterthought. Indeed, the gathering storm that dominates the sky was a clear case of landscape being used to articulate some figurative drama.

Above all Blechen felt the need at this time to extend his experience as a landscape painter. The large painting of the *Semnons* indicated his willingness and ability to work in the field of historical landscape, and its successful reception led the Prussian government to award him a grant to visit Italy. After a visit to Rügen he set out for Rome in October 1828, visiting Dahl once again in Dresden on his journey south.

Blechen's time in Italy was not long—only ten months altogether—and he returned to Berlin by the end of 1829. Whether the shortness of this visit was due to the parsimoniousness of his patrons or Blechen's own restlessness (he had left a wife and family in Berlin), he worked there with feverish activity—as is evidenced by the vast number of oil sketches and drawings from this time now preserved in the National-Galerie, Berlin (East).

Like Rottmann, Blechen recorded the Italian landscape in a colourful spontaneous

style quite opposed to the muscular heroic manner of Koch and his followers. No doubt like Rottmann, too, he saw the exhibition that Turner staged in Rome in December 1828, for his sketches have a similar feeling for the dissolving effects of southern light.[11] This was especially the case with the coastland scenes he painted on a journey down to Naples in the spring of 1829 and on the Ligurian coast on his return journey to the north. In some of these, such as the study of a bank of purplish clouds over a bay at evening time (Plate 106), he also captures something of the drama of the English master. But on the whole his Italian pictures have a lightness of touch alien to the more penetrating investigations of Turner.

The most important consequence of the Italian journey for Blechen was the way in which this new sense of luminosity encouraged him to paint his pictures in terms of positive colours, to create harmonies that provided an equivalent sensation to the vibrancy of light, rather than imitate the local colour of individual forms. It was this that disconcerted the critics of the paintings from his Italian studies that he exhibited at the Berlin Academy in 1830. 'Where did the artist get the red brown shadows in the background of that gorge from?' asked one reviewer, comparing a Campagna view with his own recollections of the area. 'If he has seen such—and we would give much for his vision—then we thank him for drawing our attention to it. However, we cannot recall any such coloration, or discern any circumstances that would give occasion to it.'[12]

Most critics, resolved their perplexity by resorting to the notion of satire. They agreed with the lexicographer Nagler when he wrote in his *Neues Allgemeines Künstler-Lexikon* in 1835 that 'Blechen shows more of the irony than the charm of the Italian landscape.'[13] They felt that it was quixotic of him to insist upon the parched land and searing light of Italy—one critic referred to his tree trunks being 'scalped' by the sunlight—rather than emulate the noble and poetic vision of green glades and cool mountains dear to the classicists.

In retrospect there seems nothing perverse about Blechen's insistence that Italy rarely looked like the landscapes of Claude and Poussin. He can, however, be considered ironical in his approach to the subjects of these scenes: he often parodies the staffage of both classical and Romantic landscapes. This can certainly be seen in his most popular theme, *In the Park at Terni* (Plate 107), which he repeated at least five times. At first glance this picture of girls bathing in a glade seems a perfect idyll. While there are a few hints of his 'scalping' sunlight on the sandy earth and tree trunks of the foreground, these serve merely to heighten the charm of the main scene. Here the light diffuses amongst the shady foliage producing a subdued glow on the backs of the maidens who, with the reds and whites of their discarded clothes and the deep blue of the stream they are entering, provide a colourful focus for the painting. Yet when we come closer to them we encounter not tranquility, but alarm and disapproval as they try to conceal themselves from our gaze. For they are not the carefree nymphs of antiquity, but prim modern ladies whose private bath we are disturbing by our presence. Parody, as Thomas Mann once remarked, is the expression of love for a form that is no longer viable.[14] Like Heine, Blechen destroys with a shock the idyll he is so adept at but of which he is no longer convinced.

As this picture was exhibited in 1836, it is clear that Blechen continued to play 'serious games' up to the end of his artistic career. Just as the notion of the Italian idyll is subverted by both his perceptive observation of light and the mockery of his subjects, so his old repertoire of Northern landscapes take on a new piquancy. When he painted the diorama the Alpine view *Devil's Bridge* (1830, Neue Pinakothek, Munich), he employed all the sublime effects of Friedrich's high mountain pictures, which he would have known from the Berlin Academy.[16] Yet it is not the precarious old bridge that is the focus of the scene,

107. Carl Blechen: *In the Park at Terni. c.* 1836. Oil (105 × 78.5 cm). Georg Schäfer Collection, Schweinfurt.

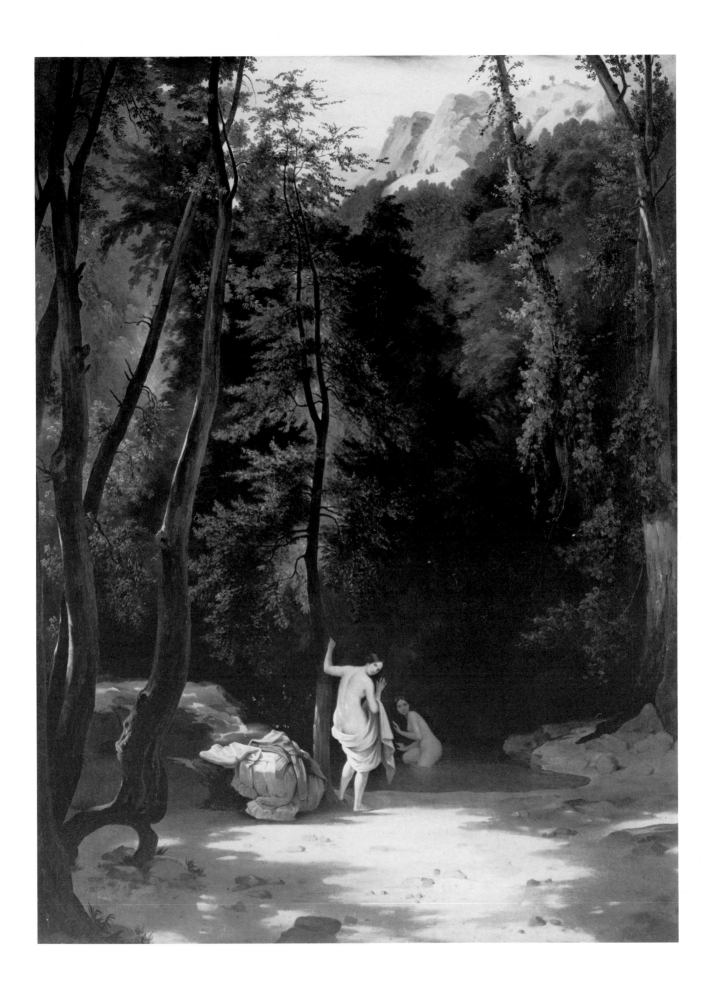

but the new, safer one that is under construction—the foreground is littered with the paraphernalia of workmen. Quirks of fate also attracted him, such as a man being killed by a lightning-struck tree (1835, formerly National Gallery, Berlin (burnt 1931)). His masterful unfinished *Gallows Hill* (Plate XXIII)—which is probably related to his tour of the Harz Mountains in 1833—is very much in the tradition of the 'terrifying' elemental scene. But, while the climax of the picture is the bleached silhouette of the instruments of punishment and death against darkened storm clouds, one can feel his attention wandering at the edges to a pure delight in the painterly effect of thickly applied bands of blue and orange. The vividness of this depiction contrasts strongly with the photographic descriptiveness that was being brought to the Northern landscape by Lessing in Düsseldorf.

While Blechen could parody the conventions of landscape, he found it a more difficult matter, however, to discard them. Even when invited to depict contemporary views of Berlin his playfulness frequently came to the fore. A commission from Friedrich Wilhelm III to paint for his daughter, the Russian Tsarina, two interiors of the newly erected Royal Palm House led to a joke at the expense of the current achievements of botany and technology that it represented. He exposed the artifice of the neatly bedded specimens,

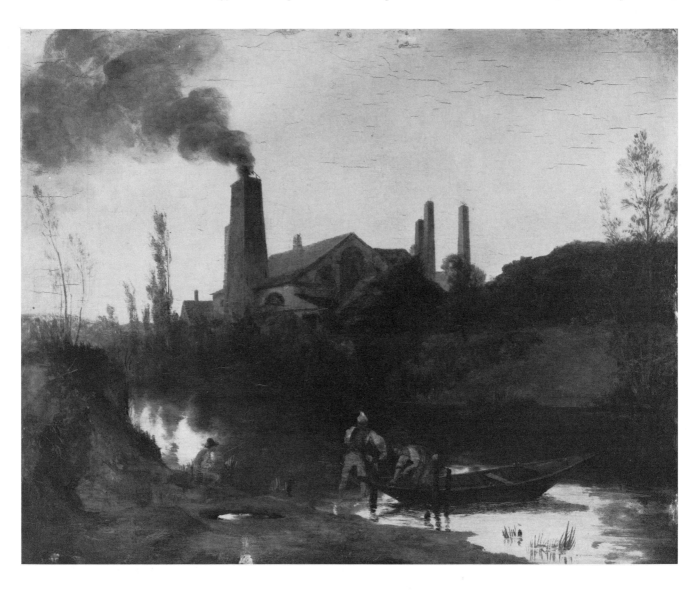

cast iron columns, drainage ducts and heating pipes by placing in their midst the denizens of an Oriental harem. The King appears to have appreciated this puncturing of pretence as much as he did the informal treatment of state ceremonials by Krüger, for he ordered two more views of the Palm House for himself.[16] Indeed, the curiosity aroused by the changes in Blechen's style after his visit to Italy seem only to have enhanced his status in the Prussian capital. In 1831, on the death of Lütke, he was elected professor of landscape at the Academy.

Only in his private studies did Blechen totally abandon his pleasantries. In these views he moved away from the grandiose new embellishments in Berlin and even from the world of traditional craftsmanship of Gärtner's *Parochialstrasse* to explore more problematic realities. The *Iron Rolling Mill* (Plate 108) depicts the rapidly growing industrial complex of Neustadt-Eberswalde, part of the grimy foundation of recent Prussian prosperity. Perhaps there is some comment intended by the foreground figures, fishing still in the blackened waters of the canal by the factory. But more striking is the unrelieved dullness and murkiness of the blighted industrial landscape. The immediacy of effect learned in Italy is applied here to the dirty blues and greys, giving them a grittiness that makes them seem to have been painted with the soot that is emerging from the factory's stubby chimney. There had been industrial landscapes before this date, particularly in England; but none of the fantasies of De Loutherbourg and Martin, or the neat inventories of the topographers, had conveyed the sheer presence of industrial squalor in the way this work does. It is this sense of authenticity that lends authority, too, to his motif-less views in the Berlin suburbs. This is particularly the case with *View over Roofs and Gardens* (Plate XXIV), a matchless example of direct painting before a view from a window. The scene has all the alertness that comes from an artist thinking as he paints, discovering at every stroke a new effect to measure against his observation. Yet there is none of the enthralment that is attached to this process by Dahl and the Biedermeier landscapists. Like Van Gogh in his early cityscapes, Blechen does not romance about his corner of nothingness. It remains a view over a faceless higgledypiggle of sheds, shrubberies and slatted fences, with a tonal range that hardly ventures beyond earth brown, dun and dull green. Almost a quarter of the picture is taken up by the interjection of the featureless sloping roofs immediately before the window. Yet by simply taking the motifs as they stood he was able to stretch his faculties to their limits to build a picture supremely controlled in its handling of form and light. The angle of the foreground roof becomes part of a series of diagonals and horizontals that pivot around a central hut; the sharp edge of light that it brings into the middle of the painting forms the incisive keynote to the sensitive modulations of tones in the landscapes behind it. The deliberateness of the treatment makes this study more than a sketch. It is one of the rare occasions when Blechen managed to paint objects for themselves alone, to appreciate pure forms and colours and their interrelationships without a hint of the Romantics' associationalism.

These works do not represent a development from ironic landscape, but rather an alternative. They are another way of coming to terms with natural motifs that have lost their former resonances. For Blechen there was to be no synthesis of divergent tendencies. Always hypersensitive he began to find the tensions of his life and official duties too great for him, and in 1835 suffered a nervous collapse. Neither a trip to Paris—where his art was greatly admired by Horace Vernet and other masters of modernity—nor the efforts of his doctors could provide the necessary relief. Most tragic of all, Blechen was unable himself to accept his condition, and there are pathetic accounts of him seated before his easel for hours on end, making meaningless movements of the brush. Eventually he was removed to an asylum, where the brutal treatment he received eliminated the last hopes for a cure.

Blechen's death in 1840 was much lamented by his colleagues; and it was in recognition

108. Carl Blechen: *Iron Rolling Mill, Neustadt-Eberswalde. c.* 1834. Oil (25.5 × 33 cm). Nationalgalerie, Berlin (West).

of his genius that the government awarded his widow a generous pension. Yet it was typical of Prussian judiciousness that this pension should have been tied to a condition: that the contents of the artist's studio should be made over to the state. The outcome of this for his reputation has been fortunate, for it has led to the side of his achievement that was less well known during his lifetime being preserved. Indeed, it was the government's keenness to know what kind of a bargain they were striking that focussed the attention of his contemporaries on the quality of the studies and sketches. Four established painters—Begas, Dähling, Herbig and Schirmer—were requested to provide a valuation of these. Their reports were unanimously complimentary. Begas went as far as to place them on a level with the studies of Claude, Poussin and Ruysdael. And even if the hyperbole was somewhat contrived—perhaps even charitably motivated—he went on to record a genuine amazement for the pictures' expertise:

> I can never recall having seen drawings and oil sketches in which such characterization of the varying forms of nature, such feelings for the perspectival shifts of terrain, were expressed with such economy of means. As well as this the supreme sureness of the representation of the modulations of light and shade, which is paid attention to everywhere, must be taken into consideration.[17]

It is not surprising that an artistic world that could respect Blechen's technical achievement to this degree should be one in which Adolph Menzel could rapidly make his reputation.

The art and career of Menzel is for the most part outside the scope of this book. He is, after all, the great virtuoso of German naturalism, the figure who was to dominate Berlin art during the latter half of the nineteenth century, and was to win admiration throughout Europe for his skilful and protean powers of observation. 'Yes, who is Menzel?' asked his friend, the realist novelist Theodore Fontane. 'Menzel is much, if not to say everything . . . He investigates the great and the small. Everything that so much as creaks or flutters is captured for us by him.'[18] Fontane knew well the almost baffling ubiquitousness of the man. A constant and addicted sketcher he was forever putting down rapid sharp-eyed records of the people around him, usually seen from curious and unsuspected angles. It was this precision and inventive voyeurism that made him one of the artists admired by the French Impressionist Degas.[19]

The skilful—almost too skilful—*reportage* of Menzel belongs to a different age; but the art of the early years of his lengthy career is closely connected with the milieu of Berlin in the 1830s and 1840s. And while his observation was always clear and unsentimental the paintings and drawings that he made before 1850 have a quality that becomes rare in the consummate performances of his later years. They are above all intimate—full of the warmth and homeliness of Biedermeier society before this had hardened into the coarser materialism of the German Empire.

Menzel was a highly attentive artist, and the changes in his art appear to reflect those that took place in the society he lived in. But there was also an internal consistency in the development of his style. It had always been his intention to be a painter of *grandes machines* and after 1850 he had achieved the means and reputation necessary to devote himself to large-scale reconstructions of scenes from the life of his hero Frederick the Great, and complex compositions based on his studies of contemporary society. Furthermore, a visit to Paris in 1855 acquainted him more closely with the work of French popularizers of naturalism such as Vernet and Meissonier, and encouraged him to develop the naturalistic virtuosity in his own art.

Menzel's expertise was also an outcome of his obsession for work. In his early years, this had been a necessity. At the age of sixteen his father had died, leaving him the sole means

109. Adolph von Menzel: *Musicians and People Talking*. 1846. Pencil (20.9 × 13 cm, reproduced larger than size). National-Galerie, Berlin (East).

of support for his mother, brother and sisters. Two years before this his father, a poor teacher, had brought the family from their native Silesia to Berlin, where he had sought to establish himself by setting up a lithographic press. Menzel inherited this business and used it to achieve his first artistic success, a series of clever illustrations to Goethe's *Des Künstlers Erdenwallen* (1843), which gained him admission to the Berlin Verein der Jungen Künstler (Berlin Association of Young Artists) at the age of nineteen.

It was as an illustrator that Menzel established his reputation. The turning point for him was the designs he made for the three volumes of Kugler's *History of Frederick the Great* (1839–42). Planned as a sequel to the life of Napoleon illustrated by Horace Vernet, it became for the young artist both a national and an artistic challenge. Following the lead of Vernet's historical realism, he set himself the highest standards of accuracy, researching the minutiae of the life of the Prussian court and army in the eighteenth century with great thoroughness. In the illustrations he combined this knowledge—as Blechen had done in his *Semnons*—with equally detailed records of the scenery around Berlin and Potsdam where the principal events he depicted had taken place.

Menzel's view of Frederick, like Kugler's, is frankly affectionate. He emphasized the monarch's wit and valour, his skills as a leader, his learning and love of music, rather than the coldness and autocracy that had so shocked Voltaire when he came to Sanssouci. Menzel's view of the King is supported by the elegance and playfulness of the designs— particularly evident in the small vignettes and decorated letters—which show a clear debt to the illustrations of Frederick's contemporary Chodowiecki. This was appropriate to the historical reconstruction of the figurative scenes. Menzel also displayed a more contemporary naturalism in the larger views—such as the scene of land surveyors at work, where our attention is dominated by a brilliant study of some brambles and a tumbledown garden fence (Plate 13). For contemporaries these works were most impressive for their sheer expertise—the marrying of historical research and accurate observation, the inventiveness of the compositions, and not least for the way in which he had trained the wood engravers who cut his designs to reproduce the fluidity of his penmanship with all the faithfulness of a lithograph. They are also a witness to Menzel's curiosity and delight in capturing the intimacy of a particular locality.

In these early years Menzel's relationship with his family whom he was supporting was necessarily close. It was to remain close. He never married and he lived with relatives for the rest of his life. In his reminiscences he recorded how his father's dying words to him had been 'you are still not ready for marriage, but you are good enough to be head of the family'.[20] That he never did find himself ready for marriage and was never able to leave the security of his family, was due to a natural shyness intensified by his own physique. He was a near dwarf, being well under five feet tall.

Perhaps it was the distance that Menzel felt between himself and normal life that accounts for the voyeuristic nature of his sketches. His sketchbooks are full of rapid lively pencil notations (Plate 109) of people moving about in public places or preoccupied with their work. This is particularly noticeable in his frequent studies of musicians. As with the French Impressionists, these studies reflect the normal activities of nineteenth-century city life, and much of their interest comes from the way in which the artist has captured the scene without disturbing it or imposing his personality on it. Yet in Menzel's case this also reflects a desire not to be noticed himself, evident in his almost pathological hatred in being seen about his work. Only in the privacy of his own home circle did he make studies in a more open manner. And it was only within his own house that he made direct studies in the more cumbersome and noticeable technique of oil. The oil paintings that Menzel made in this way during the mid-1840s are amongst the artist's most admired works today. But he does not seem to have regarded them as a significant part of his oeuvre for he

did not include them in the list of his works that he prepared for Friedrich Pecht in 1872. Despite this they are evidently more than sketches, or exercises to develop his skill as an oil painter. He had been exhibiting oils since 1837 and had used oil to make studies of details for the Kugler series before 1844, the year in which the first of his domestic interior paintings can be dated. By the mid-1840s Menzel was certainly aware of the studies of Blechen, as he was of the paintings of Constable, which he had seen exhibited in Berlin during these years.[21] The influence of the English master can be felt particularly in the *View over the Gardens of Prince Albrecht's Palace* (Plate 110), painted from a window of his new lodgings in Schöneberger Strasse. There is a Constabelian feel about a number of small landscapes in and around Berlin made at this time, yet it should be emphasized that these were not *plein air* studies, but paintings worked up in the studio from pencil drawings that he made on the spot. The reason for this appears to have been his shyness about being observed at work. The *Gardens of Prince Albrecht's Palace* has affinities with the cloud studies made by Constable, Blechen and Dahl. But it has a different emphasis. The rather dull weather effects of the day on which the picture was painted do not seem to have been the predominant interest. Instead it was the sense of the cut off view that obsessed him.

It is this interest that enlivens his finest interiors. The *Balcony Room* (Plate XX) is, as has already been remarked, striking for being of the mere corner of a room. The randomness is emphasized even by the angle that the wall makes with the edge of the picture on the left-hand side. Yet it is a picture superbly enriched by spontaneous thoughts. This can be seen in particular in the way the sofa becomes a dull patch of green, the carpet a bright slash of red on the left-hand side. They bring an air of surprise to the moment. There is a sense of the flat laying on of paint that comes from direct observation, the capturing of the freshness

110. Adolph von Menzel: *View over the Gardens of Prince Albrecht's Palace*. 1846. Oil (24.7 × 40 cm). Staatliche Museen, National-Galerie, Berlin (East).

of the light and wind as it blows through the window in creamy wholesome paint, and the understanding of the forms in the shadows, the way the chair nearer to the light appears darker by contrast than the one by the mirror. Similar effects were observed by Friedrich and Kersting, but they were always recorded by these artists in a measured way. In the *Balcony Room* they have been put down with the spontaneity that gives naturalism its supreme quality: the capturing of the transience of light.

Menzel could convey this in the *Balcony Room* in an inanimate scene. He did the same elsewhere in the house, most beautifully in a night study on the stairs (Folkwang Museum, Essen). Others show the quality that Degas so admired, the bringing together of unrelated figures. Most superb of these is the study of his favourite sister Emilie leaning against a door and staring into the stairwell while another woman sews in the room behind (Plate XXV). It has all the sense of the momentary, of the chance fall of two different sources of light, and of a surprise element in the cupid hanging from the ceiling. Everything is brushed in hastily and with bravura. Yet it was undoubtedly posed, like the painting in which his own self-portrait is included.[22]

Menzel's interest in these scenes was an empirical one. It grew out of his close study of life in Berlin. His small interiors record the everyday activities of the city's bourgeoisie. Similarly his attention was rivetted by the political events at the end of the 1840s that shook this world to its roots. No one could have ignored the uprising of March 1848. It was part of the wave of revolutions that swept Europe during that year. The demands of the insurgents were liberal, and they had the sympathy of the majority of the bourgeoisie. Matters came to a head when a large number of protestors were 'mistakenly' shot by the King's guard during a demonstration on 18 March. To quell the uproar over this occurrence the King conceded to the insurgents to the point of ordering a public memorial service to honour the fallen. Menzel's own excitement at these events is known from his letters. On the chosen day, 22 March, he wrote to his friend Arnold, 'I was on my legs all evening, and have hardly been home since.' His own representation of the subject (Plate 7) was begun in a spirit of high idealism. He sketched the steps of the Neu Kirche—the location of the coffins of the fallen—in the Gendarmeplatz, and figures in the foreground of the painting were based on pencil studies of people he had observed in the crowd. Menzel chose the moment just before the ceremony began—one of the coffins is still being brought in from the left. The emphasis on the chattering crowd is similar to that found in Krüger's *Parade in the Opernplatz*. Yet there is a great poignancy given to them here. As we know from Lichtwark,[23] the figures represent different groups talking about their own exploits.

The artist's enthusiasm for the theme declined as the liberal parliament, elected at Frankfurt as a result of the uprisings, became increasingly ineffectual. Eventually he abandoned the picture because he felt the whole movement had been 'lies and rubbish'.[24] There had been no liberal achievement, only stalemate. The artist felt it would be wrong to complete the work even though he was frequently asked to do so in later years by prospective purchasers. Politically Menzel moved towards favouring authoritarianism. His admiration for Fredrick the Great increased, and he celebrated the life of his hero in a series of grandiose paintings.[25]

It was around this time that the sense of charm began to disappear from Menzel's paintings. He became even more remote in his recording of the world around him. That delight in the workings of the world that was one of the more innocent of the legacies of Romanticism gave way to a dispassionate and unyielding sense of naturalistic virtuosity.

The Nazarenes

THAT A BOOK on German Romantic painting should give pride of place to landscape would have seemed highly perverse to contemporaries. The prestige of this nation's art at the time rested upon a quite different achievement. When a commentator in the English magazine *Art Union* wrote in 1839, 'The Germans are assuredly the great artists of Europe',[1] he was not referring to their landscapists—whom in fact he explicitly excepted—but to those painters who had sought to revive historical and religious art by a return to the principles of the time of Dürer and Raphael.

It was above all the Nazarenes—a group who had gained their nickname through adopting an archaic mode of dress and had sought at one point to insulate themselves from the corruption of the present by living in a quasi-monastic community—who had provided a focus for this tendency in German art. At first sight their communal action and curtailment of experience might seem to be at variance with the Romantics' emphasis on individualism and personal revelation—those qualities which became so consequential for developments in landscape painting. Yet both attitudes reach back to a common premiss. The Nazarenes never doubted the need for heartfelt emotion of faithful observation in their work. Their contention was rather that the conditions of the contemporary world were preventing artists from achieving this sincerity—that their eyes had been dazzled and deceived by the mere technical virtuosity of painters who, as one of their leaders Franz Pforr put it, 'had aimed no higher than a stimulation of the senses'.[2] They withdrew from the present, so that they could chasten it by their example.

This viewpoint was shared by other artists of the time who seriously felt the need for a regeneration in art and society. For some the paradigm happened to be classical, as in the case of the 'Primitif' sect in David's studio; for some it was medieval, as in the case of Blake and Samuel Palmer; for some it was both, as in the case of Flaxman and Runge. Even Friedrich, an artist opposed to all forms of copying, was prepared to admit the inspirational value of the 'pious simplicity' of artists of former times. What was unique about the Nazarenes—and what gained them their prestige—was the extent to which they were prepared to go to effect a revival; and the rationale for their single-mindedness lay less in the example of other painters than in the conclusions that could be drawn from certain theories held by Romantic critics and writers in Germany.

For the German Romantics the work that provided the most inspiring evocation of the virtuous simplicity of medieval art was Wilhelm Wackenroder's *Herzensergiessungen eines kunstliebenden Klosterbrüders* (Heartfelt Effusions of an Art-Loving Monk, 1797). This slender, impassioned volume, published a year before its author's death at the age of twenty-five, consisted largely of stories from the lives of fifteenth and sixteenth-century artists culled from such familiar sources as Vasari and Sandrart and retold in a simple archaizing manner. It was not Wackenroder's principal intention to stimulate a revival of the art of this period. His main concern was to demonstrate the spiritual nature of true art. This—as the last essay in his book shows—he found to an equally striking degree in the

devotional music of his own day. Indeed, the conceit of having the tales related by a monk was no more than an afterthought suggested by his friend the more theatrically minded poet Ludwig Tieck. As is so often the case, it was the descriptive coloration of the work rather than its underlying message that was to make the greatest impact, Tieck himself further emphasized this side both in his presentation of more essays by Wackenroder in conjunction with some of his own in *Phantasian über Kunst* (1799) and in his romance on the life of a fictitious pupil of Dürer, *Franz Sternbalds Wanderungen* (1798). Such productions made it easy for the opponents of the cult to dismiss as pretentious play-acting what Goethe called 'that monkish, Sternbaldish nuisance which is threatening the visual arts with more danger than all those Calibans who cry out for realism'.[3] But there were nevertheless two central notions in Wackenroder's book that survived and provided the basis for a more enduring revivalism. The first was the view of art as a form of religious worship. In the essay 'Concerning two wonderful Languages and their Secret Power' Wackenroder characterizes nature as the language of God and art as the language of man. Through recreating the wonders of nature by means of art man is offering up a prayer to God and praising him according to his own lights. The spiritual approach to art was already a familiar one, but Wackenroder emphasized in particular its devotional nature. In the place of the image of the artist as prophet adhered to by the *Stürmer und Dränger* and William Blake, he put that of the artist as priest, guiding the community towards piety and humility.

The second seminal notion of Wackenroder was also a modification of an idea first mooted by the *Stürmer und Dränger*. This was the relationship of art to national characteristics. For Herder this relationship had become the means of accounting for the different developments of the separate cultures in the world, and he issued a plea for approaching each on its own merits rather than measuring them all according to some single normative standard. Wackenroder followed this line with his appeal for the restoration of the indigenous qualities of Northern art that had been supressed through the imposition of the alien conventions of classical antiquity: 'Why do you not condemn the Indian for speaking his language rather than ours? And yet you want to condemn the Middle Ages because they did not build temples like those in Greece.'[4]

Wackenroder accepted the importance of recognizing the differences between peoples and the right of each to self-expression. But he kept little of the *Stürmer und Dränger*'s accompanying emphasis on the independence of original genius. When Goethe, as a young *Stürmer und Dränger* in 1772, had written his famous defence of the Gothic cathedral of Strasbourg he had certainly seen the genius of its reputed creator, Erwin von Steinbach, as deriving strength from the 'folk' tradition of Gothic. But he had also emphasized that it was as a form of individual expression that Steinbach's art was eventually to be understood, as something that had risen above the benighted age in which he lived: 'Here stands his work. Step up to it and bear witness to the deepest feelings of truth and beauty of proportions emanating from a strong, rude German soul, and towering above the restrictiveness and gloom of the priest-dominated Middle Ages.'[5]

The geniuses of Wackenroder's book—Raphael, Dürer, Michelangelo—on the other hand, are seen as the flowers of their age. They are witnesses not just to their individual strength, but also to the qualities of the time and of the places in which they lived. Dürer and Raphael both flourished at the climax of the Age of Faith and each differed according to his locality. Dürer, the German, was full of character and frank realism. Raphael, the Italian living in the soft idyllic South, could present the world with a unique vision of the ideal.

It was this view of art as the outcome of a cultural milieu rather than of pure individual insight that was to be so crucial in the development of new attitude to that period still then

considered as part of the Middle Ages but which we prefer to think of now as the initiation of the Renaissance. It provided a consolation to those who could not follow the most extreme expressions of individual genius amongst the Romantics. By 1802, the year of the publication of Novalis's bizarre and mystical *Heinrich von Ofterdingen*, it seemed to many within the Romantic circle itself that matters had gone too far. Certain individuals (notably Novalis) appeared to have made the mistake of cutting themselves off from the main currents of their culture, and paid the price of non-communication. They had ignored that primal, instinctive groundswell of experience summed up in the notion of *Volk* and preserved in the national heritage.

This was essentially the position arrived at by Friedrich Schlegel, the very man who had proclaimed the 'progressive, universal' nature of Romantic poetry in 1798. By 1802, after the death of Novalis and the breakup of the original *Athenaeum* group, he was turning back once more to his historical studies, developing his interest in philology and national culture. A stay in Dresden in the autumn of that year renewed his interest in the visual arts. He moved on to Paris during the winter in order to study the Sanskrit documents in the Bibliothèque Nationale. But he was also in a frame of mind to benefit from the vast agglomeration of booty from the French Campaigns in the Musée Napoléon. Here he encountered not only many classic masterpieces—notably the *Transfiguration* of Raphael and the Apollo Belvedere—but also pictures by Dürer, Van Eyck and Fra Angelico. In the articles that he wrote describing this collection in the new magazine he had begun to edit, *Europa*, he warmly praised these 'primitives' at the expense of all post-Raphaelesque art.

Schlegel's reasons for preferring this early work—its sincerity and spirituality—was a natural development from that of Wackenroder. Yet when he began to characterize this art he mentioned qualities that hardly seem to be different from those of classical art:

> No confused massive groupings, but few individual figures, finished with such care and diligence as bespeaks a just idea of the beauty and holiness of that most glorious of all hieroglyphic images, the human form; no contrast of effects produced by blending chiaroscuro and murky gloom and cast shadows, but pure proportions and masses of colour in distinct intervals; draperies and contours which appear to belong to the figures, and are as simple and unsophisticated as they.[6]

Friedrich Schlegel would no doubt not have gone beyond such a generalized evocation of the primitive had it not been for his meeting in Paris with the Boisserée brothers. These two merchants from Cologne had already formed an interest in early German and Netherlandish art from the point of view of connoisseurs. Like Ferdinand Franz Wallraff, they were already buying up old religious pictures that were being auctioned or simply thrown out in their native city of Cologne as a result of the secularization of monastic institutions by Napoleon. Their attitude to the reinstatement of Northern medieval art was a totally committed one. Not only did they eventually sell their superb collections to Munich, where it formed the basis of the collection of the Northern primitives in the Altes Pinakothek, but they also instigated the completion of Cologne cathedral in accordance with the thirteenth-century plans for it that they unearthed.

Through the Boisserées, Friedrich Schlegel became aware of the specific characteristics of Northern art and architecture. They took him to see Notre Dame—which, amazingly, he had not previously visited—and in 1804 accompanied him on a tour of the Rhineland which further increased his acquaintance with the early Flemish and Cologne schools and with Gothic buildings.

It was this contact which explains the growing dogmatic tenor of the letters that he wrote in Europe about early Northern art. From a universal love of the primitive close to

that of Wackenroder in the first letter, he ended up by placing Northern art of the Middle Ages above all others: 'Old German painting is superior to the Italian, not only in its more exact and painstaking technical execution, but also in its longer attachment to the oldest, most marvellous, profound, Christian–Catholic symbols, of which it has preserved a far greater wealth.'[7]

Schlegel's love of these old masters had now grown to the extent that he was prepared to assert that they should be the direct model for contemporary painters. Indeed, he used their example as a means of chastizing the untrammelled subjectivism of the art and literature that he had previously defended so assiduously. It was the lack of 'religious feeling, devotion and love', rather than any technical shortcomings, that would make it difficult for a true painter to 'arise and flourish' in his own day. Furthermore, he warned, even if an artist were to arise who was able to 'rediscover the correct conception of art, that its proper purpose is the symbolical indication of Divine secrets' he would only arrive at 'arbitrary' results if he were to attempt to realize his vision directly from 'feelings, insights, or intuitions about nature'. It was 'safer by far', he concluded, 'to follow the old masters completely, particularly the oldest, and to imitate their individual truths and simplicities until they become a second nature to eye and mind'.[8] In other words, it was only by a return to the lost tradition of Northern art that the German artist could reintroduce the spiritual into the contemporary world.

Since Schlegel had recently come from Dresden and was writing these letters with his friend Ludwig Tieck in mind, it is clear that when he was talking about the 'arbitrary' modern artist he was hinting at Runge, who was then the close companion of Tieck. And, indeed, when republishing these letters in an expanded form in 1823 he went so far as to add a footnote in which he referred to Runge's *Times of Day* outlines (Plate 31) as a cautionary example of the risks entailed 'when an artist of high talent attempts to paint pure nature-hieroglyphs in total detachment from time-hallowed traditions'.[9] For Runge, Schlegel's letters marked the beginning of the decline of interest in his art in Dresden that encouraged him to leave the city and settle in Hamburg in 1804.

The growing dogmatism of Schlegel's taste was matched by a growing definiteness in his beliefs, and, despite a fascination with Indian mysticism, he entered the Catholic Church in 1808. It was a move greatly encouraged by the Boisserée brothers, who were Catholics from birth. It did in fact follow on the conversion of a number of other lesser figures in the original *Athenaeum* circle, such as Maria Alberti, the painter and sister-in-law of Ludwig Tieck.

Friedrich Schlegel's religious and aesthetic change of heart were crucial events in the development of a sympathetic attitude towards revivalist art in Germany. But there were many others who were following parallel paths in the first decade of the nineteenth century. Some, like the Boisserée brothers, were inspired to look anew at the old devotional art through its dispersal from the religious institutions in which it had been housed in obscurity over the centuries. Collections grew up not only in the Catholic west and south of Germany—in Cologne, Heidelberg, Frankfurt and Munich—but even in the Protestant north, in Berlin, where the timber merchant Solly's stupendous collection included a generous selection of old German masters. Goethe continued to hold out against the tendency, but his position became increasingly isolated. The developing patriotic mood after the French invasion of 1806 provided a context in which both Catholic and Protestant could look to medieval Northern art as a symbol of an age in which Germany had been vigorous and strong. Indeed, the title of the article that the Weimar Friends of Art brought out against the movement in 1817, 'Neudeutsche religiös–patriotische Kunst', emphasizes the kind of associations that favoured the revival.

Schlegel's original characterization of medieval art had been couched in terms generally applicable to all primitive art. Similarly the artists most sensitive to the simplicity of Greek art were the first to find comparable characteristics in the pictures of the Middle Ages. The tendency was an international one, equally discernible in the designs of Blake in England and in the paintings of Ingres and Fleury Richard in France. Most significant for the German artists was the interest in early Italian pictures pioneered by such enthusiasts as Thomas Patch and Séroux d'Agincourt which began to affect artists' work in Rome during the 1790s.[10] In particular, the Flaxman illustrations of 1793 to Dante and the Carstens drawings of *Faust*[11] provided examples of classical artists assimilating medieval motifs and linear rhythms into their styles. As in Germany, this interest was stimulated and supported by the parallel development of a historical investigation into the art of the early masters. For example, Flaxman was a close friend in Rome of William Young Ottley, who was then already preparing a publication of engravings after these artists in collaboration with the Dutchman Humbert de Superville.[12] In the succeeding decades the close relationships between historical investigators and revivalist painters remained, and amongst the strongest supports of the Nazarenes were the German pioneers of art history August Kestner, Karl Friedrich and Freiherr von Rumohr.[13]

The support of such enthusiasts could on its own no more generate a truly revivalist art than could the sympathetic critical attitude to medievalism in Germany. In the decade before the emergence of the Brotherhood of St Luke in Vienna in 1808 there were a number of German artists both at home and in Rome who espoused the medieval cause. They worked in an eclectic classico-gothic style quite analogous to those of Blake and Ingres, though lacking their originality. A highpoint in this development in Rome was Gottlieb Schick's *Sacrifice of Noah* (Plate 111). Schick was a Stuttgart artist who arrived in Rome in 1802 after four years of study with David in Paris. He soon became acquainted with Joseph Anton Koch, who was extending the archaic tendencies of his mentor, Carstens. Schick did in fact collaborate with Koch on a *Sacrifice of Noah* (Städel Institut, Frankfurt am Main) in 1803 in which the thanksgiving takes place in a tersely schematized wasteland. When he exhibited his own version at the Pantheon in 1805, Schick was felt in revivalist circles to have achieved a spiritual as well as a technical regeneration. August Wilhelm Schlegel, who was in Rome at the time, described the work in a letter to Goethe as possessing 'the feeling of devotion which had been totally absent from contemporary painting'.[14]

Schick was an artist of undeniable piety, but his relief-like picture has little of the early masters about it. Like Koch, he took his cue from Poussin, in this case basing the circular composition and even the disposition of the individual figures upon a work then believed to be by the French master.[15] Although Schick has taken pains to give the forms in his picture—even those in the background—a linear clarity, he still resorts to the use of chiaroscuro to articulate their actions. The rhetorical gestures of the protagonists are nearer to the conventions of the Bolognese than to the more restrained motions in pre-Raphaelesque art.

Schick looked to the archaic more as a form of corrective than as a paradigm. But even those artists more closely involved with revivalist critics, scholars and collectors were hardly more radical than he in their work. This is certainly the case with the first artists to be actively involved with the medievalism of the Schlegel circle, the brothers Franz (1786–1831) and Joseph Riepenhausen (1788–1860). These Göttingen-born painters were the sons of the engraver Franz Ludwig Riepenhausen, the man who had engraved the German edition of Flaxman's outlines to Dante's *Divine Comedy* in 1802. In 1804 the brothers also made a series of engravings in the strictest neoclassical taste, a reconstruction

of the Homeric murals at Delphi by Polygnautus as described by Pausanias. When published in 1805 these were highly praised by the Weimar Friends of Art for the authenticity of their archaism, their use of pure outline and their eschewal of perspective effects in favour of a frieze-like arrangement. Yet in the interim the brothers had already become converted to the new medievalism. They had been encouraged to pursue this direction by the Freiherr von Rumohr. He brought them to Dresden where they completed their training under Runge's former friend Ferdinand Hartmann. Here they produced a series of outlines of scenes from Tieck's drama on the life of St Genevieve (Plate 2) in which full attention was paid to the evocation of the period through the elaboration of detail. The Catholic and devotional nature of the scenes was emphasized by commentaries written by another patron of the Riepenhausens', Christian Schlosser. Schlosser was an enthusiastic follower of Schelling and the Schlegels, and the instigation of the whole project may well have come from him. In any case the Genevieve outlines were immediately identified with the Schlegels' circle—to the extent that they appear to have been the first works of art described as having been executed in a 'romantic' style.[16] In this case the style was essentially a revision of the outline method of Flaxman—a revision that entailed a greater elaboration of detail and an attempt to replace Flaxman's generalized forms with figures of more individual expression and 'character'.

Despite this, there is little about these illustrations that could be called German in a historical sense. For the Riepenhausens, devotion was more important than nationalism, and in September 1805 they moved to Rome, where they were to remain for the rest of their lives. In Rome they played their part in the revival of early Italian art by planning a history of Italian art, of which the first and only volume appeared in 1810. Although it was not a commercial success, the drawings for this volume—from Cimabue and Giotto and other early masters—provided an inspiration for the young Overbeck in Lübeck when he was shown them by a mutual friend, August Kestner, in 1806.[17]

Although the Riepenhausens were committed in a programmatic sense to the revival of Christian art, their own paintings still did not make a total break with the conventions of classicism. Their forms were still rounded and modelled, there is a sense of a generalized aesthetic in them, the medievalism being in reality no more than a trapping. Apparently their own beliefs had a similar shallowness; or so Rumohr, their original patron, was to feel by 1807. In that year his friend, Schelling's wife Caroline, reported: 'Rumohr has expended all faith, love and hope in the Riepenhausens since he fancied that he saw art reborn in them. He has found their piety to be as empty as their work.'[18]

The Riepenhausens continued to survive in Rome for several decades, making a modest living with their Madonnas, scenes from the life of Raphael and (it must be admitted) a few antique indiscretions, for example the *Death of Socrates*.[19] But they never regained their brief moment of glory as innovators in the medieval revival.

In view of the earlier work of Schick and the Riepenhausens, it might seem to be fortuitous that the group of six students at the Vienna Academy who founded the Brotherhood of St Luke on 10 July 1809 as a mark of the anniversary of their first meeting should have become the focus for revivalist art amongst German painters. There was nothing unique in their outburst against the teaching of the Academy, or in their semi-metaphysical dedication to Truth, the virtue whose initial was inscribed upon the keystone of the arch in the design by Overbeck that they chose as their emblem. Nor, in the first instance, was their revivalism of a dogmatic nature. Their outlook was nearer to that of Wackenroder than to Schlegel's. They were prepared to admit that there was more than one path to perfection, and that each artist must choose according to his individual talent. Within their own group there were a variety of choices. Franz Pforr, the leader, painted scenes from 'the time of the Middle Ages, when the full force of human dignity

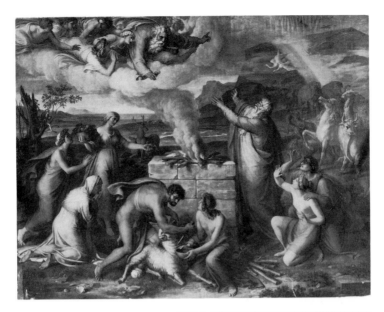

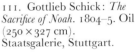

111. Gottlieb Schick: *The Sacrifice of Noah*. 1804–5. Oil (250 × 327 cm). Staatsgalerie, Stuttgart.

112. Friedrich Overbeck: *The Raising of Lazarus*. 1808. Oil (41 × 53 cm). Museum für Künst und Kulturgeschichte, Lübeck.

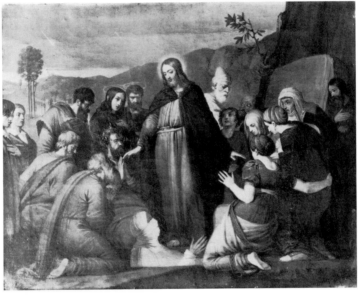

was still manifest'.[20] His close friend and co-leader, Friedrich Overbeck, dedicated himself exclusively to religious works. The other, lesser talents—Johann Konrad Hottinger (1788–1828), Joseph Sutter (1781–1866), Ludwig Vogel (1788–1879) and Joseph Wintergerst (1783–1867)—were even more diverse. Two of them were not even primarily interested in the medieval revival: Hottinger wished to paint more modern subjects and Sutter those of antiquity.

As this variety suggest, the students' quarrel with the Academy had little to do with its classical bias, but was aimed instead at its apparently mindless routines. The one teacher they did admire, Eberhardt Wächter, was in fact a classical follower of Carstens and Koch. This painter regaled them with tales of Rome. He was appreciated by them above all for his honesty—for the 'individual character' that they felt emanated from his works.

'Truth' and 'Individual Character' were very much the keywords of the Brotherhood. Indeed, the two were linked for them, as they felt truth could only be arrived at through sincere individual expression. Furthermore, they recognized the need for approaching the ideal by means of the real, to prevent it from 'leaving us cold'. It was this combination of a spiritual ideal with honest description that they found in the works of the early German masters Dürer, Cranach and Holbein, whose work they came across when they visited the

Imperial Gallery in the Belvedere. When Pforr wrote of how the 'noble simplicity and definite character' of early German works spoke to their hearts, he was making a significant amendment to the well-known definition of the qualities of Greek art of Winckelmann: 'noble simplicity and quiet grandeur'. To the classicist's idealism he was adding a sense of the personal.

The imaginativeness and individualism of the Brotherhood's early years seem to have been due largely to the personality of Franz Pforr. It was not until after his death in 1812 at the age of twenty-four that the movement began to emerge as the representative of a more conventional patriotism and piety. Pforr's own art and career were pursued with an almost pathological emotionalism that may well have contributed to his early death. The son of an animal painter in Frankfurt, he was orphaned at an early age and brought up by a guardian. After having studied from 1801 under a maternal uncle, J. H. Tischbein, he went in 1805 to the Vienna Academy. Here the size and impersonality of the institution made him more introspective and precipitated a personal crisis. Previously he had wished to be a painter of horses and battle scenes, following in the footsteps of his father. There now developed in him a contrary longing for peace and security, and a recognition that with his sickly health and nervous disposition he was, as he wrote on 6 January 1809 to Johann Passavant, his close childhood friend and the son of his guardian, 'unfit for the unquiet, large life'. His earlier ambition was not finally laid aside, however, until 5 July of the same year, when he was present at the decisive battle of Wagram near Vienna, at which Napoleon defeated the Austrians. His disappointment at the misfortunes of the present and his own powerlessness became a further incentive to submerge his passionate longings in an adulation of the heroism of the Middle Ages. It was only four days after the battle of Wagram that the Brotherhood was established.

These events seem also to have resolved a duality in Pforr's style. Previously he had oscillated in his drawings between spirited scenes of battle or dramatic literary moments such as *Macbeth and the Witches* (1807–8, Städel Institut, Frankfurt am Main), in which the excitement is conveyed through the use of dark washes and vigorous contrasts, and a more static and exacting outline style, as that used in the *Allegory of Friendship* (1808, Städel Institut, Frankfurt am Main), in which a pair of embracing idealised female figures surrounded by symbols represent Pforr's own relationship with his friends Passavant and Overbeck. It was the latter manner that he was to develop. This clear linear style of drawing showed all details meticulously outlined and all shading executed by means of careful hatchings. It was influenced by sixteenth-century engravings and early silverpoint and pen drawings and became a talisman of the Brotherhood. As with Pforr's amendment of Winckelmann's definition, this was a revision of the neoclassical outline method in the direction of the characteristic. It also became an indication for the Brotherhood of honest craftsmanship. They contrasted it with the facile effects of the broad chalk drawing manner favoured in the Academy.

Above all, Pforr was encouraged to work in this more tranquil manner through his friendship with Overbeck, who entered the Academy in 1805 and became a firm friend a year later, once Pforr had overcome his jealousy at the younger artist's greater technical accomplishment. A quiet prudish youth, Overbeck had arrived from his native Lübeck already fully resolved to devote his life to painting religious subjects. In contrast to Pforr, there was a curious passivity in Overbeck's character. The strength of his piety and convictions is not in doubt. But he often seemed cold in his personal relations. For example, he never returned to his home town to visit his family once in his long life, despite the affection and sympathy evident in his father's letters. And when in 1810 he was faced with the choice of using some money he had been given either to finance his journey to Rome or to assist his family (who were hard-pressed due to the reversals of the war), he

decided upon the former without, it seems, undue soul-searching. In his closest artistic friendship he was more the receiver, Pforr the giver. Indeed, it seems to have been the sheer placidity of Overbeck and his art that attracted Pforr in the first place. Never a painter of dramatic scenes, Overbeck assimilated the new primitivism as effortlessly as he formerly had the sub-classicism of the Riepenhausens' outlines in Lübeck. His *Raising of Lazarus* (Plate 112), the picture he later referred to as his 'firstborn', was begun as an outcome of his first discussions with Pforr. It has a calm Raphaelesque design. Christ stands in the middle, his outstretched hands held low, permitting, rather than commanding, the figure of Lazarus to rise, hands clasped in prayer, from the hole in the ground before him. The crowd—which includes Overbeck and Pforr—show less wonderment than acceptance as they gather in a neat circle around the miracle. The chiaroscuro is subdued, the landscape complementary. There is nothing to disturb the gentle undulation of the lines as they pattern the picture's unassuming symmetry. It may not be a very exciting work, but it certainly has the calm normality that Pforr so admired in the early masters, where 'everything is presented simply, as though it had not been painted but had grown thus'.[21]

113. Franz Pforr: *Count Rudolph of Hapsburg and the Priest*. 1809. Oil (45.5 × 54.5 cm). Städelsches Kunstinstitut, Frankfurt.

By contrast, the first picture that Pforr had chosen to paint after making friends with Overbeck was that of *Wallenstein at the Battle of Lützen*—a subject from Schiller—which revealed 'the steadfast spirit of this man, who showed himself so decisive in this fearful moment'.[22] After his conversion to a more tranquil approach a year later he still maintained a sense of the heroic although now the performance of duty tended to be emphasized, rather than the making of decisions. The subjects of Schiller and Goethe that had a chivalric bias remained a favourite source. In 1810 he undertook a series of illustrations to Goethe's *Götz von Berlichingen* (Städel Institut, Frankfurt am Main) which received the slightly condescending approval of the author. At the same time he painted his first fully archaic picture, *Count Rudolph of Hapsburg and the Priest* (Plate 113). The theme was taken from a poem by Schiller which describes Rudolph, the first member of the illustrious dynasty to be elected to the German monarchy. While out hunting the Count had come across a priest hindered by a river from reaching the house of a dying man to give him the last sacrament. Rudolph offers the priest his horse, and the act is later remembered to his advantage when he has achieved greatness. Like Wallenstein, Rudolph was venerated by Pforr as a figure who had worked for German unity; but in this scene he represents as well the respect of secular for ecclesiastical authority.

Just as Schiller's poem harks back to the simple form of the Ballad, so this picture has a naïve directness in its presentation of the story. Pforr was typical of his generation in considering medieval painting to be an expression of popular culture. Like Wackenroder and Tieck he saw Dürer's strength as having derived from his close connections with the people. At the same time as he collected Dürer engravings, he also acquired popular woodcut books from the sixteenth century and admired the examples of contemporary peasant art that Vogel had brought with him to Vienna from his native Zurich. In *Rudolph of Hapsburg and the Priest* the simple poses, clearly outlined shapes, flatly applied colours and lack of chiaroscuro have a primal directness that is if anything closer to folk art than to the painting of the late Middle Ages.

No revivalist painter had risked such artlessness before, and, indeed, it is hardly likely that one with a less innocent imagination would have been able to do so effectively. This picture stands apart from the main direction of modern primitivism, where the gaucheries of some naïve artist are used to revive the sophisticated palate. The effect here is dependent upon a close identification with the tradition from which the simplicities have been drawn.

It seems unlikely that even if Pforr had lived such innocence could have been sustained in the movement for long. Already in their decision to move to Rome in 1810 the Brotherhood were laying themselves open to new and more overwhelming experiences. It is true that they went to this conventional artistic haven to discover the medieval Christian world rather than that of pagan antiquity; but they were nevertheless removing themselves from their native soil, from the source that according to Wackenroder had preserved the strength and character of the art of Dürer and his contemporaries.

Perhaps the Nazarenes did not feel themselves so dependent upon locality, because they carried their own microcosm with them. They sealed themselves off from contemporary society, and found within themselves Wackenroder's artistic polarities. Pforr, the 'leader', was likened by them to Dürer—passionate, direct and full of character. Overbeck, the 'priest', was compared to Raphael on account of his piety and tranquil idealism.

In Rome, those members of the Brotherhood who had made the journey—Pforr, Overbeck, Vogel, Hottinger and, a year later, Wintergerst—found encouragement for their separateness in an atmosphere sympathetic to artistic isolation. They gained, through the good office of the director of the French Academy, permission to occupy the

XXV. Adolph von Menzel: *The Artist's Sister*. 1847. Oil (46 × 32 cm). Bayerische Staatsgemäldesammlungen, Munich.

nearby monastery of S. Isidoro, which had been devoid of its original community of Irish monks since the suppression of religious orders by the occupying French forces. Here each of the Brothers slept and worked in a cell and joined the rest of the group in the evenings for meals and communal reading and drawing from the model. This last activity became the focus of a small academy which was attended not only by the Brothers, but also by like-minded artists such as the Riepenhausens. At about the same time, the Brotherhood began to grow their hair long and to adopt long, flowing robes in the Biblical manner, such as that worn by Overbeck in Pforr's *Shulamit and Maria* (Plate XXVI).

The degree of make-believe that was practised in the monastery can be felt in the portrait of Pforr (Plate I) painted by Overbeck soon after their arrival in Rome, while awaiting delivery of the large canvasses they had each been working on at their departure from Vienna—Overbeck's *Entry of Christ into Jerusalem* (1810–24, formerly Marienkirche, Lübeck) and Pforr's *Entry of Count Rudolph of Habsburg into Basle in 1273* (1809–10, Städel Institut, Frankfurt am Main). This portrait showed Pforr, as Overbeck remarked, in the surrounding in which he would perhaps feel happiest.[23] Appropriately Overbeck chose a Northern prototype with which to portray his Düreresque friend. The picture is painted with the illusionism of Flemish fifteenth-century art, with its *trompe-l'oeil* frame and view through a window to a Gothic town by the sea. As in the portraits of the fifteenth century, the man is described by his attributes. Beside him is a cat, whose markings mimic the hairline of the young painter. The cat's meek pose is echoed by the virtuous woman, Pforr's ideal, who reads and knits in the room behind him. All this conveys a feeling of sleekness, modesty and tranquility—what Pforr dreamed of. But other symbols have more sombre overtones. Around the frame are the grapes that allude to Christ's passion. This meaning is emphasized by the meditative symbol of a skull surmounted by a cross. This last had been chosen by Pforr at the time of the foundation of the Brotherhood as his

XXVI. Franz Pforr: *Shulamit and Maria*. 1811. Oil (34.5 × 32 cm). Georg Schäfer Collection, Schweinfurt.

114. Franz Pforr: *The Morning of the Weddings of Shulamit and Maria*. 1810. Pencil (23.7 × 40.5 cm). Staatliche Museen, Kupferstichkabinett und Sammlung der Zeichnungen, Berlin (East).

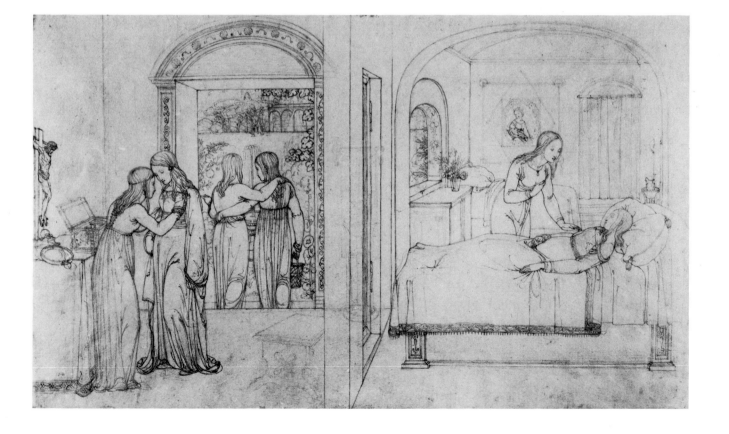

personal emblem—no doubt as a reflection of his own precarious hold on life. Overbeck had on this occasion, equally typically, chosen for himself the palm of peace.

The picture bears witness to Overbeck's skill in portraiture—a genre that he practised all too rarely. While he increasingly turned his eyes towards the ideal—to the point of resolving never again to draw from the female nude in case this should coarsen his sensibilities—he left untapped a remarkable gift for observation. It was regretted even amongst the Brotherhood that Overbeck did not base his religious paintings more closely on his studies, and that the exquisite drawings that he did produce (Plate 12) were not pursued further.[24]

While Pforr continued to paint chivalric scenes in Rome—completing the *Entry of Rudolph* and augmenting his *Götz von Berlichingen* series—his declining health led him to become increasingly obsessed with his own fate and that of his companion. In 1810 they each agreed to paint a picture on the theme of their friendship and their ideals. Overbeck's allegory—a pastiche on Pforr's 'Friendship' drawing of 1808—was left unfinished for seventeen years, when it emerged as the impersonal *Italia and Germania* (Neue Pinakothek, Munich); Pforr's was completed in an intensive burst of activity a few months prior to his death. It was as though he wished to record the depth of his vision, his artistic credo, before he died. Designed as a diptych linked by a spandrel containing the figure of St John—the most spiritual of the evangelists—it encompassed the dual aspirations of German revivalism. In the left-hand compartment is the peaceful, Italianate ideal of Overbeck. The female who embodies this ideal is named Shulamit after the loved-one of the Song of Songs and of Klopstock's Odes. On the right is Pforr's Northern ideal, the contemplative Maria, seated in a darkened room. As might be suspected from the meticulous settings, these two ideal forms had built around them an elaborate legend. In creating such a context for his art Pforr was attempting to provide it with what Friedrich Schlegel described as 'a centre, such as mythology gave to the ancients'.[25] He even went so far as to write a ten-chapter fable around the girls, a fairy-tale of his own devising very much along the lines of those that Tieck, Brentano and La Motte Fouqué were providing in contemporary literature.[25] The 'Book of Shulamit and Maria' presented to Overbeck on 24 September 1811, told the story of two sisters who eventually became betrothed to two artists who bore the names that Pforr and Overbeck had chosen for themselves—Albrecht and Johannes. He made as well a series of illustrations for it (Plate 114): neat, outline designs charting the hermetic world and its denizens.

The painting, the lapidary culmination of this legend woven around the personae of Pforr and Overbeck, has the silence and enigma of a private altarpiece. Its diptych form suggests the small devotional paintings that were used in houses and taken on journeys in the Middle Ages. As in these works, too, one side provides the focus for attention. In this picture the focus is on the left, where Shulamit, the ideal of the South sits in a garden of peaceable imagery like Raphael's *Belle Jardinière*. It is this idyll that the window of Maria's slanted chamber—so reminiscent of that in Dürer's contemplative *St Jerome*—overlooks. This bias is emphasized by the colours. The side evoking the South is bathed in a gold light, with bright reds and blues and greens. The other side (which Pforr saw as the 'silver' side of the picture) has a dulled harmony of black and ochre, which subdues even the greens and reds that appear in it. Above the Northern interior is a lunette with a cross, laurel wreath and swallow; the lunette that surmounts Shulamit's side holds a dove and flowers. All this suggests a general distinction between Northern longing and Southern fulfilment. But the allegory ends on a more personal note. While Overbeck is shown entering the garden of his Shulamit, Pforr's presence is suggested by no more than the cat nestling at Maria's feet. Pforr knew well enough that he would never fully enter the domain of his art.

Even before the death of Pforr on 16 June 1812, the Brotherhood were developing in new directions. Their presence in the Roman community had forced a division between classicists and medievalists. It was probably one of the former, the landscape painter Johann Christian Reinhart, who dubbed them 'Nazarenes' in the first place.[26] They found themselves turned into the leaders of a movement enthusiastically supported by Koch, the Riepenhausens and several apologists for the Catholic revival, Rumohr, Schlosser and Count Stolberg. Overbeck's admission to the Catholic Church on Palm Sunday, 1813, further emphasized the movement's involvement with religious dogmatism.

Overbeck was to become in the succeeding years the principal exponent of revivalist painting in Rome. However, it was another artist, a new arrival from Germany, who was to provide the Nazarenes with a prestigious secular role. When Peter Cornelius (1783–1867) reached Rome in the autumn of 1811 he was already fully trained as an artist. From the time of his apprenticeship from 1795 to 1800 at the Düsseldorf Academy where his father was a teacher, his primary ambition had been to become a monumental painter. When he first came to Rome he was uncertain as to whether this aim would be best served by aligning himself with the classicists or with the 'Christian Romantics'. However, he soon fell under the spell of the medieval camp, and in September 1812 he was formally received into the Brotherhood.

Rome was not the beginning of Cornelius's association with the archaic. Previously he had come into contact with the revivalists through the Boisserées and Wallraf in Cologne. Indeed, it had been through a recommendation of the latter that he had received his first mural commission, the decoration of the choir of St Quirin in Neuss in 1807–8. In the following year he was in Frankfurt, where Dahlberg encouraged him to develop his interest in the Gothic. In the absence of further mural commissions he gave vent to his penchant for dealing with themes on a cyclical scale by designing illustrations. Part one of Goethe's *Faust*, published in 1808 and immediately hailed as a major achievement of the new German literature, gave him just the opportunity he sought. The story, set in the sixteenth century, seemed to be both nationalist and revivalist in its sympathies. Like many other contemporaries, Cornelius was not at first aware that these elements were peripheral to the universal dimensions of the drama; these became fully clear only when the second part of the play was published at the end of Goethe's life. For Cornelius the work provided the opportunity to display his recently acquired *altdeutsch* expertise. The seven drawings that he sent to Goethe through the agency of Sulpiz Boisserée in 1811 were above all intricate feats of penmanship (Plate 115). Full of flourishes and hatchings they reveal the impact of another publication of 1808, the lithographs by Nepomuk Strixner after the pen drawings made by Dürer in the prayer-book of the Emperor Maximilian (Plate 116). Even more than the technique, it was the inventive play of these drawings— the descendants of the drolleries of the illuminated manuscripts modulated by an Italianate decorativeness—that liberated in Cornelius a similar feeling for the grotesque.[27]

Goethe's reception of the works was full of the reservations that he habitually felt at the Gothic productions of the younger generation. He praised Cornelius's inventiveness and handling of drama, as well as his absorption of the 'mode of thought' of the sixteenth century. Yet he offered at the same time a warning against too close an imitation of the cramped style of the old Germans. He recommended as an antidote the study of the Italians and, ironically, the Maximilian drawings, which he felt showed Dürer at his most 'free, ingenious, great and beautiful'.[28]

Cornelius, never a man to be intimidated, replied in kind, pointing out to Goethe that he himself had encouraged the tendency towards the old Germans through his poems and

dramas. Nevertheless, he was already following the course the poet recommended. His *Faust* illustrations were already less Gothic than the earlier drawings from German legends that he had made, and the Maximilian illustrations provided him with an example of a synthesis of Gothic fantasy with Renaissance stylism which he was to pursue further when he came to Italy. The later Faust drawings, made after he had arrived in Rome, show increasingly the impact of the High Renaissance. This is even more the case in his sequel, the illustrations to the *Nibelungen*, published in 1818, two years after the *Faust* designs. In these the heroic forms show an emulation of Michelangelo.[29]

It was the more muscular and vigorous side of Italian Renaissance art that Cornelius admired. In contrast to Overbeck, he was always critical of Raphael, preferring instead the monumental schemes of Michelangelo, Signorelli and Mantegna. These artists encouraged not only his sense of the dramatic, but also a terse asceticism that was to disconcert many critics. He was always concerned with becoming a historical artist, but his ambitions were also strongly nationalistic. While Overbeck sought to purify, Cornelius sought to overwhelm, to affirm the strength of the Germanic tradition. It was not his intention to remain in Rome. He came merely to learn. As he wrote to King Ludwig in 1822, 'Its time is past; ours is to come.'[30]

That the first demonstration of the new national art should have taken place in Rome was largely fortuitous. Through the Prussian ambassador Niebuhr, Cornelius had been attempting to persuade the Prussian government to provide him with a mural project in Berlin. The efforts proved inconclusive, however, and in 1815 the newly arrived Prussian consul, Salomon Bartholdi, took matters into his own hands, commissioning Cornelius and other members of the Brotherhood to decorate the reception room in his lodgings. Although the original project was a modest and temporary one—Bartholdi had been

thinking of no more than arabesques and had taken out a lease on the dwelling for only five years—Cornelius and his colleagues accepted it with the utmost seriousness. The four commissioned artists—Cornelius, Wilhelm Schadow, Philipp Veit and the landscapist Franz Catel—were all from Prussian-controlled territories. But Catel agreed to reduce his part in the scheme to providing a *sopraporte*, and this allowed room for the non-Prussian Overbeck to be brought into the group. The theme chosen for the decorations was the story of Joseph—one that was dear to Overbeck's heart, but which had been selected before he was included in the scheme. The emphasis was on the story's Old Testament prefiguration of the Christian notion of forgiveness—an appropriate enough subject for the reception room of a Prussian diplomat just after the Congress of Vienna.

The scheme provided the opportunity to show the Nazarenes' ability to handle a narrative on a monumental scale; it was also a convenient demonstration of their ability to revive the practices of the past in terms of both teamwork and technique. The group worked in close collaboration, each being allotted two subjects to do. They set themselves the highest standards of craftsmanship, learning the technique of fresco from a plasterer who had once worked for Mengs. They determined to work only in the exacting method of pure fresco, without any subsequent *a secco* modifications: the kind of standard that was adhered to by the artists of the High Renaissance. But while the latter had used the method to demonstrate professional expertise, the revivalists saw it as a means of restricting themselves to the simplest and most direct effects.

The success of this technical side of the Nazarenes' venture is evidenced by the fact that the works, which were transferred to Berlin in 1887, are still in perfect condition. Stylistically, however, their achievement is more equivocal, for they seem to mark the point where the Nazarenes' archaism ceased to be inventive and came too close to the models being emulated. Despite this the personalities and inclinations of the individual artists can be clearly discerned in the works. Overbeck's principal contribution, *Joseph Sold by his Brothers* (Plate 117), is painted as a simple narrative with a sequence of events weaving across the picture, as in a medieval painting. It is far more naïve in style than the design on this subject by Raphael in the loggia of the Vatican, from which it takes its cue. The rhythms and gestures of the figures have that characteristically Overbeckian meek, doll-like air, which in this case is not altogether inappropriate to the wistful nature of the theme. Cornelius, on the other hand, remained true to his more dynamic prototypes. His *Reconciliation of Joseph and his Brothers* (Plate 118) provides a Michelangelesque conclusion to the cycle. The supporting figures in the frieze-like design positively reverberate with the energy generated by Joseph's embrace of his youngest brother Benjamin. Instead of Overbeck's background of decorous vignettes, moreover, there is a strongly perspectival view into the distance, emphasizing the gap which Joseph's gesture is symbolically bridging.

For contemporaries the frescoes represented a moral victory, a triumph of the spirit over materialism. Perhaps only in the Romantic era was it possible for a group of artists to be taken so much at their word, and for their work to be admired primarily for the spirit in which it had been created. In Germany, as Overbeck's father reported to him, it was assumed that the spirit had been primarily a nationalistic one. Commentators were quick to seize upon the political implications of this artistic regeneration. The attack on neo-German religious–patriotic art by the Weimar Friends of Art in 1817 did little more than provide the occasion for an eruption of stirring defences of revivalism by such critics and connoisseurs as August Kestner and Friedrich Schlegel. The exhibition of the cartoons for the Bartholdi frescoes in Frankfurt during this year further enhanced the reputation of these artists. They were hailed as having brought about the 'rebirth' of German art. In 1818 this role was officially accorded them when Crown Prince Ludwig of Bavaria, on an

115. Peter von Cornelius: *Faust and Mephisto on the Brocken*. 1811. Pen (40.5 × 34 cm). Städelsches Kunstinstitut, Frankfurt.

116. Johann Nepomuk Strixner: Page from *Albrecht Dürer's Christlich-Mythologische Handzeichnungen*, Munich, 1808. Lithograph.

art tour in Rome, invited Cornelius to paint murals in the sculpture gallery that he was then having erected in Munich. From the start Cornelius took the didactic nature of his role with the utmost seriousness, and the example he set in Munich created a new direction in German monumental art, which will be discussed in Chapter X.

In Rome, too, the Nazarenes' work seemed to provide the culmination of the revivalist movement in painting. Admired even by the neoclassical sculptor Canova, they were offered commissions in the Vatican[31] and an opportunity to work on a further cycle of frescoes by the head of one of the leading families of the Roman aristocracy, Carlo Massimo. This time they placed their gifts in the service of Italian nationalist pride, for the commission was to decorate three rooms of a garden pavilion with scenes from the great Italian medieval and Renaissance poets Dante, Tasso and Ariosto. The Bartholdi frescoes had marked the unity of the movement. The Massimo project signalled its dispersal. It took ten years to complete, from 1818 to 1828, and neither of the two painters originally commissioned—Overbeck and Cornelius—stayed the course. Cornelius's room—the Dante room—was painted instead by Koch and Philipp Veit: a highly discordant combination, since Koch crammed the small walls with Michelangelesque contortions while Veit decorated the ceiling with a schematic presentation of paradise that exceeded even Overbeck in its staticness. Overbeck actually painted a considerable amount of his room—the Tasso room—though with flagging enthusiasm. The death of the Marchese Massimo in 1827 released him from his obligations and the last walls were completed by a young painter from Prague, Joseph Führich.

Although the Massimo project marked the dispersal of the original group, it also showed the continuing allure of the Nazarene ideal for a younger generation. The finest works in it were the frescoes of the Ariosto room, which were painted by a new arrival in Rome, Julius Schnorr von Carolsfeld (1794–1872). Schnorr had come to study in Vienna a year after the main body of the Brotherhood had departed for Rome. He found there a

117. (left) Friedrich
Overbeck: *Joseph Sold by his
Brothers*. 1816–17. Fresco
(243 × 304 cm). Staatliche
Museen, National-Galerie,
Berlin (East).

118. Peter von Cornelius:
*The Reconciliation of Joseph
and his Brothers*. 1817. Fresco
(236 × 290 cm). Staatliche
Museen, National-Galerie,
Berlin (East).

considerable interest in revivalism through the presence of the Olivier brothers and, after
1812, of Joseph Anton Koch. There was also the critical support of Friedrich Schlegel,
who had been resident in the city since 1808 and whose stepsons Johann and Philipp Veit
were adherents of the movement. Through the Olivier brothers, who became his mentors,
Schnorr turned towards carefully hatched drawings and a naïve painting style, depicting
religious and legendary subjects with all the innocent charm of Pforr. Indeed Schnorr,
who remained a Protestant, was always drawn most by the chivalric side of the
movement. Long before his commission for the Casino Massimo in Rome he had painted
as his first major oil scene from Ariosto, the *Battle of Lipadusa* (1816, Kunsthalle, Bremen).
Unlike Pforr he had a sophisticated—almost mannerist—use of the gaucheries of the
naïve. He seemed at the same time both to use simple narrative method of the primitive
and to revel self-consciously in its charm. His delightful portrait of the wife of his early
major patron, *Frau Bianca von Quandt* (Plate XXVII), is a quite different type of make-
believe from that of Overbeck's portrait of Pforr. Seated in a loggia, playing a lute (she
was an accomplished guitar player) Frau von Quandt is shown wearing a costume similar
to that of Raphael's Joanna of Aragon. But there is a self-awareness in her pose that
suggests that this is no more than a fancy dress she has donned for the occasion; that
columns, emphatically simplified plants and distant castle in a mountainous terrain are
not the product of her imagination, but are the artist's flattery. The rich, deep-toned
colours, the full curves and repeating oval shapes—even the playful hint of a halo in her
hat—are all part of a game of gallantry that can be found as well in the *risqué* wit of certain
remarks intended for her in the letters the artist wrote to her husband at this time.

Even in Schnorr's more serious works there is a lyrical charm. In the most influential
achievement of his life, the *Bible in Pictures*—a didactic project that he conceived in Rome
and worked on for most of his life, and which was published in wood-engravings in
1855[32]—the Biblical legends are told in a simple, clear, yet moving manner (Plate 119).

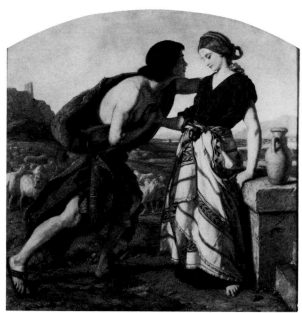

Although the intimacy of Schnorr is often lost in his later monumental paintings, this quality is sustained in the work that he did in the Casino Massimo in 1822–5. On the wall which shows Angelo dallying with the Saracen Medoro while Orlando fumes in the shaded foreground, Schnorr responded fully to the imaginativeness and rhythmic perfection of Ariosto's reinterpretation of chivalric legends. His fine sense of colour and feeling for nature are combined through vivid, simple patterns. This can be seen in the way the gracefully declining movements of the seated couple flow on into the rocks beneath them, and are picked up in the hillside behind. This use of landscape shows how well he had absorbed the fresh and original observation of the Olivier brothers.

In 1825 Schnorr was offered a mural commission by Ludwig of Bavaria, and in 1827 he left for Munich, where he worked on a suite of rooms illustrating the *Nibelungen* in the royal residence. In these pictures his talent gradually lost its impetus. But he was still one of the Nazarenes whom foreigners found most attractive, for his work in the Casino Massimo, for his drawings and for his personality. When the Royal Commission in England began to take an interest in the achievements of contemporary German artists as part of a study to see how English artists could best profit from the opportunity of decorating the New Palace of Westminster in the 1840s, it was Schnorr who provided its secretary, Sir Charles Eastlake, with the most helpful advice.[33] Schnorr's opinion was that, even if they did not have much previous experience in this field, British artists should be chosen to execute this national project both because they would be able to come closest to interpreting a national pictorial culture, and because of the incalculable value of the opportunity for the younger generation. The outcome of this decision was not quite what was expected, and the series of competitions held in 1843–7 to select the artists for the frescoes in the Houses of Parliament did no more than encourage a superficial Germanism in the art of many contemporary British history painters, among them Daniel Maclise.[34] Yet in another sense this phenomenon was fruitful, for it stimulated a reaction that led to a truly indigenous interpretation of the archaic in the art of the Pre-Raphaelite Brotherhood established by a group of Royal Academy students in 1848. It also stimulated the thoughtful archaism of William Dyce (1806–64), an artist who had interests similar to the Nazarenes. Dyce was a friend of Overbeck, whom he met in Rome in 1829. He wished to reintroduce 'Christian' art into the Anglican Church, but could not accept the full implications of the Nazarene creed. Dyce faced the dilemma common to many Victorian painters of how to re-create the spiritual purity of ancient art in a

materialist age. He could not condone the limits on naturalism found in the art of the Nazarenes. He criticized their lack of cast shadows, for to him the knowledge of the present age could not be ignored or diminished. His own solution was a synthesis, an art in which the directness of Nazarene design was combined with historical knowledge and penetrating observation. This can be found in his *Meeting of Jacob and Rachel* (Plate 120), where he drew up on his memory of Schnorr's design for the same scene, which he had seen on his visit to the German artist's studio in 1836. But in place of Schnorr's medievalizing presentation Dyce has painted the Biblical scenery and costumes he imagined would have been correct for the time and place, and has backed up this historical realism with a minutely observed naturalism of effect.

119. * Julius Schnorr von Carolsfeld: *The Meeting of Jacob and Rachel*. Wood-engraving from the *Bilderbibel*, Leipzig, 1855.

120. William Dyce: *The Meeting of Jacob and Rachel*. 1853. Oil (58 × 58 cm). Kunsthalle, Hamburg.

This turning towards the Nazarenes for design but not for detail was a common response to their art throughout Europe, and one that was greatly enhanced by the propagation of their designs through engravings. The art and propaganda of the Overbeckian school was to find support from the Catholic revivalists of all western European countries—from Montalembert in France and Pugin in England. Their pictorial effects were to find resonances even in such unlikely places as the lithographic cartoons of Daumier.[35] In pursuing their course to the end the Nazarenes had demonstrated, if nothing else, the enduring power of the archaic.

Despite the Nazarenes' position, the revivalist movement had involved a close study of the natural. This is evident in the Nazarenes' own drawings—before their experiences had been edited into a more schematic form. It also led to the brief emergence of a type of landscape that is close to that of Friedrich in the quality of feeling that it conveys.

The emergence of revivalist landscape—that which sought to bring archaic methods to the description of nature—took place in a number of centres in south and western Germany as well as in Austria. The most significant, were in Vienna, Munich and Heidelberg. In all cases, too, the development was focussed by the art of the leading follower of Carstens, Joseph Anton Koch. In Vienna, where Koch lived from 1812 to 1815, having elected to go there after the French occupation of Rome, the effect was decisive. Not least important was the praise of Friedrich Schlegel, who emphasized the Germanness of Koch's landscapes, and encouraged his exploration of characteristic effects. Koch's muscular style—which had reached its peak in the *Schmadribach Falls* (Plate IV) he completed in the year prior to his departure from Rome—now became overlaid with terser silhouettes in which the individuality of particular rocks and trees became emphasized. He turned as well to the depiction of Christian legends, and the *Landscape with St Benedict* (Plate 121) was painted in the year that he left Vienna to return to Rome. Here the 'characteristic' landscape is of the area around Subiaco; the monastery can be seen in the distance. Benedict is in the foreground praying in his retreat, while a neighbouring hermit lowers bread to him by means of a rope. All these features are taken from medieval and Renaissance representations, such as that of the Master of Messkirch in the Stäatsgalerie, Stuttgart.[35] The legendary nature of the scene is emphasized by the exotic fowl who sport themselves in the pool near the meditating hermit. The whole landscape expresses a simple faith. It is a view with religious implications, with a contemplative religious figure at the front of it. The clearly defined planes of Koch's vertical classical landscapes can still be found in it. But they have now lost their tension. Instead there is a simpler delight in the description of detail.

Koch shows himself to have been highly responsive to the mood of the revivalist in Vienna. But he also provided the revivalist with a positive view of landscape as a part of the tradition of German art. It is significant that, while the Dresden Romantic landscape painters should have been concerned primarily with the representation of light effects and atmospherics—the fugitive, transient, living spirit—Koch's main interest was a

geological one. It was the structure of the earth that he investigated, the enduring, underlying pattern and the way it controlled the fauna and life of man above it.

It was contact with the art of Koch that brought a sense of structure into the art of the younger revivalist painters. Though this structure was eventually to overwhelm, in the first instance it created an exciting interchange that stimulated a new sensibility. This is certainly the case with the Olivier brothers, Ferdinand (1785–1841) and Friedrich (1791–1859). Ferdinand, the more dominant, had previously trained in his native Dessau under Kolbe, who would have made him aware of the expressive potential of the incisive line and have introduced him to the notion of discovering new relationships in natural forms through the choice of unusual angles and intensifications of effect. He had then studied in Dresden, where he made the acquaintance of Caspar David Friedrich and would have come into contact with the religious use of landscape. After this he went to Paris, where he studied together with Friedrich and another brother, Heinrich, from 1807 to 1810.

121. Joseph Anton Koch: *Landscape with St Benedict.* 1815. Oil (54.5 × 47.5 cm). Staatliche Kunstsammlungen, Gemäldegalerie Neue Meister, Dresden.

122. (facing page top) Ferdinand Olivier: *Quarry by the Parish Church of Matzleindorf.* 1814–15. Pen (16 × 24 cm). Private Collection.

123. (facing page bottom) Ferdinand Olivier: *Saturday: The Graveyard of St Peter's Salzburg. c.* 1817. Pen (19.6 × 27.5 cm). Staatliche Museen, Kupferstichkabinett und Sammlung der Zeichnungen, Berlin (East).

Once in Vienna, the Olivier brothers soon fell in with the nationalistic and religious aspects of revivalism. Friedrich and Heinrich went off to fight in the Wars of Liberation. But Ferdinand remained in Vienna, becoming closely acquainted with Friedrich Schlegel and falling under the influence of the critic's confessor, Clemens Maria Hofbauer. While never abandoning his Protestant faith, Ferdinand Olivier fully absorbed the emotionalism of Hofbauer, the founder of the populist order of the Redemptionists.

Whatever the exact nature of these influences, they enabled Ferdinand Olivier to express a deeply personal sensitivity before nature. In the next five years he was to produce a series of remarkable drawings of the neighbourhood of Vienna and of Salzburg, which he visited in the company of Koch and Philipp Veit in 1814. The *Quarry by the Parish Church of Matzleindorf* (Plate 122) shows a full absorption of the revivalist technique. In place of the bold washes that he used in his drawings on his return from Paris there is a carefully wrought Düreresque surface of cross hatchings. The framing arch at the top shows how much this drawing must be considered as a finished work, a meticulous piece of craftsmanship. But most remarkable of all is the way this careful form of description has been combined with a rigorous sense of design. The strong side light creates a series of surfaces that have an almost cubist rigour about them. In place of the rather placid nature of much of Koch's organization, here there is the exciting sense of multiplicity brought to order; the view of an insignificant part of nature—the backs of houses looking across a working site to the side of a church—has been given importance. It is this involvement with the everyday that gives Olivier's work its charm. It is at the same time spiritual and worldly.

This can be felt best of all in a series of drawings of Salzburg and its surroundings that he had issued as lithographs, the *Seven Days of the Week*, in 1823. In this more public statement Ferdinand made it clear that landscape was being seen in a religious sense, for the seven days of the week are the seven days of Holy Week, and stand for the stages of Christ's passion. It is in effect like a book of hours, yet despite the archaism of the technique each view conveys the most intense personal feeling. *Saturday*, the day of Christ's death, after the crucifixion and before the resurrection, shows the graveyard of St Peter's in Salzburg (Plate 123). Our viewpoint is close to the ground, with a rapidly receding perspective adding to the feeling of disorientation as iron crosses rise around us. The view ends at the rock wall of the mountain against which Salzburg is built. As though heightened by grief, everything is seen more clearly than before, emphatically outlined and described; and as we gradually explore the graves and grasses we find in the background a funeral procession that reflects the mood of the whole.

Such individual sensibility reveals well the quality of mood generated by these followers of the Nazarenes (Ferdinand was admitted to the Brotherhood in 1816) in Vienna. Even his less-gifted brother Friedrich could rise to a similar quality in his studies of withered leaves, meticulously and lovingly recorded (Plates 124–5). Even if he did not have the inventive gifts of his brother, he could still follow the creed of the craftsman with simple faith. In 1818 Friedrich was to go to Rome, where his art was soon submerged in the general stream of revivalism. Nor did Ferdinand's art evade this fate. The intensity and intimacy of his graphic work translated uneasily into the sphere of large-scale oil painting, and by the time he came to settle in Munich in 1830 there was little in his art to raise it above the pastiche. Once in Munich, reunited with his brother Friedrich and his old friend Julius Schnorr he absorbed almost completely the Italianate manner of the Roman Nazarenes.

The degree to which revivalist landscape failed on a public level can also be felt in the work of two other late arrivals in Rome. Franz Theobald Horny (1798–1824) was a Weimar pupil of Heinrich Meyer who became a protégé of Rumohr and was taken by

124. Friedrich Olivier: *Withered Leaves*. 1817. Pen (15.3 × 24.9 cm). Staatliche Museen, Kupferstichkabinett und Sammlung der Zeichnungen, Berlin (East).

125. (facing page) Julius Schnorr von Carolsfeld: *Friedrich Olivier Sketching*. 1817. Pencil (26.2 × 19.2 cm). Albertina, Vienna.

Friedrich Olivier.

den 14ten August ge
aus Barthol: See bey
Berchtesgaden

18 $ 17

him to Rome in 1816. Here his sensitive nature studies (Plate 126) caused Cornelius to engage him to do border decoration for him in the Casino Massimo. His few finished works show all too well the deadening effect of Koch's influence. Horny died young, but the direction his art was taking seems clear. A more unresolved case was that of Carl Philipp Fohr (1795–1818), a brilliant young painter who was drowned in the Tiber at the tragically early age of twenty-two, at a time when his first attempt at a large-scale work, *Mountain Landscape with Shepherds*, remained incomplete.

A glance at his earlier work (Plate 127) will show the vigorous imagination that he had originally brought to his medievalism. Early in his life he had been inspired by the fascination for folklore and local history that had been generated in his native Heidelberg by the poets Brentano and Arnim, the editors of the seminal collection of traditional ballads and poems, *Des Knaben Wunderhorns* (1808). Fohr had been discovered in 1810 by an official of the nearby Hesse court and through him had become employed by the Crown Princess of Hesse, producing for her albums of local legends and scenery. Though Fohr, aided by the historian Philipp Diefenbach, made detailed historical researches for

126. (left) Franz Horny: *View of Olevano.* 1822. Pen and wash (52.9 × 42.9 cm). Staatliche Museen, Kupferstichkabinett und Sammlung der Zeichnungen, Berlin (East).

127. Carl Philipp Fohr: *Reward and Punishment.* *c.* 1814–15. Watercolour (19.8 × 24.5 cm). Staatliche Kunsthalle, Karlsruhe.

these, the atmosphere that pervades them is essentially a mythical one. Their association of the natural with the miraculous is borne out not only by the subjects but also by the vivid textures and rich sense of growth that pervades their surfaces. A period at the Munich Academy—as a pensionary of the Crown Princess—brought an end to such work. Fohr rapidly developed an antipathy for the academic routine there. But he also encountered Koch's grandiose *Landscape with a Rainbow* (1815, Neue Pinakothek, Munich). This work, recently acquired by the Academy as an example for the students of the way to treat heroic landscape, made Fohr aware of a new dimension in the relationship of man to nature. In 1818 he left for Rome and set himself to work in Koch's studio.

The sense of legend did not altogether leave him. A lively, high-spirited youth, he threw himself fully into the make-believe of student life, wearing the subversive *altdeutsch* costume, fighting duels, and using his gift for portraiture to make rapid humorous sketches of his circle of friends. He emulated Koch's formalization of the Roman Campagna in his *Mountain Landscape with Shepherds* (Plate 128), but his curiosity for differing human types enlivens the extensive foreground. Pilgrims, locals and travellers weave in and out along the mountain path. Nor are we, the spectators, absent from the scene, for the young mother with her children in the foreground draws us in with her glance.

It is this balancing of the personal and the public, the individual and the universal, that enlivens the work. Whether Fohr himself would have been able to maintain this balance or not, its position reflects the general dilemma of revivalism. The movement had arisen in an attempt to put the intuition of the Romantics on a generally communicable basis. Yet the more common this basis became, the less interesting it became too. As they moved towards explicitness and certainty the revivalists forfeited feeling and belief for dogma.

128. Carl Philipp Fohr: *Mountain Landscape with Shepherds*. 1818. Oil (98.4 × 135.5 cm). Private Collection, Darmstadt.

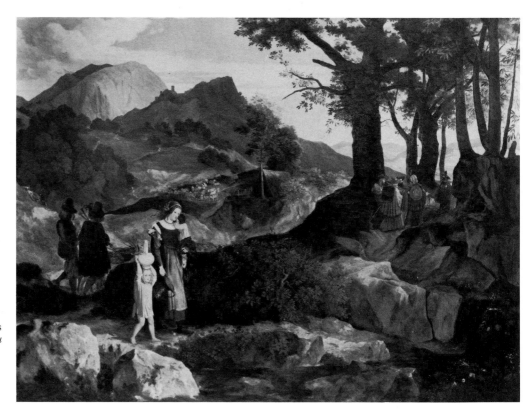

XXVII. (facing page) Julius Schnorr von Carolsfeld: *Frau Bianca von Quandt* (unfinished). *c.* 1820. Oil (37 × 26 cm). Nationalgalerie, Berlin (West).

Legends and Fairy-Tales

SCHINKEL's painting *Castle by a River* (Plate XXVIII) was the outcome of a remarkable competition. According to an eyewitness, the landscape painter Carl Wilhelm Gropius, the design for it was sketched out at two consecutive gatherings in Berlin in 1815 while the poet Brentano was extemporizing a poem using the same features.[1] Schinkel's task was to prove that the illustrator could depict even the most 'fantastic and improbable' inventions of the writer, and at the end of the competition he was considered by those present to have succeeded.

The competition was a notable example of the Romantic preoccupation with the interrelationship of the arts: the use of painting and poetry to vie with each other in evocation and description. As Brentano never recorded the story he invented on this occasion it is not possible for us to judge the extent to which Schinkel's imagination measured up to that of his rival. Gropius mentions that the poem described a deer entering the terrace of a castle without fear of harm as the coffin of its former steward, a head forester, is ferried across the river below to a cemetery. These features certainly exist in Schinkel's picture too; but the work is more than an illustration. Above all it attempts to create a sense of fable by means of a particular style of presentation. The deer, the castle, the funeral procession are revealed in glinting vignettes, set on either side of the mysterious silhouette of a darkened burgeoning tree.

Schinkel, whose talents were extremely adaptable, frequently excelled at topical genres. His attempt in *Castle by a River* to suggest a fairy-tale form of narrative as well as use a fairy-tale theme emphasizes the degree to which this form of popular literature had been reabsorbed into German high culture by 1820. Indeed, one of the most striking features of German Romanticism was the importance attached to such stories. As with the medieval revival, the common renewal of interest in this naïve art that spread throughout Europe in the late eighteenth century began to take on a special significance in the German states. For the *Stürmer und Dränger* the works had appealed on account of both their ethnic connotations and their natural expressiveness. Herder, who believed that great literature derived from the popular tradition published a seminal collection of folk ballads (*Volkslieder*) in 1778–9. He admired the vivid and direct descriptiveness of the narratives and the powerful, lithe metre of the poems. He asserted that the main virtue of Homer's verse lay in its close relationship to a similar oral tradition. It was under the influence of this viewpoint that the dramatic ballads on ancient legends Bürger's *Lenore* (1773) and Goethe's *Erlkönig* (1788) were created; and Fuseli's illustrations of similar legends (Plate 16) certainly shared these modern ballads' obsession with elemental force.

Within the Romantic generation, however, interest shifted from the expressiveness of popular tales and ballads to their enigma. It was the opinion of Novalis that 'all fairy-tales are no more than dreams of that native world that is everywhere and nowhere'. In his own novel *Heinrich von Ofterdingen* he certainly followed this paradoxical dictum, taking as a *leitmotiv* the mysterious blue flower of which the hero dreams at the beginning of the book.

XXVIII. Carl Friedrich Schinkel: *Castle by a River*. 1820. Oil (70 × 94 cm). Staatliche Schlösser und Gärten, Schloss Charlottenburg, Berlin (West).

His fascination with the irrational in the folk-tale, its intimation of a subconscious wish, can be found as well in the works of Runge, who not only sought to embody folklore into his self-devised mythology of flowers, but also recorded local legends, such as *Von dem Fischer un syner Fru*, in their original north German dialect of Plattdeutsch.

The fairy-tale and the folk legend continued to provide the basis for personal mythologies throughout the nineteenth century. Their popularity was strengthened by the belief that the sagas of the ancient and modern worlds—the tales of Homer and Hesiod, for instance, and the legend of the *Nibelungen*—were considered to stem from a similar ancestry. The example of these sagas encouraged an exploration of the irrational and bolstered the Romantics' view of the symbolic function of art. But it also led to a more public development. Just as the Middle Ages were regarded as a Germanic paradigm, so folk legends came to be seen as the core of a national inheritance. It was a view greatly encouraged by the development of philological studies. It is no accident that the greatest and most assiduous collectors of folk-tales, the brothers Grimm, were also pioneers in the history of the German language. Jacob Grimm saw language as the central feature of German identity.[2] The folk-tale became the image of the intuitive life of the people, which had too often been absent from more sophisticated forms of culture. In their own ways both Nietzsche and Wagner later paid tribute to this intuitive tradition in the myth-laden narratives of their works.

Although the renewed interest in folk culture began as a literary phenomenon, it soon infiltrated the other arts. In music this led to the exploitation of the popular forms of the folksong in *Lieder*; while in the visual arts there developed a style of illustration that emulated the naïvety and fantasy of folk art. In the first place the incentive for this development seems to have come from writers. Many were fascinated by the way in which fairy-tales expressed, as Wilhelm Grimm put it, 'supernatural phenomena in figurative conceptions', and looked to the visual arts to provide their natural accompaniment. However, while the rediscovered tales and the stories devised in emulation of them by, for example, Tieck, Brentano, Hoffmann and La Motte Fouqué were habitually illustrated, opinion was divided as to whether such pictures were worthy of the texts they accompanied. Brentano, for example, spent the larger part of his career searching for an artist capable of producing fairy-tale illustrations that would be 'of the utmost simplicity,

unpretentious, clear, childlike and merry'. In the end, having failed to find one, he tackled the problem himself and created a remarkable series of illustrations.

The one artist whom Brentano had felt capable of matching his vision was Philipp Otto Runge. Runge had already worked in this field in 1803, when he designed a series of pictures for Tieck's *Minnelieder*. Like the Riepenhausens' *Genoveva* pictures (Plate 2) these drawings had emulated the epic outline manner of Flaxman; and indeed this form of illustration for German tales was to survive until the middle of the century in the work of the artists Ludwig Ruhl and Moritz Retzsch. Brentano was less interested in Runge's outline technique, however, than in his symbolic use of imagery. When producing the collection of folk songs *Des Knaben Wunderhorns* in 1808 with Achim von Arnim, he borrowed Runge's imagery and symmetrical mode of composition to provide a frontispiece for the section devoted to children's songs. On this occasion he had the sketch he made worked up into a finished drawing by Ludwig Emil Grimm, the brother of the philologists. The resultant image was far more folksy in technique than the elegant outlines of Runge, for the whole design was executed in thick contours and rugged cross hatchings. In the following year Brentano asked Runge to illustrate his *Romanzen von Rosenkranz*; but significantly he tried to interest him in executing his designs in a more naïve manner, suggesting the Strixner Dürer border illustrations as a model (Plate 116). It is characteristic of Brentano's attitude that he should have expressed most delight not at Runge's outline work, but at designs Runge had made in a broad manner for playing cards.

Although Runge welcomed the project, he died before he was able to set to work on it. He remained a potent influence on Brentano, none the less, and when the poet came to make illustrations of his own for his story *Gockel Hinkel und Gackelaia* in 1838 (Plate 129) he drew inspiration from the genii and flowers of Runge's *Times of Day*. In some, actual motifs and designs are borrowed, yet Brentano did not absorb the allegorical dimensions of Runge's work. Instead he transposed the image into a lyrical fantasia. At times he emerges as the Hieronymus Bosch of the Nursery.

129. * Clemens Brentano: *Gackeleia in the Town of the Mice*. Lithograph from *Gockel Hinkel und Gackeleia*, Frankfurt, 1838.

130. Ernst Theodor Amadeus Hoffmann: *Kreisler after he had Gone Mad*. *c.* 1820. Pencil. Private Collection.

131. George Cruickshank: *Jorinda and Jorindel*. Etching from *German Popular Stories*, London, 1823.

Brentano's success as a fairy-tale illustrator was to a large extent due to his sheer amateurism. He evoked the irrational in his designs with an uninhibited wit and vigour that no professional illustrator cared to risk. He took the imaginative exaggeration of the fairy-tale to its extreme. Another writer, E. T. A. Hoffmann, performed a similar function for the bizarre. For the most part his illustrations were vigorous sketches dashed off for his own stories or for those of his friend Chamisso. The folk-tale provided Hoffmann with the vehicle for exploring his own aberrant fantasy, the daemonic *alter ego* that lay beneath the surface of his life as a struggling professional musician and, after 1815, as a judge working for the Prussian administration. His character Kreisler, the musician who eventually lapses into madness, became the main personification of this other life. One of his last drawings shows Kreisler in his final condition (Plate 130). The thin febrile lines by which this self-deluding creature is portrayed at the final moment of his disintegration exemplify the incisive technique that he admired so much in the engravings of the seventeenth-century French artist Jacques Callot.

Amongst the professional artists it was left to the English and the French—notably Cruikshank in his illustrations to the Grimms' tales (Plate 131) and Delacroix in his lithographs to *Faust* (1828)—to explore the fantastic side of German narratives. The German illustrators, on the other hand, were more interested in these stories as part of a living national heritage. They interpreted them in a manner that was simple, rhythmic and placid. It was this attitude, which fitted in so well with the self-conscious charm of the Biedermeier world, that gave great vogue to the ballad book.

This form of illustration, in which a text is surrounded by a continuous illustrative and decorative border as in a medieval manuscript, provided the closest interrelation of picture and word. It had first been revived by William Blake for his Prophetic Books in England. Although certain of Blake's border illustrations did come to Germany during the period—notably those for Blair's *Grave* which were acquired by Goethe[3]—the real revival of border illustration in Germany derived from the publication of Dürer's *Prayer-Book* border designs by Strixner in 1808. From the start these designs were seen in a national context, and were recommended as such both by Goethe to Cornelius for his *Faust* illustrations and by Brentano to Runge for the *Romanzen von Rosenkranz* in 1810. Cornelius did in fact make use of the genre for the title pages of his *Faust* and *Nibelungen* designs. However, it was a pupil of his, Eugen Neureuther (1806–82), who first made border illustration popular with his *Randzeichnungen zu Goethes Balladen* (Border Designs to Goethe's Ballads) in 1828 (Plate 132). Previously Neureuther had worked on the borders of Cornelius's Glyptothek frescoes. Having achieved a modest success with these he continued in the genre for the rest of his life. He used borders not only in his illustrations, but also in his oil paintings. In the drawings for Goethe's ballads he imitated Dürer's border designs to the point of having each page decorated in a different shade of ink as the master had done. But, whereas the figures that emerge from the scrollwork of Dürer's penmanship are humorous or bizarre, those from Neureuther's are simply charming. His illustration to Goethe's 'Fischer'—a poem which ends with the drowning of its protagonist—is without a hint of violence.

Limited though Neureuther's designs are, they do at least have a lyrical integrity. They are not vulgar displays of penmanship as are those of the Düsseldorf imitator J. B. Sonderland. In Sonderland's work, so much space is given up to convolutions of strapwork that there is frequently only space for a single verse of a ballad to appear on the page. It was not until Rethel made designs for a publication cast in the ballad-book style, the *Nibelungen* of 1840 (Plate 133), that a more restrained form of design was achieved: one that had a terse, simple line, innocent of any attempt to disguise the two-dimensional surface of the page.

132. * Eugen Neureuther: *The Fisher*. Lithograph from *Randzeichnungen zu Goethes Balladen*, Munich, 1828.

133. * Alfred Rethel: *How the Queen Had the Hall Burnt Down*. Wood-engraving by W. Nicholl from *Das Nibelungenlied*, Leipzig, 1840.

These designs of Rethel were executed as wood-engravings. It was the growing popularity of this technique for reproductions around 1840 that created the means of re-establishing a folk style in German illustration. With the use of this medium—so convenient for mass production—there emerged a method that had genuine ethnic associations. The woodcut had been used, after all, as a popular form of illustration by Dürer and Holbein. In the succeeding centuries, after it had fallen into disfavour among fine artists, it had survived as the habitual means of illustrating broadsides and advertisements. Although the modern wood-engraving had greatly refined the cruder method of the woodcut to the point where it could be used to capture the finest nuances of Menzel's incisive penmanship (Plate 13), it was also capable of recalling the properties of its archaic forebear. It was this quality that Rethel, Moritz von Schwind and Adrian Ludwig Richter were to exploit to the full. For each of them, however, the woodcut style was intimately connected with the traditionalism of his paintings. And, though each is more highly valued today for his graphic work than for his painting, the two media are nevertheless so closely connected that they cannot be considered separately.

The association of Moritz von Schwind (1804–71) with the proverbial charm of the Biedermeier world is so close that his whole existence seems to belong to the realm of the fairy-tale. Viennese by birth, he lived the whole of his life in Austria and south Germany, producing a prolific number of pictures of legendary scenes and the more enchanting aspects of contemporary life. A friend of Schubert's, his art is full of the self-conscious

lyricism that seemed to come so easily to the generation of the 1820s, and from which Heine and Blechen fought so hard to free themselves. Schwind, on the other hand, wished for no such liberation. 'My dream is real', he exclaimed to Schubert in 1824.[4] His early life was spent in affirmation of this claim, and his later years, after 1848, were occupied with a nostalgic retrospective of those idyllic early days, summed up in an extensive cycle of pictures, the Travel Pictures (*Reisebilder*).

It seems appropriate that Schwind should have been an artist of immense and varied natural gifts. The son of a diplomat, he was already studying philosophy at Vienna University in 1818 when only fourteen. By that time he was also an accomplished violinist—a skill that he kept up throughout his life, taking part in concerts on many occasions. But his life in the 1820s was not an easy one. His father strongly opposed his artistic ambitions, and his death in 1821 did not make matters any easier, for he left the seventeen-year-old youth penniless. Thus, while Schwind was now free to enroll at the Vienna Academy, he was also forced to spend much of his time engaged in hackwork. The basis of his style therefore was popular in a less lyrical sense than is often supposed. His early commercial illustrations—such as those to *Robinson Crusoe* made in 1823—are crudely emphasized, almost to the point of caricature.

At the same time, however, Schwind was also becoming acquainted with the cult of folklore. He was encouraged to do this by his teacher Ludwig Schnorr von Carolsfeld (1788–1835). Ludwig moved in the same revivalist circles in Vienna as his brother Julius, and had recently made his reputation with a series of illustrations to *Faust*. Even more than his brother, he brought a lyrical sensibility to the Nazarene manner, and concentrated on legendary themes, as in the *Leap from the Rock* (Plate 134) where two lovers commit suicide to evade being caught by a huntsman pursuer. This work has all the pathos and gaucheness of a tragic ballad, the neatness and modesty of the lovers giving them a puppet-like naïvety as though performing some preordained action. One can discern in this picture, as in most of Ludwig's work, a certain academic restraint. But this was less evident in the works of his pupil. Schwind was more completely a denizen of the care-free, poverty-stricken 'Schubert circle' of young poets, artists and musicians in Vienna, and could abandon himself more fully to the poetry of make-believe. His *Apparition in the Forest* (Plate XXIX) shows a complete involvement with the supernatural. Depicting the moment in the *Sleeping Beauty* when a wood spirit guides the Prince towards the castle where his bride lies, Schwind has exploited the charm of the archaic to the full. His stiffly curious horseman peers through the darkened verdant wood towards the delicately enticing apparition. It is hardly surprising to learn that his favourite old German masters were the fanciful landscapists of the Danube School.

This early work shows how closely Schwind's art was involved with story-telling from the beginning. It was his skill at this that soon led to him being employed on a finer form of illustration than the *Robinson Crusoe*; but it was also to restrict the scope of his activities. Having established himself as a painter of fairy-tales, it was hard for him to gain recognition in the field he always longed to excel in, that of monumental mural painting. In 1828 he moved to Munich in order to learn this craft under the tutelage of Cornelius. Yet, although he was well received by the master, he did not become one of his inheritors. The only royal commission he received was for a series of delicate arabesques after stories by Tieck for one of the private rooms in the Residenz. In the succeeding decades he competed for several of the numerous public commissions for high-minded allegorical mural cycles then in vogue throughout Germany. But he was successful on only one occasion before being appointed a professor at the Munich Academy in 1847. This was at Karlsruhe in 1840, where he provided an appropriate allegory on the visual arts for the stairwell of the Kunsthalle.

134. Ludwig Schnorr von Carolsfeld: *The Leap from the Rock*. 1853. Oil (74 × 44 cm). Georg Schäfer Collection, Schweinfurt.

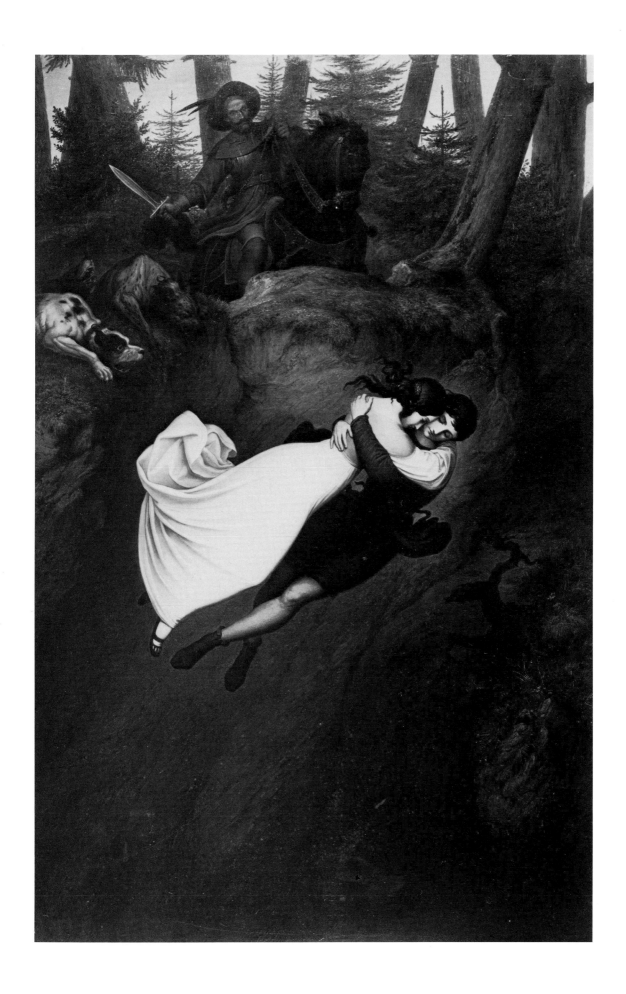

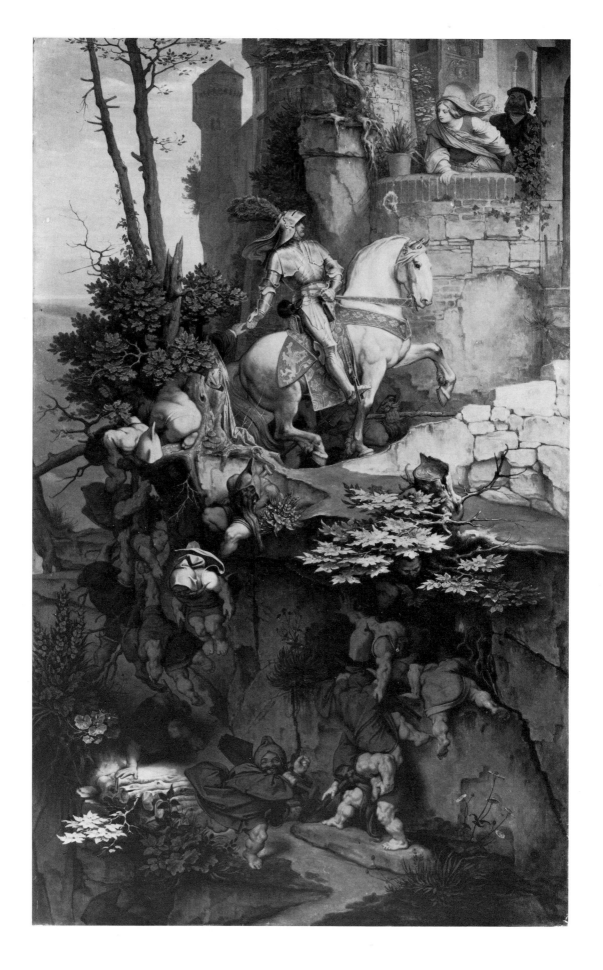

Meanwhile, Schwind's monumental aspirations had a decisive impact on his less ambitious works. Under the influence of Cornelius he learned to pay attention to the broad underlying rhythms of his designs, and he used this to give a new import to his depiction of legends. This can be seen first in *Sir Kurt's Bridal Journey* (*Ritter Kurts Brautfahrt*) a representation of one of Goethe's comic narrative poems—rather along the lines of John Gilpin—in which the knight's picaresque adventures are crowded into one continuous landscape as in a medieval panel. This was soon followed by more controlled works, notably the *Ride of Kuno von Falkenstein* (Plate 135), and *The Rose* (Plate 11). Both are large vertical designs (*The Rose* is over two meters high) in which the story follows the ascending movement of the composition. In *The Rose* this is governed by the round tower, where a bride stands awaiting her groom, whose entourage approaches in the distance. Some attendants to her right are already aware of this, and draw her attention to it. Around the base of the tower there wind a company of musicians on their way to play for the wedding feast. Misshapen, comic and lowly, their tumbling rhythm accentuates and forms a contrast to the idealized ladies above them. All these movements provide a momentum to the narrative, yet there is also a more covert but equally important action. For the bride is unmoved by the approach of the groom. In her hand she holds a letter which she was on the point of dropping before her attendant grasped her arm. The attendant on her left has already dropped a rose from her bouquet, and it now lies in the path of the last of the musicians, a clumsy, humble youth. In a moment he will look up to where the rose came from, and then receive the message from the bride.

The above account is largely interpretation. The theme is one of Schwind's own invention, and, while he described the main characters in a letter to his friend the painter Genelli,[5] there is no text that is being illustrated. The narrative grows from the state of mind that the picture puts one in. Its rich colours and repetitive lyrical lines describe the world with the vividness and simple metre of the folksong. And like a folksong it combines the magical and ideal with the comic and lowly.

Whether Schwind was inventing his own situations or taking them from legends—and the distinction became increasingly less important—they habitually deal with some form of wish-fulfillment. The secret contact between the most important and least important of the characters in *The Rose* is reminiscent of the sudden changes in fortune that so often occur in the fairy-tale. Similarly, one frequently finds the treatment of the daydream in Schwind's work. Indeed, his *Dream of a Prisoner*, in which a troupe of goblins enact the escapist fantasy of a captive as he muses in his cell, was cited by Freud as a classic example of this kind of wishful, childlike fantasizing.[7] Another type of wish-fulfillment dream—the prophetic dream—was treated in the artist's *Dream of Erwin von Steinbach* (Plate 136), in which the reputed architect of Strasbourg cathedral is shown being led as a youth through a Gothic building. It is made clear that the scene is a dream by the presence of the angel who is holding his hand, and the two are shown hovering in mid-air near the cathedral's roof. While the angel floats, Erwin, his eyes closed, is treading the air as though it were the ground. This detail makes clear the distinction between the mortal and the immortal in this meeting, and the whole theme underlies the romantic view of art as divine inspiration. Curiously Schwind did not bother to make the building through which they are moving look like Strasbourg. If anything, it is closest to St Stephen's in Vienna. This association is explicable enough in the original design for the work, which was drawn in the 1820s before Schwind had left Vienna, but its repetition in the painted version (Schackgalerie, Munich), which dates from the late 1850s, is a different matter. Perhaps he wished to emphasize by it that this building is nowhere in particular, but is rather the ideal cathedral of Erwin's fantasy.

The painting of such events has clearly little to do with reality. Nevertheless, one of the

135. Moritz von Schwind: *The Ride of Kuno von Falkenstein*. 1843–4. Oil (152 × 94 cm). Museum der Bildenden Künste, Leipzig.

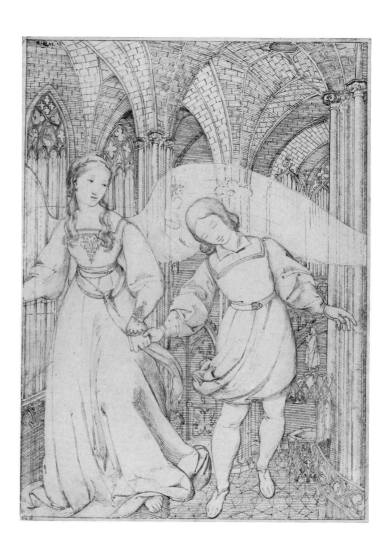

136. Moritz von Schwind:
*The Dream of Erwin von
Steinbach. c.* 1822. Pen
(30.7 × 22.6 cm). Staatliche
Graphische Sammlung,
Munich.

strengths of Schwind's style is that it contains penetrating moments of observation. His favourite early German masters were the artists of the Danube School, such as Altdorfer, who depicted mystical religious events in settings that showed a deep feeling for natural scenery. As well as by Ludwig Schnorr he had been taught at the Academy by Peter Krafft, who painted scenes of Austrian contemporary life with a precision similar to that of Kobel in Munich and Kugler in Berlin. It was the sharpness of Schwind's perception and his willingness to apply it to the comedy of manners, that separated his archaism from that of the Nazarenes. While Overbeck execrated caricature as a coarsening of the spirit, Schwind was prepared to work in this vein for the popular press. After settling in Munich in 1847 he made drawings for the satirical magazine *Fliegende Blätter*. This magazine, which took as its name the German term for broadsides, allied itself with the people in a political sense, and used its humour, in the time-honoured way, as a stalking horse for criticizing the Bavarian regime. Schwind himself contributed a number of political cartoons; but it is characteristic that he preferred to restrict his comments to social ones and to lance the pretentious on a personal level. Equally typically, he used caricature as a means of experimenting with pictorial possibilities, exploiting the cartoon's permissiveness of abstractions to evolve remarkable innovations. His drawing *Cats' Symphony* (Plate 137) borrows the conventions of a musical score to present time and movement pictorially. As we follow the tumbling silhouettes along the clef we find that the cavorting cats are the same ones repeated again and again. This concern for continuous narrative—which is evident as well in the repeating rhythms of his paintings—is a reminder that it was through such illustrations that the strip cartoon was to develop. Little more than a

decade after Schwind's contributions to *Fliegende Blätter* a young Hanoverian student of the Munich Academy, Wilhelm Busch (1832–1908), was to further the process in this magazine with his invention of the famous urchins Max and Moritz. Although Busch took far greater liberties with pictorial conventions and was far less inhibited in his use of the vernacular, his work was still strongly indebted to Romanticism. It is not fortuitous that the pictures of his cartoons should have been accompanied by simple rhyming couplets, for his characters still inhabit a folk-tale world. Despite his pessimism about human nature Busch continued to employ the lyrical line of the Biedermeier illustrators, and it was the conventions of late Romantic art that encouraged him to extend the actions of his figures to the point of fantasy, as for example in the corkscrew legs of the listener and the multiple arms of the performer in the sequence *Fuga del Diavolo* (Plate 138). In many ways Busch belonged more to the Biedermeier world of his youth than to the Imperialist Germany of his adult life. Most of the latter part of his life was spent in seclusion in his native village of Wiedensahl.

Busch's fantasy owes much to Schwind, but his amused portrayal of the commonplace and the ridiculous was more closely connected to the work of the indigenous low-life painters of Munich. The most significant of these was Carl Spitzweg (1808–85). Like Busch, Spitzweg provided illustrations for *Fliegende Blätter*, though he was first and foremost a painter. Spitzweg was a self-trained artist (he was a chemist until the age of twenty-five); perhaps this is why his works so often have stagey effects, as though the artist were self-consciously trying to demonstrate his skill. In Spitzweg's early works there is much evidence of the influence of the Dutch genre paintings the artist knew from the collection in the Munich Pinakothek. This is particularly evident in their settings and in their concentration upon local characters. However, Spitzweg looked on his small town characters—gossips, pedants, ridiculous officials—with the sentimental humour of Biedermeier. Despite his insistence upon exposing pretentions and concentrating upon the mundane, he seemed incapable of portraying a scene without telling a story. His *Poor Poet* (Plate 139) is of an old theme already explored by Hogarth. Like Hogarth, Spitzweg used the details of his room to elaborate his story. The carefully observed filtering of light

137. Moritz von Schwind: *The Cats' Symphony. c.* 1866. Pen (34 × 27 cm). Private Collection.

138. * Wilhelm Busch: *Fuga del Diavolo.* Wood-engraving from *Der Virtuos*, Munich, 1865.

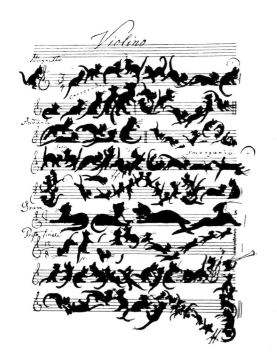

from the small window serves to set the murkiness of the poet's attic. When the spectator has explored the plight of its occupant lying in his bed to keep warm, his writing interrupted by the task of catching a flea, he finds eventually in the darkened foreground the open oven where the poet has been burning his manuscripts for fuel.

Spitzweg never pressed his comments beyond the range of sentiment. We may feel sorry for his characters, but we never laugh at them outright. There is also a homogeneity about their situation that palls after a while. In later years, especially after his visit to Paris in 1851, he showed the influence of the French Barbizon painters, and his landscape scenes took on the bright colour effects of Diaz. Yet, attractive though such paintings are—their small size adding to their gem-like lustre—there is a total lack of that experimentation, the measuring of pictorial effect against observation, that makes the French master's work so exciting. The *Hermit Reading* (Plate 140) is essentially a stage set, with its artful diagonals of light and sparkling touches of colour. The picture still revolves around a theme—in this case the ironic one of a recluse's self-denial and blindness amidst the wonders of God's world.

Almost instinctively Schwind held himself aloof from this world of humorous realism. He knew the limits within which realistic observation could be effective in his style and did not attempt to transgress them. After 1848 he withdrew increasingly from the contemporary world, giving up his work in the illustrated magazines and concentrating instead on such mural commissions that came his way.[11] He also undertook for himself the creation of a series of travel pictures (*Reisebilder*), a reprise on the themes and experiences of his early life. The majority of these were bought in bulk by the Munich collector Baron Schack in 1869 and are preserved now in his gallery.

139. Karl Spitzweg: *The Poor Poet*. 1839. Oil (35 × 44 cm). Nationalgalerie, Berlin (West).

140. (facing page) Karl Spitzweg: *Hermit Reading*. *c.* 1860. Oil (24 × 16 cm). Nationalgalerie, Berlin (West).

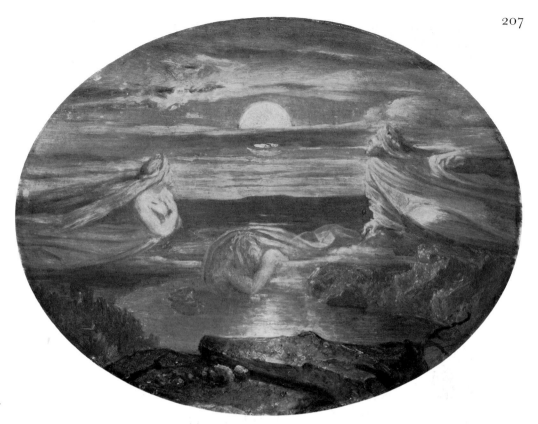

142. Moritz von Schwind:
Spirits above the Waters.
c. 1860. Oil (21.5 × 28 cm).
Schackgalerie, Munich.

141. (left) Moritz von
Schwind: *Departure in the
Early Morning. c.* 1845. Oil
(36 × 24 cm).
Nationalgalerie, Berlin
(West).

These pictures can be divided into scenes from Schwind's own life and depictions of folk legends. The distinction between the two is often tenuous. In the 'contemporary' scenes he chooses the most affecting moments, such as in the *Morning Hour* (1860, Schackgalerie, Munich), in which a young girl—apparently the artist's daughter—peers out of the window at the coming day, or in *Departure in the Early Morning* (Plate 141), where the pale light of approaching dawn is used to express the poignancy of parting. In each work the artist is avowedly poetic, yet this does not in any way detract from the sensitivity with which he has captured the mood.

Behind these works is the belief in an associative approach to nature. One feels that the figures in the pictures share the freely metaphoric attitude to the elements evident in Schwind's 'legendary' paintings, for example the *Spirits above the Waters* (Plate 142), based on Goethe's poem 'Song of the Spirits above the Waters', which Schubert set to music in 1821. It shows the personification of the elements that cannot be seen in the clear light of day. Attracted by the ghostly light of the moon, they bunch together, like the clouds that are depicted on either side of them.

Unlike the work of Runge, these allegorical pictures of Schwind do not have any complex layers of meaning. Their effect depends upon a single metaphor or the snatch of a story. Their aim is not to create the overwhelming effect of some mystic totality, but to create a moment of suspension in which the imagination is allowed to play, and perhaps to discover, some unsuspected things. In this sense the analogies to music, which Schwind himself frequently made (he once said that the painter should have a 'mouthful of music' every day) are meaningful ones. His rhythmic line can be likened to musical phrasing. But the analogy, should not be taken too far. Schwind never ascends to a world of pure abstractions. His lyricism is always bounded by the narrative it describes.

Schwind was the most interesting painter of late Romantic lyricism. The Dresden artist Adrian Ludwig Richter (1803–84) was, however, its most wholehearted exponent. Even more limited than Schwind in his range of folksy themes and their interpretation, he

preserved his innocence and naïvety to a far greater degree. Before arriving at his mature style in the late 1830s Richter had moved through the current genres of classical, Romantic and revivalist landscape and emerged modestly but firmly asserting his personal inclination to 'record nature with a sincerely pure, simple, childlike sensibility, and to portray and treat it completely without pretention, like an affectionate game'.[8]

A pupil of the Dresden Academy and a close friend of Friedrich's follower Ernst Ferdinand Oehme, Richter had early misgivings about the influence of the melancholy master on his contemporaries. During his stay in Rome from 1823 to 1826 he completely rejected their kind of symbolic landscape. Studying under Joseph Anton Koch, he found a greater affinity to his own love of 'clear form, sunshine and bright daylight' amongst the Roman school. However, his attempt to emulate Koch's *Schmadribach Falls* (Plate IV) with a similar vertical, all-embracing representation of the *Watzmann* (Plate 145) showed him to have no more penchant for the heroic than he had had for Friedrich's fatalism. Instead of representing the mountain as an overpowering climax he had shown it as a tapestry of incidents: a chapel, a herd, a hut, some foresters set in verdant woodlands around a tinkling stream and watched over by a benign old grandfather of a mountain. This narrative quality reflects Richter's contact in Rome with the Vienna-trained Julius Schnorr and with other young revivalist landscapists. Richter was nevertheless to veer more closely to genre than to archaism in the Italian views he painted after his return to Germany, as can be seen in *Forest Stream Near Ariccia* (1831, Nationalgalerie, Berlin (West)).

This tendency showed a debt to painters of Italian genre and *vedute* pictures. Particularly influential was Dietrich Wilhelm Lindow—a Dresden acquaintance of Richter's who had been living in Rome since 1821. Richter appears to have worked so hard in this field because he desired to paint works that would be generally appreciated. His reminiscences are full of the difficulties he experienced establishing himself as an artist in the years that followed his return from Rome. From 1828 to 1835 he worked as a drawing master in the porcelain factory at Meissen, under the direction of Kersting. He left the position only after he had achieved a number of successes at the Dresden Academy, and had had several works purchased by the Saxon *Kunstverein*. He freely admitted the great service that this organization provided for contemporary artists by purchasing their works from the annual exhibitions. But he was unhappy about its erratic methods of selection. It was only when he began to receive commissions for illustrations from publishers that he felt fully secure.

> When I subsequently received specific commissions from publishers to carry out compositions that, even if small, were required, used and received with friendly interest and thankfully paid for, then I was immediately transported into a far fresher element. I breathed in more freely and felt myself no longer dependent upon the favours and caprices of chance.[9]

So important was his illustrative work to him that he made it virtually the sole topic of the last chapter of his reminiscences, the chapter that dealt with his life during the decade following his return to Dresden in 1836. And indeed his major paintings of the period (none of which he mentions) were dependent upon his experiences as an illustrator. Not only did this activity show him that the popular market lay in the depiction of German lore and German countryside rather than in the more remote Italian *vedute*, but it also dictated the attitude he took to these. His *Crossing by the Schreckenstein* (Plate 84) and *Small Pool in the Riesengebirge* (Plate XXX) were both painted after a period of wanderings in which he produced drawings for the Leipzig publisher Georg Wigand's picture book *Das Malerische und Romantische Deutschland* (1839–41). Like the views in the book, these pictures

XXIX. Moritz von Schwind: *Apparition in the Forest. c.* 1858. Oil (41 × 63 cm). Schack Gallery, Munich.

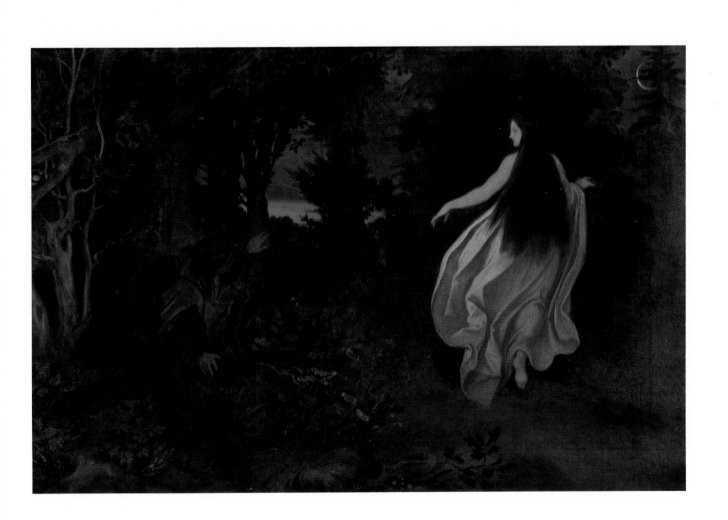

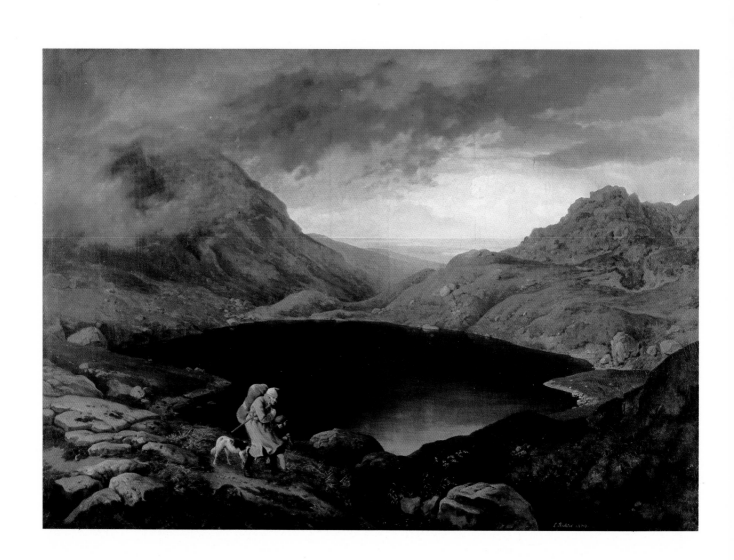

are based on scenes that had already become clichés of popular romanticism by the 1830s. Their 'poetic' character is emphasized in both by means of the presence of a wanderer and through the evocation of a sense of mood. In contrast to Friedrich, who would have brought these elements together to suggest a confrontation between man's inner being and his experiences, Richter suggests a harmonious relationship between man's life and his environment. In the *Schreckenstein* only one of the stock characters gathered together on the ferry is contemplating the scenery, yet all are affected, in one way or another, by the approach of evening. Furthermore, while Richter is lyrical here, he is also playful. There is a deliberate humour in the way that everyone is acting so perfectly to type, from the soulful lovers to the bored young boy trailing a twig in the water. It is this humour, too, that prevents the approaching storm in the *Small Pool* being taken too seriously. The spectator is inclined to smile at the dilemma of the travellers as they are bowled along through the barren landscape by the strong wind.

Like Schwind, Richter conveyed the lyricism of his scenes by means of a rhythmic, flowing line. However, his draughtsmanship was never as vigorous as that of the Viennese artist. More truly a landscape painter, he also emphasized qualities of atmosphere and colour in his work. The *Small Pool*, for all its contrived design of intersecting diagonals, conveys marvellously the purples and chalky greys cast by rainclouds over rocks and water. He could, moreover, be as variable as the moments he depicted. The *Schreckenstein* is full of the diffused pinks and purples of a sunset. Most of all he enjoyed the rich effects of sunlight on thick vegetation. In *St Genevieve in the Forest* (Plate XXXI) he used these effects to provide the focus for a scene from the legend that had been the basis of one of Tieck's plays. Richter showed St Genevieve abandoned in the forest after having been condemned to death by her husband, the Count of Brabant, on false information. There she gave birth to a child who was tended by a white doe. There is nothing here of the suffering mentioned in the story, of the hunger pangs of Genevieve, forced to survive off a diet of roots. Instead the emphasis is on the intervention of nature on behalf of a wronged person—a standard form of wish-fulfillment in legends. This accorded well with Richter's own euphoric view of the natural world. He put all his skill into rendering the blond innocent and her companions in sparkling sunshine against the deeper greens of the cool fir trees.

Despite Richter's painterly skill, such simple narratives are most convincingly portrayed in the illustrative work that he prized so highly. From the time that he

XXX. (left) Adrian Ludwig Richter: *Small Pool in the Riesengebirge*. 1839. Oil (63 × 88 cm). Nationalgalerie, Berlin (West).

143. * Adrian Ludwig Richter: *The Wind Blows*. Wood-engraving from *Es War Einmal*, Leipzig, n.d.

144. * Adrian Ludwig Richter: Wood-engraving from *The Vicar of Wakefield*, Leipzig, 1857.

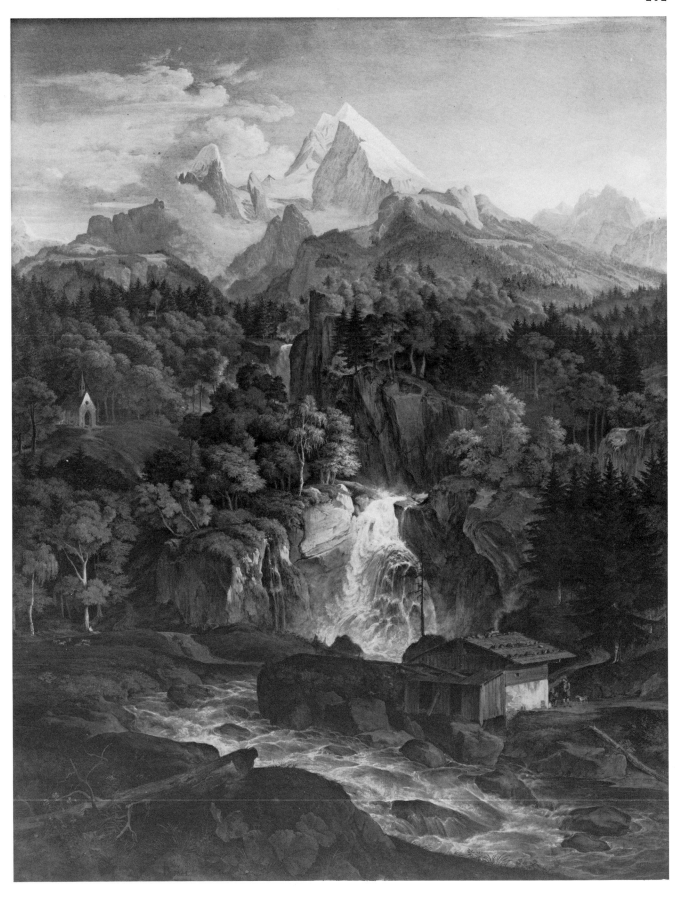

illustrated Musaeus's *Volksmarchen der Deutschen* in 1842, he was almost constantly employed designing pictures for folk-tales, ballads, and simple moral tracts. He appreciated in particular the technique of wood-engraving in which most of these were reproduced primarily for the simple, characterful expression that it encouraged. In this he found himself at variance with those engravers who, under the influence of the English followers of Thomas Bewick, sought to improve the medium's virtuosity. While Adolph Menzel in Berlin was encouraging engravers to reproduce every nuance of his penmanship, Richter in Dresden was encouraging craftsmen like Hugo Burckner to preserve the simple, expressive lines and straightforward hatching of the old woodcut.

The world of these pictures is as simple, charming, and straightforward as the technique with which they are executed (Plates 143–4). The humour is playful rather than vicious, the pathos soulful rather than tragic. And under them all lies a simple conception of morality, and acceptance of the given order of things. Like his friend Schwind, Richter wished to have no part of the materialism that developed after the 1840s. When the two visited the Munich international exhibition in 1869 they were dismayed at the new Realists, whom they felt lacked all innocence and reverence in their approach: 'Nature must be contemplated with great seriousness, with truth and love, even with devotion. Only then will she inspire one artistically and enable one to bring forth works full of the freshness of youth.'[10]

Schwind's and Richter's view of art as the balm of life, a charmed circle of wish-fulfillment, seemed irrelevant to those who wished to confront the contemporary world. But their make-believe still had its devotees in the later nineteenth century. The great Victorian escapist Burne-Jones found Richter's illustrations a constant delight. He felt they 'gave hope of what might yet be done'. Some of his early works (Plate 146) emulate the simple lines of Richter's engravings. But Burne-Jones became more conscious of the nostalgia of his position in later years. His mature works express a more complex, wistful aestheticism. Richter's real legacy lay in a sphere where innocence could be more legitimately maintained, in the art of the childrens' illustrators like Kate Greenaway. The fairy-tale sank after the Romantic era to the level of the nursery, and it is fitting that the art that had emulated its qualities so assiduously should have ended up in the same place.

145. Adrian Ludwig Richter: *The Watzmann*. 1824. Oil (120.2 × 93 cm). Neue Pinakothek, Munich.

146. * Edward Burne-Jones: *Beauty and the Beast*. 1863. Earthenware tile panel (57 × 124.5 cm). William Morris Gallery, London Borough of Waltham Forest.

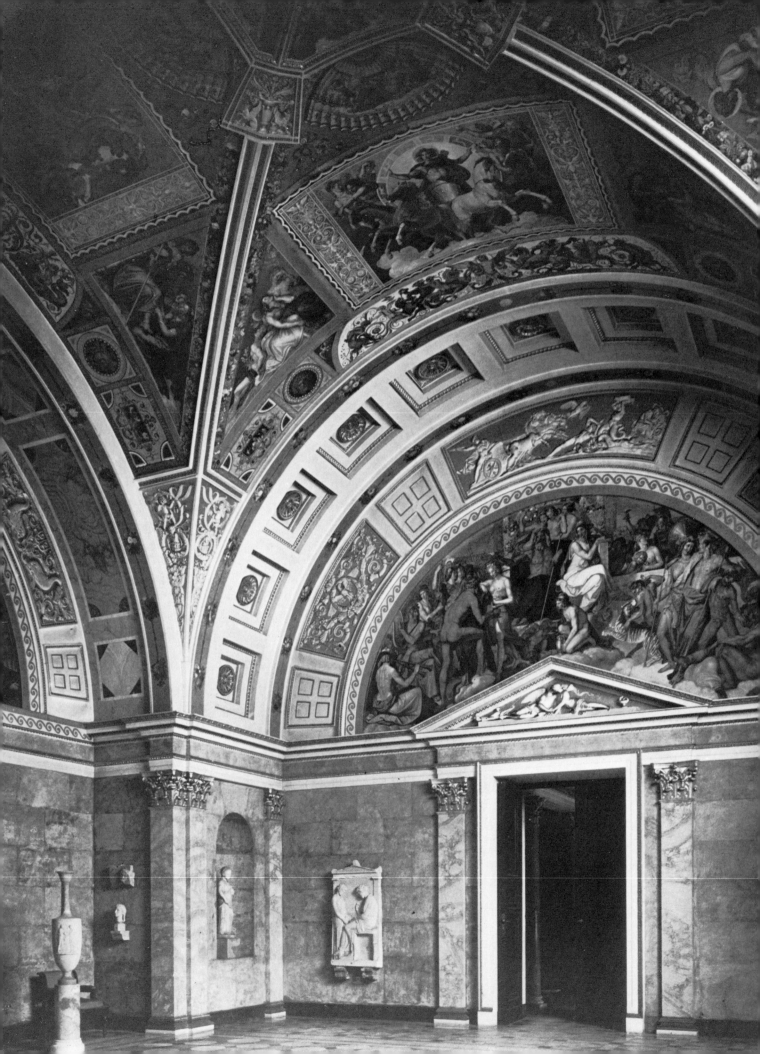

Art and Propaganda

THE OTHER SIDE of the Revivalist movement did not end so prettily. Its claims were greater and its disintegration more disturbing. The wistful regrets of Schwind and Richter in their latter years have little of the sense of tragedy expressed at the time by Cornelius, prevented by political vagaries from carrying out his grand mural cycle in Berlin, or by Rethel, condemned to complete nationalistic frescoes whose significance increasingly eluded him.

Both Cornelius and Rethel were heirs to the commonly held assumption that history painting should be ennobling and instructive; that it should represent people with—as Reynolds put it—'as much dignity as the human figure is capable of' and show them taking part in heroic and morally enlightening actions. Both felt, too, the peculiar emphasis that had been placed on the responsibility of art in Germany since the 1790s. High Art was seen as performing an expository role in every Western European country. It is a role that was fulfilled quintessentially by David's pictures during the French Revolution. In Germany this role took on an even more fundamental significance. It was seen as providing the actual means by which man could develop the ideals and sentiments necessary for the achievement of self-determination. This was the assumption made by Schiller when he insisted that his *Letters on the Aesthetic Education of Mankind* (1795) were dealing with a matter of the greatest political consequence, one that had to be settled before any true liberation could be effected. Aesthetic judgement provided for Schiller the experience of free yet responsible decision so necessary for the initiation of considered action. It was this that gave the enobling qualities of High Art their importance, and not their potential for use as a propaganda method for presenting a political creed in a vivid and appealing manner.

Yet, while Schiller's ideals provided the basis for assigning a central position to high culture, the details of his argument were soon lost. It did not take long for his followers to slide from his emphasis on aesthetic judgement back to an interest in the presentation of content, and to render style a mere matter of illustration. This was particularly the case in painting—an art with which Schiller had not been primarily concerned—where the Nazarene style provided a convenient vehicle for the exposition of traditional values. By the 1840s German history painting had become completely identified in the popular mind with what Baudelaire referred to as 'philosophical art': 'That is, a plastic art that claims to replace the book; that vies, that is to say, with printing in the teaching of history, morality and philosophy'.[1]

Baudelaire argued—with some justification—that this peculiarly Germanic tendency was an error, a misunderstanding of the true qualities of pictorial art. But he was too fine a critic not to discern that one practitioner at least—Alfred Rethel—had used this improbable medium for the creation of a supreme pictorial achievement. He also discerned that for this art to be effective it had to return to the most primitive of images, to draw on visual associations rooted in tradition. It was such thinking that made the

147. Peter von Cornelius: Frescoes in the Hall of the Gods, Glyptothek, Munich. 1825–6. Destroyed.

Nazarenes seem so important to the admirers of ideal art. The Nazarenes were felt to revive the sterling qualities of the old German world, to provide the art that would bring the Germans back into contact with their own past and enable them to achieve a national regeneration. Already when the cartoons of Overbeck's and Cornelius's Bartholdi frescoes were exhibited in Frankfurt in 1818 they were viewed in this light. As Overbeck's father reported to him, 'Your name races through every German speaking territory. Political newspapers and other journals bear it from south to north and from west to east. Your Frankfurt Cartoons, and those of the excellent Cornelius, become described in greater and greater detail, and are judged great patriotic achievements.'[2]

There is no doubt that Cornelius, in particular, wished to have his art seen as a patriotic achievement. Seeking to be 'ardent and strong' like Dürer, he felt mural painting to be the most effective means by which the new German art could measure up to its heroic task. The impact of its scale and the succinctness of its simplifications made it 'draw together, like a focus, the rays of life that stream from God, and kindle a glowing fire that benevolently lights and warms the world'.

Fortified by these high-flown metaphors, Cornelius felt that his opportunity had come when he was invited to Munich by Crown Prince Ludwig in 1818 to paint murals for the new sculpture gallery, the Glyptothek (Plate 147). A commission to decorate the walls of a collection of antique sculptures might seem an inappropriate activity with which to found a new German art, but Cornelius was undaunted. He set about making it the nucleus for his projects. The Glyptothek became the place where he could instruct young painters in his craft on a practical level, like a medieval apprenticeship. He hoped thereby to circumvent the mindless routines that he and his companions had been subjected to while students at the impersonal academies. As an educational method, these 'master-classes', as they were called, were certainly radical. Yet they were in fact the apex of a more conventional structure. In 1821 Cornelius added the directorship of the Düsseldorf Academy to his Munich commitments. At Düsseldorf he imposed a rigorous seven-year course of study. The favoured students who came from this academy to work in the 'master-classes', were not young apprentices, but fully trained academic painters. As in other Nazarene endeavours, Cornelius was not offering a revolution so much as a synthesis, in which the expertise of the present and the sincerity of the past would be bound together in a new glorious achievement. The outcome was rather more prosaic than this. But he did succeed in making Munich and Düsseldorf the twin centres of historical art in Germany.

Cornelius's interest in synthesis was also evident in the way he interpreted the Glyptothek commission. He depicted the Greek gods and heroes as prefigurers of the Christian message. In this manner he echoed the use made of antiquity in the Middle Ages—as for example in Dante's *Divine Comedy*. But he also allied this to more contemporary philosophical speculation. The philosopher Hegel had knit the divergent tendencies of the past into a coherent and dynamic view of development by means of his notion of thesis and antithesis. In a similar manner Cornelius represented antiquity as both bearing the seeds of future revelations and providing the state that would stimulate a reaction towards the higher sphere. He sought to spell out in the chilling purity of the faultless classical forms he depicted the message implicit in the sculptures that his frescoes enclosed—that classical antiquity had achieved a physical perfection which had, in its turn, stimulated Christianity to achieve a spiritual one. Significantly Cornelius was aided in the devising of his programme by the philosopher Schelling. While Schelling, a friend of the Schlegel's, was opposed to Hegel in many things, he did share his notion of the phases of historical development.

In principle Crown Prince Ludwig—who succeeded to the Bavarian throne in 1826—

shared Cornelius's intentions. The Glyptothek was but one facet of a large-scale plan to redesign the whole of Munich. His ambition was to embellish the Bavarian capital with a range of public institutions that would emphasize the importance of culture and demonstrate the historical position of the Germans. Before Cornelius had arrived in Munich, the basis for this scheme had already been worked out by Ludwig's favourite architect, Eduard Gärtner—again in collaboration with Schelling. The new museums, theatres, churches, triumphal arches and halls of fame that Gärtner and his older rival Klenze erected were designed to inspire a respect for culture, religion and patriotism. Cornelius's classically conceived Glyptothek frescoes made use of style to emphasize the deeper significance of his work. In a similar way these buildings referred by means of their style to different stages of development in the past. Klenze's Glyptothek (1816–30) was, naturally enough, classical. It combined a temple front exterior with an adaptation of the domed interiors of Roman baths inside which provided overhead lighting for viewing the sculptures. His Pinakothek (1826–33), on the other hand, was in the style of the Renaissance. This was to indicate the time when the art of painting was supposed to have reached its perfection. The main church of the new layout built by Gärtner and called, inevitably, the Ludwigskirche (1829–40), was more exclusively Christian. Its style was heavily dependent upon Byzantine and Romanesque models.

To many contemporaries the 'Art City' constructed by these heirs to Romantic notions of culture was an achievement that had weight in the general political sphere. For the English journalist William Howitt it even compensated for the regime's evident shortcomings in its methods of government and its social policies.

> I will not pretend to say whether it be envy, or whether it be the most profound and philosophical taste, which has directed so many critiques on the King of Bavaria. But this I will say, that there is no king of modern times, not excepting Napoleon, who has conferred so substantial glory on his capital, or such decisive benefits on modern art and taste. . . . Let him be an indifferent King; a neglector of the solid interests of the people, if you will; but with all this he has, from earliest youth, displayed a taste of the most honourable and refined kind. . . . The inhabitants of Munich do not now complain, but far the contrary. They see with pride the yearly growing influx of strangers from all parts of Europe and feel that what they there expend is a substantial advantage to them.[3]

For the citizens of Bavaria, however, culture was not enough. The widely felt discontent at seeing public revenues spent upon ostentatious display while more solid interests were neglected reached a climax during 1847, when Ludwig accorded his new mistress, the adventuress Lola Montez, an honoured place in public life. In the following year he was forced to abdicate.

As might be expected from his position, Ludwig's interest in culture always had a more pragmatic side than did Cornelius's. It was this difference that eventually caused them to part company. However admirable the intellectual content of Cornelius's work, the monarch found it too obscure and spartan, too lacking in those illusionistic effects that the Nazarenes had always held out against, to be effective on a popular level. After the completion of the Glyptothek frescoes in 1830 Cornelius found his activities severely curtailed. He was allowed to design decorations for the picture gallery, and prepared a series of scenes (1826–36) which showed the apotheosis of Christian virtues in the art of painting. But it was left to his pupils—who despite the 'master-classes' turned out to be more amenable to popular demand—to carry them out. Similarly the scheme that he had intended to be the climax of his career—the decoration of Ludwigskirche with a religious cycle—was reduced by the monarch to the depiction of the *Last Judgement* and some

ceiling paintings in the chancel (Plate 10). The decision was a short-sighted one. The Glyptothek frescoes executed by Cornelius's pupils are arid and uninspired. The master's *Last Judgement* on the other hand, succeeds in conveying an unswerving religious conviction. Larger than Michelangelo's Sistine mural, it rises overpoweringly with ever increasing scale through the opposing ranks of struggling and triumphant forms. The rising movement is reminiscent of the drama of Michelangelo's work. But its culmination is quite different. Whereas Michelangelo's design is held in balance by an equally dynamic, apollonian Christ, Cornelius's is presided over by a more traditional Christian deity, who is seated amidst a gathering of prophets and saints. There is no danger in Cornelius's world that order will not prevail. His Christ has the emotionless certainty of a Romanesque figure.

Such a hieratic affirmation of dogma was undoubtedly appropriate to the paternalistic authoritarianism of the Bavarian regime. However, Ludwig preferred his regime to be reinforced by cruder propaganda. His favourite artist became Wilhelm Kaulbach (1805–74), a protégé of Cornelius. A veteran of the Düsseldorf Academy, Kaulbach made his master's didactic art more palatable through the addition of painterly effects. He was capable of such flattery as the *Apotheosis of a Good King* (Plate 148) which almost mocks the sincerity of Cornelius's *Last Judgement*. Kaulbach had never known any other employer but the royal maecenas, and seems to have felt no conflict of interest between his own convictions and those of his benefactor. Like so many other pupils of Cornelius, he worked on the project most immediately accessible to the Munich populace, the murals in the arcades of the Hofgarten (1826–9). These represented the heroic and benevolent deeds of the Wittelsbach dynasty from 1155 to 1818—the year in which Maximilian I 'granted' a constitution to the Bavarians. These murals emphasized the Wittelsbachs' virtues and their unquestionable right to rule. The scheme was significantly silent about their most important recent rise in status. There was no mention in this pictorial history of the battles that Kobell had been commissioned to record on a lavish scale two decades earlier (Plate 97)—battles that were the result of the collaboration with Napoleon that had gained the Wittelsbachs the title of King. It would not have done to remind Bavarians that their monarch owed his title to the goodwill of the former French invader.

Cornelius became increasingly disillusioned in the jingoistic atmosphere of Ludwig's Munich. A similar change of heart affected other members of the Nazarene Brotherhood who came to work there, in particular Ferdinand Olivier and Julius Schnorr. Schnorr arrived in 1827 to paint a series of scenes from the *Odyssey* to form a narrative counterpart to Cornelius's Glyptothek frescoes. But once in Munich he found himself diverted instead into the more nationalistic plan of painting a sequence of rooms in the Residenz on the theme of the *Nibelungen*. The misgivings he had about this project were increased by the impatience of the King and by further demands for him to undertake even more nationalistic frescoes for the state rooms of the palace between 1835 and 1842. As a result of Schnorr's declining enthusiasm the *Nibelungen* project eventually took forty years to complete, from 1827 to 1867. Long before the end of this period, in 1846, the artist moved to Dresden where he became a professor at the academy and director of the picture gallery. It was here that he set about completing his main preoccupation, the *Bible in Pictures* (Plate 119).

However irksome to the artists who had initiated it, the revival of mural painting in Munich was the most significant factor in the prestige enjoyed by German painting throughout Europe around 1840. It was the painters of Munich who were held up as the paradigm of responsible historical artists in England when the question arose of how the new Houses of Parliament should be decorated,[4] and the German influence does much to explain the heavy heroism of some Victorian artists such as Daniel Maclise. It was the

148. Wilhelm von Kaulbach: *The Apotheosis of a Good King. c.* 1840. Oil (220 × 132 cm). Bayerische Staatsgemäldesammlungen, Munich.

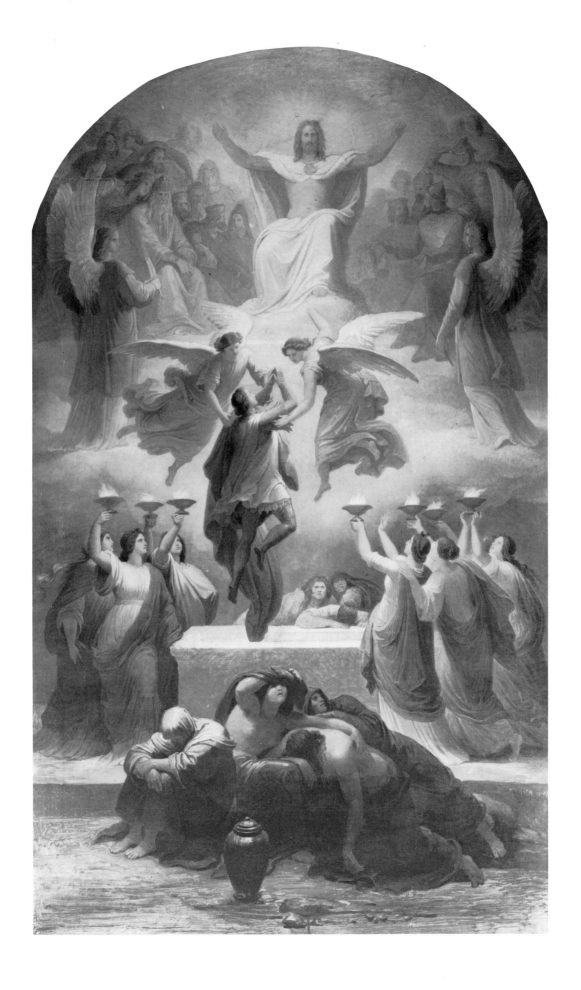

success of Munich, too, that finally enabled Cornelius to break loose. In 1840 there succeeded to the Prussian throne a monarch every bit as keen as Ludwig of Bavaria to play the role of the art prince. In the year of his accession Frederick William IV invited Cornelius to come to Berlin. Although belonging to a much younger generation, Frederick William shared many of the ideals of the Romantics of the Napoleonic Wars of Liberation. He dreamed of the unification of Germany on the old medieval model, with the Holy Roman Emperor once more at its head and the King of Prussia as his powerful lieutenant. Like Ludwig, his view of society was a paternalistic one, with peasants and nobles happily living in their appointed places. Unfortunately for him, however, this attitude was even more insupportable in Prussia in the 1840s than it was in Bavaria; for, while the latter state was still rural in its economy, the former with its new political power and growing industrial strength was facing the modern problems of a new industrial proletariat. In the territories of the Rhineland and Silesia the Prussian government had to cope with insurgency. In the Rhineland there was the opposition of Karl Marx, editor of the Radical paper *Rheinische Zeitung* until its suppression in 1843. In Silesia there was the uprising of the ill-treated Silesian weavers of the town of Peterswaldau in 1844. Unlike Ludwig, however, Frederick William was shrewd enough to moderate his policies

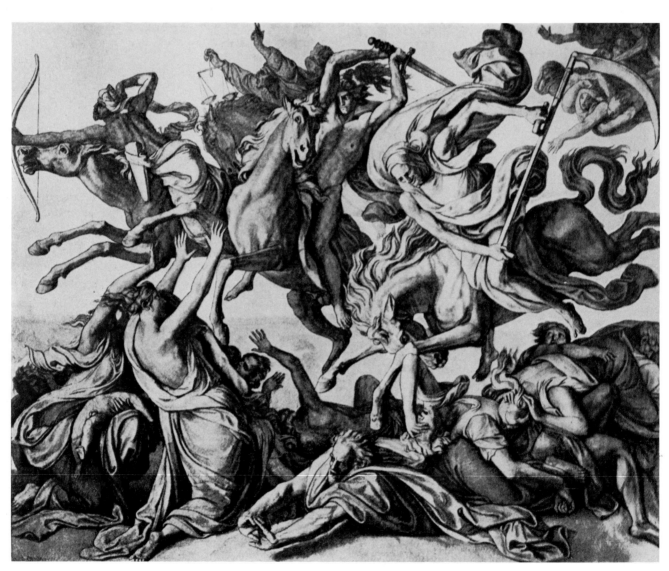

according to the actualities of the moment. His dissembling reaction to the Berlin uprising of 1848 enabled him to preserve his crown and even appear, for the moment, as the hope of the liberals.

Cornelius gratefully accepted the young King's summons. He arrived in Berlin in 1841 after a brief visit to London, where he had advised on the Houses of Parliament project. Unfortunately he soon found himself in a position that was even less favourable than that in Munich to the realization of his ideals. Commissioned to decorate the mausoleum of the Prussian kings attached to the Berlin cathedral, he took this as the opportunity to demonstrate the synthesis of classical and medieval, the unification of religion that he felt the new age demanded. As with the Glyptothek, it was a highly intellectual notion, and would probably never have become a convincing entity. But he was not in the end given the chance, since the plan for the Campo Santo was revoked by the Landtag after 1848 as part of a cut-down on extravagant regal projects. Cornelius himself could never accept this final defeat, and went on with his cartoons in the hope that they would one day be executed.

Most of these designs seem lifeless today—except for the *Four Horsemen of the Apocalypse* (Plate 149). Based on Dürer's famous design and on the horsemen of the Elgin marbles, which he had admired on his visit to London, it has that sense of power and control that one associates with truly heroic art. The maelstrom of panic is held in balance by a strictly circular design. This superb handling of a dramatic theme makes one wish that his other designs had had more action and less exposition in them; yet to have expected this would be to misunderstand Cornelius's own position. He believed in the necessity for art to instruct to herald the new age by making its citizens fully aware of their historical position and their responsibilities.

The use of the old to confront the new was no innovation in history painting. It had, of course, been fully exploited in the eighteenth century, particularly by French painters in their appeal to the example of the antique during the Revolution. By the time Cornelius had moved to Berlin there had emerged in Düsseldorf a generation of historical painters who were closer to the French than to the Nazarenes in their alliance of such high-mindedness to a sensationalist manner, and in their use of a historical narrative rather than an expository allegory to make their point.

The genesis of this school was partly due to the removal of Cornelius's influence from Düsseldorf in 1826. In that year he had handed over the directorship of the Academy to the Berlin painter Wilhelm Schadow. Schadow was a veteran Nazarene—he had been one of the decorators of the Casa Bartholdi—and a supporter of the seven-year apprenticeship system, though he was less insistent than Cornelius on a cerebral style amongst his followers. His own pictures have a surface realism quite alien to the schematic designs of Cornelius and Overbeck. Despite the greater sensationalism of his painting technique, however, he adhered to the simplified, symmetrical patterns of the Nazarenes. It was a combination that he summed up in his formula for the 'tendency and method' of the Düsseldorf school: 'the strictest possible conception of the subject and the most naturalistic representation of the same'.

The most popular purveyors of this synthesis in the 1830s were Schadow's star pupils Ferdinand Theodor Hildebrandt (1804–74) and Carl Friedrich Lessing (1808–80). Both had followed their master from Berlin to Düsseldorf in 1826. These younger painters profited from the relative proximity of Düsseldorf to Brussels and Paris, becoming familiar with the sensationalism of the more popular of the 'Romantiques', notably the Belgian Baron Wappers and the Frenchman Delaroche. One of Hildebrandt's most acclaimed works, the *Murder of the Sons of Edward IV* (Plate 150) was inspired by Delaroche's *Sons of Edward IV of England* which was exhibited in the Paris Salon in 1831

149. Peter von Cornelius: *The Four Horsemen of the Apocalypse*. 1845. Chalk (472 × 588 cm). Destroyed, formerly National Gallery, Berlin.

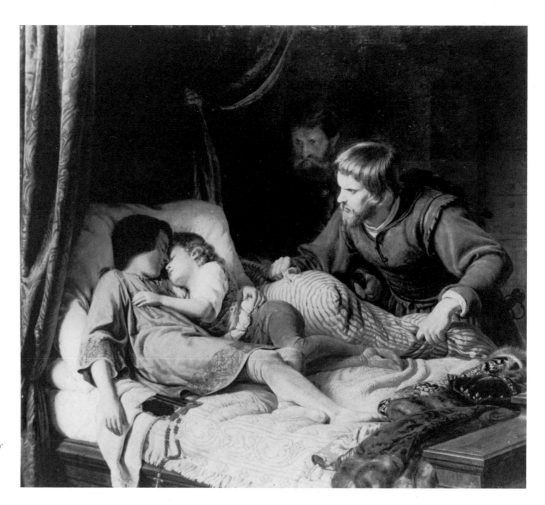

150. Ferdinand Theodor Hildebrandt: *The Murder of the Sons of Edward IV*. 1835. Oil (150 × 175 cm). Kunstmuseum, Düsseldorf.

and subsequently engraved.[5] The stark lighting, meticulous detail, even the angle of the bed, are close to Delaroche's picture. Yet the German has told his story more explicitly by showing the deed of the jailer smothering his innocent victims just on the verge of being performed. The French had achieved a more subtle effect by showing the princes alone, listening apprehensively to the sound of an undisclosed figure behind the door.

Despite this differing attitude towards the representation of subject matter, many of the younger Düsseldorf painters shared the liberal attitudes of their French and Belgium counterparts. Following in the footsteps of David the new historical painters of the 1820s had aligned themselves with the populist opposition, and both Delaroche and Wappers had reaped the rewards of their affiliations in their respective countries after the success of the 1830 revolutions. Liberalism was also a popular movement in Düsseldorf. The city lay in the rapid expanding industrial area of North-Rhine–Westphalia, a region of growing social unrest during the 1830s. The causes for this discontent reached back to the Napoleonic period, when the occupying French had provided the basis for a rapid expansion of private enterprise by abolishing feudal controls over trade and industrial production. When the area was ceded—much against its will—to Prussia in 1815, this thriving community found itself once more threatened by autocratic controls. As a result the province became one of the sharpest critics of Prussian policy—a situation borne out by the fact that nearly half of the opposition party in the Prussian *Landtag* consisted of delegates from North-Rhine–Westphalia.

The critical atmosphere of this region provided a fertile ground for art and literature that implied criticism of the regime. Ironically the industrialists were enthusiastic supporters even of radical papers like the *Rheinische Zeitung* edited by Karl Marx during

1842–3. Feudalism and authoritarianism were their common enemies. Bourgeoisie and workers fought side by side in the Revolution of 1848. It was only after the populist uprisings of 1849—provoked by the ineffectuality of the liberal Frankfurt parliament—that the wealthy burghers realized that they were seeking a different form of social justice from that of the proletariat.

In painting, this discontent was catered for in the use of satire and the *double entendre*. At the Academy Schadow himself was censorious of all but a strictly visual realism, and Hildebrandt rarely strayed towards themes that might cause controversy. But there were more disruptive forces at large. The painter Johann Peter Hasenclever must have spoken for many students when he painted his *Studio Scene* (Plate 151) in 1836. In it he showed the painting studio of the Düsseldorf Academy—known to the inmates as 'Siberia' on account of the long and tedious apprenticeship that they were forced to endure there[6]—with the artist and his friends in postures lampooning the pretentions of academic art. A hunchback mimics the pose of an antique statue, while the paraphernalia of the outworn Romantic 'troubadour' style lie scattered around. In the background, a large canvas of the kind used for large history paintings, is seen from behind. It is used here only as a

151. Johann Peter Hasenclever: *Studio Scene*. 1836. Oil (72 × 88 cm). Kunstmuseum, Düsseldorf.

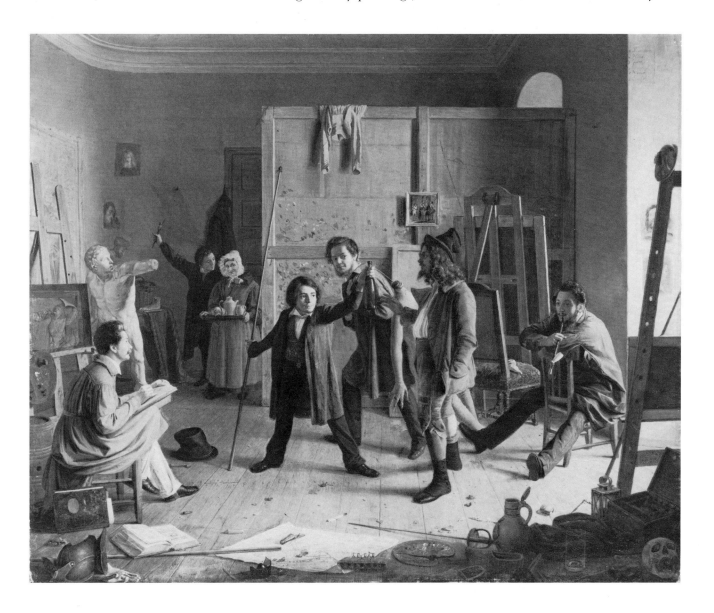

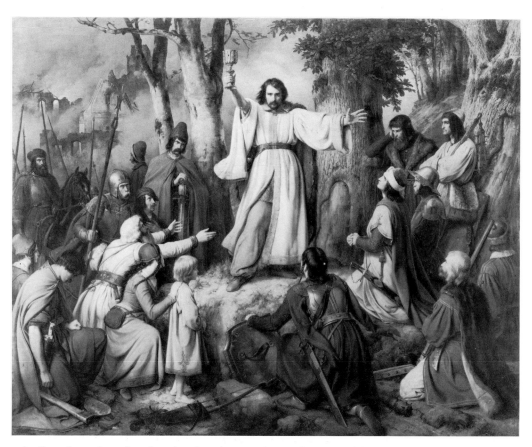

windbreak, a place for cleaning brushes, and a surface on which to hang one of the small, realistic paintings of the kind that Hasenclever himself executed. It hardly need be said that Hasenclever was regarded as something of a gadfly by the authorities. He was in fact dismissed from the Academy at one point by Schadow who had little taste for this kind of vulgarity. Hasenclever's art was irritating, but it hardly presented an effective challenge. As the mockery of the historical canvas shows, Hasenclever restricted his activities to the small-scale genre scene, basing his work on the Dutch and the 'modern moral subject' painting of Hogarth. He did not, as the French painter Courbet was later to do in his *Studio* (1855, Louvre, Paris), seek to establish realism on a monumental scale.

It was the attempt to give the monumental contemporary relevance that made the art of Lessing so popular. Unlike Hildebrandt, Lessing was never invited to become a professor at the Academy—a measure in itself of the suspicion with which his work was viewed. As early as 1830 he created a sensation in Berlin when he exhibited the *Sorrowing Couple* at the *Kunstverein*. The theme of this picture—taken from a poem by Uhland describing the termination of a dynasty through the death of a royal couple's only daughter—was readily interpreted as a comment on the passing of feudalism. In Düsseldorf he soon was hailed by the radical critic Müller von Königswinter as the greatest of contemporary history painters. Königswinter emphasized in particular the realism of Lessing's work and made it clear that he meant by this not the consummate illusionism of Lessing's style but his approach to his subjects. 'Realist' history painters to the critic were those who 'took their subject matter from periods in which a real history of the people, and not just that of the nobles . . . existed. They become inspired by thoughts that have relevance, too, for our own day.'[7]

These demands seem to have been met completely by the work that Lessing was most admired for, the *Hussite Sermon* of 1836 (Plate 152). In this scene from the Bohemian religious rebellion of the fifteenth century the hieratic format of the Nazarenes and their followers is set to a subversive purpose. This vast canvas, with its near-lifesize figures, does

not simply celebrate a popular uprising against ecclesiastical authority in the Middle Ages. It also reads as an analogue to the contemporary struggle in the Rhineland against the Catholic hierarchy, as the *Rheinische Zeitung* pointed out: 'How important this subject is for the present, which is continuing and concluding, under a different guise, the same struggle for spiritual freedom against the church.'[8]

The use of a historical subject to comment upon a contemporary situation can merge almost imperceptibly with satire. The mock-heroic form of the latter depends upon a similar appeal to idealism by means of allegory. When the journal *Rheinische Zeitung* was suppressed in 1843, a fellow-artist of Lessing and Hasenclever used the knowledge of classical mythology and the use of allegory learnt in his academic training to satirize the event in an erudite cartoon (Plate 153). In this the editor, Marx, is shown in the role of Prometheus, with the Prussian eagle tearing at his bowels.

It would be convenient if it could be shown that the greatest historical painter to be trained in Düsseldorf—Alfred Rethel—shared the radical outlook of Lessing, Hasenclever and the designer of the Marx cartoon. But this is not the case. Rethel was a traditionalist, a hater of 'red revolution', who shared the Nazarene's medieval vision of a strong authoritarian state founded upon the harmony of ecclesiastical and secular government. His description of the artist's talent as a 'blessing from heaven' was more than a figure of speech. He had a strong sense of religious duty, and felt the call 'to exert a thoroughly moral, powerful and correct influence on the development of my fellow man'.[9]

Although Rethel became increasingly disturbed by the events that surrounded him, his solution was not to withdraw, but to confront the contemporary in its own terms. At the

152. Carl Friedrich Lessing: *Hussite Sermon*. 1836. Oil (230 × 290 cm). Kunstmuseum, Düsseldorf.

153. Anon.: *Karl Marx as Prometheus*. 1843. Lithograph.

time of the 1848 Revolution his reaction to the 'babbling of newspapers and broadsheets' was to produce a series of broadsheets of his own, *Another Dance of Death* (Plates 9 and 159), a grim satire told in the boldest terms to instruct the populace in the error of their ways. Throughout his career his art derived its strength from the conflict of the real and the ideal that it embodied.

This conflict can also be found in Rethel's own life. Born in Diepenbend, near Aachen, he came from a family that fell victim to the rapidly developing entrepreneurship of the industrialized Rhineland. His father was a chemical manufacturer who went bankrupt after his works burned down, and was obliged to become an employee of the industrialist Harkort. Perhaps for this reason it was Rethel's mother who was the dominant figure in the household. She saw to it that her son's prodigious talent was given every opportunity of development. After having received instruction from a local artist, J. B. Bastiné, he was sent off to the Düsseldorf Academy at the age of thirteen.

Although his art was bound up from this time with the painting of historical subjects, Rethel was capable in his teens of bringing his clear, analytical, vision to bear on the contemporary world. His portrayal of the Harkort factory at Castle Wetter belonging to his father's employer (Plate 8) records the new order without a hint of emotionalism. Without any of the drama or irony of Blechen's contemporaneous *Iron Rolling Mill* (Plate 108) it shows the erosion of a feudal settlement by the new industry that grows around it. Technically it has the brightness and detail of topography, but the design is monumentally conceived. The low sheds and irregular chimneys are organized in a grid of rectilinear severity. The factory expands towards us and out of the picture at a measured pace. Factual and powerful, it accords well with the outlook of its owner. Harkort was an incorrigible progressive, most frequently remembered today for his remark that the 'locomotive is the funeral cart that will carry absolutism and feudalism to the graveyard'.[10]

The basis for the precision of observation and organization evident in this work had been acquired by Rethel even before he went to the Düsseldorf Academy in 1829. His teacher in Aachen had been a Belgian pupil of the French arch-classicist David. Bastiné was primarily a portrait painter, and, if Rethel's *Harkort Factory* has something of the exactness of David's view of the Luxembourg Gardens,[13] his early portraits reveal even more strongly the realist basis of the French classical tradition. Indeed, his portrait of 1833 of his mother (Plate 154) shares with Bastiné's portraits the obsessive literalness of David's last years. Despite his close ties to his mother the artist has not spared her here. There is an almost uncanny insistence on the disillusion and determination on the face of this bourgeois woman who has suffered reverses in fortune. Yet there is a presence and dignity too, brought out by the boldness of the draughtsmanship and the simple clarity of the design.

With his prodigious early development, it is not surprising that Rethel should have felt so strongly the ambition to become a history painter. He was greatly impressed by the illusionist manner of Hildebrandt and Lessing in Düsseldorf and accepted the need for history painting to have a contemporary relevance. But the subjects he chose emphasized the traditional rather than the subversive or sensational. Already in 1831, when fifteen, he was planning a series of pictures on the life of St Boniface, the introducer of Christianity into Germany, and of the religious establishment against which Lessing's Hussite had been rebelling. Indeed, the last of these pictures, *St Boniface as Church Builder* (Plate 156), was brought into direct contrast with Lessing's work when both were exhibited at the Berlin Academy in 1836. However, it is not only in its subject that Rethel's work suggests an alternative to that of Lessing. Although the younger artist has absorbed the rebel's surface illusionism, his composition also has a more telling monumentality. Both are

XXXI. Adrian Ludwig Richter: *St Genevieve in the Forest*. 1841. Oil (116.5 × 100.5 cm). Kunsthalle, Hamburg.

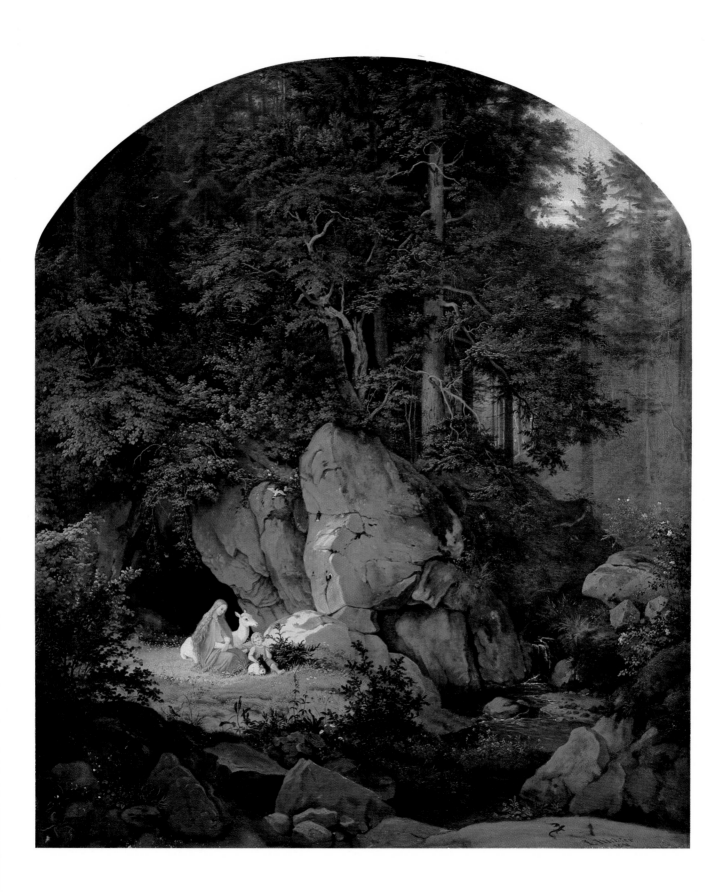

symmetrical in design but Rethel's gains its force from a cross-current of diagonal movements. And, while Lessing's figures are set on a pre-conceived stage, Rethel's figures are the generating point of his arrangement.

This work shows Rethel's appreciation that the truly monumental depends upon form rather than gesture. In the year that it was completed he turned his back on Düsseldorf and moved to Frankfurt in search of a purer tradition. Curiously his work at this time seems to have displeased the veteran Nazarene Schadow as much as that of Lessing and Hasenclever did. In Frankfurt, however, Rethel was able to profit from the sympathetic attention of another survivor of the Brotherhood, Philipp Veit, who was professor at the Städel Institute in Frankfurt. It was at the Städel, too, that Rethel was able to study the cartoons for the Bartholdi frescoes at first hand.

Rethel greatly appreciated Veit's support. He remained centred in Frankfurt until 1847, the year of Veit's retirement. Veit's support went beyond mere praise to more material benefits, notably Rethel's first commission for mural painting—four full-length portraits of Holy Roman Emperors (1839–40) for the Roman Hall of the Frankfurt town hall. While still displaying much illusionism, these figures show as well an instinct for the broad rhythmic design necessary in mural painting. There is also in them the beginnings of the terse, expressive line—bold in its movements and sudden in its changes of direction—that characterizes Rethel's mature works. Rethel's involvement with monumental art and with the lives of Holy Roman Emperors was timely, for it helped him succeed in the main event of his public career: the winning of the competition to decorate the Imperial Chamber in the town hall of Aachen in 1840.

As soon as it was announced in 1839, this competition was considered to be one of national importance. It was to provide frescoes for the room in which thirty-five Holy Roman Emperors starting with Charlemagne himself had held council. The scheme had originally been suggested by a local dignitary, Gustav Schwenger, in 1836. Three years later the Aachen town council, in collaboration with the Rhenish *Kunstverein*, held a limited competition in which Rethel and four other Düsseldorf-trained artists were invited to submit designs.

Despite the opposition of Schadow, Rethel was declared the winner in July 1840. It was a great moment for the twenty-four-year-old artist, for it offered him both prestige and security. Not only was the commission one of the most envied in Germany, it was also well paid. He received 20,000 thalers (later raised to 25,000 when an additional scene was added). Payment began in regular instalments in 1840, to remove him from financial worries and allow him to devote himself to planning the great work.

However, the course of the project was far from smooth, and Rethel was not able to begin painting the works until seven years later. The reason for this was partly that the Aachen town council decided to restore the Imperial Chamber to its original shape before proceeding with the decorations. But more significant was the uncertainty expressed over the artist's approach to the theme. While there was no criticism of the aesthetic merits of Rethel's designs, it was felt that he had ignored the spirit of the original commission. In the competition it had been stipulated that the scenes should be of 'important moments from the life of Charlemagne' and it had been added that these should 'be treated both historically and symbolically, and should relate as far as possible both to the general historical importance of the scenes and to Aachen as the favourite domicile of the Emperor'.[12] As such it was an expression of local pride, a means of expressing the historical importance of Aachen itself. Rethel, however, despite being a native of Aachen, was concerned above all with national and religious rather than regional issues. He completely ignored Aachen in all but one of his original designs and chose instead to concentrate on what he called 'the basic concepts that were always expressed in

XXXII. Alfred Rethel: *Visit of Otto III to the Crypt*. 1847. Oil (52.5 × 82.7 cm). Kunstmuseum, Düsseldorf.

Charlemagne's momentous and victorious undertakings—the infiltration of the state with Christian principles, and the destruction of paganism by the introduction of Christianity, whose head was at that time considered to be the Pope'.[13] Like the Nazarenes, Rethel grasped the occasion to demonstrate the medieval integration of Church and State and the unity of Germany under the Holy Roman Empire.

Aided and abetted by the radical press, a faction in the Aachen town council consistently opposed the decoration of their town hall with such a message. And, indeed, it was only after Rethel turned the controversy into a national issue that he received the authority to proceed. In 1846, after years of frustration, he travelled to Berlin, showed the Prussian King his plans, and appealed for his support. As a result of the monarch's approval and intervention preparations for the execution of the murals were immediately set under way.

The original commission had been for six scenes. This was augmented, after the restoration of the Chamber, to seven. Of these, one dealt with Charlemagne's repulsion of the infidel, the *Battle of Cordoba*; two with his conquest and Christianization of Germany, the *Fall of the Irmin Column* and the *Baptism of Wittekind*; two with his *rapprochement* with Rome, the *Entry into Pavia* and the *Coronation of Charlemagne in Rome*; and two with the German continuation of his tradition, the *Crowning of Ludwig the Virtuous in Aachen* and the *Visit of Otto III to the Crypt* (Plate XXXII). Arranged roughly in chronological order the cycle was to begin with Charlemagne's symbolic destruction of the pagan Irmin column after his victory over the Saxons near Paderborn in 772 and was to culminate with the visit of one of Charlemagne's successors to the crypt where the great Emperor's body was embalmed. According to the legend, Otto III made this pilgrimage in an attempt to gain the inspiration to restore the glory of Charlemagne's reign in his former German possessions. For Rethel, this 'historical apotheosis' was of course redolent with import for the present, and it was to underline the cycle's contemporary message that he chose this scene for its conclusion.

However, while the painting of the cycle was in progress its relevance was being brought into question by current events. Before Rethel had executed more than two of the frescoes the Revolution of 1848 had broken out; and by the time that the consequences of this upheaval had been resolved in 1849 it was clear that, whatever kind of unity there was likely to be in Germany in the future, it would not be along the lines of the feudal system of the Holy Roman Empire. From this time Rethel—who had been as disappointed with the monarch as he had with the agents of the 'Red Republic'—began to lose interest in his cycle. His letters after 1849 reveal increasingly his view of the project 'as a heavy burden, as the destroyer of my enjoyment of life'.[14] In 1850 this view was exacerbated by the onset of a nervous illness. Neither his marriage in 1851, nor a journey to Rome in the following year could restore his equilibrium and in the spring of 1853, when he returned to Germany, he was declared insane. He was never to recover, and died six years after the catastrophe in the care of his mother. Only four of the frescoes had been completed by 1853, and the remaining three were executed by Rethel's assistant, Joseph Kehren.

The completed frescoes were severely damaged while being stored during the Second World War, and it is hard to gain an impression now of their former quality. The cartoons and oil sketches that survive, however, show a vigorously conceived scheme and bear witness to his superb powers as a designer and draughtsman (Plates XXXII and 155). Most striking of all is the design for the concluding scene in the cycle, a scene that he was actually to execute first of all, in 1847. Unlike the other designs, this scene was placed above a window, and is smaller and more irregular in shape. Yet Rethel has exploited this to bring out the awesome and macabre nature of the event. According to tradition Charlemagne was embalmed seated upright in his throne, and it is this figure—majestic in

154. Alfred Rethel: *The Artist's Mother*. 1833. Oil (61 × 67 cm). Nationalgalerie, Berlin (West).

155. Alfred Rethel: *Choirboy*. 1851–2. Oil (54.3 × 43.2 cm). Kunstmuseum, Düsseldorf.

death—that Otto III has come to pray before. The whole force of the design comes from the gradual arrest of Otto's followers as they approach the Emperor's corpse—upright and static like the columns that surround him. There is no hint in the lines or the pungent colouring of the smoothness and surface illusionism of the Düsseldorf school. Instead the forms are conceived as weighty angular masses, their shapes emphasized by the torchlight as it casts a lurid glow over the gloomy scene.

That Rethel should have reached the height of his powers as a mural painter in such a scene may have been partly because it was seen by him as the summary of the message he wished at that time to convey in the cycle. But it also indicated that macabre streak that was to lead to his greatest achievements—the wood-engravings on the theme of the Dance of Death that he was to design after the 1848 Revolution.

Rethel's involvement with illustration at this time was not without precedent. In the years prior to the Aachen commission he had been engaged on several religious and historical projects. The first had been the outlines that he drew for lithographs to accompany a collection of Rhenish tales in 1834 (Plate 157). Dramatic and fantastic, they already showed a close acquaintance with the etchings of such early German masters as Schongauer. But the thin lines, tonal shading and multiple details have little in common with the direct and powerful forms that he was later to design for wood-engravings. This quality first began to emerge in his illustrations at much the same time as the terse line appeared in his historical paintings. The catalyst was the commission to provide designs for the sumptuously illustrated edition of the *Nibelungen* published in Leipzig in 1840 (Plate 158).

This book was a milestone in German publishing. Produced to celebrate the four-hundredth anniversary of the establishment of the first printing press by Gutenberg, it was a deliberately archaizing work. Based on the style of ballad book that the Romantics had developed out of the border illustrations of Dürer for the *Prayer-Book* of the Emperor

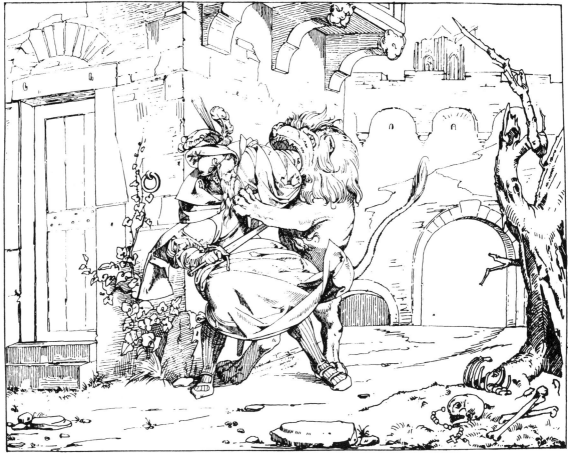

Maximilian, it had none of the whimsy that artists like Neureuther had brought to the genre (Plate 132). Instead the recent adoption of wood-engraving for quality reproduction was fully exploited to suggest the simplicity and vigour of the first pictorial productions of the printing press. Rethel played a minor part in this venture. He was called in at the last moment to help out the two artists first commissioned, Eduard Bendemann and Julius Hubner, who found they could not finish the work in time.

It was the first time that Rethel had produced designs for wood, yet his treatment was masterful. He responded far more successfully than Hubner or Bendemann to the challenge of producing a simple design that would have the vigorous effect of a woodcut and integrate with the letterpress on the page. In the illustration of Chriemhild ordering the Hall where her adversaries are taking refuge to be burnt down (Plate 133), Rethel achieved this integration by bringing two columns down in front of the scene, emphasizing the surface unity of image and text. He also emulated the economy of effect of the old German masters by modulating the simple shading and contours to suggest simultaneously volume, lighting and texture. There are no dead areas of smooth parallel lines as there are in so many of the wood-engravings of the period.

Rethel did not return to designing for wood until the cycle *Another Dance of Death* nine years later. It is symptomatic of the significance of the 1848 Revolution to him that he should have interrupted his preparations for his next Aachen fresco while wintering at Dresden in 1848–9 in order to make this series. Yet it was entirely consistent with his view of history painting that he should have sought at this point of crisis to express his political message in the sphere of popular art, to meet the propagandists of the 'Red Republic' on their own level. In format *Another Dance of Death* (Plates 9 and 159) is close to that of the broadsheets, with their simple woodcuts and verses, that flourished after the events of March 1848. Even the black irony of the theme appears to have been instigated by a radical poem, Ferdinand Freiligath's *From the Dead to the Living*. Published in July 1848 this had chided the survivors of the barricades for failing to carry on the cause for which their comrades had died.

In Rethel's cycle, however, there is also the reference to a more timeless tradition. His irony depends on a knowledge of the late medieval allegories on the Dance of Death. As in these it is not the dead but Death himself who is the propagandist. In the allegorical prologue he is called into action by a quartet of vices—folly, cunning, vanity and bloodthirstiness—who arm him for his journey. While this design has all the abstruseness of a Cornelian allegory, the rest of the series is set firmly in the present. Death rides in to a modern industrial city (Plate 9), where he deceives the proletariat into believing themselves equal to their rulers. Incited to rebellion they discover too late that Death—like Daumier's Ratapoil—has played the *agent provocateur*. And he has given them a very different equality from the one that they had expected.

Rethel's presence in Dresden in the winter of 1848 was also a contributing factor to his decision to design the series. The retirement of Veit and his replacement at the Städel by Lessing in 1847 seems to have convinced Rethel that he could no longer use Frankfurt as a base, and from this time he fell into the habit of spending his winters in Dresden to prepare for his programme of fresco painting in Aachen during the summer months. As a traditionalist he found the less industrialized city of Dresden a welcome relief from the Rhineland, and he found there too a circle of poets and artists sympathetic to his viewpoint. Apart from his former collaborators on the *Nibelungen*—Bendemann and Hubner—there was also Robert Reinick, a painter and poet with antiquarian interests who provided the verses for the *Another Dance of Death*. He also made friends with Adrian Ludwig Richter, and may well have been encouraged by this producer of simple 'folk' illustrations, to adopt a similar simplified woodcut style. Both artists made use of the same

156. Alfred Rethel: *St Boniface as Church Builder*. 1836. Oil (60 × 85.5 cm). Kunstmuseum, Düsseldorf.

157. * Alfred Rethel: *The Tale of the Burgomeister of Cologne*. Lithograph from *Rheinische Sagenkreis*, Frankfurt, 1835.

Wie Iring erschlagen ward.

Fünfunddreißigstes Abenteuer.

Da rief der Markgraf Iring von Dänemark der Held:
„Ich habe all mein Leben auf Ehre längst gestellt,
Es ist von mir des Besten in Stürmen viel geschehn:
Bringet mir meine Waffen; ich will Hagen bestehn!" —

Dresden engraving studio—that of Hugo Burckner—where there was a strong sympathy with their stylistic aims. Both, too, took trouble to indicate in the drawings they made on the wood blocks the exact direction of the shading, keeping this to the simplest of cross hatchings. Indeed their names were often cited together for their skill in such designing. In *The Elements of Drawing*, for example, John Ruskin commented that 'when an artist is reduced to showing the black lines either drawn by the pen, or on the wood, it is better to make these lines help, as far as may be, the expression of texture and form . . . you will see that Alfred Rethel and Richter constantly express the direction and rounding of surfaces by the direction of the lines which shade them'.[15]

However, despite this technical similarity, the broad effect of their work is utterly different. Where Richter's broad line and curved shading is rhythmic and lyrical, that of Rethel's is powerful and dynamic. Richter seeks to lull, Rethel to startle. With a masterful sense of balance he brings forceful conflicting actions into momentary suspension—as when Death dangles the sword of 'Popular Justice' tantalizingly above the heads of the crowd.

In the format, design and clarity of the series, Rethel succeeded masterfully in his objective of producing a *Volksblatt* (broadsheet). And, though the radical Müller von Konigswinter complained—as one might have expected—that the result was 'a caricature of the whole tendency of our time',[16] the work certainly endured. Throughout the period of the German Empire it was commonly used in schools as a warning of the consequences of revolution.[17]

158. * Alfred Rethel: *How Iring was Slain*. Wood-engraving by F. Unzelmann from *Das Nibelungenlied*, Leipzig, 1840.

159. Alfred Rethel: *Death as a Folk Hero*. Design for Plate 4 of *Another Dance of Death*, Dresden, 1849. Pen and Wash (22 × 32 cm). Staatliche Kunstsammlungen, Kupferstichkabinett, Dresden.

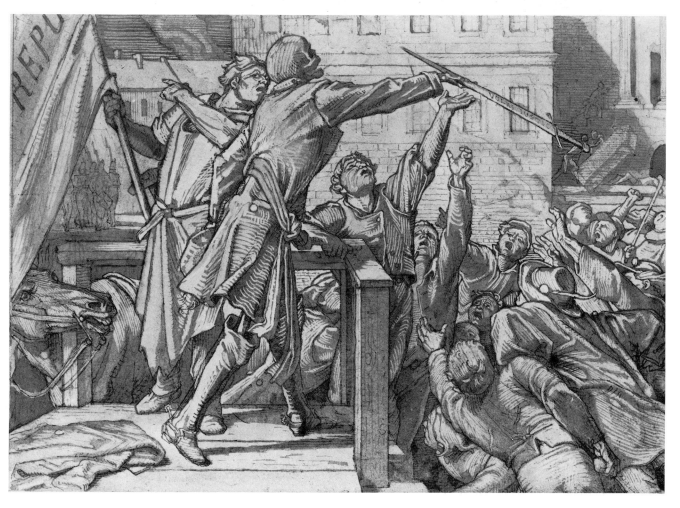

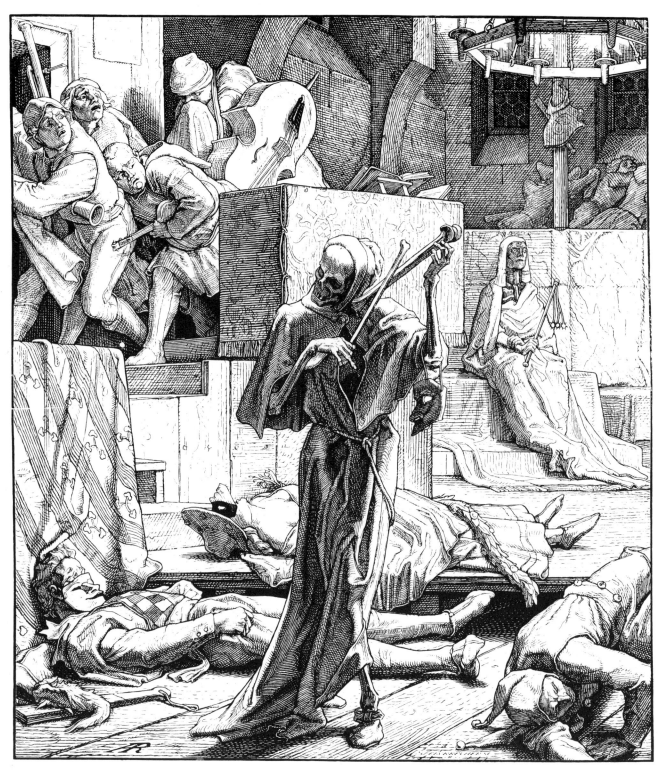

160. * Alfred Rethel: *Death as an Avenger.* 1851. Wood-engraving by J. Jungtow.

161. * Alfred Rethel: *Death
as a Friend*. 1851. Wood-
engraving by J. Jungtow.

Yet the final irony of the series was that Rethel himself was to feel that he had caricatured the situation even before the work was published. In May 1849, just before the engravings were ready, he witnessed in Dresden the final act of the upheavals, the popular uprising due to frustration at the inadequacies of the Frankfurt parliament. The outcome of this revolt was not the nervous capitulation of the monarchs of the former year, but a brutal suppression. The prime mover in this was the Prussian King, who now saw himself as the enforcer of order, and provided troops for other weaker monarchies—including that of Saxony—to follow his lead. In this year, therefore, Rethel saw a popular movement in favour of a stronger national institution being suppressed by the provincial interests of the monarchies. The movement that he had thought to be against his political ideal now seemed to be fighting on its side. 'I watched the rise of this movement with mistrust and expected a Red Republic', he wrote to his mother. 'But in fact it was nothing but the genuine enthusiasm of the people—in the most honourable sense—for the creation of a great and honourable Germany, a mission put into their hearts by God and *not* called forth by the radical prattle of bad newspapers and mob orators.'[18]

While *Another Dance of Death* was making his name famous throughout Germany, France and England, Rethel returned once more to work on the Aachen frescoes. But as these became increasingly burdensome it seemed to him that his 'true artistic interest' lay in graphic design. He even planned to establish a wood-engraving studio in collaboration with his brother, but this project, like all others, had to be abandoned at the outbreak of his madness.

Meanwhile he had continued to explore the theme of *Another Dance of Death*, though the emphasis changed from the political to the personal. In 1851 *Death as an Avenger* (Plate 160) and *Death as a Friend* (Plate 161), were published as pendants, engraved once more by Burckner's firm in Dresden. All reference to the modern political cartoon had ceased in these works. Instead they rely to an even greater degree upon the old woodcut moralities—in particular those of Holbein. But they are none the less addressed to the present. *Death as an Avenger* was based on Heine's account of the cholera epidemic in Paris in 1831 during the carnival season. Drama and action is used in it to display fear in much the same way as in the 1848 cycle. *Death as a Friend*, on the other hand, is a quiet authoritative work. The slow heavy rhythms of the cowled figure of Death tolling the bell for the custodian at sunset echo throughout the picture's tranquil forms.

Rethel was aiming at a more sophisticated market in these works and had them executed with a much finer sense of detail. Although the surfaces are cut far more minutely than would have been possible with the old method of woodcut, the method is still essentially the same. For the style was an integral part of the message. Indeed the sense of wood seems to have pervaded the very texture and design of these pictures—the 'Avenger' gnarled and knotted—the 'Friend' smoother and more evenly grained.

On the surface these pictures are highly didactic. Yet it is not the quality of their reasoning that appeals. They are within the genre of Baudelaire's 'philosophical art', but they have reached beyond the vocabulary of history painting to a more primal level. Unlike the art of the Nazarenes, they are not expressions of good intentions but evocations of instinctive states of being. More than any other revivalist art they are rooted in a Germanic tradition, a tradition that does not treat the grotesque and macabre as fantastic—as its English and French imitators tend to do—but as real.

Rethel's art was a fateful one. A traditionalist through and through he emerged at the moment when the world that the Romantics had dreamed up was on the point of disintegration. He was the last of his line, but he was also one of the strongest, and the image that he left behind was not so easy to disperse.

Epilogue

'ROMANTICISM is finished on this earth; the age of the railway has dawned.' There were many in the middle of the century who felt, like the writer Theodore Fontane, that the new materialism had rendered the imaginative and subjective in art irrelevant. They failed to recognize that the Romantics had addressed themselves to fundamental human problems that could not be eradicated by the events of the 1840s. If pantheism and revivalism had become outmoded, many of the attitudes that accompanied them survived in a transmuted form.

The most obvious survival in Germany was the faith in a national identity. This fostered the emphasis on a German art, independent of other cultures. Today we are all too aware of the line that runs between the nationalistic assertions of Fichte, Kleist and Friedrich to those of Nietzsche and Wagner and eventually to those of the National Socialists. When Hitler gave his speech at the opening of the German Art exhibition in 1937 as part of his campaign against degenerate 'international' art he singled out the Romantics as people who were 'in essence . . . the most glorious representatives of those noble Germans in search of the true intrinsic virtues of our people'.[1] Support from this quarter can only alienate. Yet it is as well to remember that the Nazis based their claims upon the distortion of a tradition. In fact it was not they, but the 'degenerate' artists whom they ridiculed—Nolde, Munch, Ernst, Barlach and Klee—who were continuing the Romantics' exploration of an indigenous art.

To some extent the tradition was a continuous one. This is especially so in the case of landscape. At the time that the Düsseldorf artists Lessing and Schirmer were exhausting the vocabulary of the symbolic Northern landscape, a young student at the Academy there, the Swiss-German Arnold Böcklin (1827–1901), was deriving a new kind of message from it. He rejected the pantheistic approach to landscape. But he continued to explore the ability of nature to arouse subconscious states in man. His *Island of the Dead* (Plate 162) does not derive its appeal from any programme—the title, in fact, was not his— but from its sense of enigma. It is, as he said, 'a picture for dreaming about'. While this interest in 'objectifying the subjective' has its parallels in symbolist art in France, the gloomy doom-laden air shows a concern with a very different kind of experience. In the 1890s the Northern landscape became a potent force for the Norwegian painter Edvard Munch (1863–1944). When he came to Berlin in 1892, Munch had already studied in Paris and was coming to terms with the art of the Impressionists and of Van Gogh and Gauguin. But it was in Berlin that he was able to bring these experiences to individual expression through the alliance of human emotion at the point of crisis with the 'voice of nature'. His remark that 'nature is not only what is visible to the eye—it also shows the inner images of the soul—the images on the reverse side of the eyes',[2] has the ring of Friedrich about it. It seems to be more than a coincidence that Munch should have been living in Berlin at a time when Friedrich's work was being rediscovered. Certainly *The Lonely Ones* (Plate 163) seems to be associated with the imagery of Friedrich. Like the earlier artist's Baltic scenes, two figures stand on a bare shore staring out into the sea. Yet

in place of Friedrich's simple faith there are more complex tensions: the spiritual has been replaced by the psychological. There is no divinity to be found in the surrounding water—only the reflection of the figures' own isolation. This kind of landscape remained a potent source for the symbolists of Northern Europe. It is hardly surprising to find that it also attracted those twentieth-century explorers of the subconscious, the Surrealists. Böcklin was a formative influence on both de Chirico and Salvador Dali; and Friedrich was a favourite painter of Max Ernst.

The connections between revivalist art and the twentieth century might seem more tenuous. But it is as well to remember that the Nazarenes were the first artists to advocate a full-scale revival of the primitive. Perhaps Overbeck's only direct descendants are the pious pin-ups of Catholic propaganda. But the Gothic daemonism of the young Cornelius and of Rethel prefigured the more extreme experiments of the expressionists. Rethel's very obsession with the medium of wood has its affinities with that of Kirchner and Barlach. And in both cases there was a conscious relationship to a German tradition of woodcutting and graphic art. Even though the German expressionists emulated the technical innovations of the Post-Impressionists and the Fauves, they differed from the French artists in basing their exploration of the primitive on ethnic as well as aesthetic grounds.

It was not just the motifs of German Romanticism that survived. Many of its assumptions about the nature of art, too, remained significant. In a general sense the metaphysical view of beauty as a 'symbolical representation of the infinite' became a common assumption amongst Romantics and Symbolists throughout Europe, after having been popularized in the first place by the writings of August Wilhelm Schlegel. There is no space here to trace the impact of Schelling's *Naturphilosophie*, the view of the parallelism between art and nature, synaesthesia, and the exploration of the symbolism and psychological effects of colour in Goethe's theory upon nineteenth and twentieth-century art. These issues would provide material for a whole book. But it can at least be stated that it was in the writings of the Schlegels, Novalis, and Runge around 1800 that it was first recognized that the basic pictorial elements—lines and colours—were capable of conveying meaning independently of any figurative description. Runge's transformation of the experience of nature into primary colours and decorative arabesques and Friedrich's radical paring down of form in pictures like the *Monk by the Sea* show a desire to communicate in terms of basic elements which was not matched until the advent of abstraction in the twentieth century. And it is no coincidence that when Kandinsky was developing the theories that took him along this road in *Concerning the Spiritual in Art* (1912) he should have drawn so heavily on the notions of the Romantics.

The intention of this brief outline has not been to imply that the German Romantics were a unique generative factor in subsequent art. This would be a distortion of their historical and aesthetic importance. It has been rather to indicate that they are a significant point of reference in a complex series of dialogues involving most European countries. If this point of reference is ignored, many of the interchanges that have taken place elsewhere become hard to follow.

It will not do, either, to evaluate the Romantics primarily in terms of their influence. The true survival of an art depends upon its own intrinsic merits. The emulation of qualities in one art form by another necessarily involves misunderstanding and misrepresentation. And if it can be shown that the German Romantics have been referred to by later artists it does neither a service to imply an identity of purpose. Runge and Friedrich were not abstract expressionists, nor even symbolists. Their art belongs to a different world and possesses an identity of its own that is closely linked with the beliefs and preoccupations of its time. And it is only by attempting to understand them on these terms that they can be appreciated and, in the fullest sense, remain contemporary.

162. Arnold Böcklin: *The Island of the Dead*. 1880. Oil (111 × 155 cm). Eidg. Gottfried Keller Stiftung, Kunstmuseum, Basle.

163. Edvard Munch: *The Lonely Ones*. 1899. Woodcut. Munch Museum, Oslo.

Notes to the Text

NOTES TO CHAPTER I

1. E. Reitharova and W. Sumowski, 'Beiträge zu Caspar David Friedrich', *Pantheon*, XXX, 1977, pp. 41–50.
2. F. W. B. von Ramdohr, 'Über ein zum Altarblatt bestimmtes Landschaftgemälde von Herrn Friedrich in Dresden . . .' in *Zeitung für die elegante Welt*, 1809; reprinted in S. Hinz, *Caspar David Friedrich in Briefen und Bekenntnissen*, Berlin, 1968, pp. 138–57.
3. This description appeared in *Journal des Luxus und der Moden*, 1809, p. 239; reprinted in Hinz, 1968, p. 137; English translation in *Caspar David Friedrich* (exh. cat., Tate Gallery), London, 1972, p. 104.
4. Ramdohr, 1809; Hinz, 1968, p. 156.
5. W. H. Wackenroder, *Werke und Briefe* (facsimile edn), Heidelberg, 1967, p. 10.
6. See p. 29.
7. Novalis, *Dichtungen* (Rowohlt Deutsche Literatur, Bd 11), Reihbek bei Hamburg, 1963, p. 46.
8. Athenäums-Fragment 116; see H. Eichner, *Friedrich Schlegel*, New York, 1970, pp. 57–8.
9. W. Vaughan, *German Romanticism and English Art*, New Haven and London, 1979, p. 78.
10. For Hoffmann's involvement with the visual arts, see p. 196.
11. See especially this argument in A. W. Schlegel, *Vorlesungen über Schöne und Kunst*, Stuttgart, 1884; summarized in P. Frankl, *The Gothic*, Princeton, 1960, p. 453.
12. G. Berefelt, *Philipp Otto Runge zwischen Aufbruch und Opposition*, Uppsala, 1961, pp. 47–8; M. Howitt, *Friedrich Overbeck*, Freiburg, 1886, pp. 11ff.
13. J. and W. Grimm, *Deutsche Wörterbuch*, Leipzig, 1854, I, p. iii.
14. P. O. Runge, *Hinterlassene Schriften*, Hamburg, 1840–1, I, p. 360.
15. See p. 197.
16. W. Geismeier, *Caspar David Friedrich*, Vienna and Munich, 1973, p. 46.
17. H. Heine, *Die romantische Schule* (Reclam edn), Leipzig, 1955, p. 44.
18. G. Mann, *The History of Germany since 1789* (Pelican edn), Harmondsworth, 1974, pp. 158–62.
19. See especially W. Becker, *Paris und die deutsche Malerei*, Munich, 1971.
20. H. Honour, *Neo-classicism*, London, 1968, pp. 57–62.
21. Friedrich to J. L. G. Lund, 11 July 1816 (Hinz, 1968, p. 30).
22. J. Murray, *A Handbook for Travellers in Southern Germany*, London, 1837, p. 28.
23. *Art Union*, 1839, p. 136.
24. Berefelt, 1961, pp. 84–5.
25. H. Gagel, 'Die Wiederspiegelung bürgerlich-demokratischer Strömungen in den Bildmotiven der Düsseldorfer Malerschule 1830–50' in *Kunst der Bürgerlichen Revolution von 1830 bis 1848/9* (exh. cat., Schloss Charlottenburg), Berlin, 1972, p. 121.
26. A. L. Richter (ed. H. Richter), *Lebenserinnerungen eines deutschen Malers* (Volksausgabe des Dürerbundes), Leipzig, 1909, p. 342.
27. Vaughan, 1979, p. 8.

NOTES TO CHAPTER II

1. Runge, 1840–1, I, p. 6.
2. G. Schiff, 'Teutons in Togas', *Art News Annual*, XXXIII, 1967, pp. 46–58.
3. J. J. Winkelmann, *Gedanken über die Nachahmung der griechischen Werke in der Mahlerey und Bildhauer-Kunst*, Dresden, 1755.
4. D. Honisch, *Anton Raphael Mengs*, Berlin, 1965, pp. 11–15.
5. *Österreichische Galerie des 19. & 20. Jahrhunderts* (cat. of collection), Vienna, 1954, p. 18.
6. See p. 33.
7. R. Benz, *Die deutsche Romantik* (5th edn), Stuttgart, 1956, p. 107.
8. See p. 12.
9. Lavater to Herder, 4 November 1773 (*Henry Fuseli* (exh. cat., Tate Gallery), London, 1975, p. 40).
10. G. Schiff, 'Fuseli, Lucifer and the Medusa' in *Fuseli* (exh. cat.), 1975, pp. 9–20.
11. C. L. Fernow (ed. H. Riegel), *Carstens Leben und Werke*, Hanover, 1867, pp. 214–15.
12. K. W. Kolbe, *Mein Lebenslauf und mein Wirken im Fache der Sprache und der Kunst . . .*, Berlin and Leipzig, 1825.
13. An up-to-date account of Kolbe's oeuvre and career can be found in U. Martens, *Der Zeichner und Radirer C. W. Kolbe*, Berlin, 1976.
14. Fernow, 1867, p. 215.
15. *Ibid*, pp. 136ff.
16. Goethe to E. Förster, 1825 (Goethe, *Werke* (Gedenkausgabe, Artemis Verlag), Zurich, 1950, XXI, p. 412).
17. Weimer, Schlossmuseum; A. F. Heine, *Asmus Jakob Carstens und die Entwicklung des Figurenbildes*, Strassburg, 1928, p. 75.
18. Heine, 1928, p. 138.
19. H. von Einem, *Deutsche Malerei des Klassizismus und der Romantik, 1760–1840*, Munich, 1978, pp. 60–2.
20. K. Simon, *Gottlieb Schick*, Leipzig, 1914, pp. 62ff.
21. *Sacrifice of Noah*, private collection, England; A. Blunt, *The Paintings of Nicolas Poussin*, London, 1966, no. 7; see J. E. von Borries, *Joseph Anton Koch. Heroische Landschaft mit Regenbogen*, Karlsruhe, 1967, p. 14, pl. 9.

NOTES TO CHAPTER III

1. Runge, 1840–1, I, p. 7.
2. W. Heinse, *Ardinghello*, Lemgo, 1787; this extract quoted by H. Ost in *Klassizismus und Romantik in Deutschland* (exh. cat., Germanisches Museum), Nuremberg, 1966, p. 292.
3. Berefelt, 1961, pp. 60–71.
4. Runge, 1840–1, I, p. 9.
5. J. Traeger, *Philipp Otto Runge und sein Werk*, Munich, 1975, p. 19.
6. *Ibid*, p. 27.
7. Runge, 1840–1, II, pp. 266–7.
8. *Ibid*, p. 131.
9. Traeger, 1975, pp. 285–9.
10. Runge, 1840–1, II, p. 54.
11. Vaughan, 1979, p. 125.
12. Goethe, 'Über Heinrich Füssli's Arbeiten' (Goethe, 1954, XIII, p. 119).
13. Runge, 1840–1, I, p. 6.
14. Traeger, 1975, p. 16.
15. Runge, 1840–1, II, p. 128.
16. *Ibid*, I, p. 7.
17. F. Schelling, 'Über das Verhältnis der bildenden Künste zu der Natur', 1807 (*Sämmtliche Werke*, Stuttgart, 1860, VII, pp. 291ff); extracts in translation in L. Eitner, *Neoclassicism and Romanticism*, Englewood Cliffs, N.J., 1970, II, pp. 43–7.
18. Runge, 1840–1, I, p. 233.
19. Vaughan, 1979, pp. 18, 269.
20. Said to Sulpiz Boisserée in 1811 (E. Firmenich-Richartz, *Die Brüder Boisserée*, Jena, 1916, I, p. 130).
21. These articles were republished under the title 'Gemäldebeschreibungen aus Paris und den Niederlanden in den Jahren 1802–4' in F. Schlegel, *Sämmtliche Werke*, Vienna, 1823; an English translation appeared in F. Schlegel (trans. Millington), *Aesthetic and Miscellaneous Works*, London, 1849; a modern selection of extracts in translation—including the censure of Runge—occurs in Eitner, 1970, II, p. 31.
22. H. von Einem, *Philipp Otto Runge. Das Bildnis der Eltern*, Stuttgart, 1957, p. 5.
23. Runge, 1840–1, I, p. 365.
24. Painted in 1742; Tate Gallery, London.
25. Runge, 1840–1, II, p. 291.
26. For the importance of landscape in the genesis of this work, see O. von Simson, 'Philipp Otto Runge and the Mythology of Landscape', *Art Bulletin*, XXIV, 1942, pp. 335–50.
27. Runge, 1840–1, I, p. 17.
28. *Ibid*, pp. 233–6.

NOTES TO CHAPTER IV

1. C. G. Carus, *Lebenserinnerungen und Denkwürdigkeiten*, Leipzig, 1865–6; reprinted in Hinz, 1968, p. 200.
2. Hinz, 1968, p. 201.
3. *Erinnerungen und Leben der Malerin Louis Seidler* (ed. H. Uhde), Berlin, 1875; Hinz, 1968, p. 233.
4. V. A. Zhukovski (ed. Krasnova and Wolf), *Polnoe Sobranie Scohinenii*, St Petersburg and Moscow, n.d.; English extracts in *Friedrich* (exh. cat.), 1972, pp. 107–8.
5. A. Aubert, 'Caspar Friedrich', *Kunst und Künstler*, 1905, p. 198; *Friedrich* (exh. cat.), 1972, p. 108.
6. *Friedrich* (exh. cat.), 1972, p. 108.
7. See Chapter III, note 17; Eitner, 1970, II, p. 47.
8. Eitner, 1970, II, p. 47.
9. Hinz, 1968, pp. 84–134; English extracts in *Friedrich* (exh. cat.), 1972, pp. 103–4.

10. Hinz, 1968, p. 137.
11. *Friedrich* (exh. cat.), 1972, p. 103.
12. Carus, 1865–6, II, p. 207; English extracts in *Friedrich* (exh. cat.), 1972, p. 108.
13. P. H. de Valenciennes, *Traité de perspective*, Paris, 1800.
14. L. Förster, *Biographische und literarische Skizzen aus dem Leben und der Zeit Karl Försters*, Dresden, 1846; Hinz, 1968, p. 219.
15. The detailed symbolic interpretation has been carried furthest by H. Börsch-Supan; see especially H. Börsch-Supan and K. W. Jähnig, *Caspar David Friedrich. Werkkatalog*, Munich, 1973, pp. 224–31.
16. A. M. Kesting, 'Ein Brief Caspar David Friedrichs an Luise Seidler', *Wallraff-Richartz Jahrbuch*, XXXI, 1969, p. 255.
17. But see Börsch-Supan and Jähnig, 1973, p. 84.
18. Hinz, 1968, p. 89.
19. *Friedrich* (exh. cat.), 1972, p. 104.
20. Hinz, 1968, p. 82.
21. W. Sumowski, *Caspar David Friedrich Studien*, Wiesbaden, 1970, pp. 11–12.
22. Hinz, 1968, p. 222.
23. *Friedrich* (exh. cat.), 1972, p. 103.
24. For Friedrich's attitude to the Gothic, see especially G. Eimer, *Caspar David Friedrich und die Gotik*, Hamburg, 1963.
25. *Journal des Luxus und der Moden*, 1808, pp. 182ff; Sumowski, 1970, p. 25.
26. Börsch-Supan and Jähnig, 1973, no. 20.
27. Dahl's report to the Dresden Academy (Sumowski, 1970, p. 206).
28. Goethe, 1954, XIII, pp. 452–4.
29. *Ibid*, pp. 722–3.
30. See Chapter I, note 2.
31. Painted in 1780; Tate Gallery, London.
32. *Friedrich* (exh. cat.), 1972, p. 28.
33. H. von Einem, *Caspar David Friedrich*, Berlin, 1938 (3rd edn, 1950, p. 32).
34. Kupferstichkabinett, Dresden; Börsch-Supan and Jähnig, 1973, no. 42.
35. Schlossmuseum, Weimar; Börsch-Supan and Jähnig, 1973, no. 147.
36. H. Börsch-Supan, *Die Bildgestaltung bei Caspar David Friedrich*, Munich, 1960, p. 71.
37. *Berliner Abendblätter*, 12 Blatt, 13 October 1810, pp. 47–8; Hinz, 1968, p. 222.
38. 450 talers; see Börsch-Supan and Jähnig, 1973, p. 302.
39. G. H. Schubert, *Lebenserinnerungen*, Erlangen, 1855, II, p. 182.
40. Kunsthalle, Bremen; Börsch-Supan and Jähnig, 1973, no. 206.
41. Sumowski, 1970, p. 199.
42. Hinz, 1968, p. 25.

NOTES TO CHAPTER V

1. 28 January 1818 (Hinz, 1968, p. 33).
2. Sumowski, 1970, p. 214; Börsch-Supan and Jähnig, 1973, no. 249.
3. S. Hinz, 'Zur Datierung der norddeutschen Landschaften C. D. Friedrichs', *Greifswalder-Stralsunder Jahrbuch*, IV, 1964, p. 265.
4. National Gallery, Oslo; S. Hinz, 'Caspar David Friedrich als Zeichner', Diss., Greifswald, 1966, no. 698.
5. Förster, 1846, p. 157; Hinz, 1968, p. 220.
6. For discussion of identities, see Börsch-Supan and Jähnig, 1973, no. 261.
7. W. Stechow, 'Caspar David Friedrich und der

"Griper" ' in *Festschrift für H. von Einem*, Berlin, 1965, pp. 241ff.

8. K. Badt, *John Constable's Clouds*, London, 1950, pp. 9ff.

9. In the National Gallery, Oslo, Sketchbook, 1806–8 (Inv. no. B160 69); Hinz, 1966, nos. 441–51.

10. *Afternoon* is closely related to a drawing dated 1815 in the National Gallery, Oslo; Sumowski, 1972, p. 76.

11. *Friedrich* (exh. cat.), 1972, p. 103.

12. Hinz, 1968, p. 234.

13. By J. G. Frenzel. Example in Graphisches Sammlung der Museum der Stadt, Nuremberg. Repr. in *Das Dürer-Stammbuch von 1828* (exh. cat., Museum der Stadt), Nuremberg, 1973, no. 120.

14. Stechow, 1965, p. 244.

15. Börsch-Supan and Jähnig, 1973, p. 397.

16. M. Bang, 'Two Alpine Landscapes by C. D. Friedrich', *Burlington Magazine*, CVII, 1965, pp. 571–5.

17. *Friedrich* (exh. cat.), 1972. p. 108.

18. Hinz, 1968, p. 125.

19. *Friedrich* (exh. cat.), 1972, p. 103.

20. Hinz, 1968, pp. 65ff.

21. Börsch-Supan and Jähnig, 1973, no. 411.

22. *Ibid*, no. 453.

23. C. G. Carus, *Friedrich der Landschaftsmaler*, Dresden, 1841.

24. Eitner, 1970, II, p. 56.

NOTES TO CHAPTER VI

1. Richter, 1909, p. 536; *Friedrich* (exh. cat.), 1972, p. 109.

2. *Friedrich* (exh. cat.), 1972, p. 109.

3. *Ibid*, p. 103.

4. See p. 158.

5. L. Eitner, 'The Open Window and the Storm-Tossed Boat', *Art Bulletin*, XXXVII, 1955, pp. 281ff.

6. *Erinnerungen . . . Seidler*, 1875, p. 43.

7. *Journal des Luxus und der Moden*, 1811, p. 371; Börsch-Supan and Jähnig, 1973, no. 190.

8. K. Leonhardi, *G. Fr. Kersting. Bilder und Zeichnungen*, Berlin, 1939, p. 18. The service is now in Apsley House, London.

9. Vermeer's painting was acquired for the Dresden Gallery in 1742.

10. 'Neudeutsche religiös–patriotische Kunst' in *Über Kunst und Alterthum*, Weimar, 1817, I, 49, pp. 5off; Hinz, 1968, p. 221.

11. *Friedrich* (exh. cat.), 1972, p. 109.

12. C. G. Carus, *Briefe über Landschaftsmalerei geschrieben in den Jahren 1815–35*, Leipzig, 1835.

13. H. J. Neidhart, 'Zur Künstlerischen Entwicklung von Carl Gustav Carus' in *C. G. Carus* (exh. cat., Gemäldegalerie Neue Meister), Dresden, 1969, p. 28.

14. W. Goldschmidt, 'Die Landschaftsbriefe des C. G. Carus und ihre Bedeutung für Theorie der romantischer Landschaftsmalerei', Diss., Rostock (Breslau), 1935.

15. Carus, 1835, p. 28.

16. Börsch-Supan and Jähnig, 1973, pp. 37–8.

17. *Ibid*, p. 38; K. K. Eberlein, 'C. D. Friedrich, Lieber und Goethe', *Kunst-Rundschau*, XLIX, 1941, pp. 5–7.

18. W. Sumowski, 'Caspar David Friedrich und Julius Leopold', *Pantheon*, XXIX, 1971, pp. 497–504.

19. Richter, 1909, p. 206.

20. H. J. Neidhart, 'Ernst Ferdinand Oehme and

Caspar David Friedrich' in *Friedrich* (exh. cat.), 1972, pp. 45–9.

21. E. Börsch-Supan, 'Die Bedeutung der Musik in Werke Karl Friedrich Schinkels', *Zeitschrift für Kunstgeschichte*, XXXIV, 1971, pp. 258–60.

22. Eimer, 1963, pp. 21–2.

23. *Kunstblatt*, VIII, 1827, p. 162.

24. Goethe to F. Förster, 1826 (Goethe, 1950, XXIII, pp. 462–3).

NOTES TO CHAPTER VII

1. F. H. Lehr, *Die Blütezeit romantischer Bildkunst. Franz Pforr der Meister des Lukasbundes*, Marburg, 1924, p. 37.

2. Richter, 1909, p. 59.

3. Badt, 1950, pp. 35ff.

4. *Friedrich* (exh. cat.), 1972, no. 123; c.f. Bellotto, *Dresden from the Right Bank of the Elbe*, 1748 (Gemäldegalerie, Dresden, no. 606).

5. *Wilhelm von Kobell* (exh. cat., Neue Pinakothek), Munich, 1966, p. 36.

6. *Ibid*, pp. 22–7.

7. R. Messerer, *Georg von Dillis*, Munich, 1961.

8. 'Flüchtige Übersicht über die Kunst in Deutschland', *Propyläen*, Goethe, 1954, XIII, p. 329.

9. G. Schadow, 'Über einige in den Propyläen abgedruckte Sätze Goethes', *Eunomia*, 1801; reprinted in G. Schadow, *Aufsätze und Briefe* (2nd edn), Stuttgart, 1890, pp. 44ff.

10. National Gallery, Berlin (West), no. 735; P. O. Rave, *Karl Blechen. Leben. Würdigung. Werk*, Berlin, 1940, no. 642, repr. p. 238.

11. Blechen certainly arrived in Rome in time to see Turner's exhibition, which was announced in the *Diario di Roma* on 17 December 1828 and ran into January 1829 (M. Butlin and E. Joll, *The Paintings of J. M. W. Turner*, New Haven and London, 1977, p. 154). Blechen's first dated Roman sketches are from 26 December 1828 (Rave, 1940, nos. 712–25).

12. W. K. Lange in *Verein mehrerer Gelehrten und Künstler*, Berlin, 1830; Rave, 1940, p. 19.

13. Nagler, *Künstlerlexikon*, Berlin, 1835, I, p. 527; Rave, 1940, pp. 41–2.

14. J. P. Stern, *Idylls and Realities*, London, 1971, p. 57.

15. Friedrich's *Hochgebirge* (formerly National Gallery, Berlin, Inv. no. A II 314) was exhibited at the Berlin Academy in 1824 (Börsch-Supan and Jähnig, 1973, no. 317).

16. However, the King did try to gain a reduction in the price of the pictures (Rave, 1940, p. 33).

17. C. Begas, 2 September 1840 (Rave, 1940, p. 64).

18. Th. Fontane in poem celebrating Menzel's seventieth birthday (I. Wirth, *Mit Adolph Menzel in Berlin*, Munich, 1965, p. 151).

19. Menzel's *Iron Rolling Mill* was exhibited at the Exposition Universelle of 1878 in Paris. It attracted much attention amongst artists. The study for one of the figures in it that was acquired by Degas was shown at the Exposition Menzel in Paris in 1885. It probably came into Degas's collection at this time. The study is now in the David Daniels Collection, U.S.A.; *Drawings from the David Daniels Collection* (exh. cat., Minneapolis Institute of Arts *et al.*), Minneapolis, 1968, no. 41.

20. K. Scheffler, *Adolf Menzel*, Leipzig, 1938, p. 18.

21. J. Meier-Graefe, *Der Junge Menzel*, Leipzig, 1906, p. 86.

22. *Abendgesellschaft*, *c.* 1847–8 (Nationalgalerie, Berlin (West)).

23. A. Lichtwark, *Menzel's Aufbahrung*, Hamburg, 1902, p. 4.
24. *Ibid.*
25. See F. Forster-Hahn, 'Adolf Menzel's Daguerrotypical Image of Frederick the Great: A Literal Bourgeois Interpretation of German History', *Art Bulletin*, LIX, 1977, no. 2, pp. 242–61.

NOTES TO CHAPTER VIII

1. *Art Union*, 1839, p. 136.
2. F. Pforr, 'Geschichte des Studiums in Wien' (Howitt, 1886, I, p. 82).
3. See R. Benz, *Goethe und die romantische Kunst*, Munich, 1940, p. 43.
4. 'Einige Worte über Allgemeinheit, Toleranz und Menschenliebe in der Kunst' in *Herzensergiessungen . . .*; Wackenroder, 1967, p. 53.
5. *Von deutscher Baukunst*, 1772; Goethe, 1954, XIII, p. 23.
6. 'Gemäldebeschreibungen aus Paris und den Niederlanden in den Jahren 1802–4' in *Europa: Kritische Friedrich Schlegel Ausgabe*, Paderborn, 1959, IV, p. 14; see also Chapter III, note 21.
7. Schlegel, 1959, IV, p. 152.
8. *Ibid*, p. 151.
9. *Ibid.*
10. C. von Klenze, 'The Growth of Interest in the Early Italian Masters', *Modern Philology*, IV, 1906, pp. 207–68. But see F. Haskell, *Rediscoveries in Art*, Oxford, 1976, pp. 37–8, note 69, for a critical view on this work.
11. R. Rosenblum, *Transformations in Late Eighteenth-Century Art*, Princeton, 1969, p. 172.
12. G. Previtali in *Mostra di Disegni di D. P. Humbert de Superville* (Saggio introduttivo Gabinetto Disengi e Stampe degli Uffizi, XIX), Florence, 1964.
13. K. Andrews, *The Nazarenes*, Oxford, 1964, pp. 39–40.
14. Simon, 1914, pp. 62ff.
15. See Chapter II, note 23.
16. Klinkowström to Runge, 27 June 1804 (Runge, 1840–1, II, p. 272).
17. Andrews, 1964, p. 4.
18. Benz, 1956, p. 369.
19. One version of this is in the Landesmuseum, Hanover.
20. F. Pforr, 'Geschichte des Studiums in Wien' (Howitt, 1886, I, p. 87).
21. Howitt, 1886, I, p. 83.
22. *Ibid*, p. 82.
23. *Ibid*, p. 84.
24. W. von Schadow, *Der moderne Vasari. Erinnerungen aus den Künstlerleben*, Berlin, 1854, p. 178.
25. F. Schlegel, 'Gespräch über die Poesie', *Athenäum* III, 1800; Benz, 1956, p. 120.
26. J. Chr. Jensen, 'I Nazareni—Das Wort, Der Stil' in *Klassizismus und Romantik* (exh. cat.), 1966, p. 47.
27. Andrews, 1964, p. 31.
28. E. Förster, *Peter von Cornelius*, Berlin, 1874, I, p. 80.
29. Städel Institut, Frankfurt am Main, Inv. nos. 6270–5.
30. Förster, 1874, I, p. 280.
31. V. Hiesinger, 'Canova and the Frescoes in the Galleria Chiaramonti', *Burlington Magazine*, CXX, 1978, pp. 654–65.
32. Andrews, 1964, pp. 64–6; A. Schahl, 'Die Geschichte der Bilderbibel von Julius Schnorr von Carolsfeld', Diss., Leipzig, 1936.
33. Vaughan, 1979, p. 60.
34. *Ibid*, pp. 215–18.

35. H. Dorra, 'Une source imprévu de Daumier', *Gazette des Beaux-Arts*, 6, LXXX, 1972, pp. 295–6.
36. H. Ost, *Einsiedler und Mönche in der deutschen Malerei des 19. Jahrhunderts*, Düsseldorf, 1971, p. 147.

NOTES TO CHAPTER IX

1. A. von Wolzogen, *Katalog des künstlerischen Nachlasses von Carl Friedrich Schinkel*, Berlin, 1862–4, II, p. 340.
2. See p. 12.
3. W. Hoffmann, 'Die Erfüllung der Zeit' in *William Blake* (exh. cat., Kunsthalle), Hamburg, 1975, p. 25.
4. O. Weigand, *Schwind. Des Meisters Werke* (Klassiker der Kunst, IX), Stuttgart, 1906, p. xv.
5. F. Haak, *Moritz von Schwind*, Bielefeld and Leipzig, 1898, p. 11.
6. H. Holland, *Moritz von Schwind*, Stuttgart, 1873, p. 110.
7. S. Freud (trans. Strachey), *Introductory Lectures on Psychoanalysis* (Penguin edn), Harmondsworth, 1978, p. 167.
8. Richter, 1909, p. 484.
9. *Ibid*, p. 377.
10. *Ibid*, p. 458.

NOTES TO CHAPTER X

1. C. Baudelaire, 'L'Art philosophique' in *Curiosités esthetiques*, Paris, 1962, pp. 503–4.
2. Howitt, 1866, I, p. 401.
3. W. Howitt, *The Rural and Domestic Life of Germany*, London, 1842, p. 31.
4. Vaughan, 1979, p. 2.
5. Musée du Louvre, Inv. no. 3834; *De David à Delacroix* (exh. cat., Grand Palais), Paris, 1974, no. 44.
6. I. Markowitz, *Die Düsseldorfer Malerschule* (cat. of Düsseldorf paintings, Kunstmuseum), Düsseldorf, 1969, no. 4376, pp. 116–17; Gagel in *Kunst der bürgerlichen Revolution* (exh. cat.), 1972, p. 122.
7. W. Müller von Königswinter, *Düsseldorfer Künstler aus den letzten 25 Jahren*, Düsseldorf, 1853, p. 186.
8. *Rheinische Zeitung*, Feuilleton, no. 132, 1842; Gagel in *Kunst der bürgerlichen Revolution* (exh. cat.), 1972, p. 120.
9. J. Ponten, *Alfred Rethels Briefe*, Berlin, 1912.
10. *Kunst der bürgerlichen Revolution* (exh. cat.), 1972, no. 64.
11. *View of the Luxembourg Gardens, Paris*, 1794 (Musée du Louvre, Paris, Inv. no. 30 59).
12. D. Hoffmann, 'Die Karlsfresken Alfred Rethels', Diss., Freiburg, 1968, p. 12.
13. *Ibid*, pp. 23–4.
14. Ponten, 1912, p. 143.
15. J. Ruskin (ed. Cooke and Wedderburn), *Elements of Drawing: Works*, London, 1903–12, XV, p. 80.
16. W. Hult, *Die Düsseldorfer Malerschule, 1819–1869*, Leipzig, 1964, p. 156.
17. *Kunst der bürgerlichen Revolution* (exh. cat.), 1972, Beilage, no. 156, p. 18.
18. Ponten, 1912, p. 152.

NOTES TO THE EPILOGUE

1. In speech inaugurating the Great Exhibition of German Art, 1937, Munich (H. B. Chipp, *Theories of Modern Art*, Berkeley, 1968, p. 478).
2. J. H. Langaard and R. Revold, *Edvard Munch*, Oslo, 1963, p. 62.

Select Bibliography

Most of the important publications on German Romantic painting are in German, though a number of studies of substance do exist in English and French. In the following list I have put an emphasis on these, as they are cited less frequently in German language bibliographies. I have also included the principal German publications. Those wishing to find a fuller list of German publications should consult: H. von Einem, *Deutsche Malerei des Klassizismus und der Romantik, 1760–1840*, Munich, 1978; H. Lietzmann, *Bibliographie zur Kunstgeschichte des 19. Jahrhunderts, 1940–66*, Munich, 1968. Additional bibliographical studies by H. Lietzmann have appeared in editions of *Zeitschrift für Kunstgeschichte*.

Each group has been arranged chronologically.

1. Cultural Background

Kluckhorn, P. *Das Ideengut der deutschen Romantik*, Tübingen, 1953.
Tymms, R. *German Romantic Literature*, London, 1955.
Robson-Scott, W. D. *The Literary Background to the Gothic Revival in Germany*, Oxford, 1965.
Walzel, O. *German Romanticism*, New York, 1966.
Pramer, S. (ed.). *The Romantic Period in Germany*, London, 1970.
Podro, M. *The Manifold in Perception: Theories of Art from Kant to Hildebrandt*, Oxford, 1972.
Cardinal, R. *German Romantics in Context*, London, 1975.
Wiedmann, A. K. *Romantic Roots in Modern Art*, Old Woking, 1979.

2. General

Raczynski, A. *Histoire de l'art modern en Allemagne*, 3 vols., Paris, 1836–41.
Muther, R. *The History of Modern Painting*, 3 vols., London, 1895–6.
Schmitt, P. F. *Deutsche Landschaftsmalerei von 1750 bis 1830*, Munich, 1922.
Gurlitt, C. *Deutsche Kunst seit 1800*, Berlin, 1924.
Pauli, G. *Die Kunst des Klassizismus und der Romantik*, Berlin, 1925.
Landsberger, F. *Die Kunst der Goethezeit*, Leipzig, 1931.
Benz, R. and A. von Schneider. *Die Kunst der deutschen Romantik*, Munich, 1939.
Pevsner, N. *Academies of Art*, Cambridge, 1940.
Zeitler, R. *Klassizismus und Utopia*, Stockholm, 1954.
Eitner, L. 'The Open Window and the Storm-tossed Boat', *Art Bulletin*, XXXVII, 1955, pp. 281–90.
Novotny, F. *Painting and Sculpture in Europe, 1780–1880*, Harmondsworth, 1960.
Hofmann, W. *The Earthly Paradise*, New York, 1961.
Geismeier, W. *Deutsche Malerei des 19. Jahrhunderts*, Leipzig, 1966.
Zeitler, R. *Die Kunst des 19. Jahrhunderts*, Berlin, 1966.
Schiff, G. 'Teutons in Togas', *Art News Annual*, XXXIII, 1967, pp. 46–58.
Gerdts, W. 'Washington Allston and the German Romantic Classicists in Rome', *Art Quarterly*, XXXII, no. 2, 1969, pp. 167–96.
Becker, W. *Paris und die deutsche Malerei, 1750–1840*, Munich, 1971.
Börsch-Supan, H. *Deutsche Romantik*, Munich, 1972.
Rosenblum, R. 'German Romantic Painting in International Perspective', *Yale University Art Gallery Bulletin*, XXXIII, no. 3, 1972, pp. 23–36.
Finke, U. *German Painting from Romanticism to Expressionism*, London, 1975.
Rosenblum, R. *Modern Painting and the Northern Romantic Tradition: Friedrich to Rothko*, London, 1975.
Einem, H. von. *Deutsche Malerei des Klassizismus und der Romantik, 1760–1840*, Munich, 1978.
Vaughan, W. *Romantic Art*, London, 1978.
Schrade, H. *German Romantic Painting*, New York, 1978.
Honour, H. *Romanticism*, Harmondsworth, 1979.
Vaughan, W. *German Romanticism and English Art*, New Haven and London, 1979.

3. EXHIBITION CATALOGUES

Austellung deutsche Kunst aus der Zeit von 1775–1875 in der Berlin Nationalgalerie, 2 vols., Munich, 1906.
The Romantic Movement (Council of Europe; Tate Gallery), London, 1959.
Deutsche Romantik (National Gallery), Berlin (East), 1965.
Klassizismus und Romantik in Deutschland (Germanisches Museum), Nuremberg, 1966.
Der Frühe Realismus in Deutschland (Germanisches Museum), Nuremberg, 1967.
Nineteenth-Century German Drawings (Victoria and Albert Museum), London, 1968.
German Painting of the Nineteenth Century (Yale University Art Gallery), New Haven, 1970.
The Age of Neo-Classicism (Council of Europe; Royal Academy), London, 1972.
La Peinture allemande à l'époque du Romantisme (Orangerie), Paris, 1976.

4. CRITICAL AND THEORETICAL TEXTS AVAILABLE IN ENGLISH

Schlegel, F. (trans. Millington). *Aesthetic and Miscellaneous Works*, London, 1848.
Schelling, F. W. J. von (trans. Bullock). 'Concerning the Relation of the Plastic Arts to Nature' in H. Read, *The True Voice of Feeling*, London, 1953.
Schiller, F. (trans. Wilkinson and Willoughby). *On the Aesthetic Education of Man. 1795*, Oxford, 1967.
Goethe, J. W. von (trans. Eastlake, intr. Matthai). *Goethe's Colour Theory*, London, 1971.
Wackenroder, F. H. (trans. Schubert). *Confessions and Fantasies*, University Park, Pa., 1971.
Winckelmann J. (ed. Irwin). *Writings on Art*, London, 1972.
Goethe, J. W. von (trans. and ed. Gage). *Goethe on Art*. London, 1980.

Extracts from the writings of German Romantic artists can be found in:

Holt, E. G. *A Documentary History of Art, III: From the Classicists to the Impressionists*, New York, 1966.
Eitner, L. *Neoclassicism and Romanticism*, 2 vols., Englewood Cliffs, N.J., 1970.

5. INDIVIDUAL ARTISTS AND GROUPS

BLECHEN

Rave, P. O. *Karl Blechen. Leben. Würdigung. Werke*, Berlin, 1940.
Heider, G. *Karl Blechen*, Leipzig, 1970.

CARSTENS

Fernow, C. L. *Leben des Künstlers Asmus Jacob Carstens*, Leipzig, 1806 (new edn, expanded by H. Riegl, Hanover, 1867).
Kamphausen, A. *Asmus Jacob Carstens*, Neumünster, 1941.

CARUS

Carus, C. G. *Neun Briefe über Landschaftsmalerei*, Leipzig, 1831 (new edn, ed. K. Gerstenberg, Dresden, 1955).
Carus, C. G. *Lebenserinnerungen und Denkwürdigkeiten*, 2 vols., Weimar, 1865–6 (new edn, ed. E. Janson, 1966).
Prause, M. *Carl Gustav Carus als Maler, Leben und Werk*, Berlin, 1968.

CORNELIUS

Riegel, H. *Cornelius, der Meister des deutschen Malerei*, Hanover, 1866.
Kuhn, A. *Peter Cornelius und die geistigen Strömungen seiner Zeit*, Berlin, 1921.
Einem, H. von. 'Peter Cornelius', *Wallraf-Richartz Jahrbuch*, XVI, 1954, pp. 104–60 (reprinted in H. von Einem, *Stil und Uberlieferung*, Düsseldorf, 1971).

DAHL

Aubert, A. *Die nordische Landschaftsmalerei und Johann Christian Dahl*, Berlin, 1947.
Mras, G. 'Romantic Birch Tree by Johan Christian Dahl', *Princeton University Art Museum Record*, XXIV, 1965, pp. 12–19.

FOHR

Dieffenbach, P. *Das Leben des Malers Karl Fohr*, Frankfurt, 1823 (new edn, 1918).
Carl Philipp Fohr (exh. cat., Städel Institut), Frankfurt am Main, 1968.

FRIEDRICH

Eberlein, K. (ed.). *Caspar David Friedrich. Bekenntnisse*, Leipzig, 1924.
Einem, H. von. *Caspar David Friedrich*, Berlin, 1938 (3rd edn, 1950).

Ettlinger, L. *Caspar David Friedrich*, London, 1963.
Bang, M. 'Two Alpine Landscapes by C. D. Friedrich', *Burlington Magazine*, CVII, 1965, pp. 571–5.
Rosenblum, R. 'Caspar David Friedrich and Modern Painting', *Art and Literature*, X, 1966, pp. 134–46.
Hinz, S. *Caspar David Friedrich in Briefen und Bekenntnissen*, Berlin, 1968.
Sumowski, W. *Caspar David Friedrich Studien*, Wiesbaden, 1970.
Börsch-Supan, H. 'Caspar David Friedrich's Landscapes with Self-Portraits', *Burlington Magazine*, CXIV, 1972, pp. 620–30.
Vaughan, W. 'Caspar David Friedrich' in *Caspar David Friedrich* (exh. cat., Tate Gallery), London, 1972, intr., pp. 9–44.
Börsch-Supan, H. and K. W. Jähnig. *Caspar David Friedrich. Werkkatalog*, Munich, 1973.
Geismeier, W. *Caspar David Friedrich*, Vienna and Munich, 1973.
Börsch-Supan, H. *Caspar David Friedrich*, London, 1974.
Caspar David Friedrich. Das gesamte graphische Werk, Munich, 1974.
Caspar David Friedrich (exh. cat., Kunsthalle), Hamburg, 1974.
Miller, P. B. 'Anxiety and Abstraction: Kleist and Brentano on Caspar David Friedrich', *Art Journal*, XXXIII, no. 3, 1974, pp. 205–10.
Siegel, L. 'Synaesthesia and the Paintings of Caspar David Friedrich', *Art Journal*, XXXIII, no. 3, 1974, pp. 196–204.
Börsch-Supan, H. 'L'Arbre aux corbeaux', *Revue du Louvre*, XXVI, no. 4, 1976, pp. 275–96.
Sumowski, W. (ed.). *Caspar David Friedrich. Sein Werk im Urteil von Zeitgenossen*, Wiesbaden, 1976.

FÜGER

Stix, A. *H. F. Füger*, Vienna and Leipzig, 1925.
Füger (exh. cat., Historisches Museum), Heilbronn, 1968.

FUSELI

Knowles, J. *The Life and Writings of Henry Fuseli*, 3 vols., London, 1831.
Antal, F. *Fuseli Studies*, London, 1956.
Fuseli (exh. cat., Tate Gallery), London, 1975.
Schiff, G. *Johann Heinrich Füssli, 1741–1825*, 2 vols., Zürich, 1975.

GESSNER

Wölfflin, H. *Salomon Gessner*, Frauenfeld, 1889.
Elck, L. von. *Salomon Gessner*, Leipzig, 1930.
Roskamp, D. *Salomon Gessner im Lichte der Kunsttheorie seiner Zeit*, Marburg, 1935.

KAUFFMANN

Manners, V. and G. C. Williamson. *Angelica Kauffmann*, London, 1924.
Angelika Kauffmann und ihre Zeitgenossen (exh. cat., Vorarlberg Museum), Bregenz, 1968.

KERSTING

Gehrig, O. *Georg Friedrich Kersting*, Leipzig, 1931.
Vriesen, G. *Die Innenraumbilder G. F. Kerstings*, Berlin, 1935.

KOBELL

Lessing, W. *Wilhelm von Kobell*, Munich, 1923 (new edn, 1966).
Wichmann, S. *Wilhelm von Kobell*, Munich, 1970.

KOCH

Lutterotti, O. von. *Joseph Anton Koch, 1758–1839*, Berlin, 1940.
Frey, D. 'Die Bildkomposition bei Joseph Anton Koch in ihrer Beziehung zur Dichtung', *Wiener Jahrbuch für Kunstgeschichte*, 1950, pp. 195–224.
Bailey, C. 'Joseph Anton Koch's *Landscape with William Tell*: An Early Watercolour Rediscovered', *Walker Art Gallery Bulletin*, V, 1974–5, pp. 60–71.

KOLBE

Kolbe, K. W. *Mein Lebenslauf und mein Wirken im Fache der Sprache und der Kunst*, Berlin and Leipzig, 1825.
Martens, U. *Der Zeichner und Radierer Carl Wilhelm Kolbe d. Ä*, Berlin, 1976.

MENGS

Azara, J. N. de. *The Works of Anton Raphael Mengs*, London, 1796.
Honisch, D. *Anton Raphael Mengs*, Recklinghausen, 1965.

MENZEL

Meier-Graefe, J. *Der Junge Menzel*, Leipzig, 1906.
Singer, C. *The Drawings of Adolf Menzel*, London, 1906.
Scheffler, K. *Adolf Menzel. Der Mensch, das Werk*, Berlin, 1938.
Kaiser, K. *Adolph Menzel, der Maler*, Stuttgart, 1965.
Wirth, I. *Drawings and Watercolours by Adolph Menzel* (exh. cat., Arts Council), London, 1965.
Allan, W. 'Fridericus Rex: The Image of a King', *Connoisseur*, CXCV, 1977, pp. 42–51.
Forster-Hahn, F. 'Adolf Menzel's Daguerreotypical Image of Frederick the Great: A Literal Bourgeois Interpretation of German History', *Art Bulletin*, LIX, no. 2, 1977, pp. 242–61.

NAZARENES

Donop, L. von. *Die Wandgemälde der Casa Bartholdy in der Nationalgalerie*, Berlin, 1889.
Overbeck und sein Kreis (exh. cat., Behnhaus), Lübeck, 1926.
Andrews, K. *The Nazarenes: A Brotherhood of German Painters in Rome*, Oxford, 1964.
Balsev, J. 'Thorwaldsen and the Nazarenes', *Apollo*, XCVI, 1972, pp. 220–7.
Dorra, H. 'Montalembert, Orsel, les Nazaréens et "l'art abstrait" ', *Gazette des Beaux-Arts*, LXXXV, 1975, pp. 137–46.
Bachleitner, R. *Die Nazarener*, Munich, 1976.
Die Nazarener (exh. cat., Städel Institut), Frankfurt am Main, 1977.
Hiesinger, U. 'Canova and the Frescoes of the Galleria Chiaramonti', *Burlington Magazine*, CXX, 1978, pp. 654–65.

NEUREUTHER

Ludwig, H. 'Neureuther und die Illustrationsgroteske', Diss., Munich, 1971.

OEHME

Neidhart, H. J. 'Ernst Ferdinand Oehme and Caspar David Friedrich' in *Caspar David Friedrich* (exh. cat., Tate Gallery), London, 1972, pp. 45–9.

OLIVIER BROTHERS

Grote, L. *Die Brüder Olivier und die deutsche Romantik*, Berlin, 1938.
Novotny, F. *Ferdinand Oliviers Landschaftzeichnungen in Wien und Umgebung*, Graz, 1971.

OVERBECK

Atkinson, J. B. *Friedrich Overbeck*, London, 1882.
Howitt, M. *Friedrich Overbeck. Sein Leben und Schaffen*, Freiburg, 1886 (reprinted Bern, 1971).
Jensen, J. Chr. *Friedrich Overbeck. Die Werk im Behnhaus*, Lübeck, 1963.
Jensen, J. Chr. *Friedrich Overbeck, ein Maler des 19. Jahrhunderts* (forthcoming).

PFORR

Lehr, F. H. *Die Blütezeit romantischer Bildkunst. Franz Pforr, der Meister des Lukasbundes*, Marburg, 1924.
Benz, R. *Goethes Götz von Berlichingen in den Zeichnungen der Franz Pforr*, Weimar, 1941.

RAYSKI

Walter, M. *Ferdinand von Rayski. Sein Leben und sein Werk*, Bielefeld, 1943.

REINHART

Feuchtmayr, I. *Johann Christian Reinhart, 1761–1847*, Munich, 1975.

RETHEL

Ponten, J. *Alfred Rethel. Des Meisters Werke*, Stuttgart and Leipzig, 1911.
Ponten, J. (ed.). *Alfred Rethels Briefe*, Berlin, 1912.
Schmidt, H. J. 'Alfred Rethels Gedanken über seine Kunst', *Jahrbuch für Ästhetik und allgemeine Kunstwissenschaft*, VI, 1961, pp. 139–58.
Einem, H. von. 'Die Tragödie der Karlsfresken Alfred Rethels' in *Karl der Grosse*, Düsseldorf, 1967, IV, pp. 306–25.
Hoffmann, D. 'Die Karlsfresken Alfred Rethels', Diss., Freiburg, 1968.

RICHTER

Richter, A. L. (ed. H. Richter). *Lebenserinnerung eines deutschen Malers*, Leipzig, 1886.
Friedrich, K. J. *Die Gemälde Ludwig Richters*, Berlin, 1937.
Neidhart, H. J. *Ludwig Richter*, Leipzig, 1969 (with English summary).

ROTTMANN

Bierhaus-Rödiger, E. *Carl Rottmann, 1797–1850. Leben und Künstlerische Entwicklung*, Munich, 1976.

RUNGE

Runge, P. O. (ed. D. Runge). *Hinterlassene Schriften*, Hamburg, 1840–1 (reprinted Göttingen, 1965).
Grundy, J. B. C. *Tieck and Runge*, Heidelberg, 1930.
Simson, O. von. 'Philipp Otto Runge and the Mythology of Landscape', *Art Bulletin*, XXIV, 1942, pp. 335–50.
Waetzoldt, S. 'Philipp Otto Runge's "Vier Zeiten" ' Diss., Hamburg, 1951.
Berefelt, G. *Philipp Otto Runge zwischen Aufbruch und Opposition*, Stockholm, 1961.
Traeger, J. *Philipp Otto Runge und sein Werk*, Munich, 1975.
Runge in seiner Zeit (exh. cat., Kunsthalle), Hamburg, 1977.

SCHICK

Simon, K. *Gottlieb Schick. Ein Beitrag zur Geschichte der deutschen Malerei um 1800*, Leipzig, 1924.
Gottlieb Schick, ein Maler des Klassizismus (exh. cat., Staatgalerie), Stuttgart, 1976.

SCHINKEL

Schinkel, K. F. (ed. H. Mackowski). *Briefe, Tagebücher, Gedanken*, Berlin, 1922.

SCHNORR

Schnorr von Carolsfeld, J. *Briefe aus Italien, 1817–1827*, Gotha, 1886.
Schnorr von Carolsfeld (exh. cat., Städel Institut), Frankfurt am Main, 1968.

SCHWIND

Weigmann, O. *Moritz von Schwind*, Leipzig, 1906.
Eggert-Windegg, W. (ed.). *Künstlers Erdenwallen. Briefe von Moritz von Schwind*, Munich, 1912.
Bünemann, H. *Moritz von Schwind*, Königstein, 1963.
Bailey, C. 'The Drawings of Moritz von Schwind in the Ashmolean Museum Oxford' in *Master Drawings*, Oxford, 1975, XIII, no. 1, pp. 40–7.

SPITZWEG

Roennefahrt, G. *Carl Spitzweg*, Munich, 1960.
Kalkschmidt, E. *Carl Spitzweg und seine Welt*, Munich, 1966.

STEINLE

Steinle, A. M. von. *Edouard von Steinle. Des Meisters Gesamtwerk*, Munich, 1910.

TISCHBEIN

Landsberger, F. *Wilhelm Tischbein. Ein Künstlerleben des 18. Jahrhunderts*, Leipzig, 1908.

WASMANN

Nathan, P. *Friedrich Wasmann. Sein Leben und Werk*, Munich, 1974.

List of Plates

Pages 227–8
XXXI. Adrian Ludwig Richter: *St Genevieve in the Forest*. Kunsthalle, Hamburg.
XXXII. Alfred Rethel: *Visit of Otto III to the Crypt*. Kunstmuseum, Düsseldorf.

BLACK AND WHITE PLATES

* *Indicates engraving after artist named.*
Title page. Caspar David Friedrich: *Morning* (detail reproduced larger than size). Niedersächsische Landesmuseum, Hanover.
1. Asmus Jakob Carstens: *Allegory on the Eighteenth Century*. Georg Schäfer Collection, Schweinfurt.
2. Franz and Josef Riepenhausen: *St Genevieve*. Engraving from Tieck's *Genoveva*, Dresden, 1806.
3. Map of Germany in 1815.
4. Philipp Otto Runge: *The Downfall of the Fatherland*. Kunsthalle, Hamburg.
5. Georg Friedrich Kersting: *On Sentry Duty*. Nationalgalerie, Staatliche Museen Preußischer Kulturbesitz, Berlin (West) (photograph: Jörg P. Anders).
6. Anon.: *Ways of Wearing Coats*. Wood-engraving.
7. Adolph von Menzel: *The Honouring of the Insurgents Killed in March 1848*. Kunsthalle, Hamburg.
8. Alfred Rethel: *The Harkort Factory at Burg Wetter*. Private Collection, Duisburg.
9. * Alfred Rethel: Plate 2 of *Another Dance of Death*, Dresden, 1849. Wood-engraving.
10. Peter von Cornelius: *The Last Judgement*. Ludwigskirche, Munich.
11. Moritz von Schwind. *The Rose*. Staatliche Museen, National-Galerie, Berlin (East).
12. Friedrich Overbeck. *Nina, the Artist's Wife*. Ashmolean Museum, Oxford.
13. * Adolph von Menzel: Wood-engraving from *History of Frederick the Great*, Berlin, 1840.
14. Anton Raphael Mengs: *Parnassus*. Villa Albani, Rome.
15. Friedrich Heinrich Füger: *Hortensia, the Artist's Wife*. Österreichische Galerie, Vienna.
16. Henry Fuseli: *Thor Battering the Midgard Serpent*. Royal Academy of Arts, London.
17. Nicholas Abraham Abildgaard: *Malvina Mourning the Dead Oscar*. Nationalmuseum, Stockholm.
18. Karl Wilhelm Kolbe: *Dead Oak*. Engraving.
19. Karl Wilhelm Kolbe: *Thicket with Antique Figures*. Staatliche Kunsthalle, Karlsruhe.
20. Asmus Jacob Carstens: *Battle between the Titans and Gods*. Georg Schäfer Collection, Schweinfurt.
21. Asmus Jakob Carstens: *Night with her Children Sleep and Death*. Staatliche Kunstsammlungen, Graphische Sammlung, Weimar.
22. Gottlieb Schick: *Eve*. Wallraf-Richartz-Museum, Cologne.
23. Philipp Otto Runge: *Self-Portrait*. Kunsthalle, Hamburg.
24. Philipp Otto Runge: *The Child in the Meadow* (detail of the large version of *Morning*). Kunsthalle, Hamburg.
25. Philipp Otto Runge: *Leaves and Firelily*. Kunsthalle, Hamburg.
26. Philipp Otto Runge: *The Return of the Sons*. Kunsthalle, Hamburg.
27. * John Flaxman: *Achilles Fighting Xanton*. Engraving from the *Iliad*, Rome, 1793.
28. Philipp Otto Runge: *Fingal with his Spear Raised* (illustration to Ossian). Kunsthalle, Hamburg.
29. Philipp Otto Runge: *Achilles and Skamandros*.

Kunsthalle, Hamburg.
30. Philipp Otto Runge: *The Triumph of Love*. Kunsthalle, Hamburg.
31. Philipp Otto Runge: *The Times of Day*. Kunsthalle, Hamburg.
32. William Blake: Plate 14 from *The Book of Job*, London, 1826. Engraving.
33. Philipp Otto Runge: *We Three*. Destroyed, formerly Kunsthalle, Hamburg.
34. Philipp Otto Runge: *The Artist's Parents*. Kunsthalle, Hamburg.
35. Philipp Otto Runge: *The Artist's Mother* (study). Kunsthalle, Hamburg.
36. Philipp Otto Runge: *Rest on the Flight into Egypt*. Kunsthalle, Hamburg.
37. Philipp Otto Runge: *Colour Sphere*. Illustration from *Die Farbenkugel*, Hamburg, 1810.
38. Philipp Otto Runge: *Lily of Light and the Morning Star* (study for large version of *Morning*). Kunsthalle, Hamburg.
39. Caspar David Friedrich: *Self-Portrait*. Staatliche Museen, Kupferstichkabinett und Sammlung der Zeichnungen, Berlin (East).
40. Georg Friedrich Kersting: *Caspar David Friedrich in his Studio*. Nationalgalerie, Staatliche Museen Preußischer, Kulturbesitz, Berlin (West).
41. Caspar David Friedrich: *Oak Tree with Stork's Nest*. Kunsthalle, Hamburg.
42. Caspar David Friedrich: *Village Landscape in the Morning Light*. Nationalgalerie, Staatliche Museen Preußischer Kulturbesitz, Berlin (West) (photograph: Jörg P. Anders).
43. Caspar David Friedrich: *Dolmen by the Sea*. Staatliche Kunstsammlungen, Graphische Sammlung, Weimar.
44. Joseph Mallord William Turner: *The Shipwreck*. Tate Gallery, London.
45. Théodore Gericault: *The Raft of the Medusa*. Musée du Louvre, Paris (cliché des Musées Nationaux).
46. Caspar David Friedrich: *Cross by the Baltic*. Wallraf-Richartz-Museum, Cologne.
47. Caspar David Friedrich: *Emilias Kilde: Monument in Park near Copenhagen*. Kunsthalle, Hamburg.
48. Caspar David Friedrich: *Plant Study*. Staatliche Museen, Kupferstichkabinett und Sammlung der Zeichnungen, Berlin (East).
49. Jens Juel: *View of Hindsgavl*. Thorwaldsens Museum, Copenhagen.
50. Caspar David Friedrich: *View of Arkona with Rising Moon*, Albertina, Vienna.
51. Caspar David Friedrich: *Procession at Dawn*. Staatliche Kunstsammlungen, Graphische Sammlung, Weimar.
52. *Caspar David Friedrich: *Boy Sleeping on a Grave*. Woodcut.
53. Caspar David Friedrich: *Spring* from *The Times of Year*. Kunsthalle, Hamburg.
54. Caspar David Friedrich: *Summer* from *The Times of Year*. Kunsthalle, Hamburg.
55. Caspar David Friedrich: *Winter*. Destroyed, formerly Neue Pinakothek, Munich.
56. Caspar David Friedrich: *Rocky George in Elbesandsteingebirge*. Neue Galerie, Kunsthistorisches Museum, Vienna.
57. Caspar David Friedrich: *Morning Mist in the Mountains*. Staatliches Museum, Heidecksburg, Rudolstadt.
58. Caspar David Friedrich: *Abbey in the Oakwoods*. Staatliche Schlösser und Gärten, Schloss Charlottenburg, Berlin (West).

59. Caspar David Friedrich: *Bohemian Landscape.* Staatsgalerie, Stuttgart.

60. Caspar David Friedrich: *Garden Terrace.* Staatliche Schlösser und Gärten, Potsdam-Sanssouci.

61. Caspar David Friedrich: *The Chasseur in the Forest.* Private Collection, Bielefeld.

62. Caspar David Friedrich: *War Memorial Design.* Städtische Kunsthalle, Mannheim.

63. Caspar David Friedrich: *Memorial Picture for Johann Emanuel Bremer.* Staatliche Schlösser und Gärten, Schloss Charlottenburg, Berlin (West).

64. Caspar David Friedrich: *The Cathedral.* Georg Schäfer Collection, Schweinfurt.

65. Caspar David Friedrich: *Ruin at Eldena.* Nationalgalerie, Staatliche Museen Preußischer Kulturbesitz, Berlin (West) (photograph: Jörg P. Anders).

66. Caspar David Friedrich: *Ulrich von Hutten's Grave.* Staatliche Kunstsammlungen, Schlossmuseum, Weimar.

67. Caspar David Friedrich: *On the Sailing Ship.* Hermitage State Museum, Leningrad.

68. Caspar David Friedrich: *Woman in the Morning Sun.* Folkwang Museum, Essen.

69. Caspar David Friedrich: *Two Men Contemplating the Moon.* Staatliche Kunstsammlungen, Gemäldegalerie Neue Meister, Dresden (Deutsche Fotothek Dresden).

70. Caspar David Friedrich: *Evening.* Städtische Kunsthalle, Mannheim.

71. Caspar David Friedrich: *Morning.* Niedersächsisches Landesmuseum, Hanover.

72. Caspar David Friedrich: *Evening.* Niedersächsisches Landesmuseum, Hanover.

73. Caspar David Friedrich: *Moonrise over the Sea.* Hermitage State Museum, Leningrad.

74. Caspar David Friedrich: *Moonrise over the Sea.* Nationalgalerie, Staatliche Museen Preußischer Kulturbesitz, Berlin (West) (photograph: Jörg P. Anders).

75. Caspar David Friedrich: *High Mountains.* Destroyed, formerly National Gallery, Berlin.

76. Caspar David Friedrich: *Early Snow.* Kunsthalle, Hamburg.

77. Caspar David Friedrich: *Easter Morning.* Private Collection.

78. Caspar David Friedrich: *Evening on the Baltic.* Staatliche Kunstsammlungen, Gemäldegalerie Neue Meister, Dresden (Deutsche Fotothek Dresden).

79. Caspar David Friedrich: *The Large Enclosure near Dresden.* Staatliche Kunstsammlungen, Gemäldegalerie Neue Meister, Dresden.

80. Caspar David Friedrich: *Before Sunrise.* Nationalgalerie, Staatliche Museen Preußischer Kulturbesitz, Berlin (West) (photograph: Jörg P. Anders).

81. Caspar David Friedrich: *Pinewoods with Pool.* Wallraff-Richartz-Museum, Cologne.

82. Caspar David Friedrich: *Landscape with Grave and Owl.* Kunsthalle, Hamburg.

83. Caspar David Friedrich. *Clumps of Grass and Palette.* Private Collection.

84. Adrian Ludwig Richter: *Crossing by the Schreckenstein.* Staatliche Kunstsammlungen, Gemäldegalerie Neue Meister, Dresden.

85. Caspar David Friedrich: *View through the Studio Window.* Kunsthistorisches Museum, Vienna.

86. Carl Ludwig Kaaz: *View through an Open Window.* Private Collection, Dortmund.

87. Carl Gustav Carus: *Woman on the Terrace.* Staatliche Kunstsammlungen, Gemäldegalerie Neue Meister, Dresden.

88. Carl Gustav Carus: *Leafless Oaks in a Storm.* Staatliche Kunstsammlungen, Kupferstichkabinett, Dresden.

89. * Moritz von Schwind: *Organic Life in Nature.* Wood-engraving from *Fliegende Blätter*, 1847–8.

90. Carl Friedrich Schinkel: *Gothic Cathedral by a River.* Nationalgalerie, Staatliche Museen Preußischer Kulturbesitz, Berlin (West) (photograph: Jörg P. Anders).

91. * Carl Friedrich Schinkel: *The Hall of Stars of the Queen of the Night.* Engraving after design for *The Magic Flute.*

92. Karl Blechen: *Rocky Gorge in Winter.* Nationalgalerie, Staatliche Museen Preußischer Kulturbesitz, Berlin (West) (photograph: Jörg P. Anders).

93. Karl Friedrich Lessing: *Cloister in the Snow.* Wallraff-Richartz-Museum, Cologne.

94. Ferdinand von Rayski: *View of Castle Bieberstein.* Staatliche Museen, National-Galerie, Berlin (East).

95. Johan Christian Clausen Dahl: *Evening.* National Gallery, Oslo.

96. Johan Christian Clausen Dahl: *Dresden by Moonlight.* Staatliche Kunstsammlungen, Gemäldegalerie Neue Meister, Dresden.

97. Wilhelm von Kobell: *The Siege of Kosel.* Neue Pinakothek, Munich.

98. Johann Georg von Dillis: *The Isar Falls near Munich.* Georg Schäfer Collection, Schweinfurt.

99. Carl Julius Milde: *Pastor Rautenberg and his Family.* Kunsthalle, Hamburg.

100. Carl Rottmann: *Aegina.* Georg Schäfer Collection, Schweinfurt.

101. Friedrich Wasmann: *Mary Krämer.* Kunsthalle, Hamburg.

102. Johann Erdmann Hummel: *The Granite Bowl in the Pleasure Gardens of Berlin.* Nationalgalerie, Staatliche Museen Preußischer Kulturbesitz, Berlin (West) (photograph: Jörg P. Anders).

103. Franz Krüger: *Parade in the Opernplatz.* Staatliche Schlösser und Gärten, Potsdam-Sanssouci.

104. Eduard Gärtner: *The Neue Wache, Unter den Linden.* Nationalgalerie, Staatliche Museen Preußischer Kulturbesitz, Berlin (West) (photograph: Jörg P. Anders).

105. Eduard Gärtner: *Parochialstrasse.* Nationalgalerie, Staatliche Museen Preußischer Kulturbesitz, Berlin (West) (photograph: Jörg P. Anders).

106. Carl Blechen: *Sea at Evening.* Oskar Reinhart Foundation, Winterthur.

107. Carl Blechen: *In the Park at Terni.* Georg Schäfer Collection, Schweinfurt.

108. Carl Blechen: *Iron Rolling Mill, Neustadt-Eberswalde.* Nationalgalerie, Staatliche Museen Preußischer Kulturbesitz, Berlin (West) (photograph Jörg P. Anders).

109. Adolph von Menzel: *Musicians and People Talking.* Staatliche Museen, National-Galerie, Berlin (East).

110. Adolph von Menzel: *View over the Gardens of Prince Albrecht's Palace.* Staatliche Museen, National-Galerie, Berlin (East).

111. Gottlieb Schick: *The Sacrifice of Noah.* Staatsgalerie, Stuttgart.

112. Friedrich Overbeck: *The Raising of Lazarus.* Museum für Künst und Kulturgeschichte, Lübeck.

113. Franz Pforr: *Count Rudolph of Hapsburg and the Priest.* Städelsches Kunstinstitut, Frankfurt.

114. Franz Pforr: *The Morning of the Weddings of Shulamit and Maria.* Staatliche Museen, Kupfer-

stichkabinett und Sammlung der Zeichnungen, Berlin (East).

115. Peter von Cornelius: *Faust and Mephisto on the Brocken.* Städelsches Kunstinstitut, Frankfurt.

116. Johann Nepomuk Strixner: Page from *Albrecht Dürer's Christlich-Mythologische Handzeichnungen,* Munich, 1808. Lithograph.

117. Friedrich Overbeck: *Joseph Sold by his Brothers.* Staatliche Museen, National-Galerie, Berlin (East).

118. Peter von Cornelius: *The Reconciliation of Joseph and his Brothers.* Staatliche Museen, National-Galerie, Berlin (East).

119. * Julius Schnorr von Carolsfeld: *The Meeting of Jacob and Rachel.* Wood-engraving from the *Bilder-bibel,* Leipzig, 1855.

120. William Dyce: *The Meeting of Jacob and Rachel.* Kunsthalle, Hamburg.

121. Joseph Anton Koch: *Landscape with St Benedict.* Staatliche Kunstsammlungen, Gemäldegalerie Neue Meister, Dresden (Deutsche Fotothek Dresden).

122. Ferdinand Olivier: *Quarry by the Parish Church of Matzleindorf.* Private Collection.

123. Ferdinand Olivier: *Saturday: The Graveyard of St Peter's Salzburg.* Staatliche Museen, Kupferstich-kabinett und Sammlung der Zeichnungen, Berlin (East).

124. Friedrich Olivier: *Withered Leaves.* Staatliche Museen, Kupferstichkabinett und Sammlung der Zeichnungen, Berlin (East).

125. Julius Schnorr von Carolsfeld: *Friedrich Olivier Sketching.* Albertina, Vienna.

126. Franz Horny: *View of Olevano.* Staatliche Museen, Kupferstichkabinett und Sammlung der Zeichnungen, Berlin (East).

127. Carl Philipp Fohr: *Reward and Punishment.* Staatliche Kunsthalle, Karlsruhe.

128. Carl Philipp Fohr: *Mountain Landscape with Shepherds.* Private Collection, Darmstadt.

129. * Clemens Brentano: *Gackeleia in the Town of the Mice.* Lithograph from *Gockel Hinkel und Gackeleia,* Frankfurt, 1838.

130. Ernst Theodor Amadeus Hoffmann: *Kreisler after he had Gone Mad.* Private Collection.

131. George Cruickshank: *Jorinda and Jorindel.* Etching from *German Popular Stories,* London, 1823.

132. * Eugen Neureuther: *The Fisher.* Lithograph from *Randzeichnungen zu Goethes Balladen,* Munich, 1828.

133. * Alfred Rethel: *How the Queen Had the Hall Burnt Down.* Wood-engraving by W. Nicholl from *Das Nibelungenlied,* Leipzig, 1840.

134. Ludwig Schnorr von Carolsfeld: *The Leap from the Rock.* Georg Schäfer Collection, Schweinfurt.

135. Moritz von Schwind: *The Ride of Kuno von Falkenstein.* Museum der Bildenden Künste, Leipzig.

136. Moritz von Schwind: *The Dream of Erwin von Steinbach.* Staatliche Graphische Sammlung, Munich.

137. Moritz von Schwind: *The Cats' Symphony.* Private Collection.

138. * Wilhelm Busch: *Fuga del Diavolo.* Wood-engraving from *Der Virtuos,* Munich, 1865.

139. Karl Spitzweg: *The Poor Poet.* Nationalgalerie, Staatliche Museen Preußischer Kulturbesitz, Berlin (West) (photograph: Jörg P. Anders).

140. Karl Spitzweg: *Hermit Reading.* National-galerie, Staatliche Museen Preußischer Kulturbesitz. Berlin (West) (photograph: Jörg P. Anders).

141. Moritz von Schwind: *Departure in the Early Morning.* Nationalgalerie, Staatliche Museen Preußischer Kulturbesitz, Berlin (West) (photo-graph: Jörg P. Anders).

142. Moritz von Schwind: *Spirits above the Waters.* Schackgalerie, Munich.

143. * Adrian Ludwig Richter: *The Wind Blows.* Wood-engraving from *Es War Einmal,* Leipzig, n.d.

144. * Adrian Ludwig Richter: Wood-engraving from *The Vicar of Wakefield,* Leipzig, 1857.

145. Adrian Ludwig Richter: *The Watzmann.* Neue Pinakothek, Munich.

146. * Edward Burne-Jones: *Beauty and the Beast.* William Morris Gallery, London Borough of Wal-tham Forest.

147. Peter von Cornelius: Frescoes in the Hall of the Gods, Glyptothek, Munich. Destroyed.

148. Wilhelm von Kaulbach: *The Apotheosis of a Good King.* Bayerische Staatsgemäldesammlungen, Munich.

149. Peter von Cornelius: *The Four Horsemen of the Apocalypse.* Destroyed, formerly National Gallery, Berlin.

150. Ferdinand Theodor Hildebrandt: *The Murder of the Sons of Edward IV.* Kunstmuseum, Düsseldorf.

151. Johann Peter Hasenclever: *Studio Scene.* Kunst-museum, Düsseldorf.

152. Carl Friedrich Lessing: *Hussite Sermon.* Kunst-museum, Düsseldorf.

153. Anon.: *Karl Marx as Prometheus.* Lithograph.

154. Alfred Rethel: *The Artist's Mother.* National-galerie, Staatliche Museen Preußischer Kulturbesitz, Berlin (West) (photograph: Jörg P. Anders).

155. Alfred Rethel: *Choirboy.* Kunstmuseum, Düsseldorf.

156. Alfred Rethel: *St Boniface as Church Builder.* Kunstmuseum, Düsseldorf.

157. * Alfred Rethel: *The Tale of the Burgomeister of Cologne.* Lithograph from *Rheinische Sagenkreis,* Frank-furt, 1835.

158. * Alfred Rethel: *How Iring was Slain.* Wood-engraving by F. Unzelmann from *Das Nibelungenlied,* Leipzig, 1840.

159. Alfred Rethel: *Death as a Folk Hero.* Design for Plate 4 of *Another Dance of Death,* Dresden, 1849. Staatliche Kunstsammlungen, Kupferstichkabinett, Dresden.

160. * Alfred Rethel: *Death as an Avenger.* Wood-engraving by J. Jungtow.

161. * Alfred Rethel: *Death as a Friend.* Wood-engraving by J. Jungtow.

162. Arnold Böcklin: *The Island of the Dead.* Gott-fried Keller Stiftung, Kunstmuseum, Basle.

163. Edvard Munch: *The Lonely Ones.* Woodcut. Munch Museum, Oslo.

Index